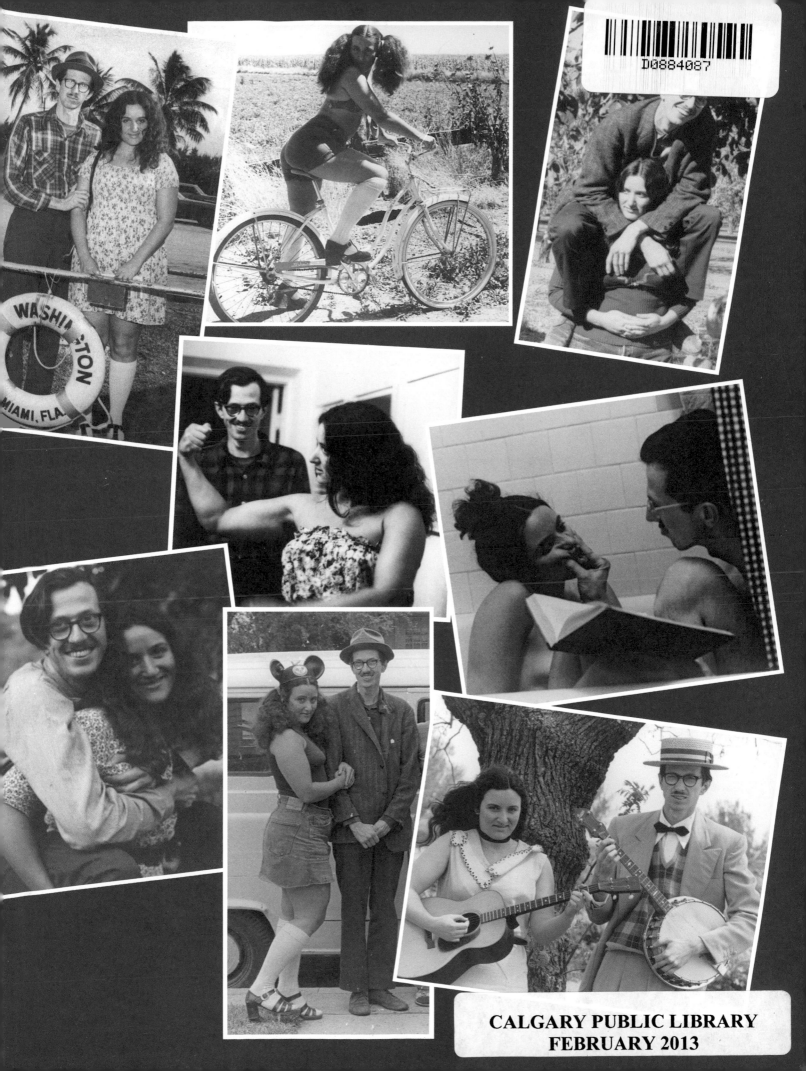

DRAWN TOGETHER

ALINE & R. CRUMB

DRAWN TOGETHER

LIVERIGHT PUBLISHING CORPORATION

A DIVISION OF W. W. NORTON & COMPANY

NEW YORK · LONDON

For information about special discounts for bulk purchases,
please contact W. W. Norton Special Sales at specialsales@wwnorton.com or 800-233-4830

Manufacturing by RR Donnelley, Willard
Production manager: Anna Oler

Library of Congress Cataloging-in-Publication Data

Kominsky-Crumb, Aline, 1948–
Drawn together / Aline & R. Crumb.
p. cm.
ISBN 978-0-87140-429-9 (hardcover)
1. Crumb, R. 2. Kominsky-Crumb, Aline, 1948– 3. Cartoonists—United States—Biography.
I. Crumb, R. II. Title.
PN6727.C7K66 2012
741.5'973—dc23
[B]
2012013566

Liveright Publishing Corporation
500 Fifth Avenue, New York, N.Y. 10110
www.wwnorton.com

W. W. Norton & Company Ltd.
Castle House, 75/76 Wells Street, London W1T 3QT

1 2 3 4 5 6 7 8 9 0

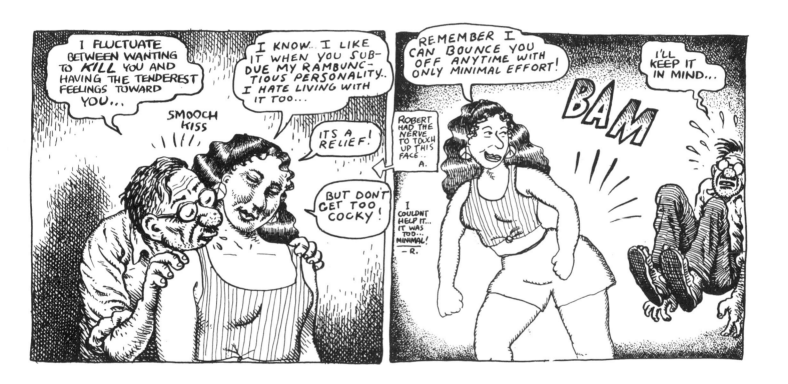

INTRODUCTION
by A. & R. CRUMB

R.: JUST THINK, ALINE, THERE ARE SIX-AND-A-HALF BILLION PEOPLE ON THIS PLANET AND WE—YOU AND I—ARE THE **ONLY COUPLE**, MALE AND FEMALE, WHO DRAW COMICS TO-GETHER. OUT OF SIX-AND-A-HALF **BILLION**, THERE IS NOT A SINGLE OTHER COUPLE WHO DO WHAT WE DO IN THE COMICS MEDIUM. "BABY, HOW CAN IT BE?" (OLD SONG)

A.: I GUESS WE'RE JUST UNIQUE GENIUSES OR SOMETHING, AN' ALSO DON'T FORGET THAT I HAVE A PARTICULARLY MASCULINE MIND, FORCED TO LIVE IN A FEMALE BODY. WE'RE KINDA LIKE TWO OLD CHIMPS JUST THROWING OUR IDEAS BACK AND FORTH.

R.: LIKE TWO CHIMPS NITPICKING EACHOTHER..., YOU **DO** HAVE A FORCEFUL, MASCU-LINE MIND, AND I'M A BIT FEMININE...BORDERLINE **HOMO** EVEN,,,, I'M ATTRACTED TO BIG, POWERFULLY BUILT WOMEN, AND I'M, LIKE, Y'KNOW, A SENSITIVE AESTHETE, RATHER PASSIVE IN MY RELATIONS WITH OTHER HUMANS, INCLUDING YOU. **YOU** ARE THE BOLD, BRAVE ONE. YOU'LL GO ANYWHERE AND EAT ANYTHING. YOU CAN BANTER WITH ROUGH WORKING MEN AND HARD-NOSED BUSINESSMEN. I'M AFRAID OF SUCH MEN. WELL, IN FACT I'M JUST AFRAID OF PEOPLE. STILL, IT STRIKES ME AS STRANGE THAT WE'RE THE ONLY COUPLE DOING COMICS TOGETHER THE WAY WE DO. WE MIGHT BE ECCENTRIC GE-NIUSES AND WHATNOT, BUT IT DOESN'T SEEM **THAT** ODD A THING TO BE DOING.

A.: I GUESS COMICS IN GENERAL ARE REALLY HARD TO DO, A LOT OF TEDIOUS WORK, AND DOING THEM TOGETHER CREATES MORE COMPLICATIONS AND BEING A CARTOONIST JUST ISN'T VERY "SEXY." YOUNGSTERS WOULD RATHER BE "GRAPHIC DESIGNERS." YA KNOW, ALL THOSE UPSTARTS WHO FUCK WITH OUR HAND-DRAWN ART WITH THEIR GHODDAMNED PHOTOSHOP SHIT... THAT'S MUCH MORE FUN AND COOL THAN WRITING AND DRAWING WITH STUPID OLD PENCILS AND PENS... AN' PLUS MOST COUPLES I KNOW GET ON EACH OTHER'S NERVES IF THEY'RE TOGETHER TOO MUCH. AN' PLUS THEY'RE COMPETITIVE AND INSECURE... IT WOULD BE A BIG DRAG TO SHARE THE SAME LITTLE PANEL...

R.: IT'S TRUE THAT COMICS ARE A LOT OF WORK IN PROPORTION TO THE FINANCIAL REWARD. RIGHT THERE YOU'RE GONNA LOSE MOST ASPIRING ARTISTIC TYPES, SO THAT NARROWS THE FIELD CONSIDERABLY. THEN, AS YOU SAY, FEW COUPLES CAN ACTUAL-LY WORK TOGETHER ON ANY CREATIVE ENDEAVOR, WHATEVER IT MIGHT BE. SOMEHOW, BY SOME MIRACLE, THAT HAS NEVER BEEN A PROBLEM FOR US. SO I GUESS THAT E-LIMINATES EVERYONE IN THE WORLD EXCEPT US! INCREDIBLE...WHAT A DISTINC-TION! BUT THEN, SAYING THAT, IT SUDDENLY OCCURS TO ME, HM, MAYBE WE'RE JUST EXCEPTIONALLY FOOLHARDY AND, Y'KNOW, TOTALLY **LAME!**

A.: ANYTHING YOU LOOK AT CLOSELY, QUICKLY BECOMES COMPLETELY LAME. YUMANS ARE, LIKE, JUST A TAD PATHETIC AS A SPECIES. BUT THAT DOESN'T STOP MOST OF THEM FROM MAKING AND DOING THE MOST IDIOTIC THINGS IMAGINA-BLE. WHY SHOULD YOU AND ME BE ANY DIFFERENT? WHY WORRY? I DON'T GIVE A SHIT... THE PUBLIC NEVER LIKED ME ANYWAY... RECENTLY ON A BLOG SOMEONE CALLED ME A "TALENTLESS PARASITE." HEY, I COULD USE THAT AS THE TITLE OF MY NEXT BOOK... HA HA... IT'S ALL GRIST FOR THE MILL!

R. : YOU'RE RIGHT, YA CAN'T WORRY ABOUT IT TOO MUCH. YOU CAN FRET YOURSELF RIGHT OUT OF DOING **ANYTHING!** I'VE SEEN MANY CASES OF THAT. THE WORST THING YOU CAN FALL INTO IS THINKING YOU HAVE TO BE **DEEP** OR **PROFOUND** IN YOUR WORK, AND BEING AFRAID TO APPEAR **DUMB, UNHIP, UNCOOL.** BECAUSE, AS YOU SAY, WHEN IT COMES DOWN TO IT, MOST HUMAN ENDEAVORS ARE —— NEVERMIND, I DON'T WANT TO SOUND TOO NEGATIVE OR, GOD FORBID, INSULT OUR DEAR READERS.

A. : I USED TO WORRY ALL THE TIME, BUT IT WAS MOSTLY ABOUT WHAT I'D DONE THE NIGHT BEFORE WHEN I WAS DRUNK. I CAN GET EMBARRASSED FAST IF I THINK BACK TO SOME OF THE SHIT THAT I DID... OY VEH!! I'M SLIGHTLY LESS ANGST RIDDEN NOW, I DON'T CARE ABOUT PUBLIC RECOGNITION, I'M SOBER AND LUCID AND I EXPERIENCE ECSTASY EVERY ONCE IN AWHILE IN MY YOGA PRACTICE. I LOOK AT OUR GRANDSON AND I SEE HOW HAPPY HE IS TO BE ALIVE, SO THERE'S GOTTA BE SOMETHING POSITIVE ABOUT OUR SORRY-ASSED SELVES.

R. : THAT LITTLE GUY'S SMILE LIGHTS UP THE WORLD, IT'S CERTAINLY TRUE. AND I MUST TELL YOU, ALINE, IT'S BEEN UPLIFTING TO WITNESS THE POSITIVE PATH YOU'VE TAKEN IN YOUR OLD AGE. YOU'RE REALLY ON TO SOMETHING WITH THAT YOGA STUFF. SO, YOU KNOW, I DON'T HAVE TO WORRY ABOUT YOU. YOU DON'T, Y'KNOW, **WEIGH** ON MY MIND.

A.: YEAH, BUT DO YOU **LIKE** ME?? LIKE I STILL LIKE YOU, YA KNOW WHAT I MEAN?!? IN FACT I'M STILL DEEPLY ATTRACTED TO YOU IN SOME CRAZY WAY...

R. : REALLY? WHEW! THANK GOD!

A.: ... AND I'M GLAD I GOT TO DRAW MYSELF GIVING YOU MY NEW YOGA-IMPROVED BLOW JOB IN OUR LATEST STORY...

R. : TEE HEE GIGGLE CHORTLE... IT'S AN IMPRESSIVE FEAT, I MUST SAY! WELL, I GUESS THAT BRINGS US FULL CIRCLE, BACK TO WHERE WE STARTED IN 1972, EXPOSING OUR CRAZY SEX LIFE TO ALL THE WORLD. DO YOU HAVE ANYTHING MORE TO SAY, ALINE? D'YOU THINK THERE ARE ENOUGH BOOKS IN THE WORLD ALREADY?

A. : BOOKS KEEP THE JERKS OFF THE STREETS AND OUTTA TROUBLE... GOTTA HAVE 'EM ... EVEN IF THEY SOMETIMES FOMENT REVOLUTION!

R.: ONE MORE THING... WE HAVE TO ACKNOWLEDGE THE PARTICIPATION OF OUR GENIUS DAUGHTER SOPHIE IN A COUPLE OF THESE STORIES. ESPECIALLY GOOD IS HER PART IN "DON'T TALK WITH YER MOUTH FULL" (2008).

A.: YEAH, WE'RE ALL GOOD AT EXPRESSING OUR **ANGST** IN THIS FAMILY AN' WE HAVE PLENTY OF IT. IT'S ONE O' THE THINGS WE'VE MANAGED TO SUCCESSFULLY TRANSMIT TO THE NEXT GENERATION.

— AUGUST 2011

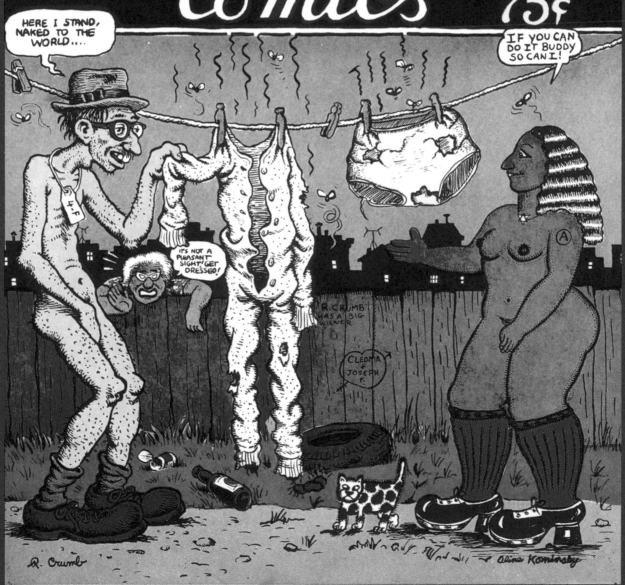

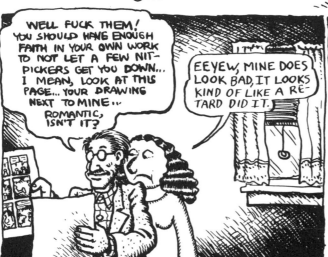

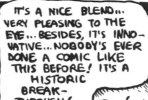

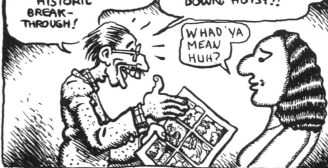

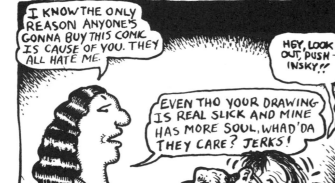

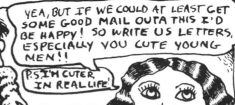

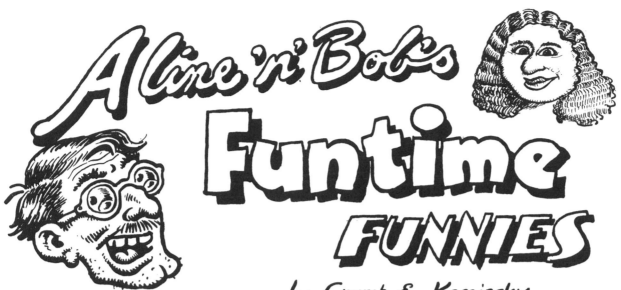

Aline 'n' Bob's Funtime FUNNIES

by Crumb & Kominsky

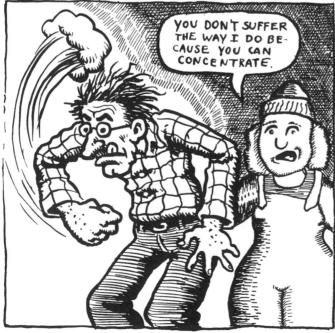

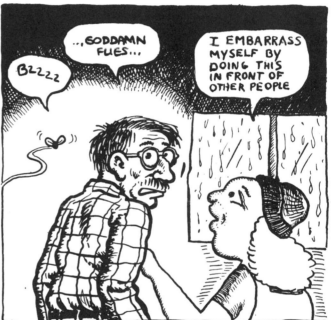

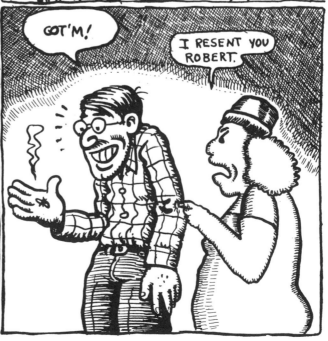

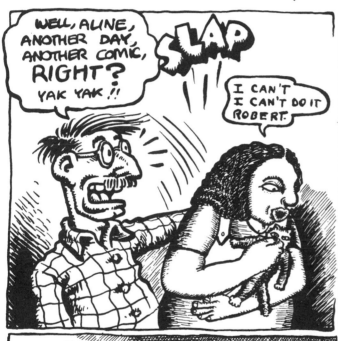

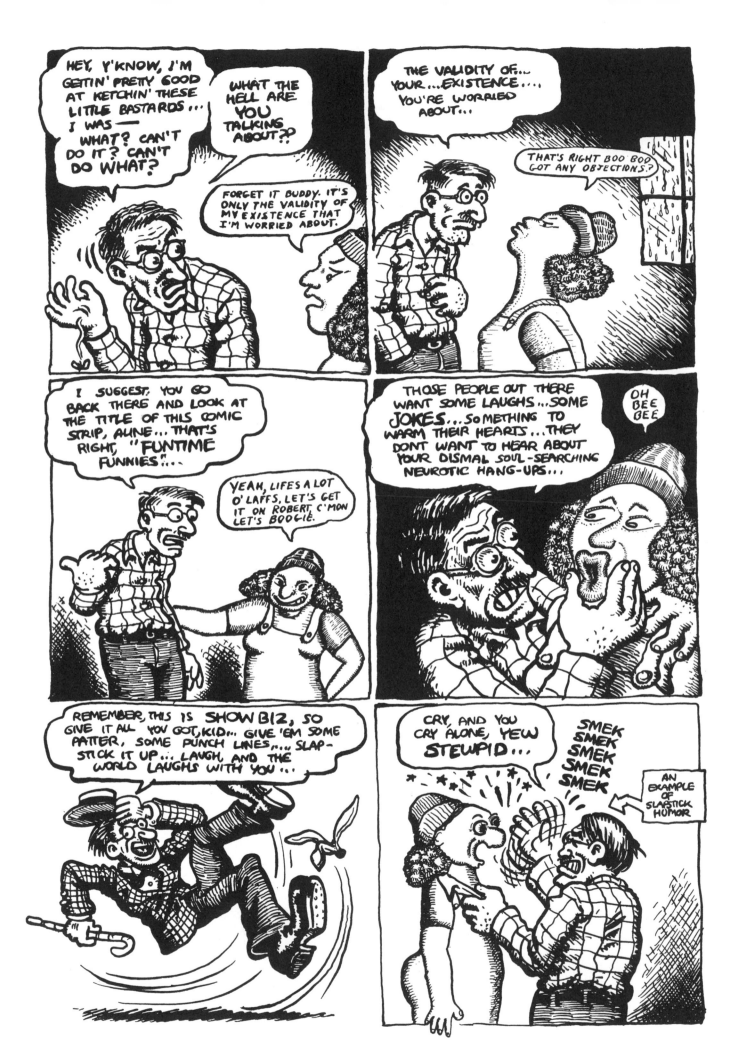

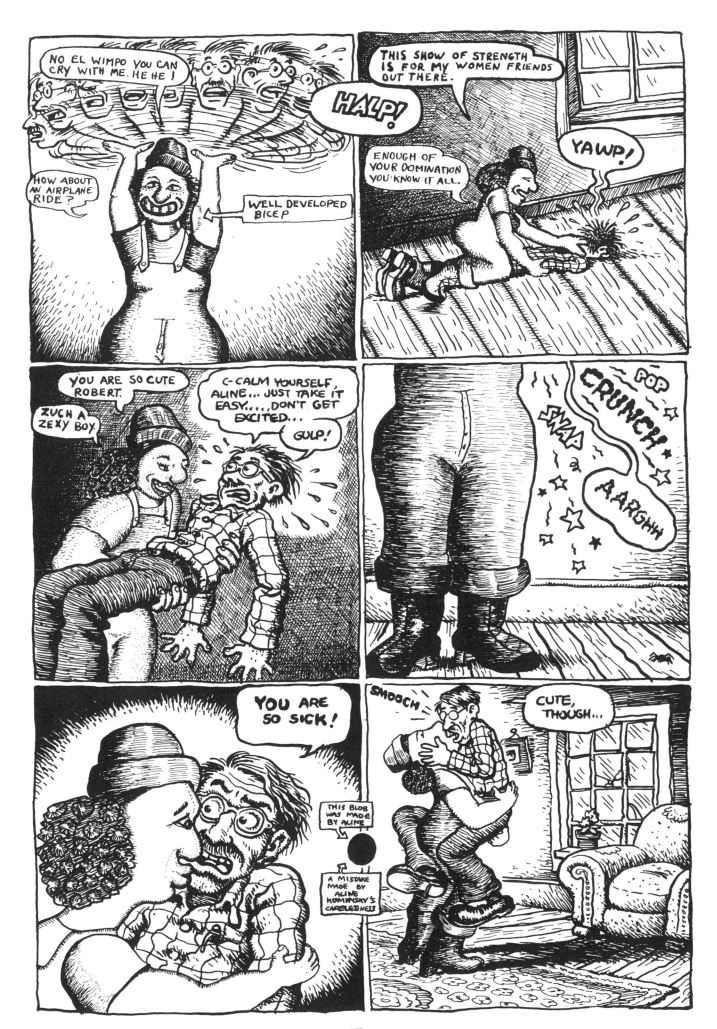

13

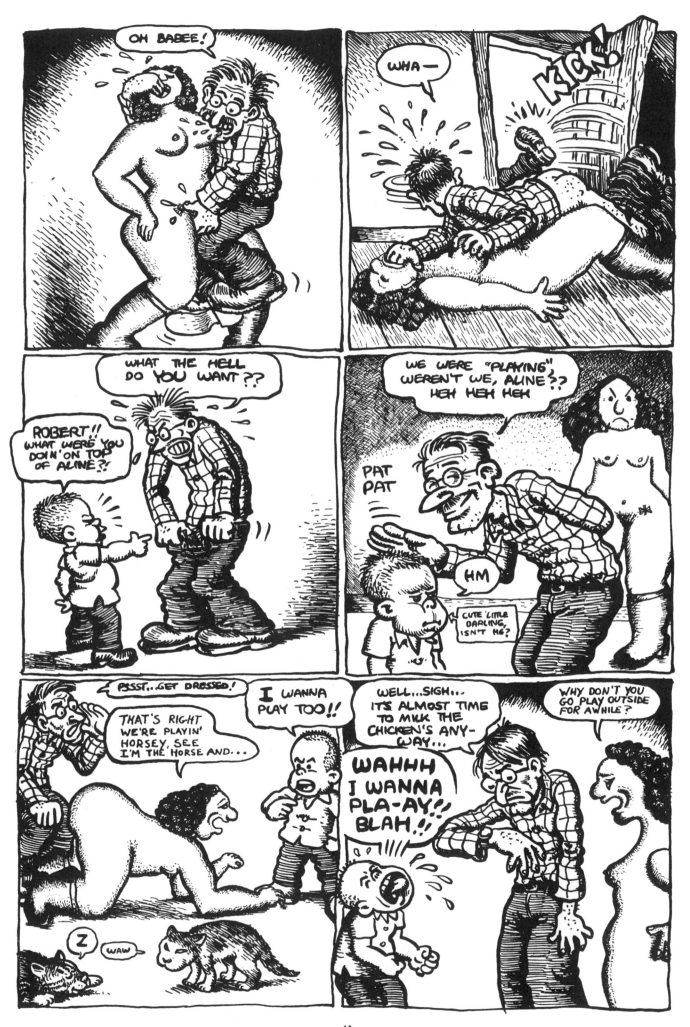

14

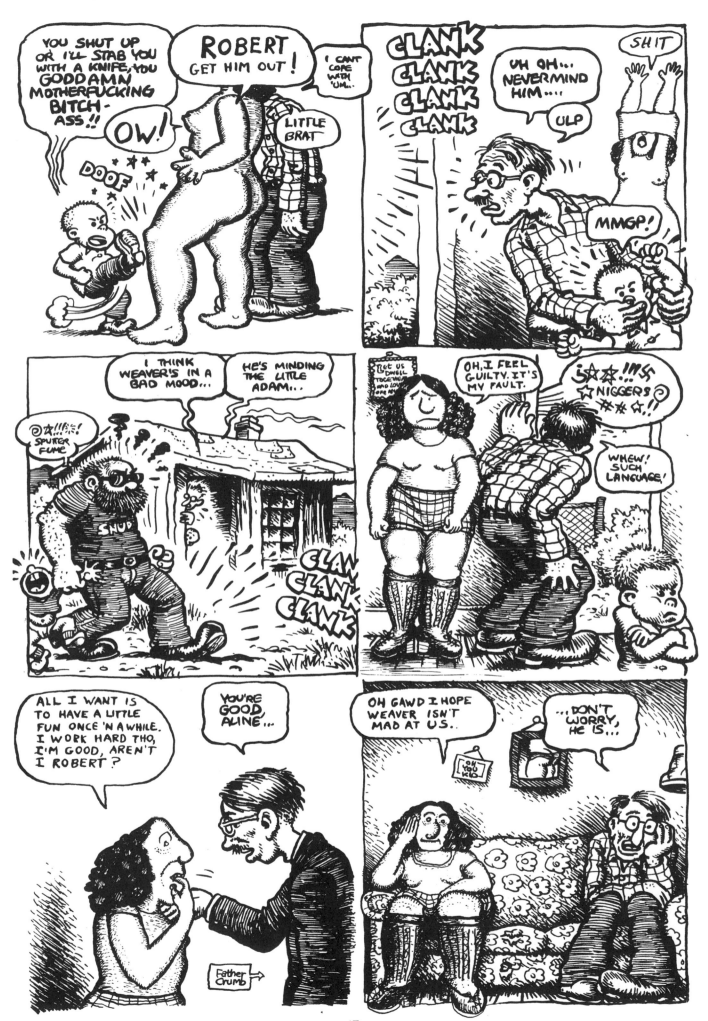

15

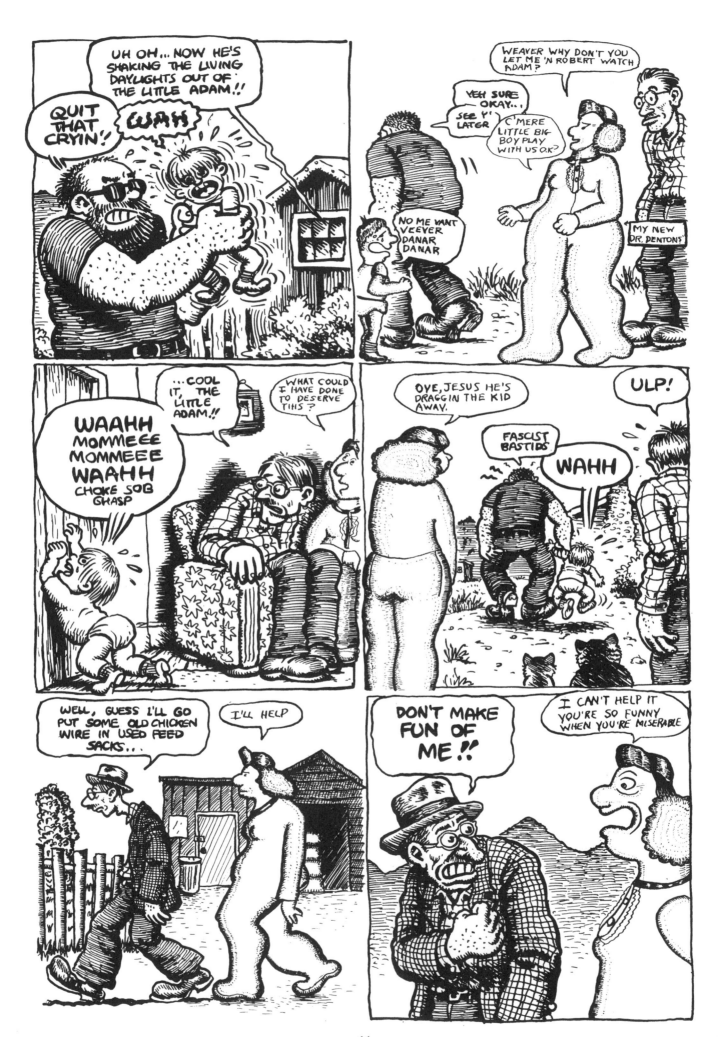

16

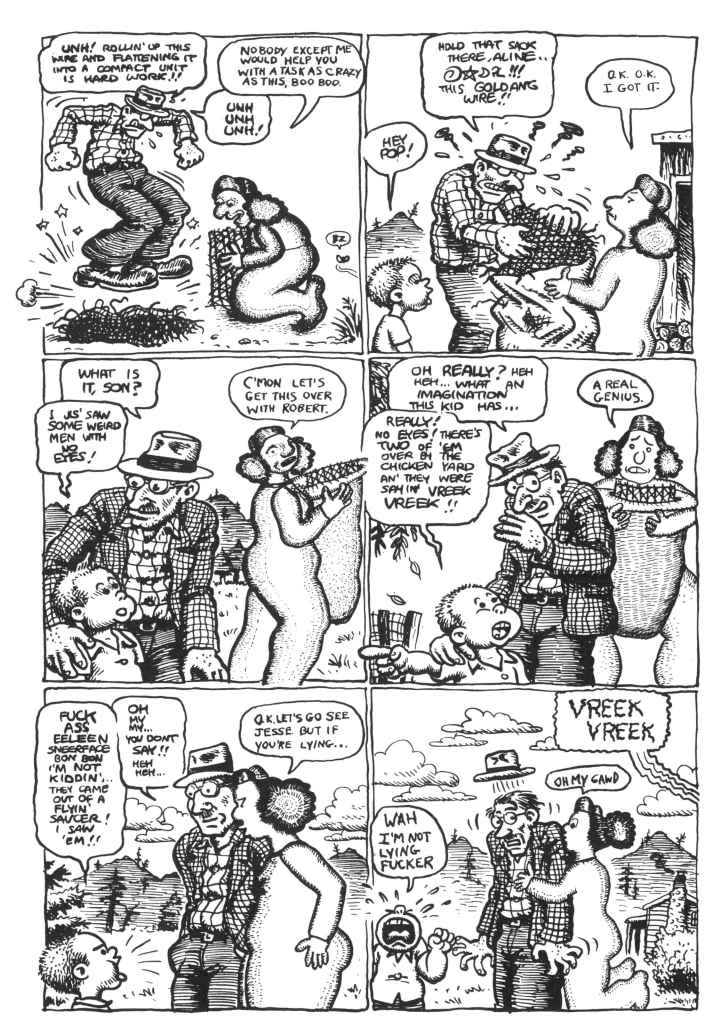

17

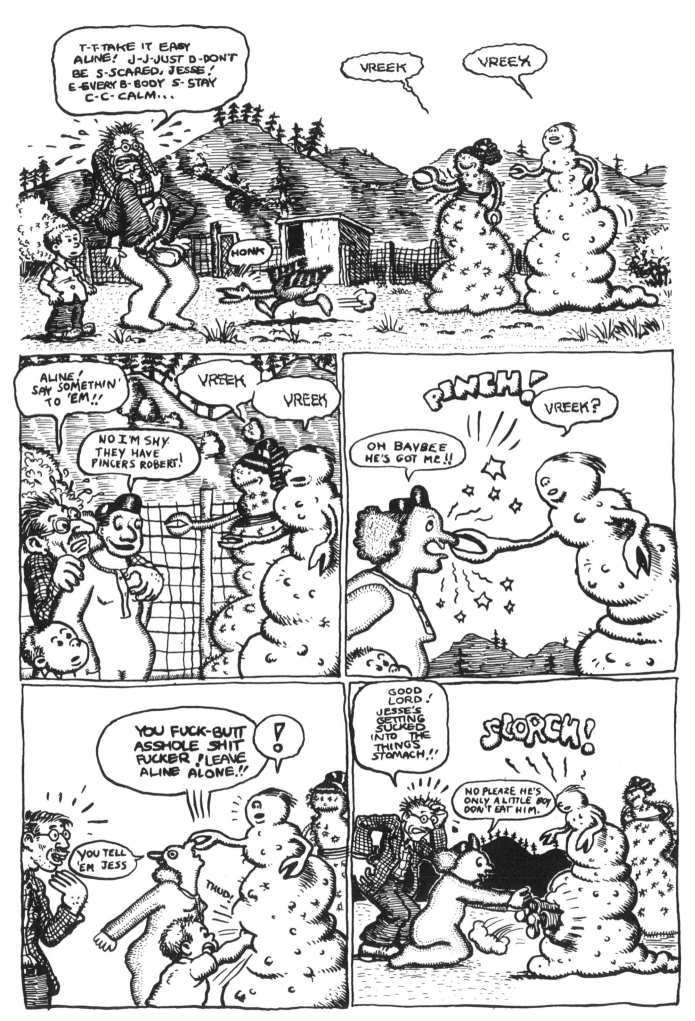

18

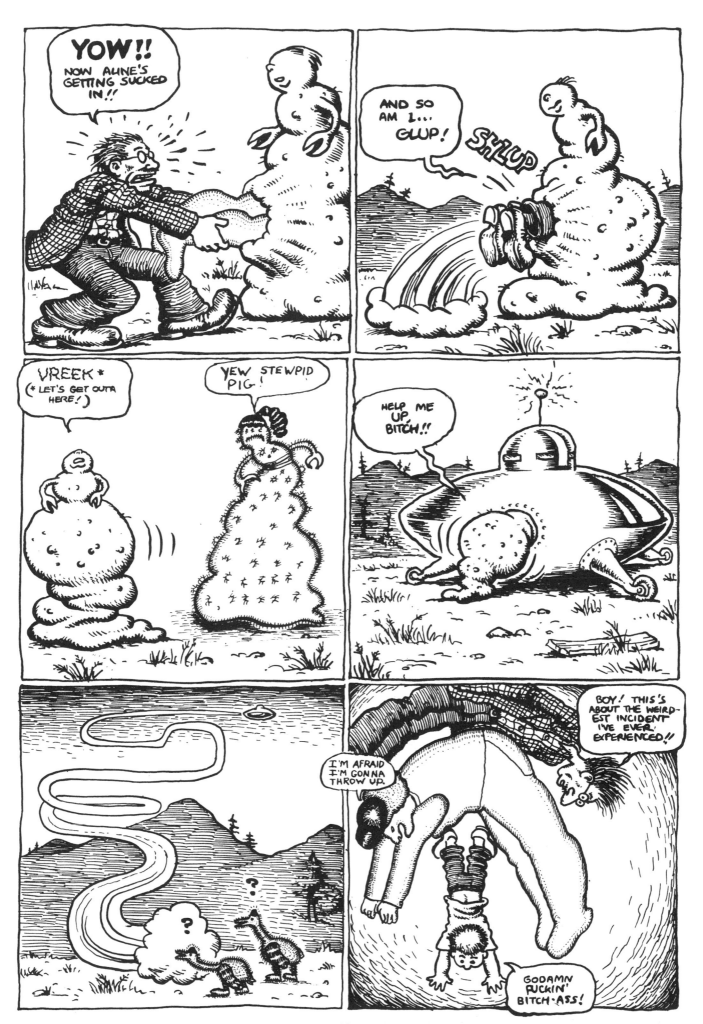

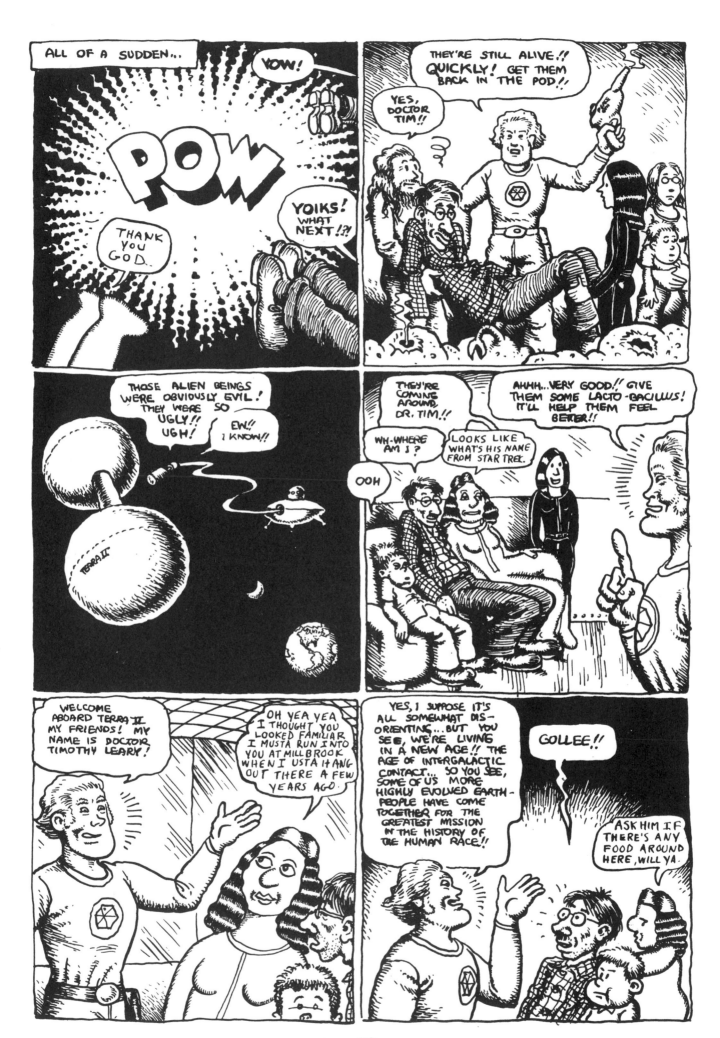

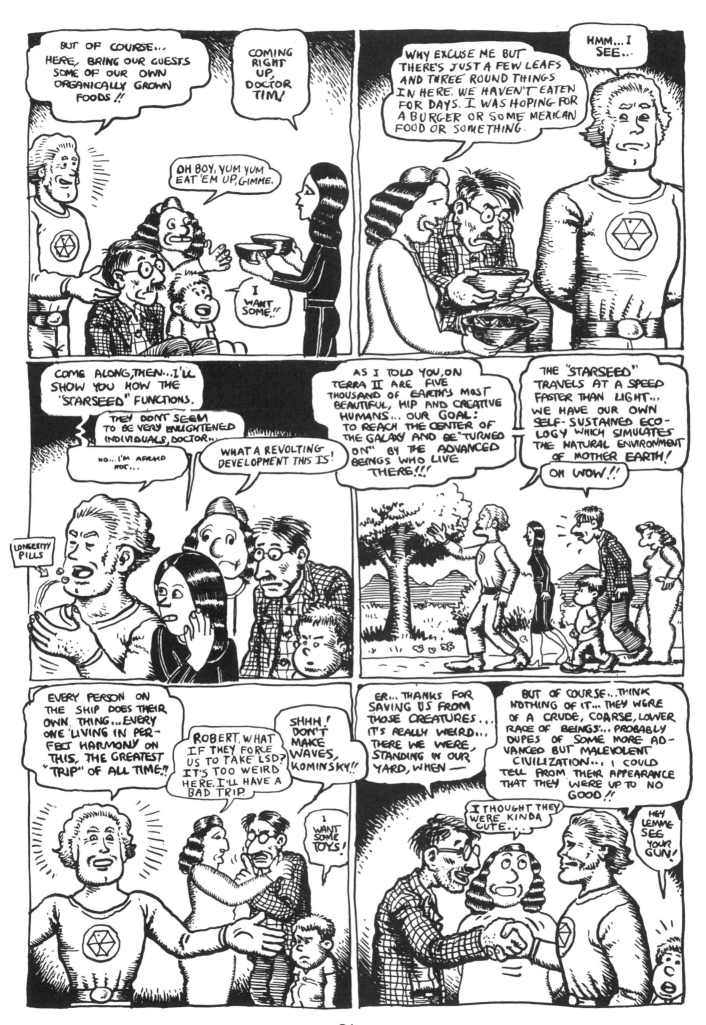

21

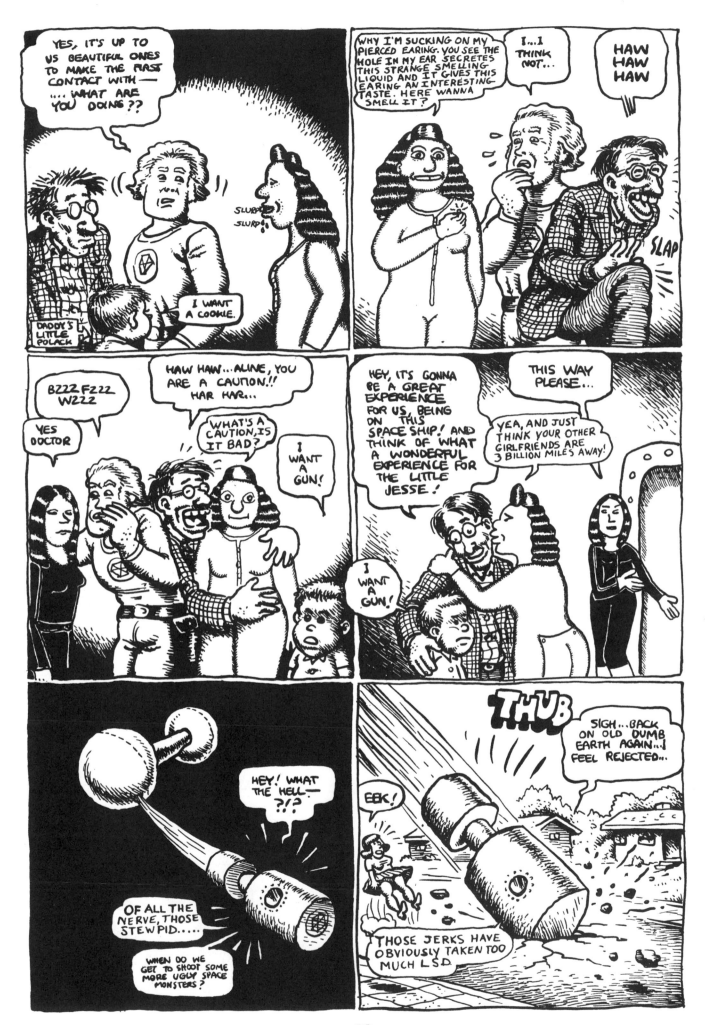

22

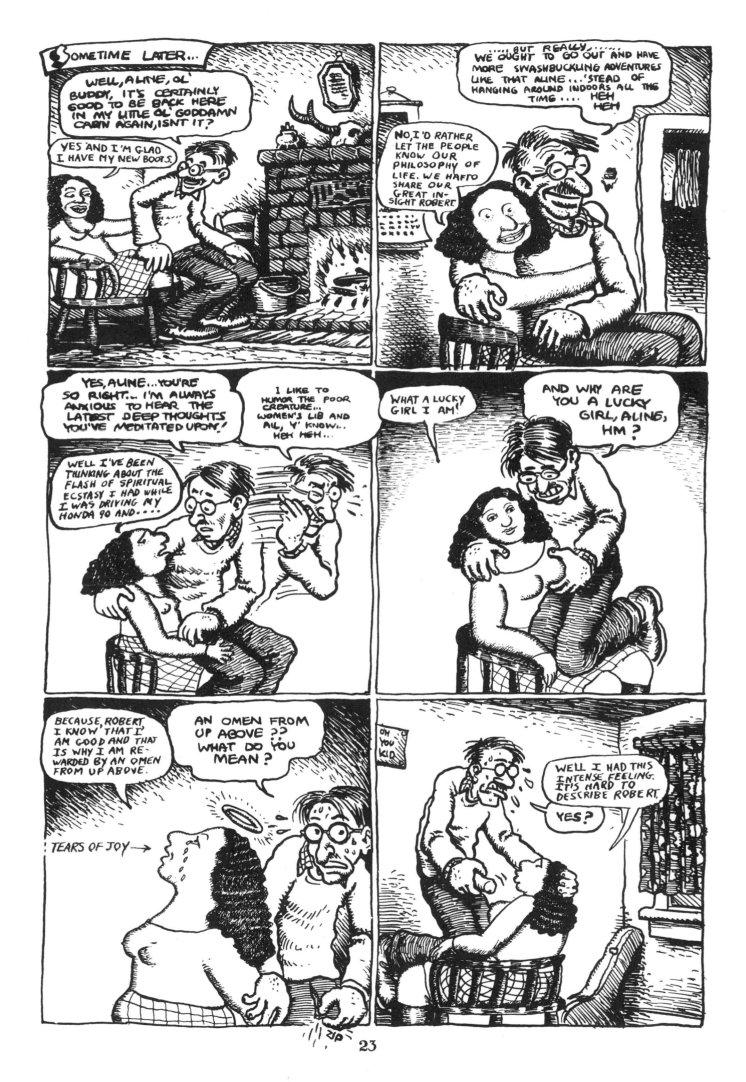

23

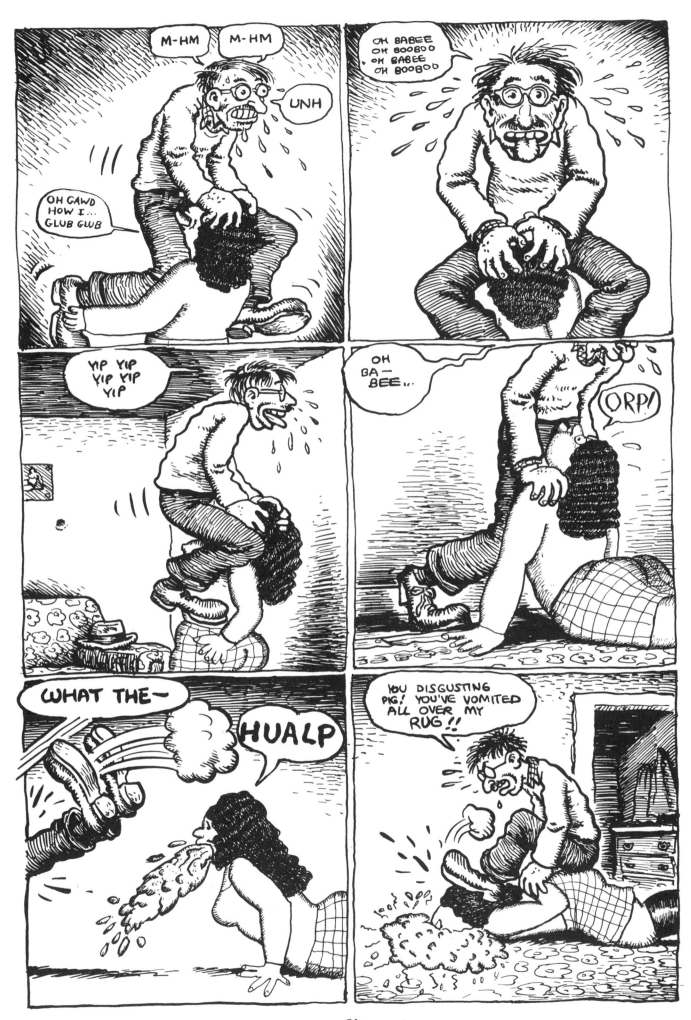

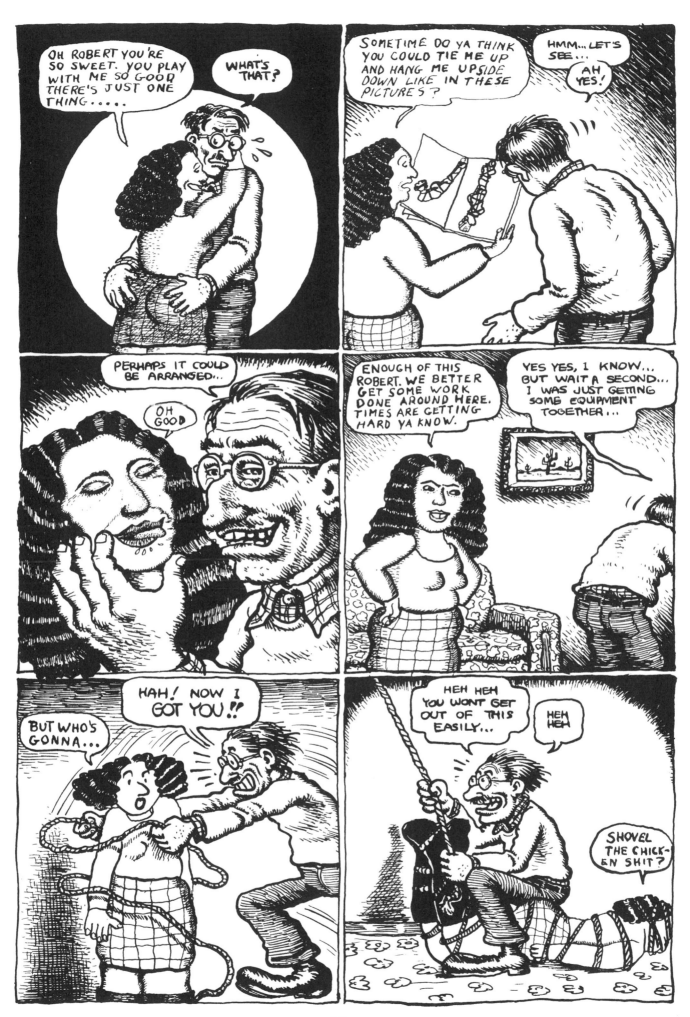

25

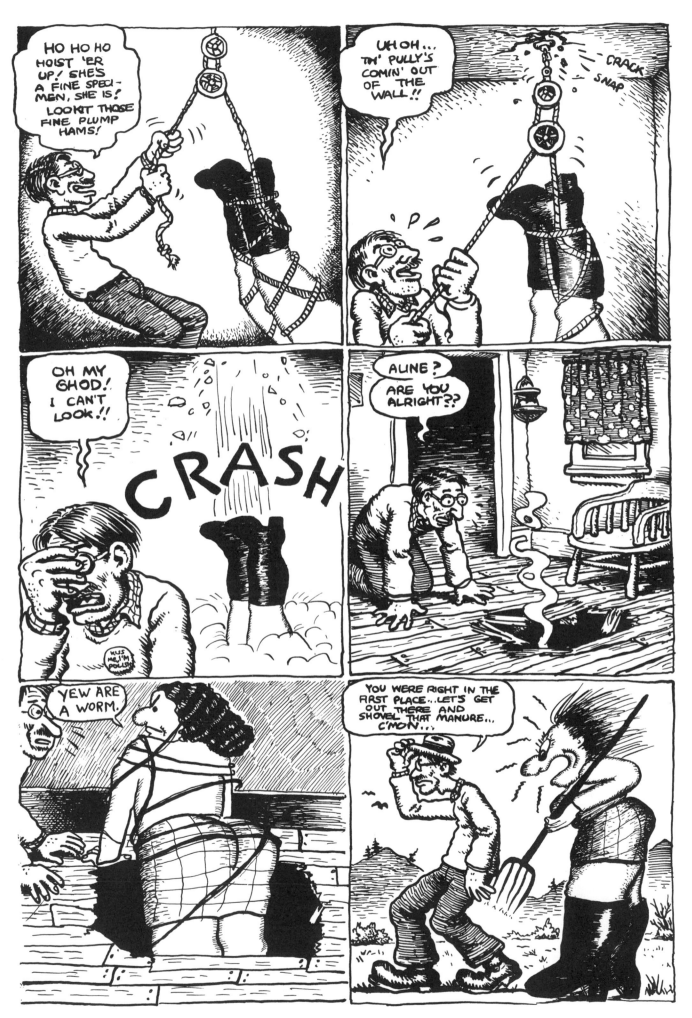

26

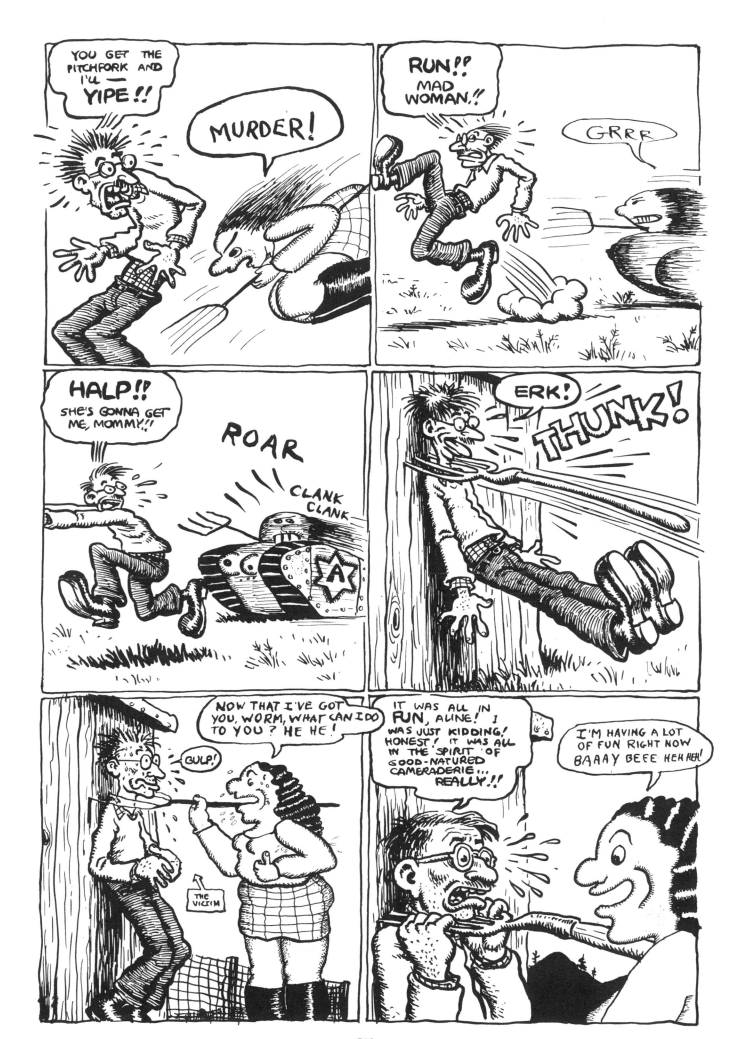

27

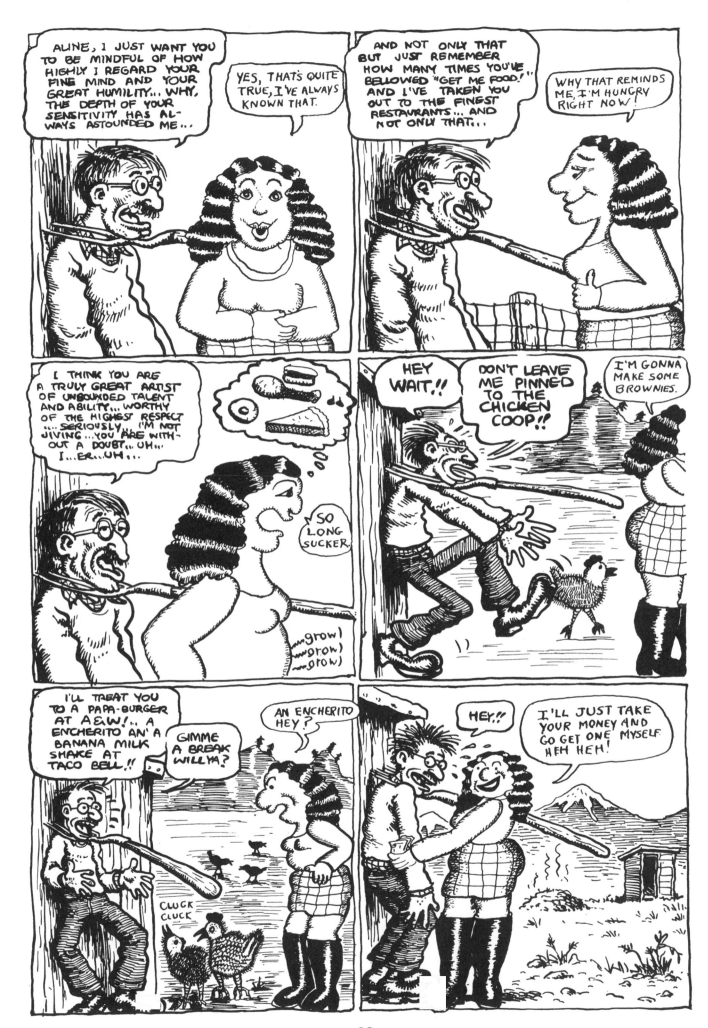

28

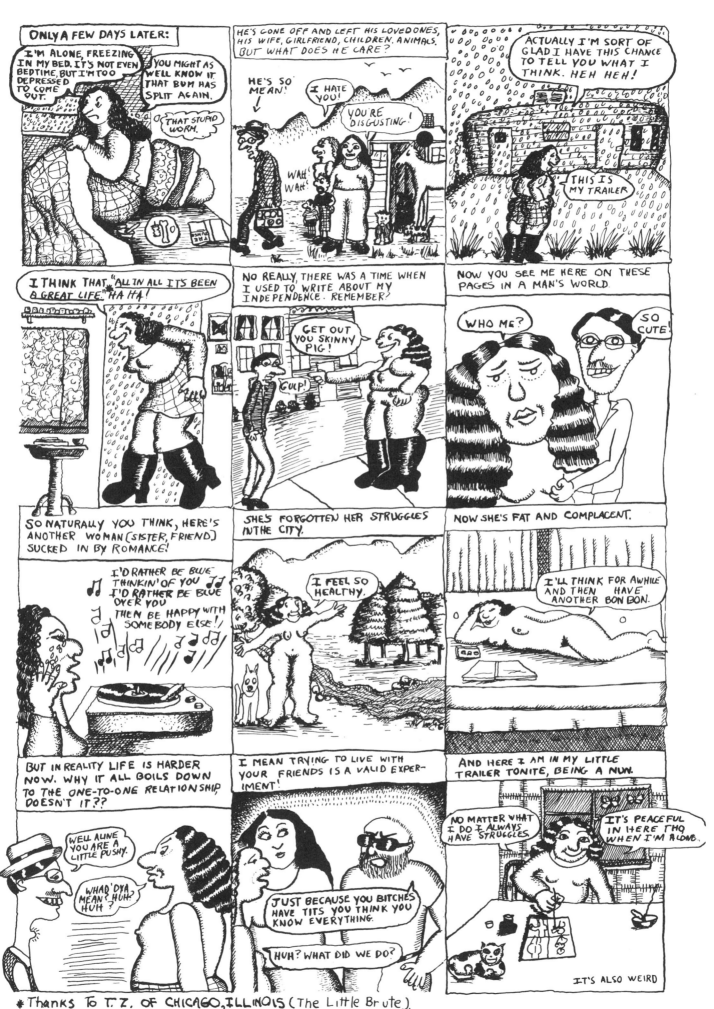

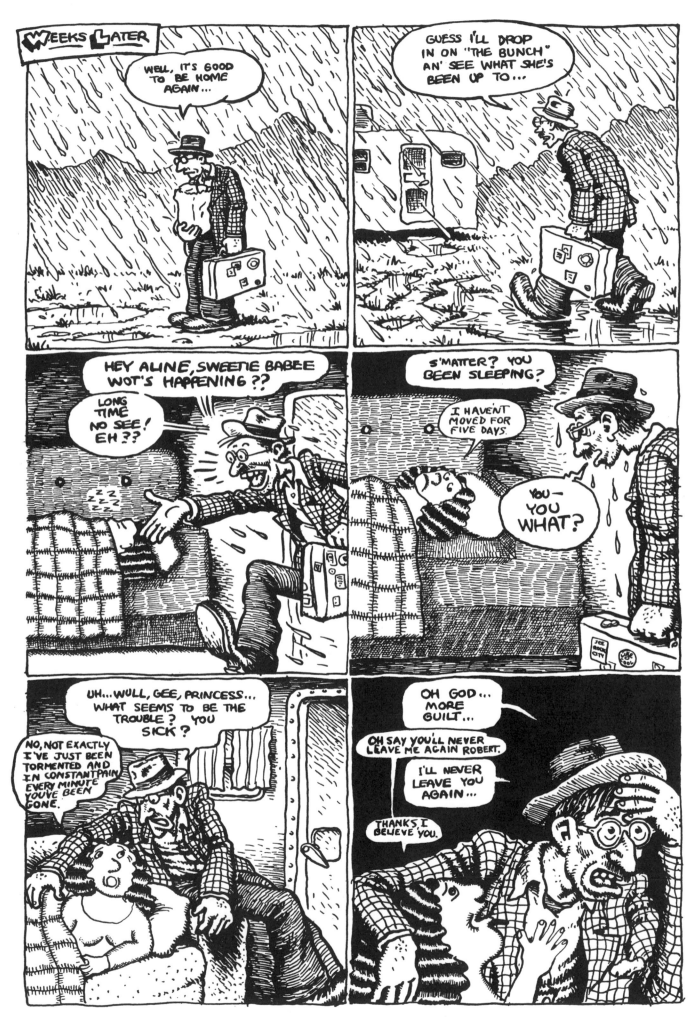

30

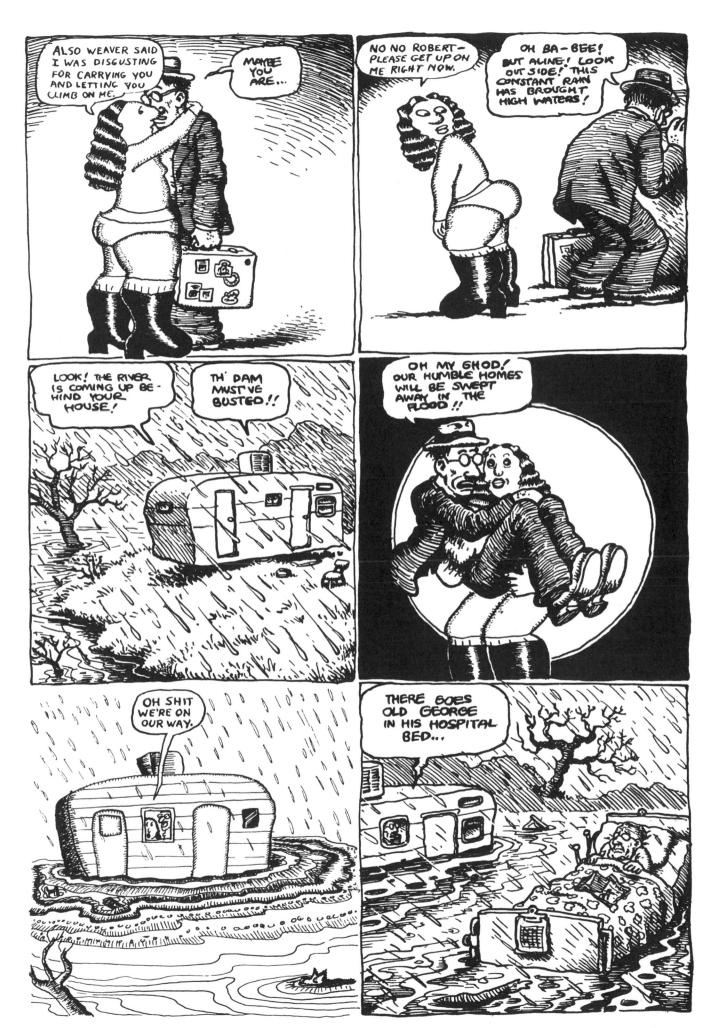

31

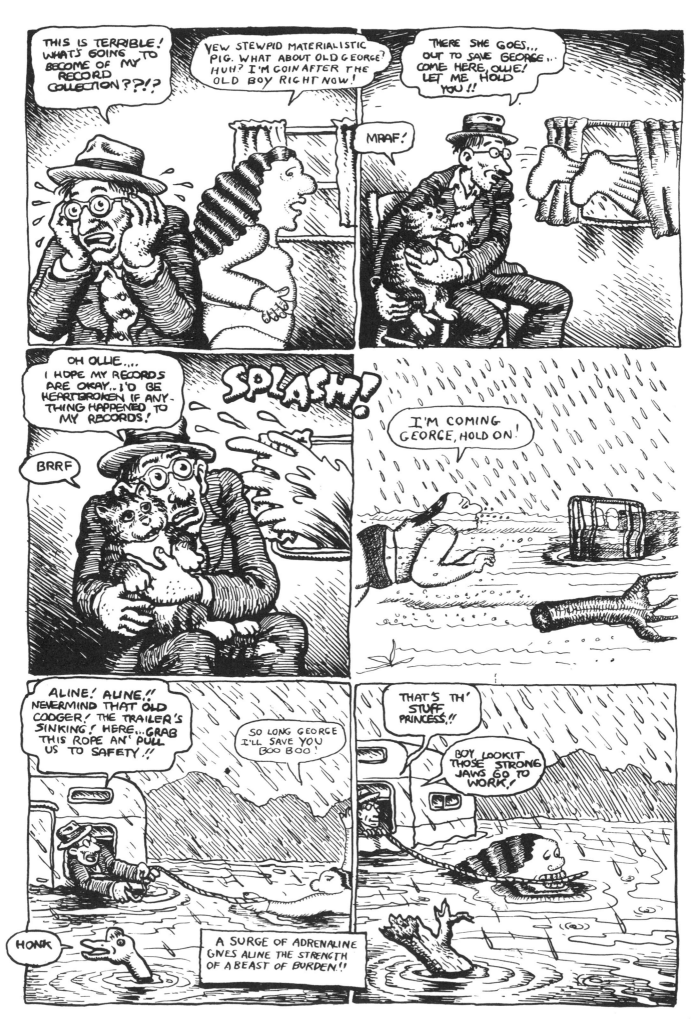

32

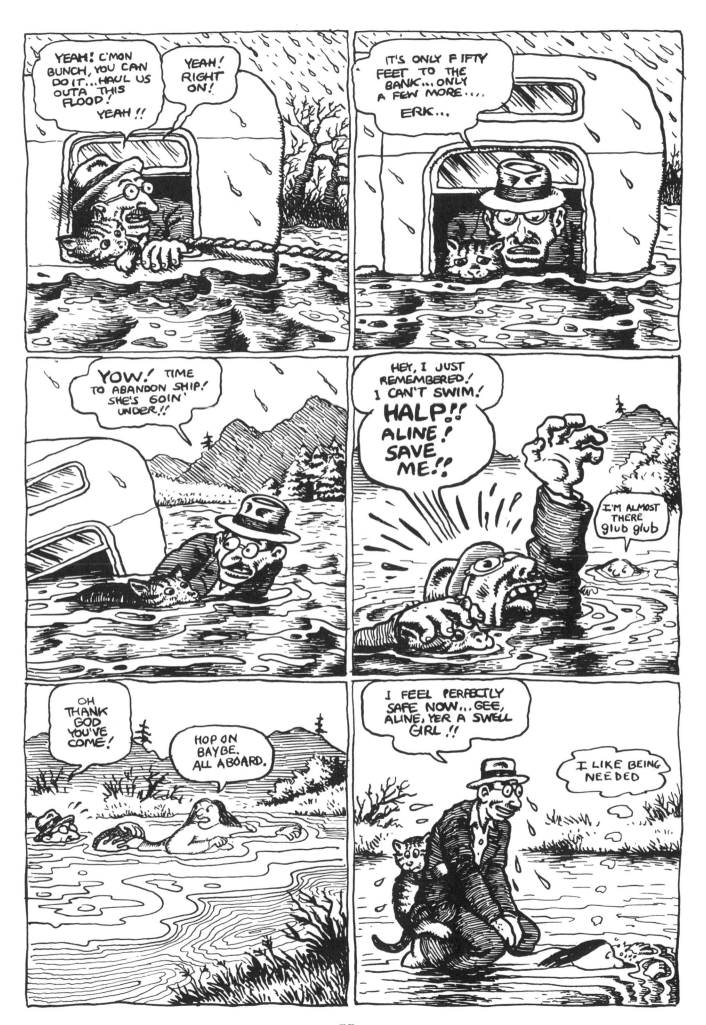

33

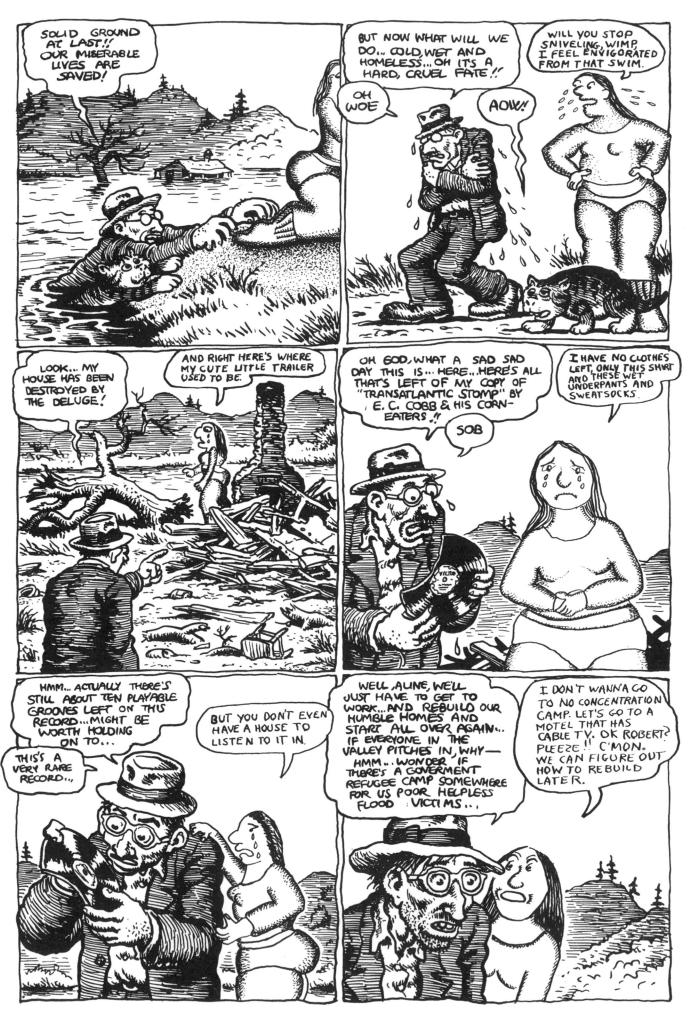

34

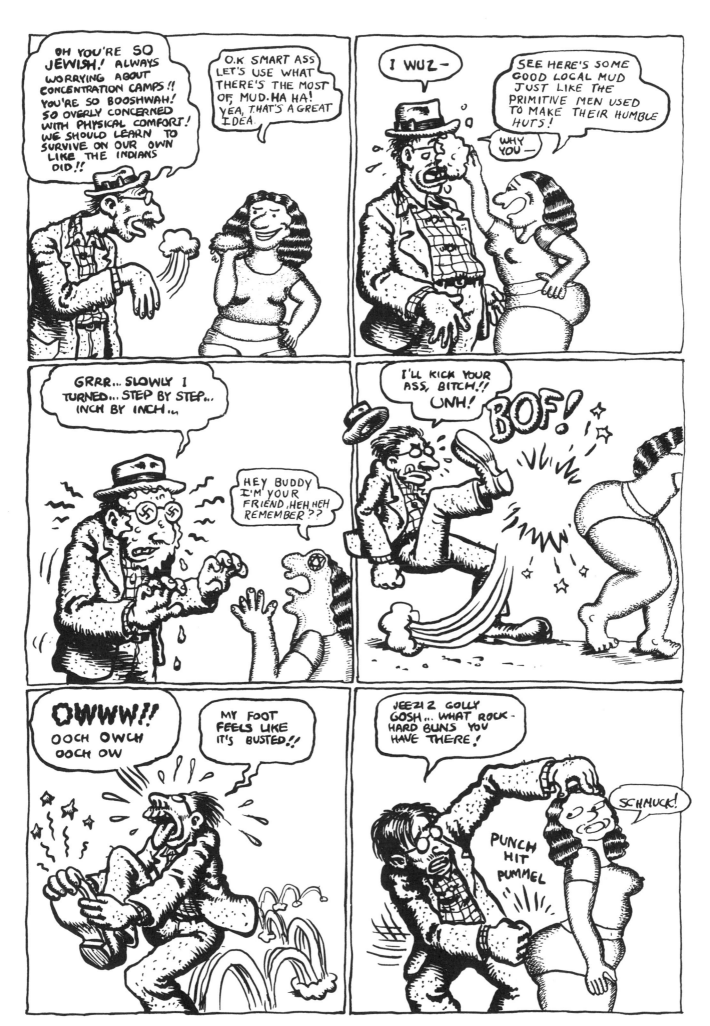

35

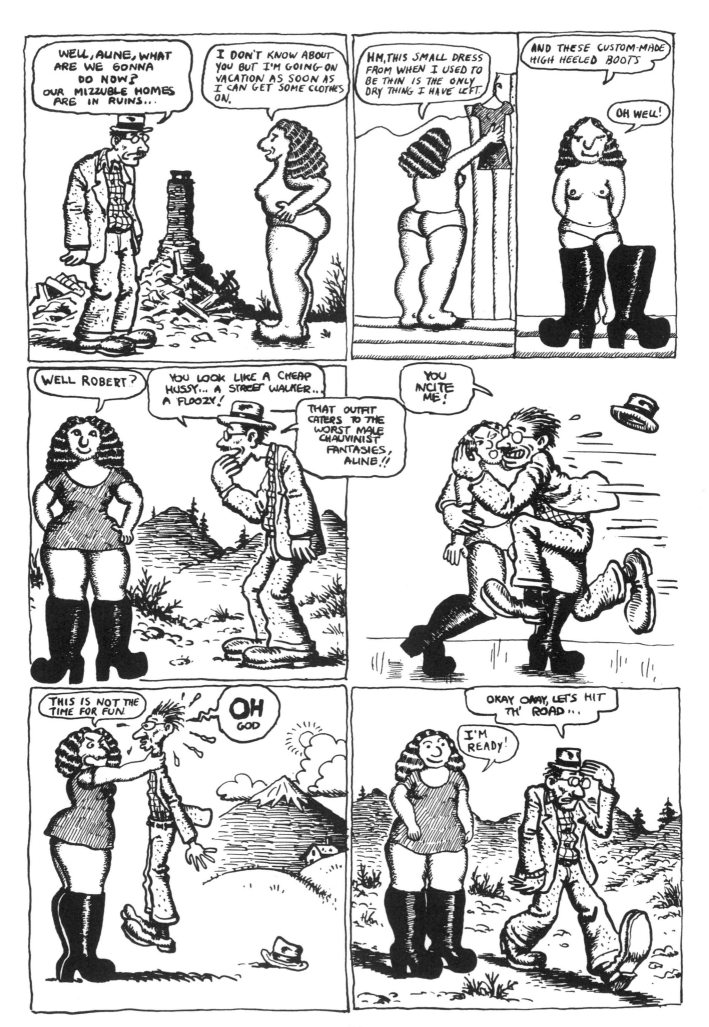

36

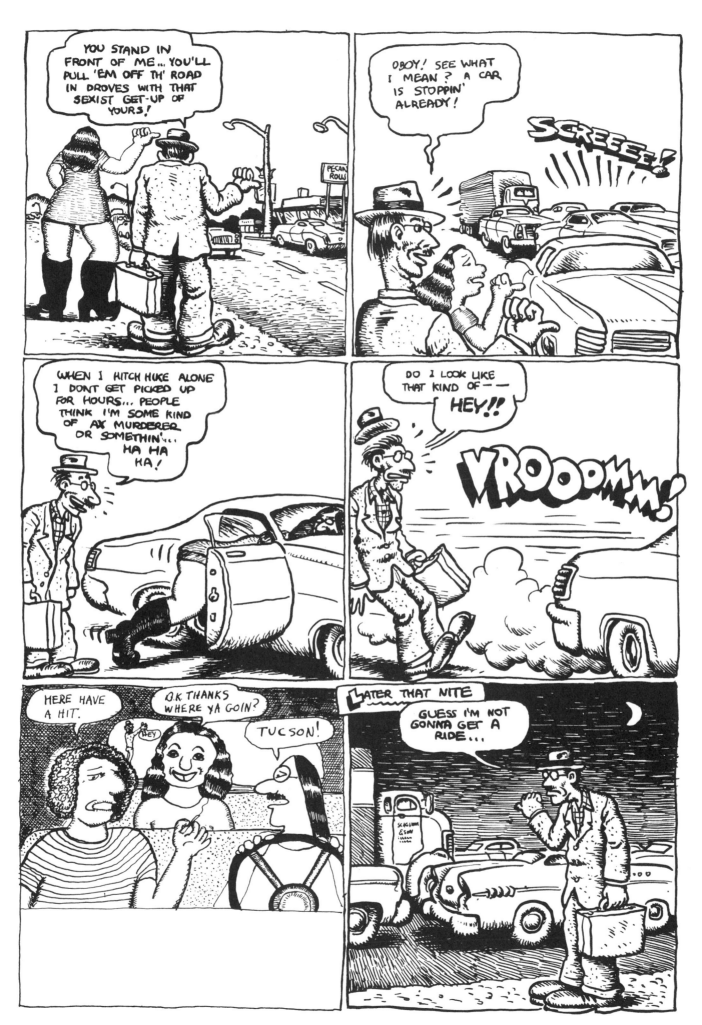

37

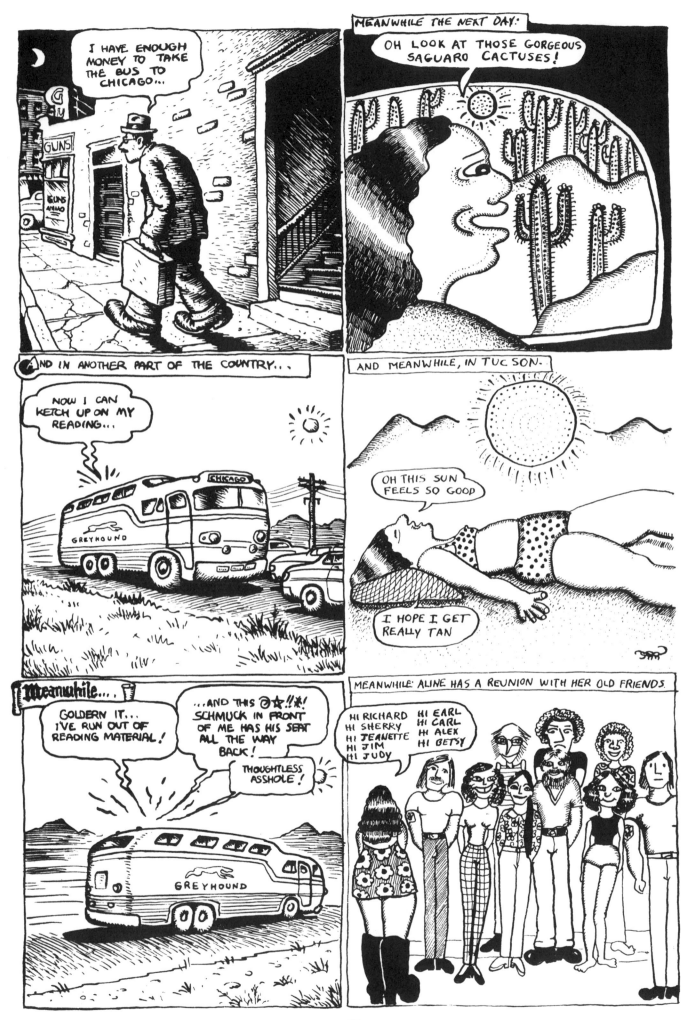

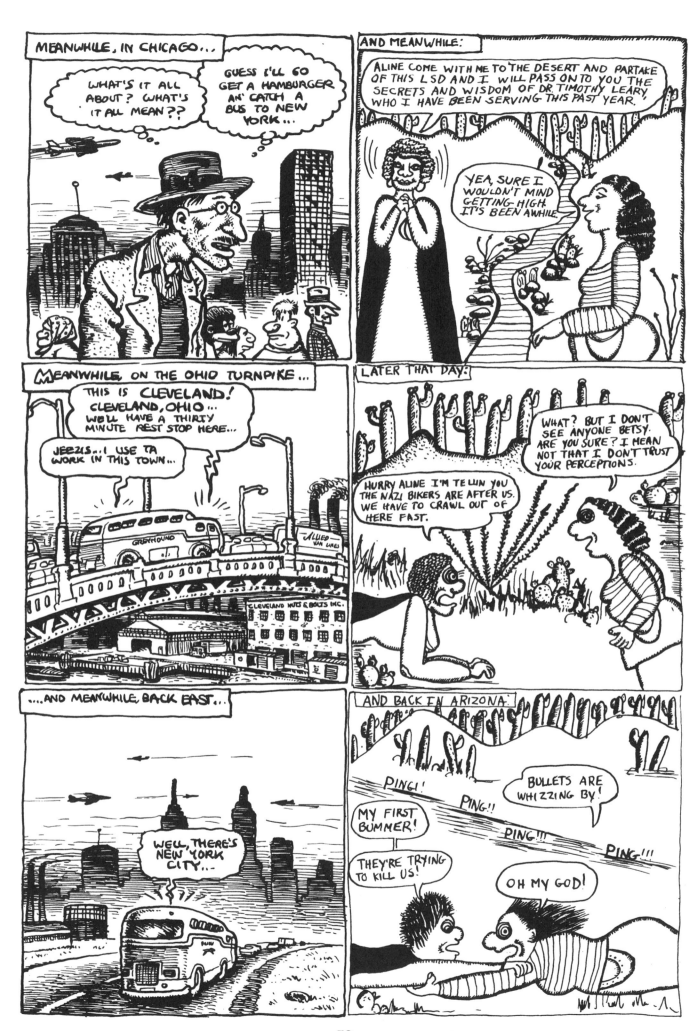

39

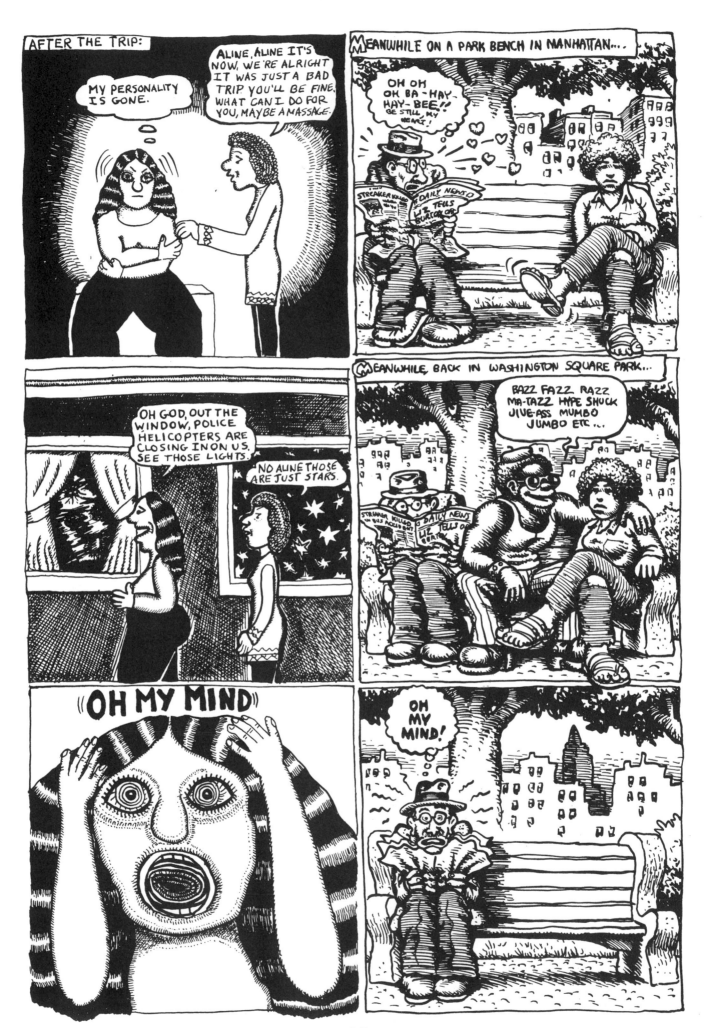

40

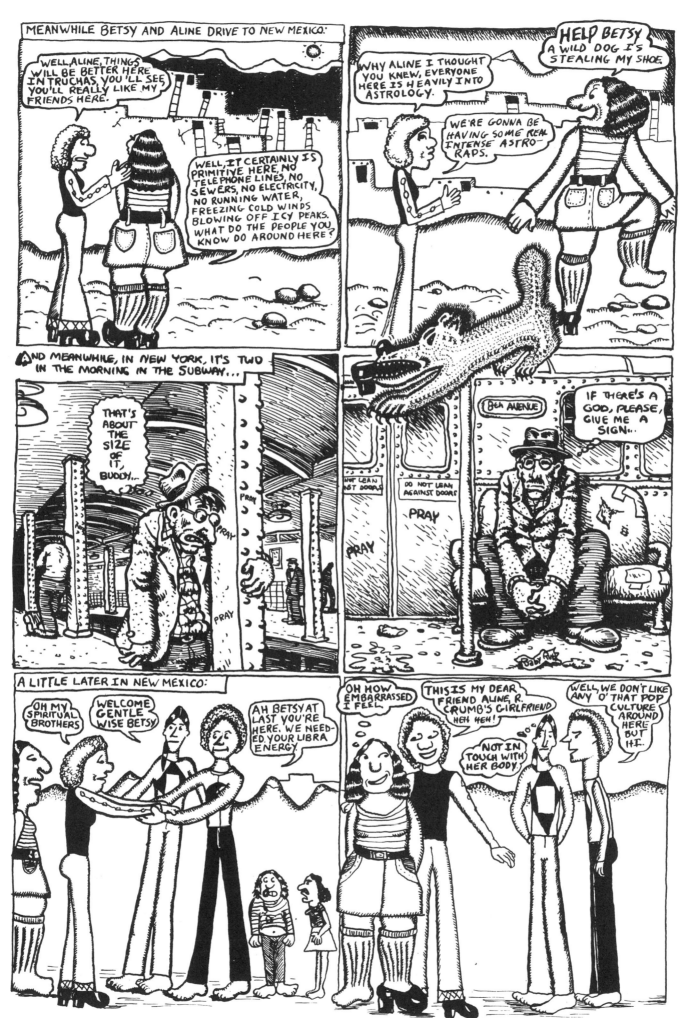

41

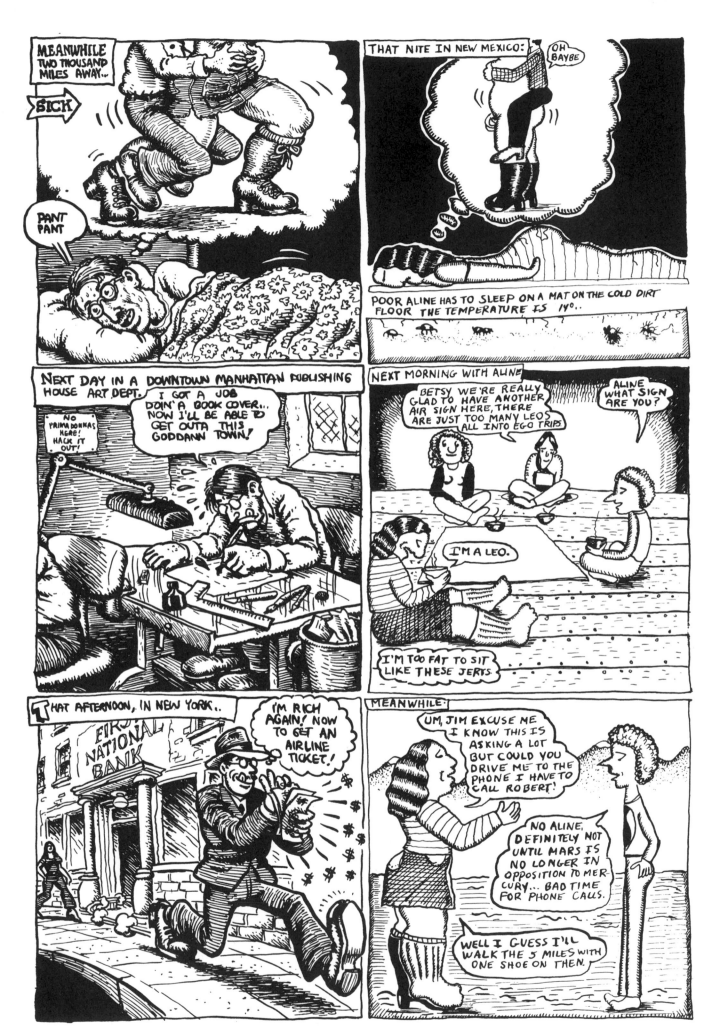

42

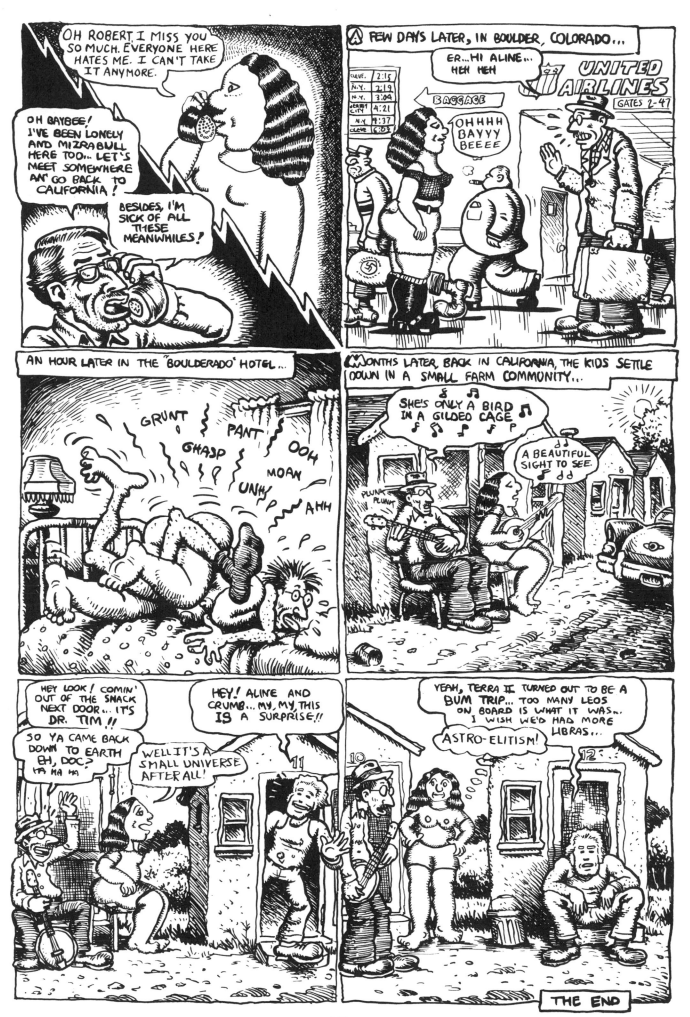

43

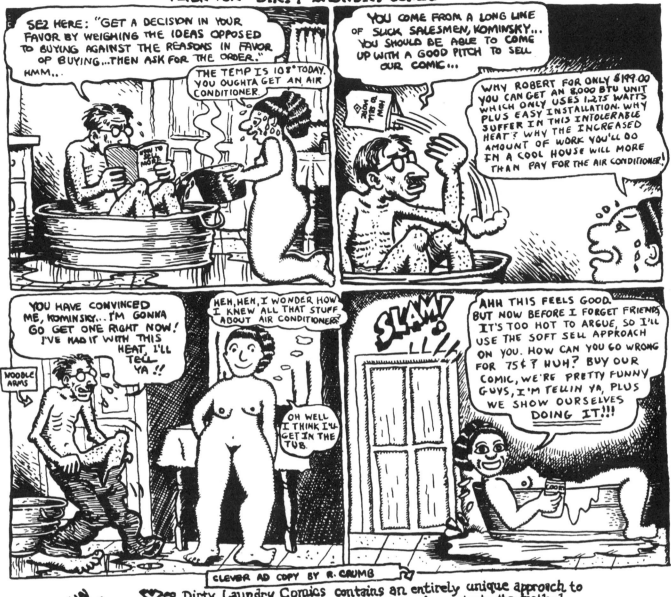

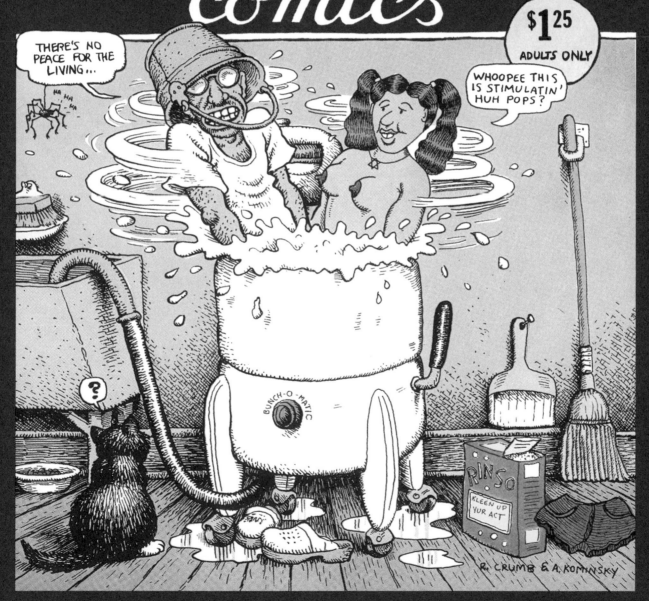

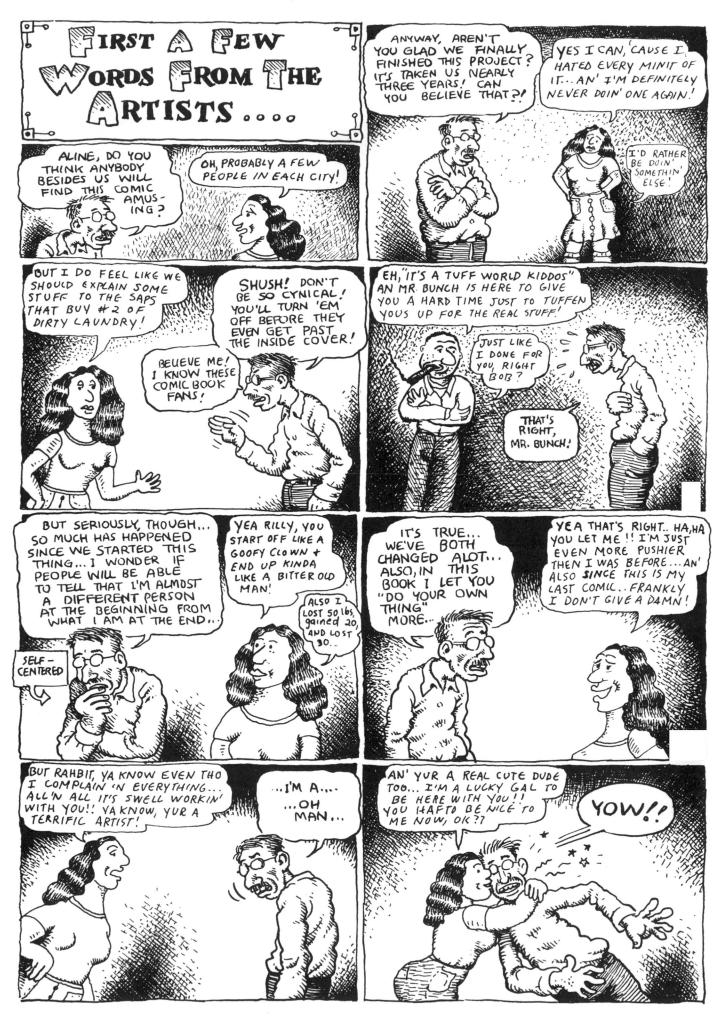

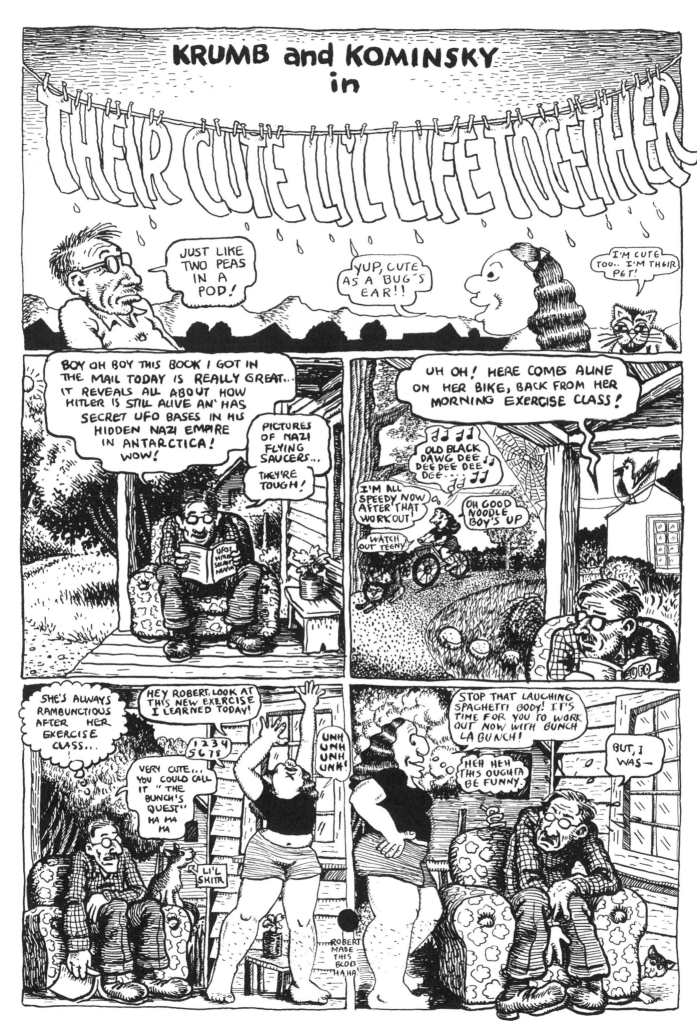

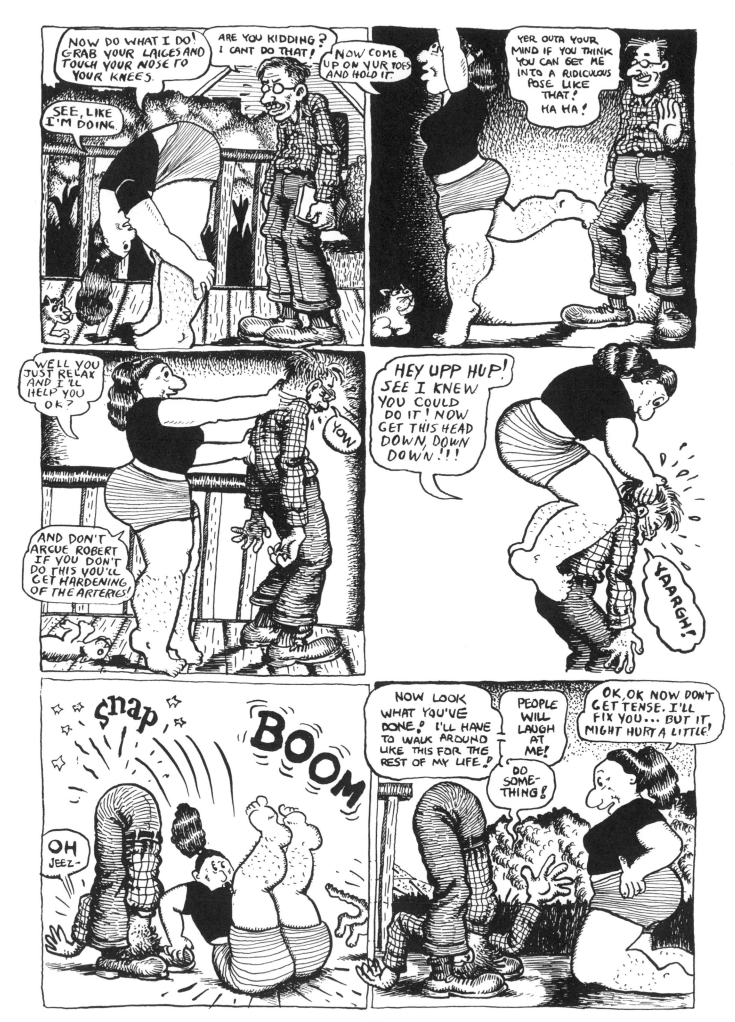

48

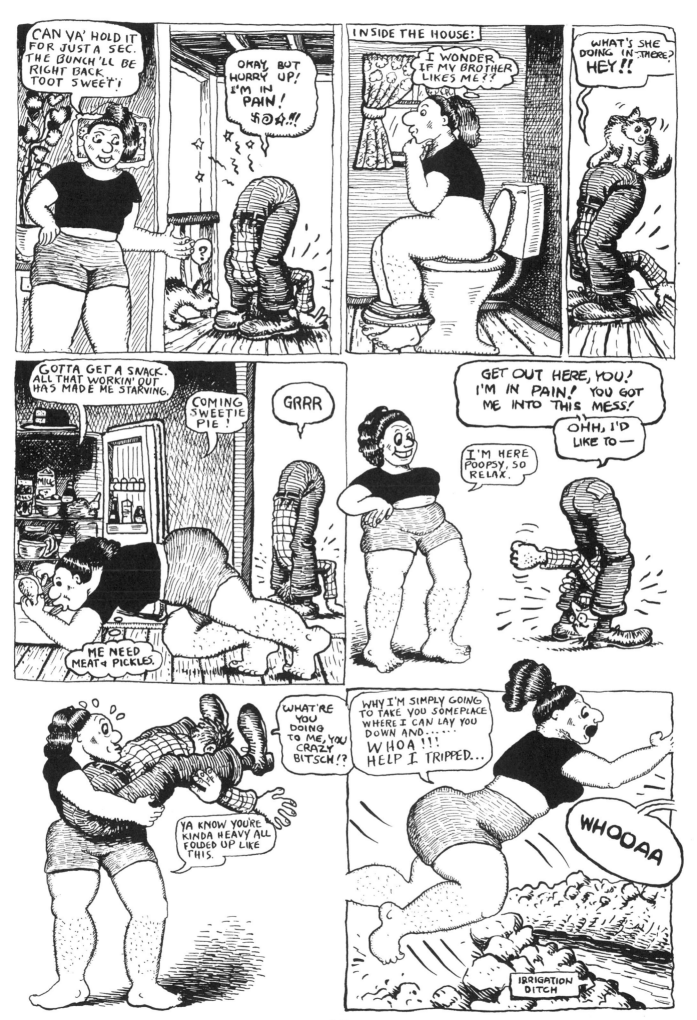

49

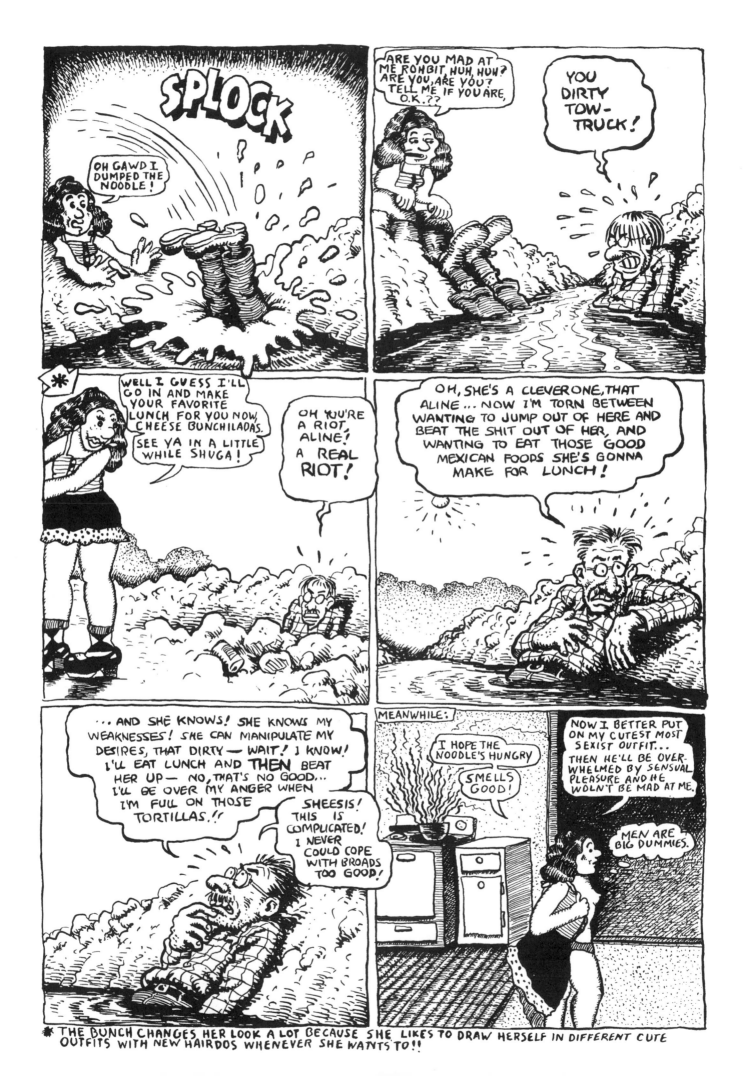

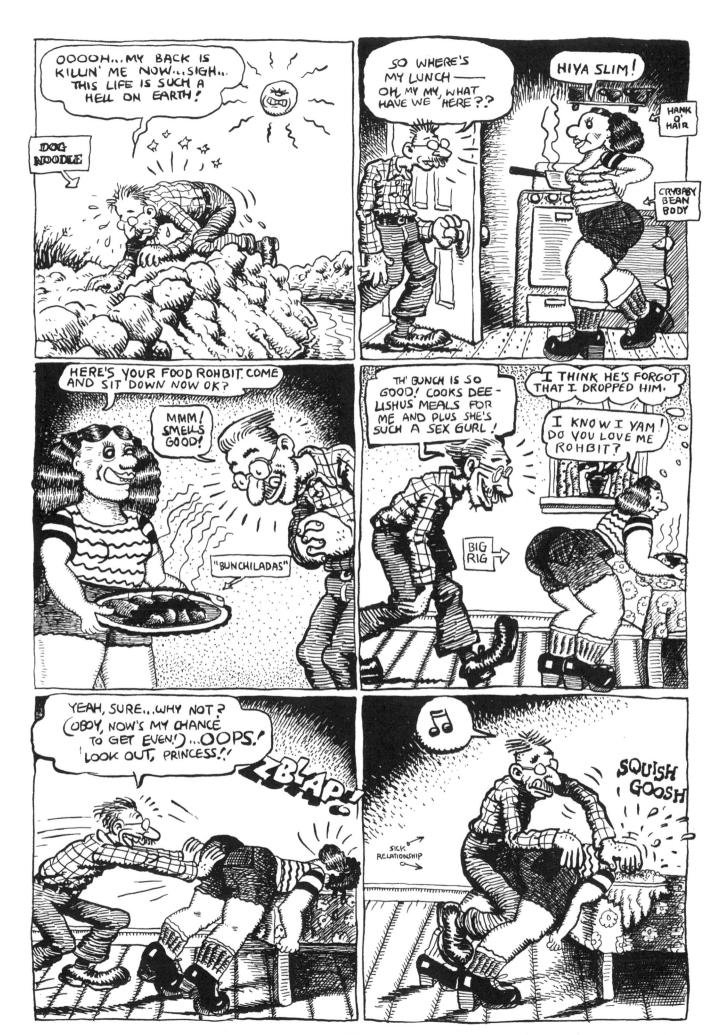

51

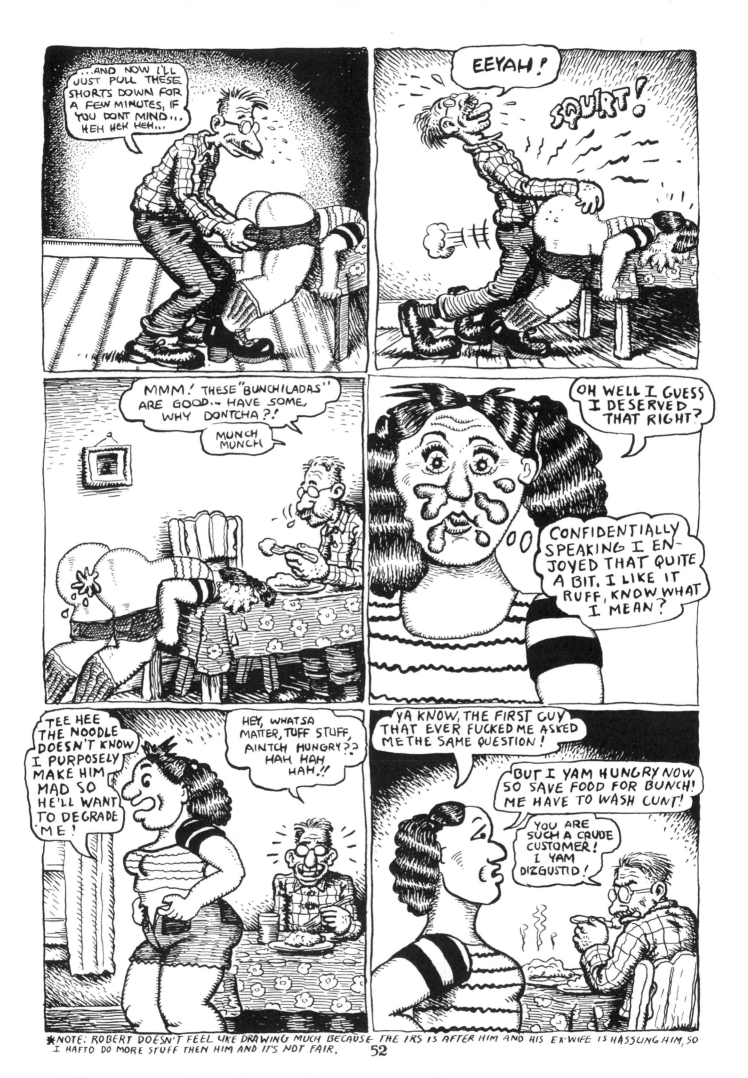

52

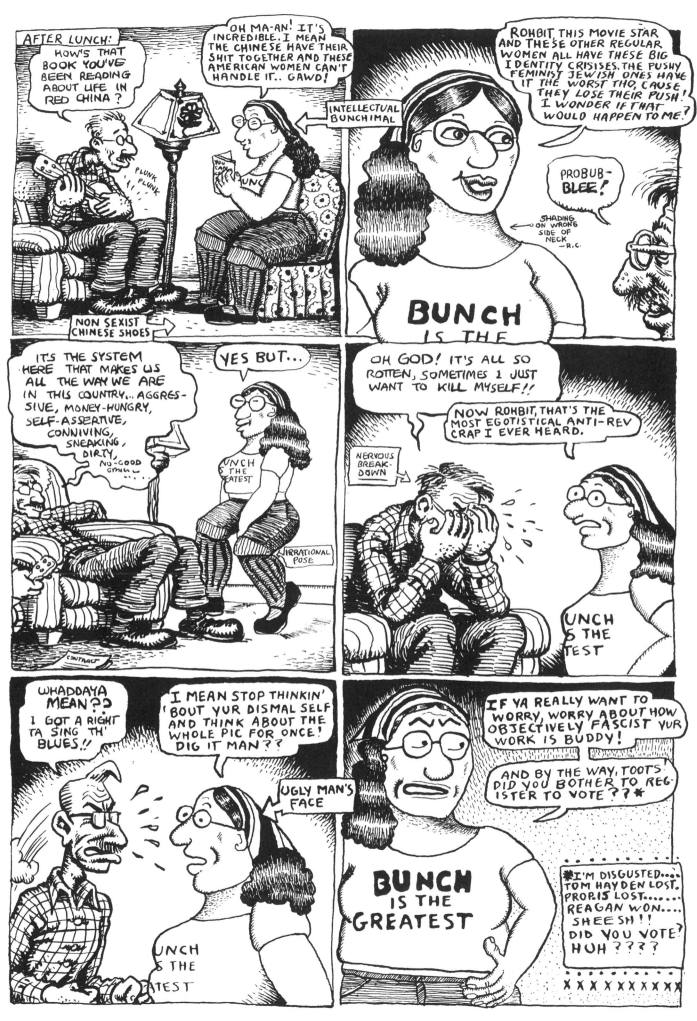

53

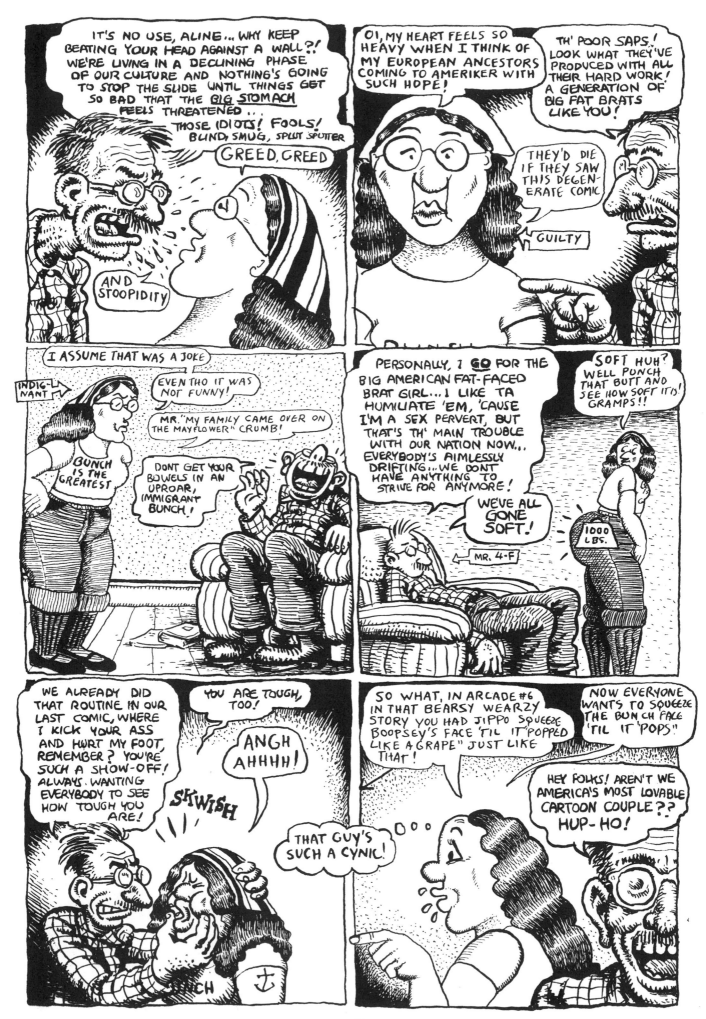

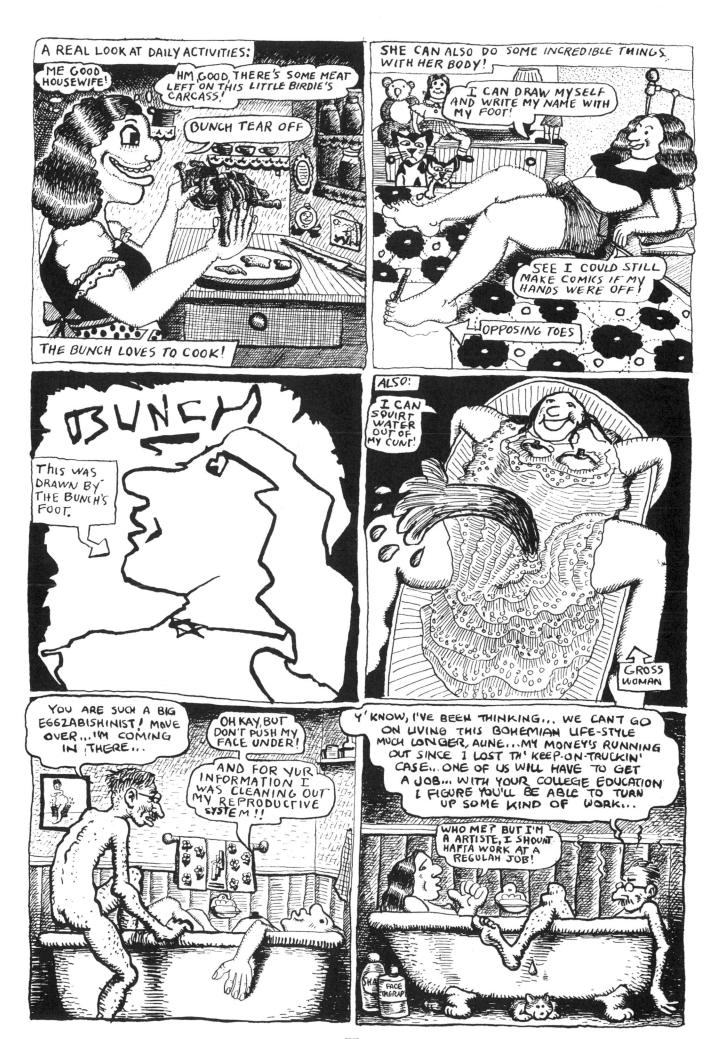

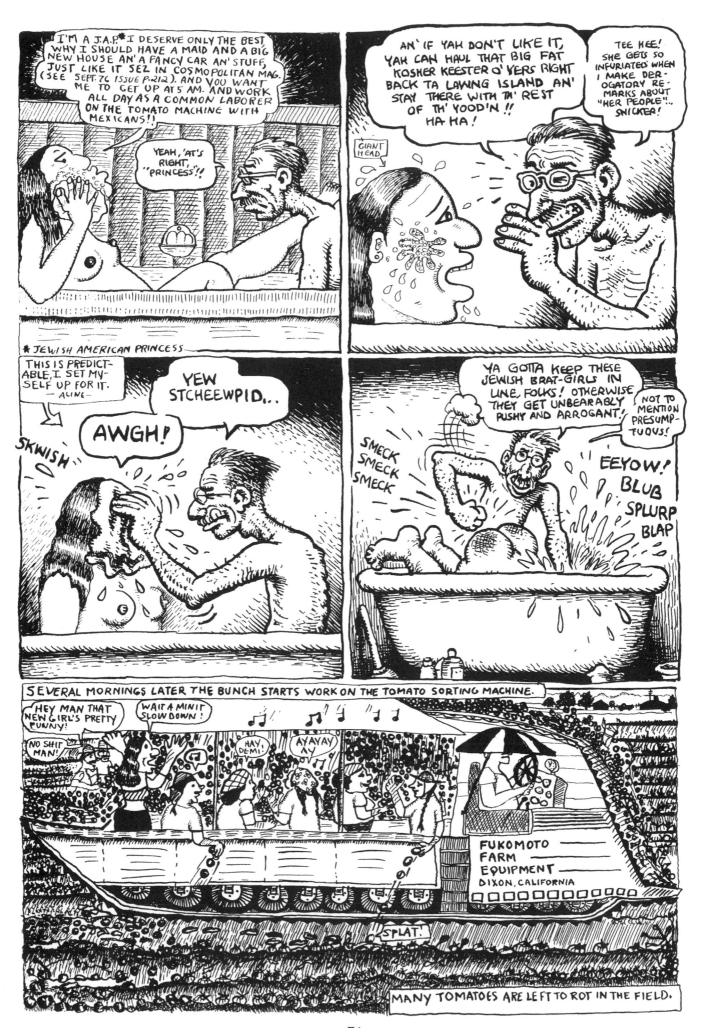

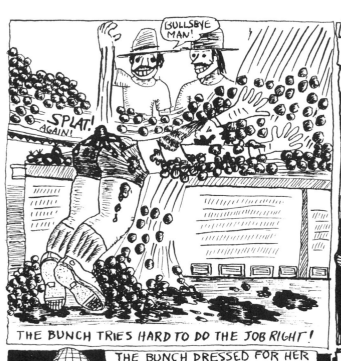

BULLSEYE MAN!

SPLAT! AGAIN!

THE BUNCH TRIES HARD TO DO THE JOB RIGHT!

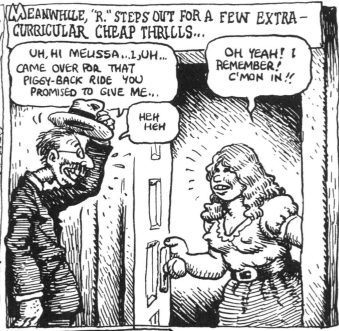

MEANWHILE, "R." STEPS OUT FOR A FEW EXTRA-CURRICULAR CHEAP THRILLS...

UH, HI MELISSA... I, UH... CAME OVER FOR THAT PIGGY-BACK RIDE YOU PROMISED TO GIVE ME...

HEH HEH

OH YEAH! I REMEMBER! C'MON IN!!

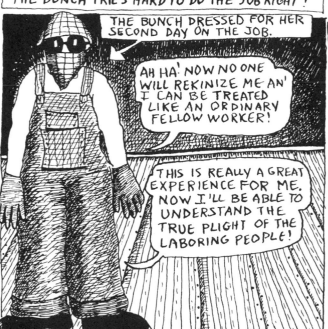

THE BUNCH DRESSED FOR HER SECOND DAY ON THE JOB.

AH HA! NOW NO ONE WILL REKINIZE ME AN' I CAN BE TREATED LIKE AN ORDINARY FELLOW WORKER!

THIS IS REALLY A GREAT EXPERIENCE FOR ME. NOW I'LL BE ABLE TO UNDERSTAND THE TRUE PLIGHT OF THE LABORING PEOPLE!

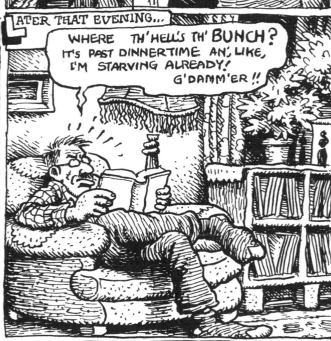

LATER THAT EVENING...

WHERE TH' HELL'S TH' BUNCH? IT'S PAST DINNERTIME AN', LIKE, I'M STARVING ALREADY! G'DAMM'ER!!

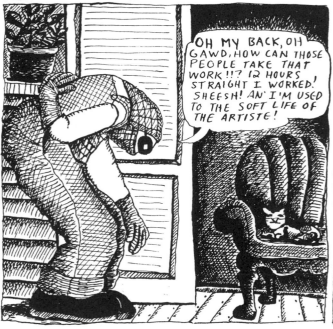

OH MY BACK, OH GAWD, HOW CAN THOSE PEOPLE TAKE THAT WORK!!? 12 HOURS STRAIGHT I WORKED! SHEESH! AN' I'M USED TO THE SOFT LIFE OF THE ARTISTE!

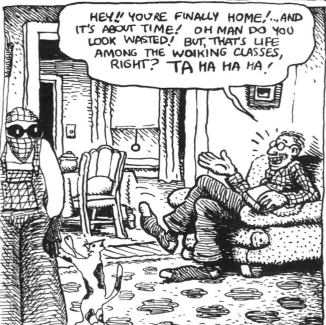

HEY!! YOU'RE FINALLY HOME!...AND IT'S ABOUT TIME! OH MAN DO YOU LOOK WASTED! BUT, THAT'S LIFE AMONG THE WOIKING CLASSES, RIGHT? TA HA HA HA!

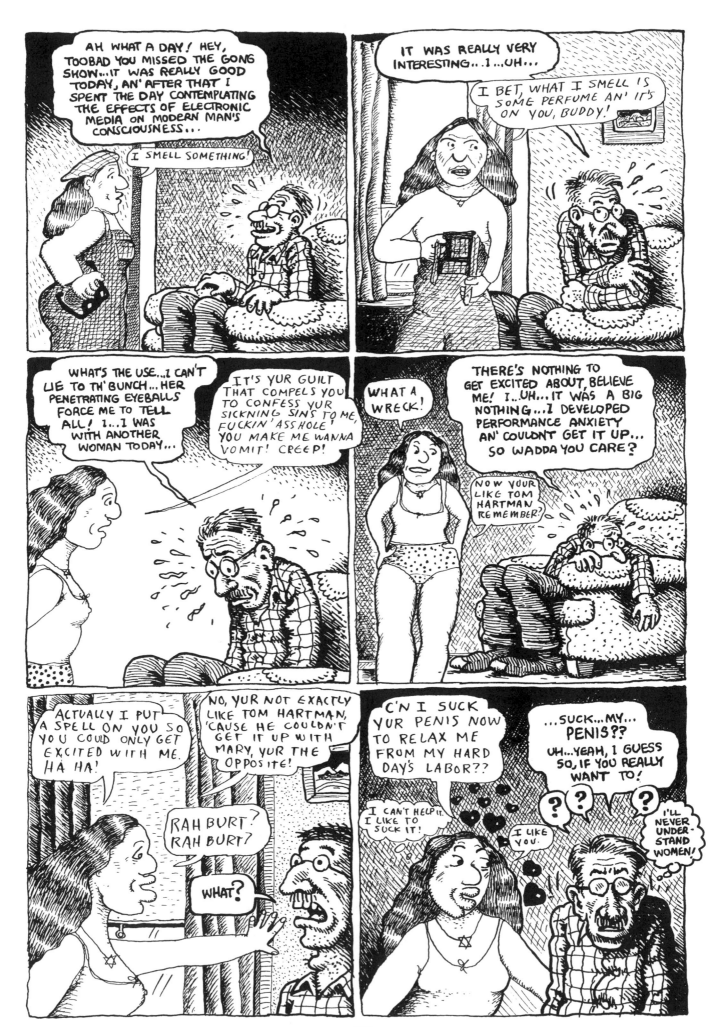

58

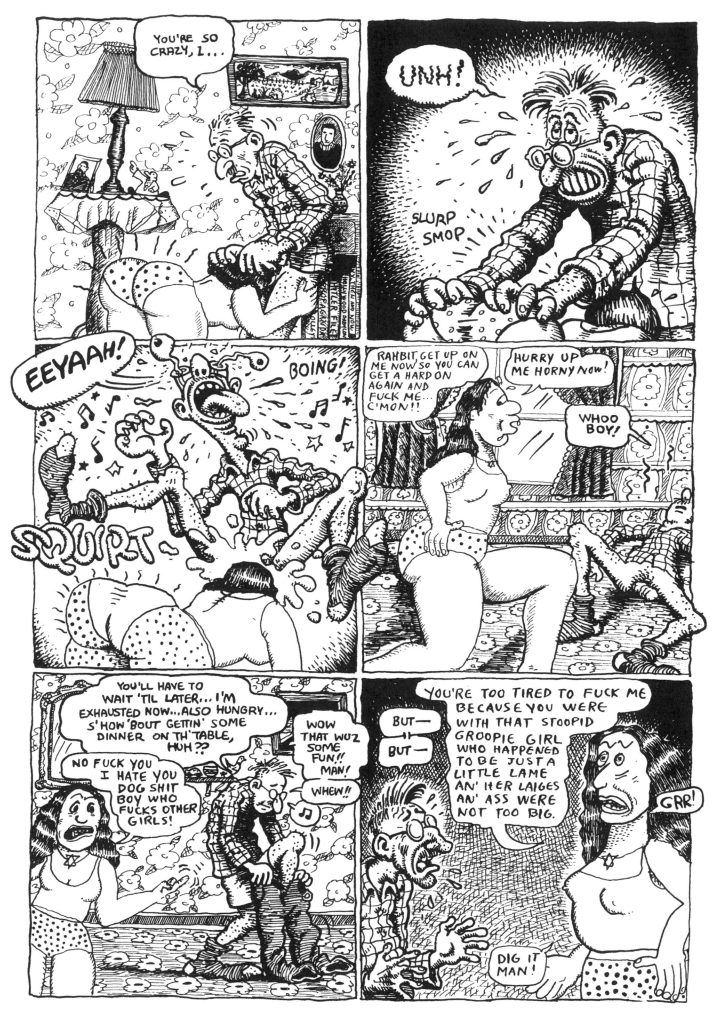

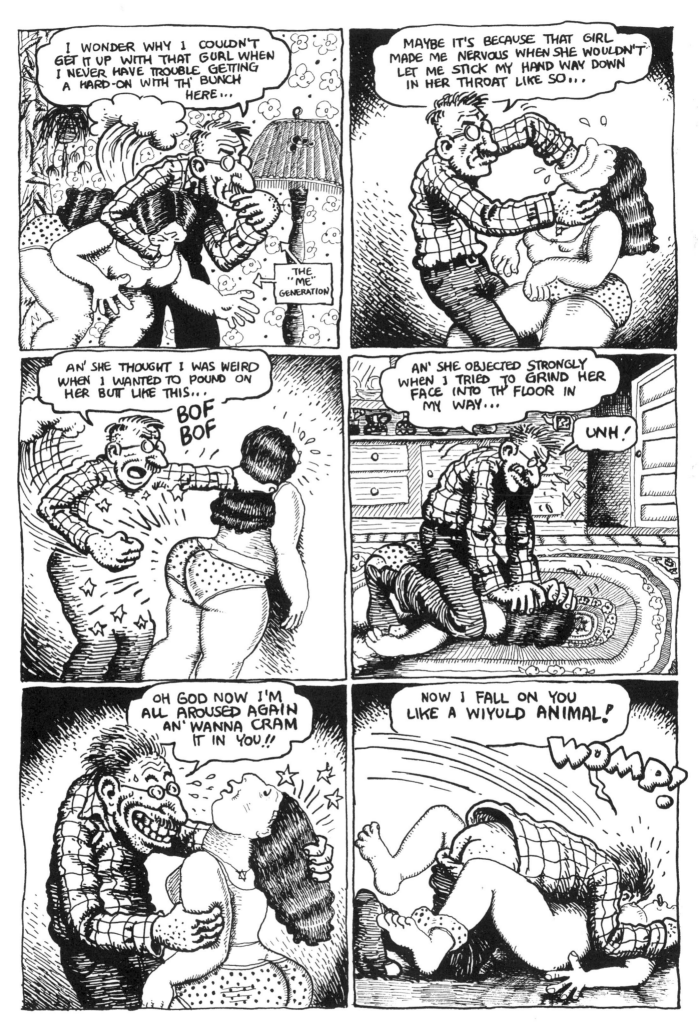

60

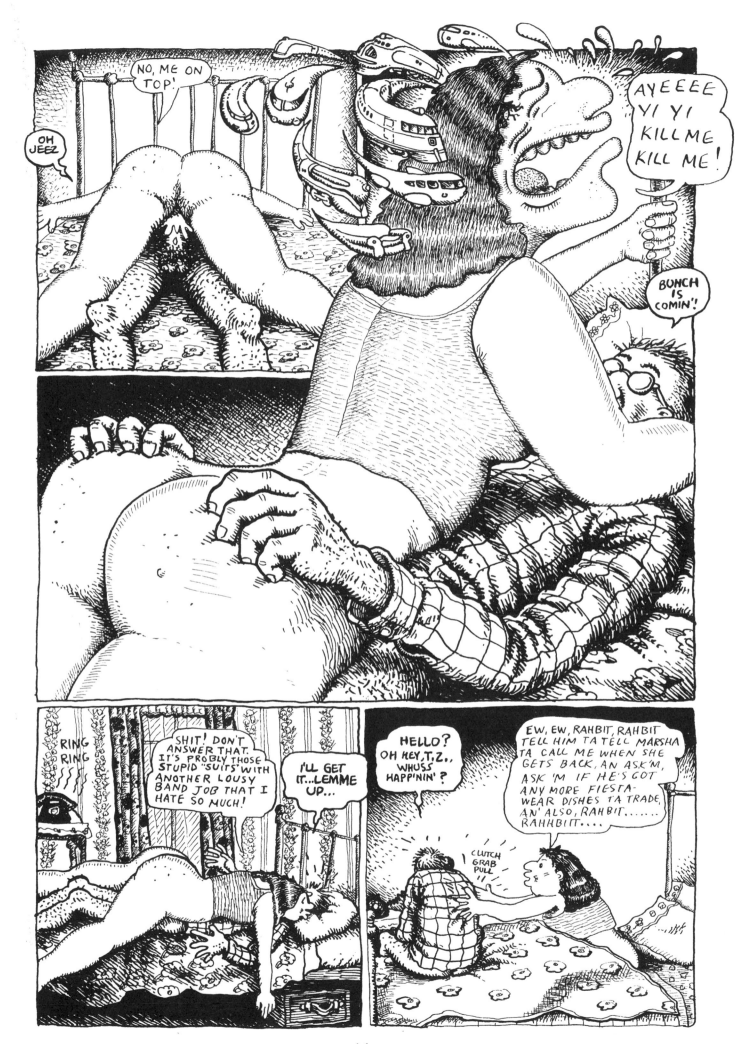

61

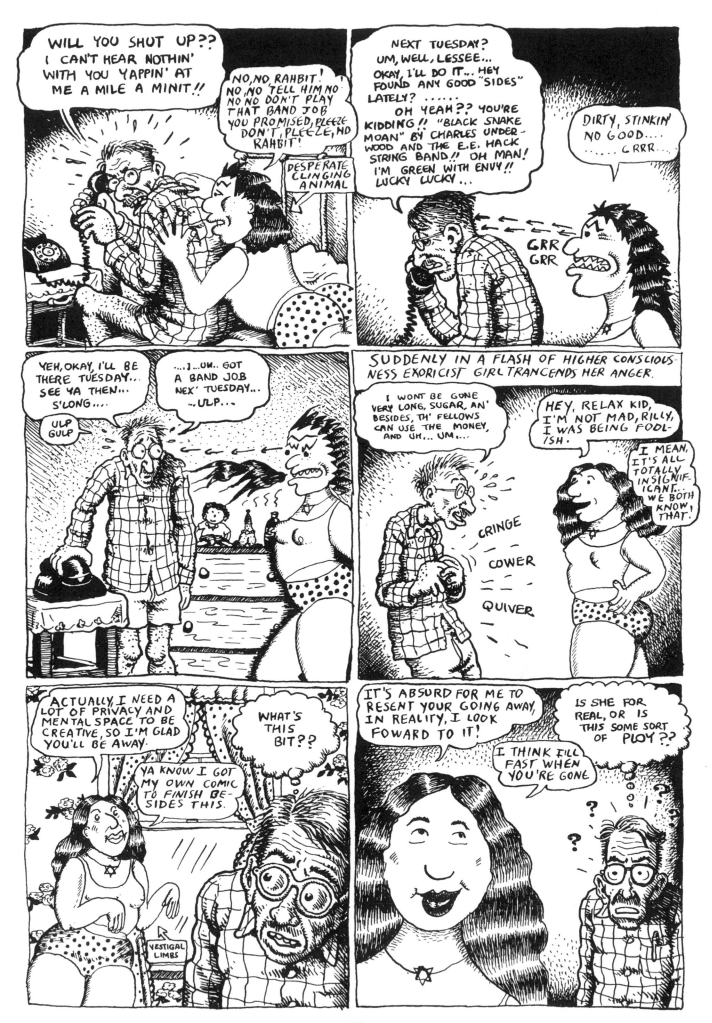

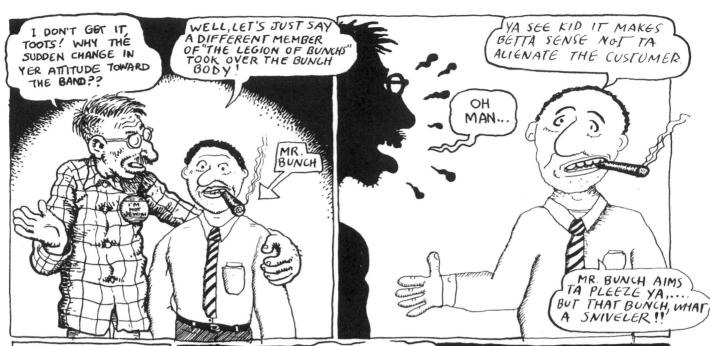

Panel 1:
I DON'T GET IT, TOOTS! WHY THE SUDDEN CHANGE IN YER ATTITUDE TOWARD THE BAND??

WELL, LET'S JUST SAY A DIFFERENT MEMBER OF "THE LEGION OF BUNCHS" TOOK OVER THE BUNCH BODY!

MR. BUNCH

Panel 2:
YA SEE KID IT MAKES BETTA SENSE NOT TA ALIENATE THE CUSTOMER.

OH MAN...

MR. BUNCH AIMS TA PLEEZE YA,.... BUT THAT BUNCH, WHAT A SNIVELER!!

AND SO, R.C. GOES OFF FROM THE OL' HOMESTEAD TO JOIN HIS ERSTWHILE COMPANIONS FOR A COUPLE OF "GIGS" WITH HIS FAMOUS STRING BAND, ONCE AGAIN WINNING THE HEARTS OF THE CROWD WITH THEIR QUAINT AND CHARMING BRAND OF OLD-TIME MUSIC!!

OBOY OBOY OBOY!

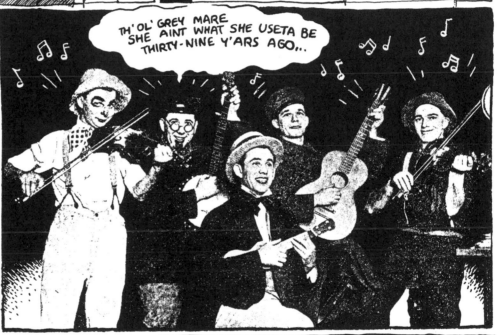

TH' OL' GREY MARE SHE AINT WHAT SHE USETA BE THIRTY-NINE Y'ARS AGO...

MEANWHILE THE BUNCH WORKS ON HER SPIRITUAL & PHYSICAL SELF IMPROVEMENT

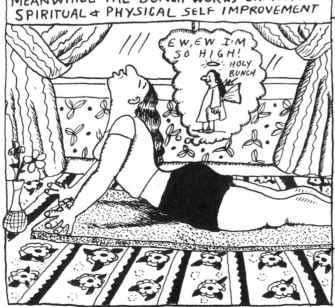

EW, EW I'M SO HIGH!

HOLY BUNCH

...AND MEANWHILE, AT THE BAND'S "CLUBHOUSE" DOWN "IN THE CITY OF SIGHS AND TEARS"....

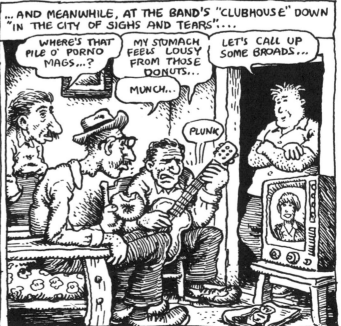

WHERE'S THAT PILE O' PORNO MAGS...?

MY STOMACH FEELS LOUSY FROM THOSE DONUTS...

LET'S CALL UP SOME BROADS...

MUNCH...

PLUNK

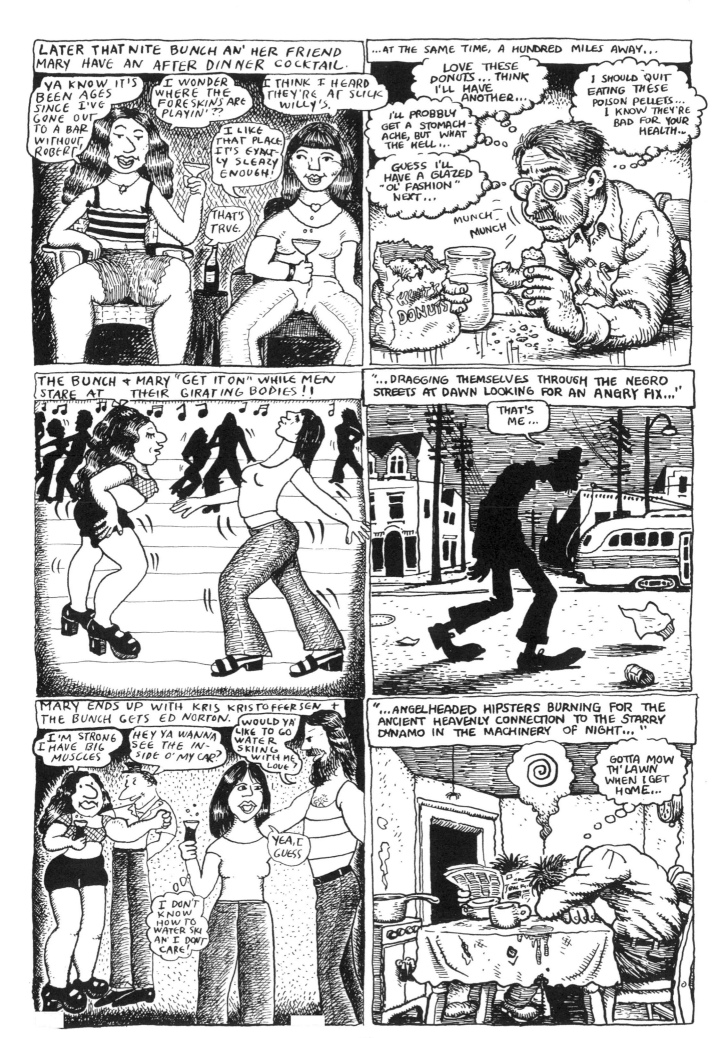

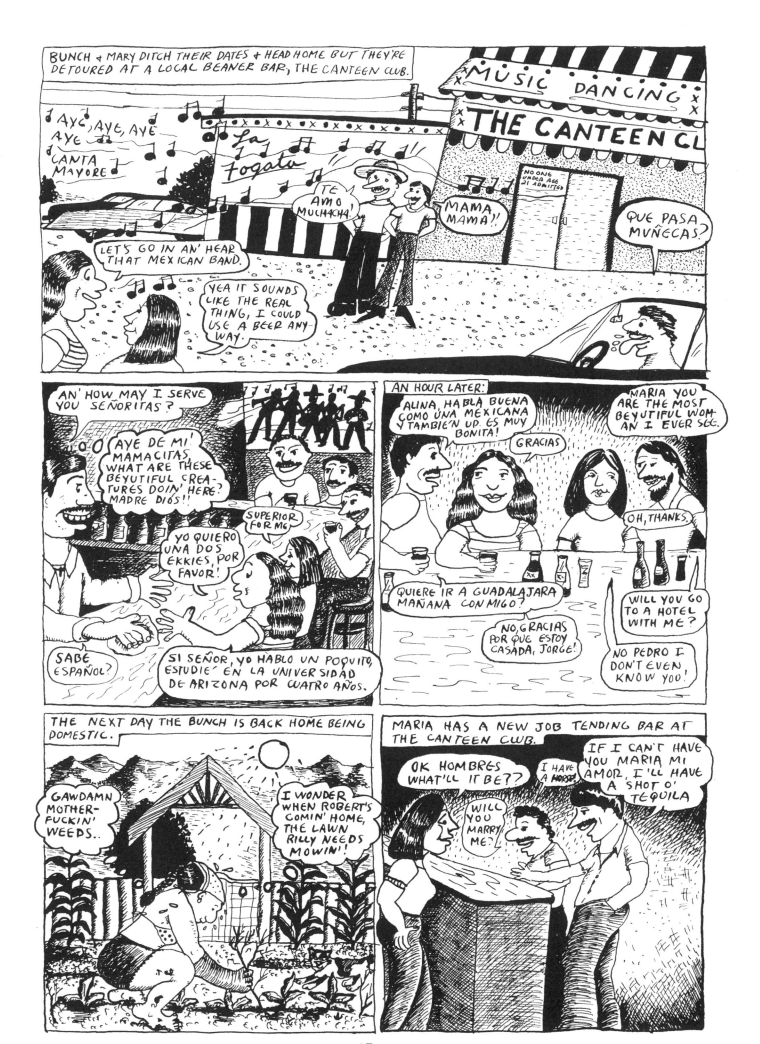

65

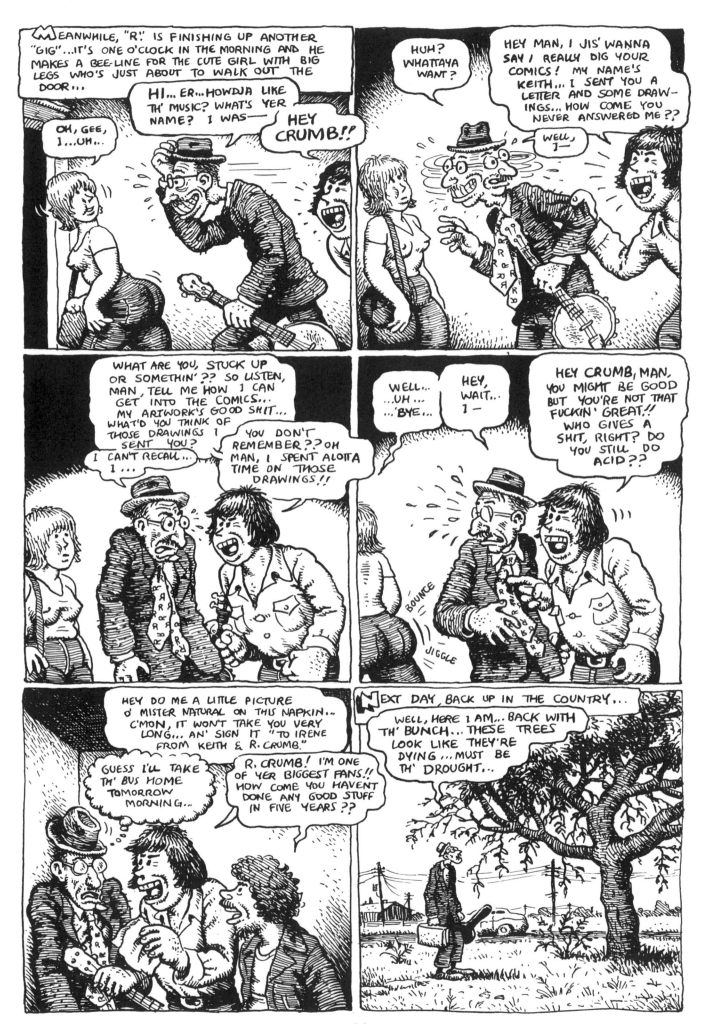

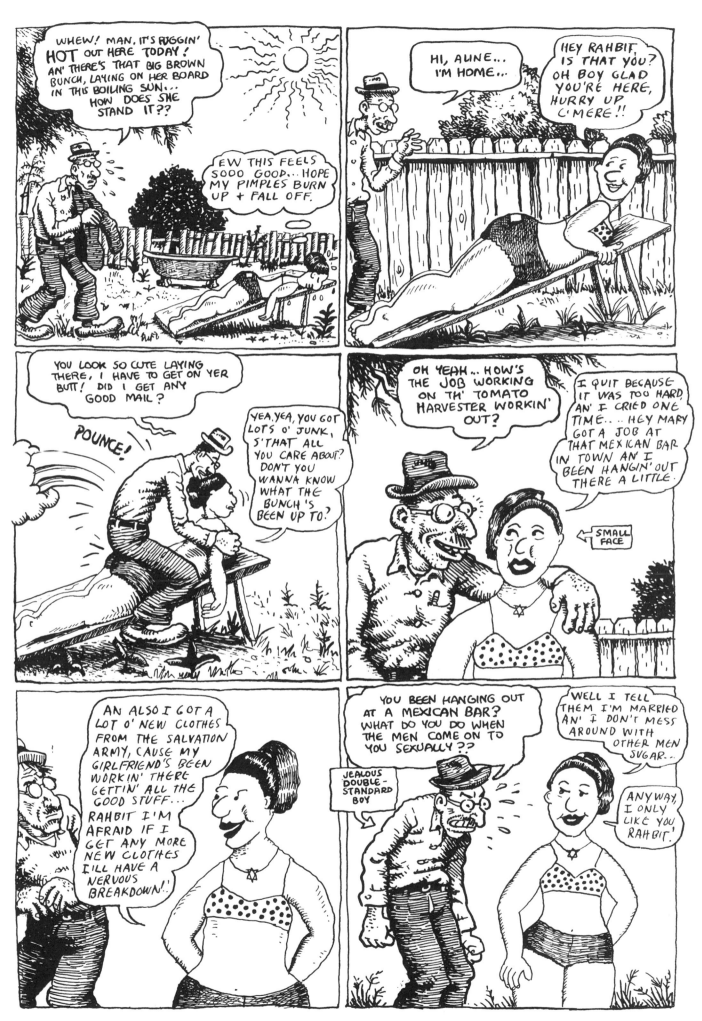

67

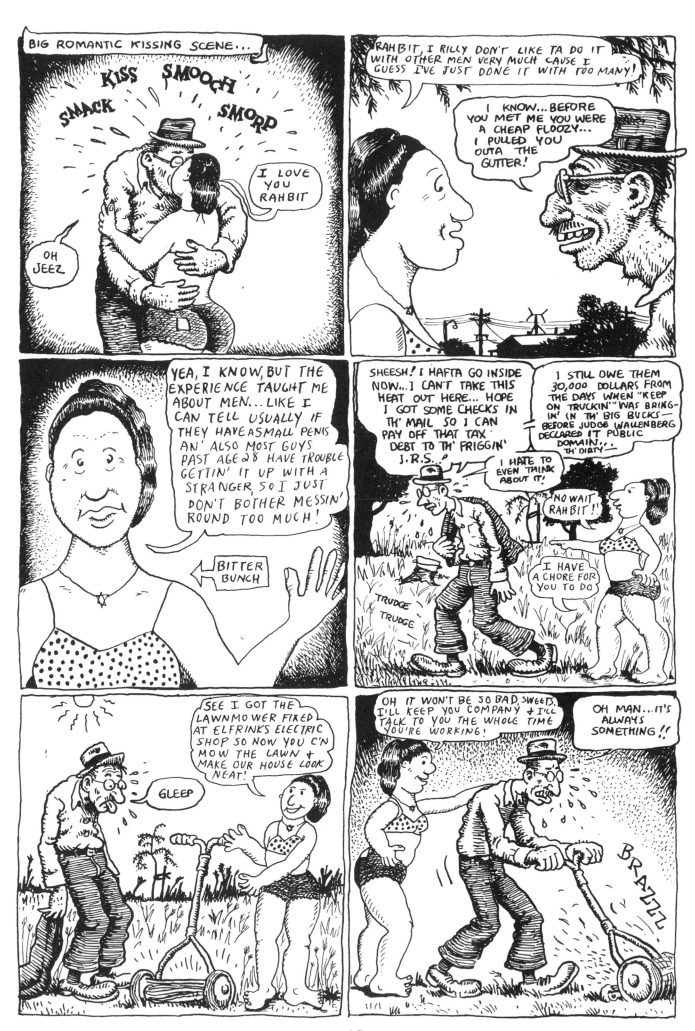

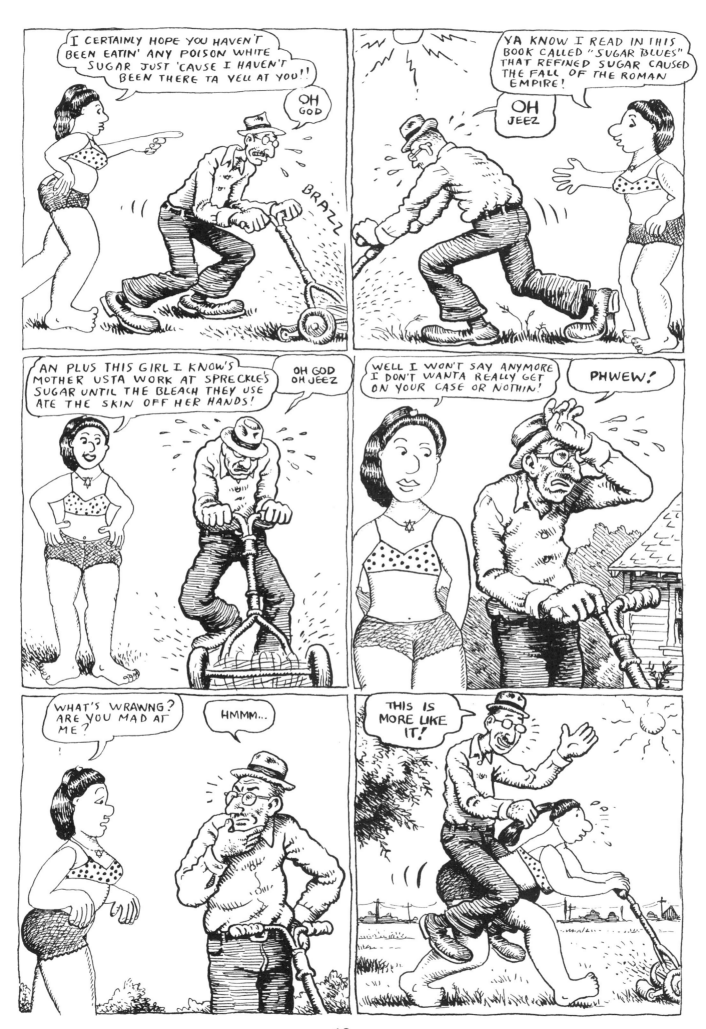

69

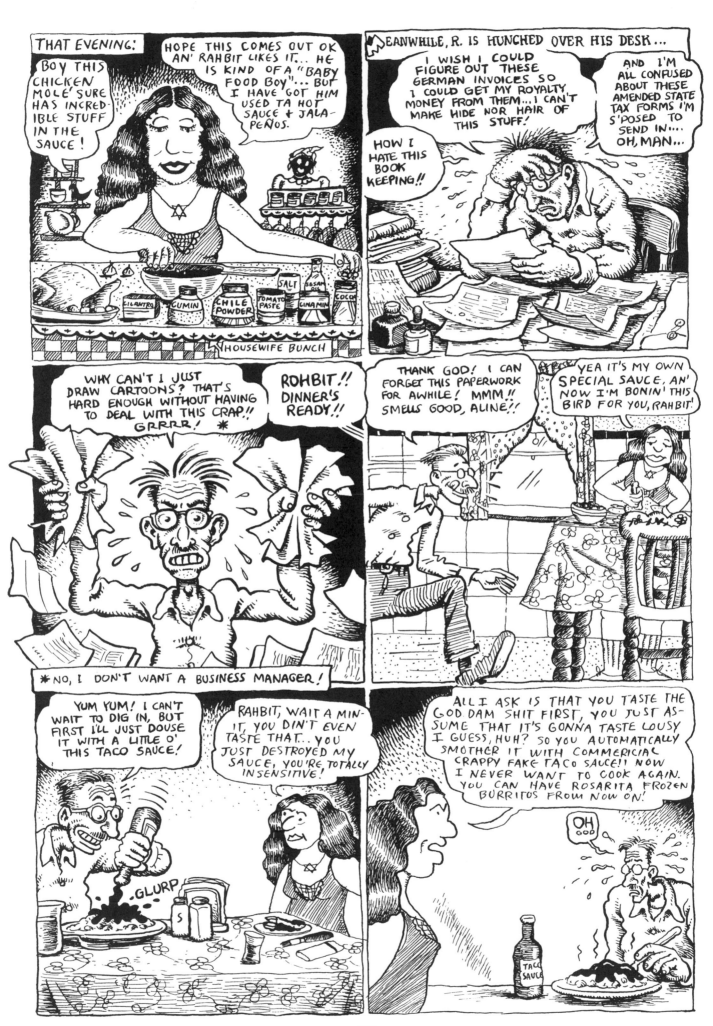

70

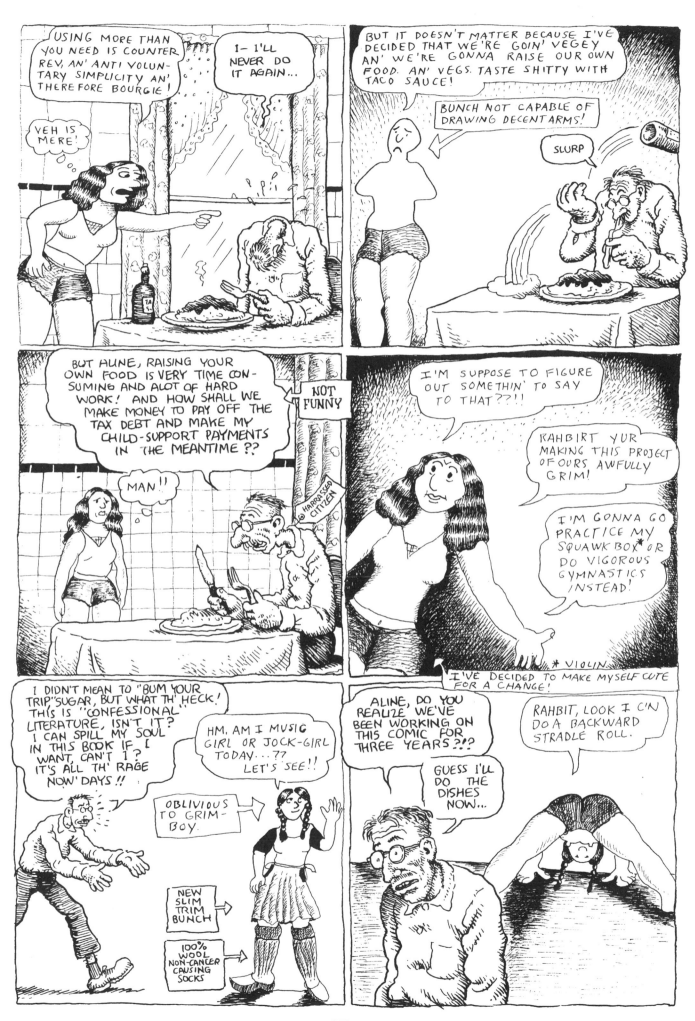

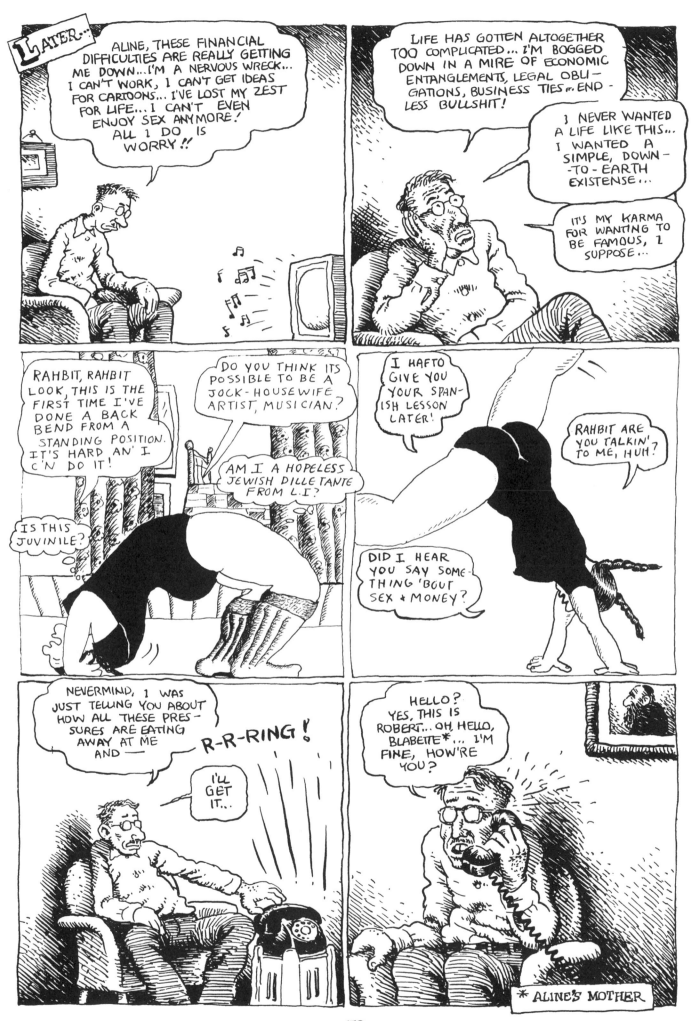

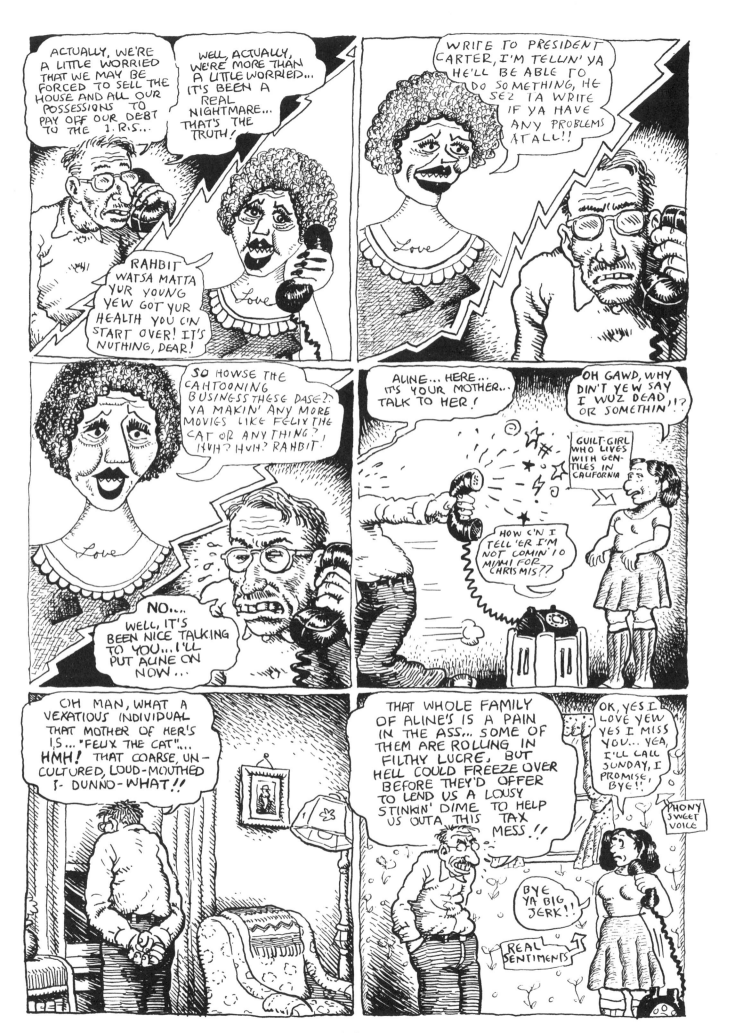

73

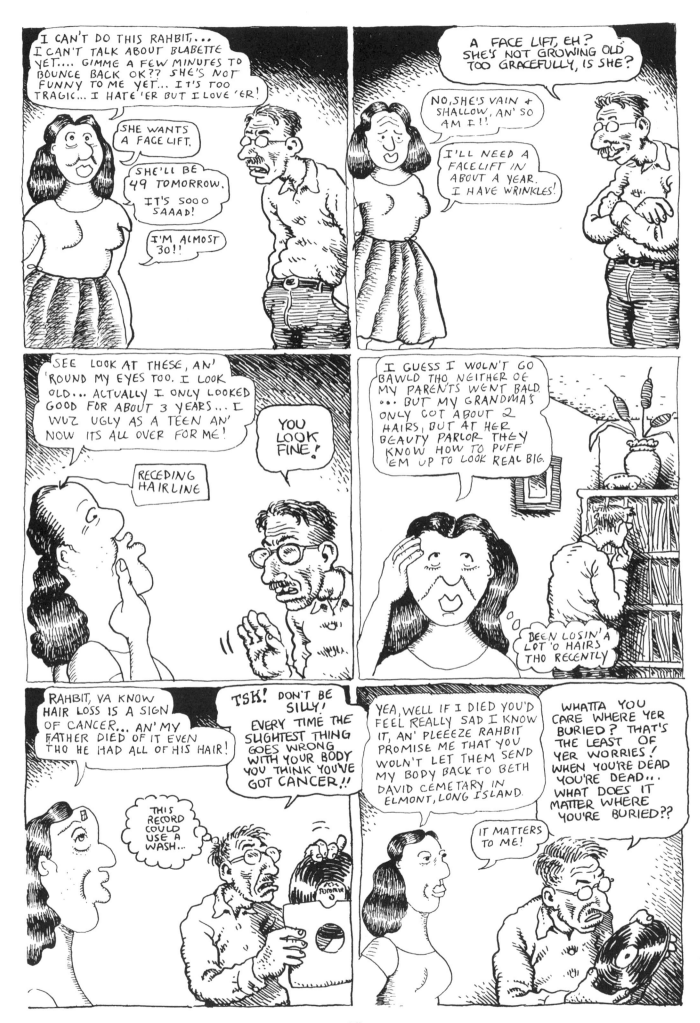

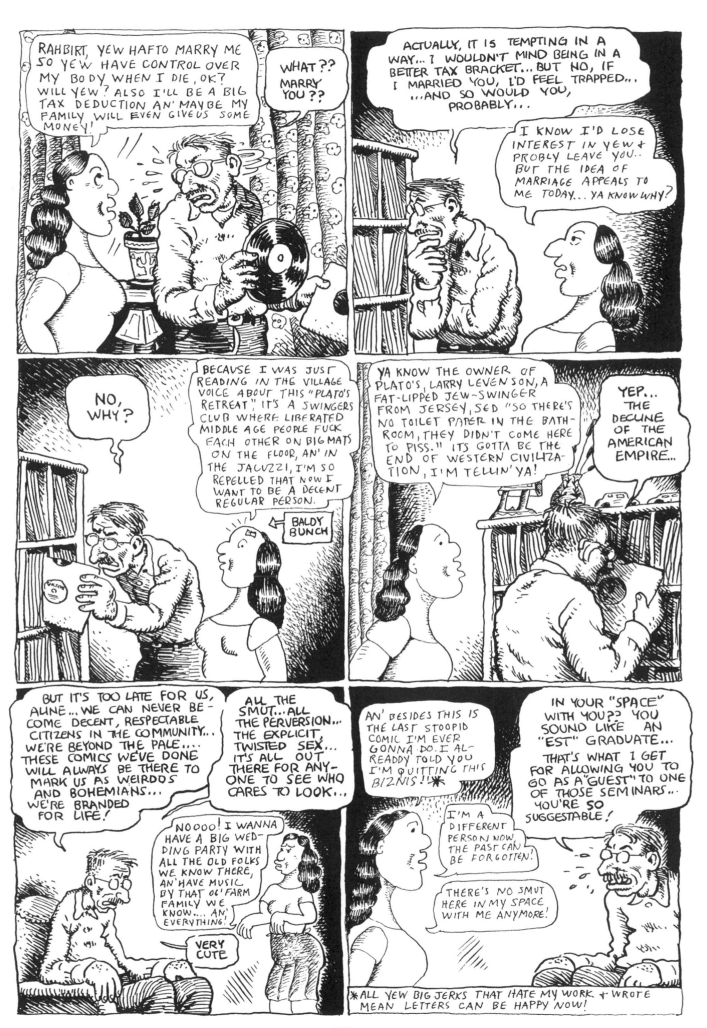

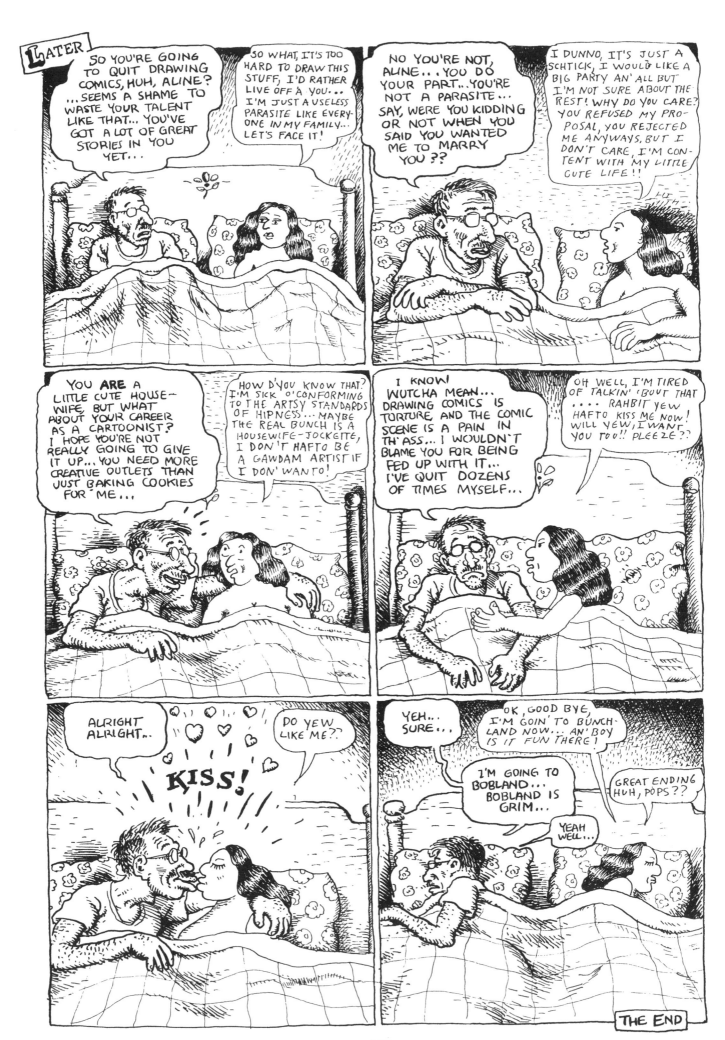

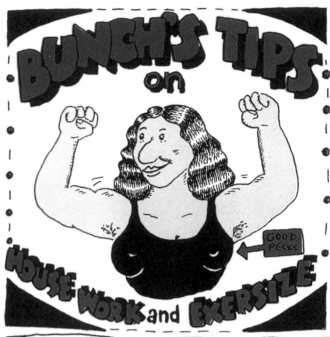

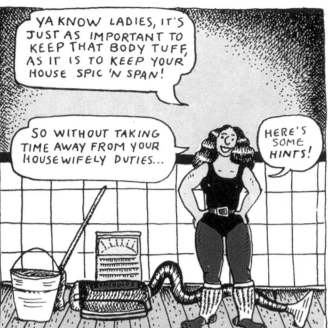

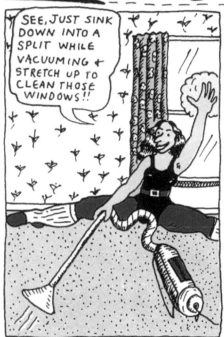

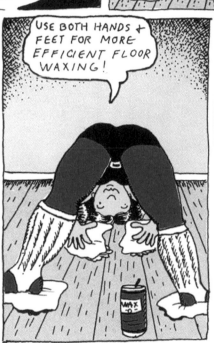

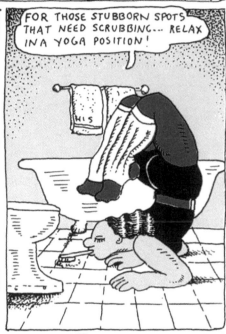

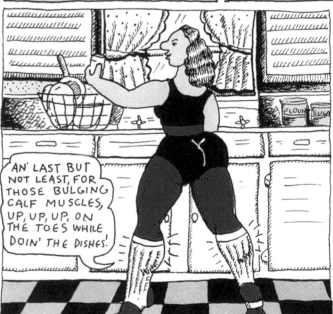

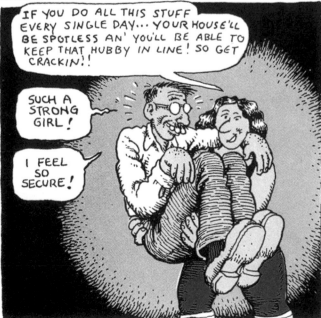

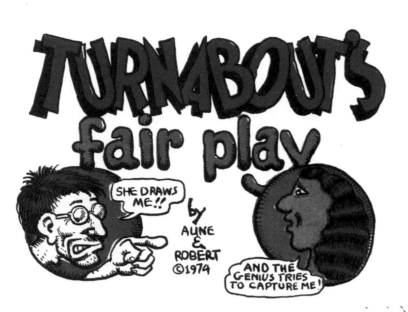

TURNABOUT'S fair play

SHE DRAWS ME!!

by ALINE & ROBERT ©1974

AND THE GENIUS TRIES TO CAPTURE ME!

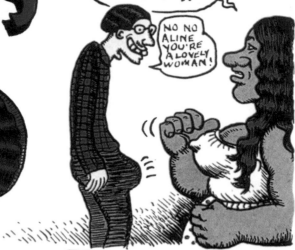

ROBERT DO YOU THINK I'M TOO FAT? TELL ME THE TRUTH! AND DON'T PATRONIZE ME, MAN!!

NO NO ALINE YOU'RE A LOVELY WOMAN!

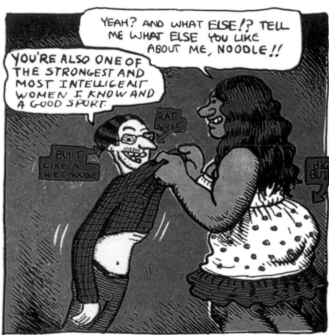

YEAH? AND WHAT ELSE!? TELL ME WHAT ELSE YOU LIKE ABOUT ME, NOODLE!!

YOU'RE ALSO ONE OF THE STRONGEST AND MOST INTELLIGENT WOMEN I KNOW AND A GOOD SPORT.

RAT NOSE

BUILT LIKE A WET NOODLE

BIG BUTT

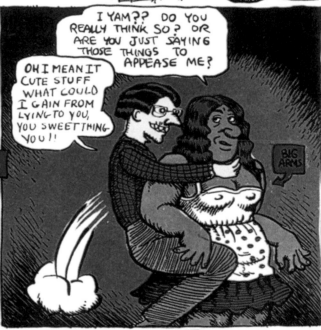

I YAM?? DO YOU REALLY THINK SO? OR ARE YOU JUST SAYING THOSE THINGS TO APPEASE ME?

OH I MEAN IT CUTE STUFF WHAT COULD I GAIN FROM LYING TO YOU, YOU SWEET THING YOU!!

BIG ARMS

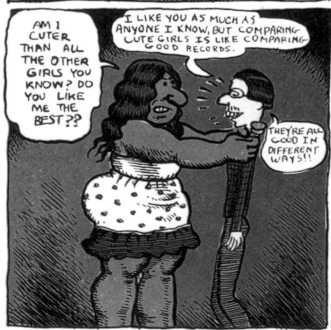

AM I CUTER THAN ALL THE OTHER GIRLS YOU KNOW? DO YOU LIKE ME THE BEST??

I LIKE YOU AS MUCH AS ANYONE I KNOW, BUT COMPARING CUTE GIRLS IS LIKE COMPARING GOOD RECORDS.

THEY'RE ALL GOOD IN DIFFERENT WAYS!!

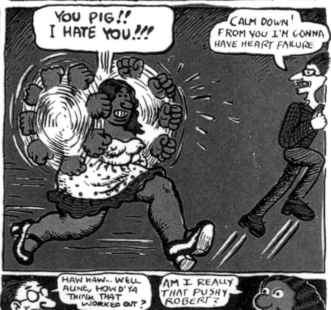

YOU PIG!! I HATE YOU!!!!

CALM DOWN! FROM YOU I'M GONNA HAVE HEART FAILURE.

HAW HAW.. WELL ALINE, HOW D'YA THINK THAT WORKED OUT?

AM I REALLY THAT PUSHY ROBERT?

NO, YOU'RE GOOD!

78

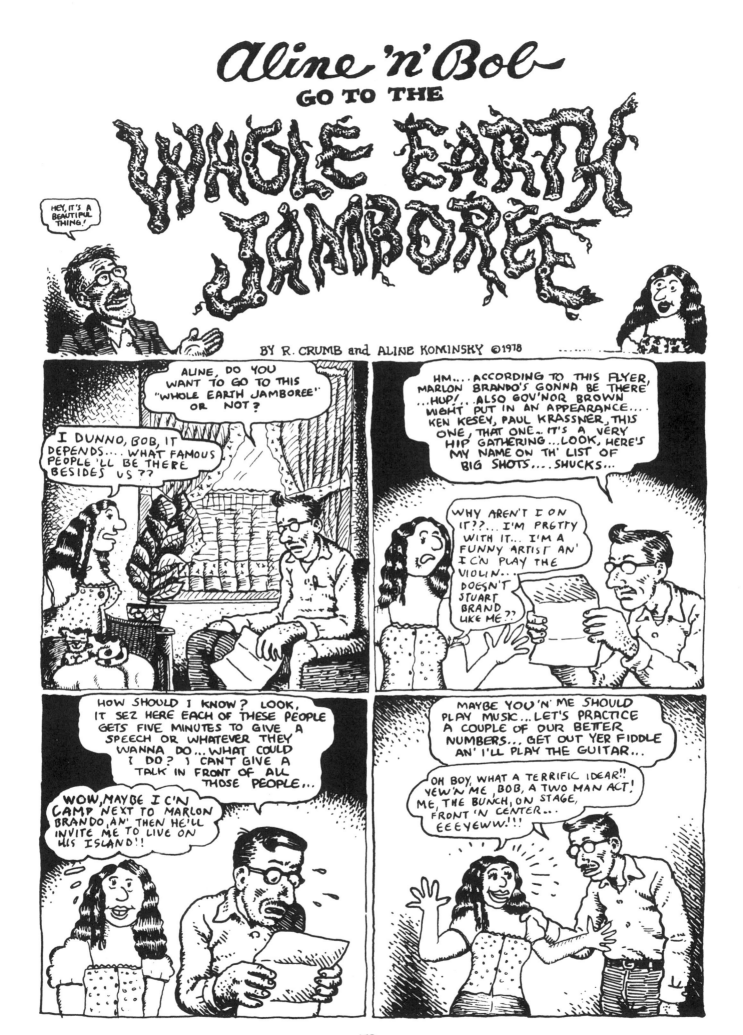

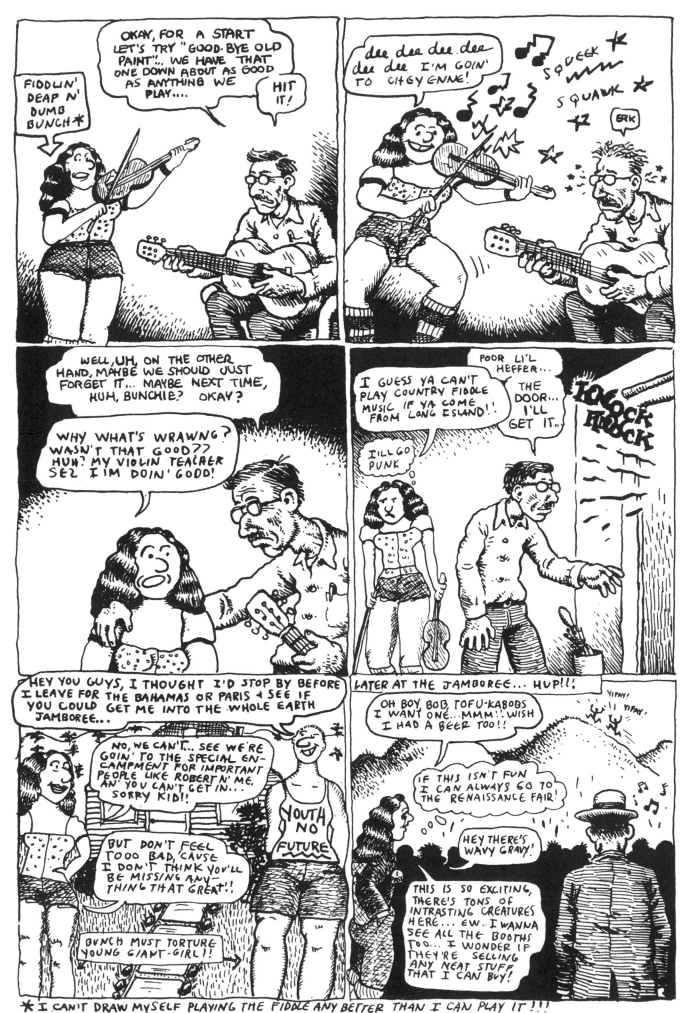

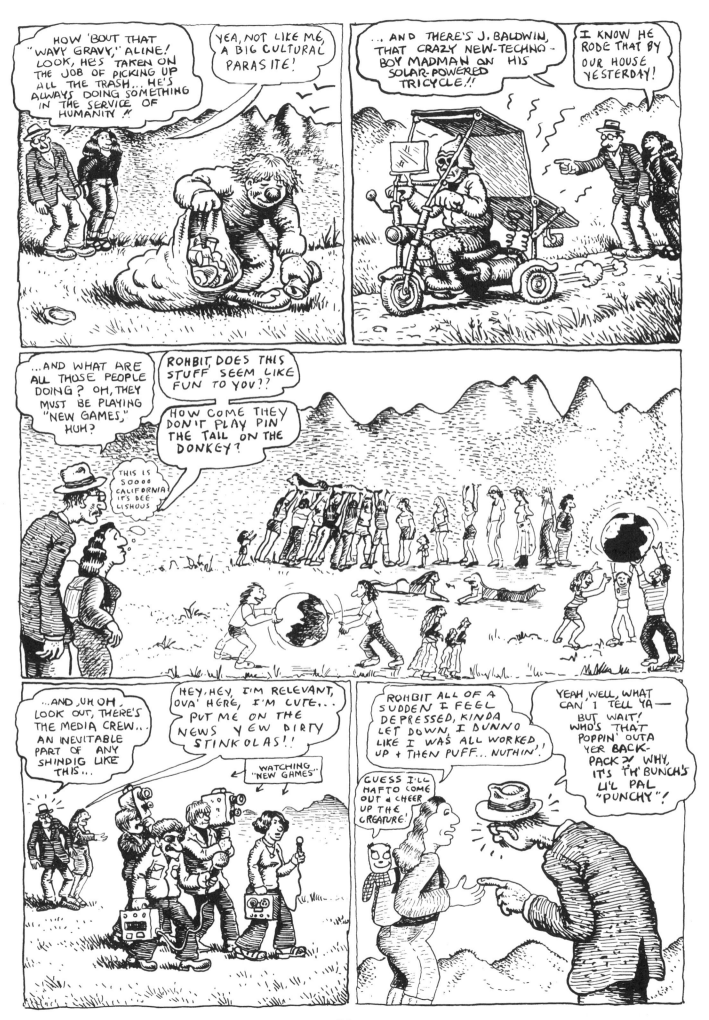

81

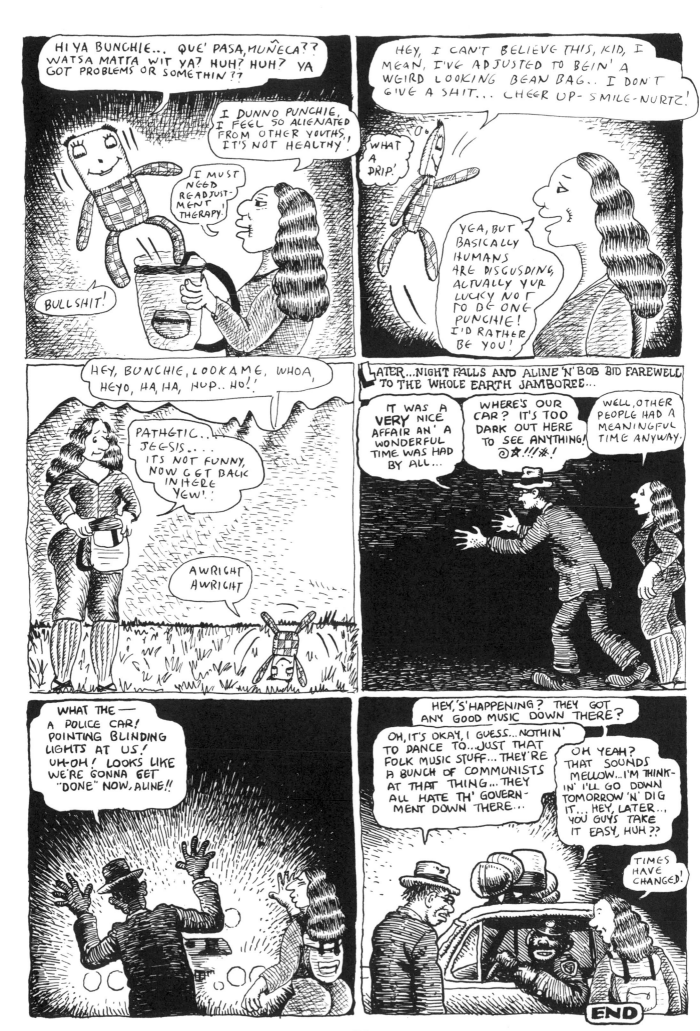

82

Everyday Funnies

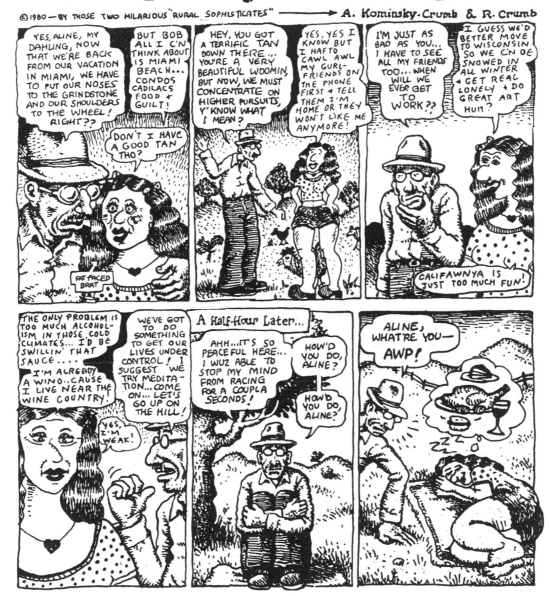

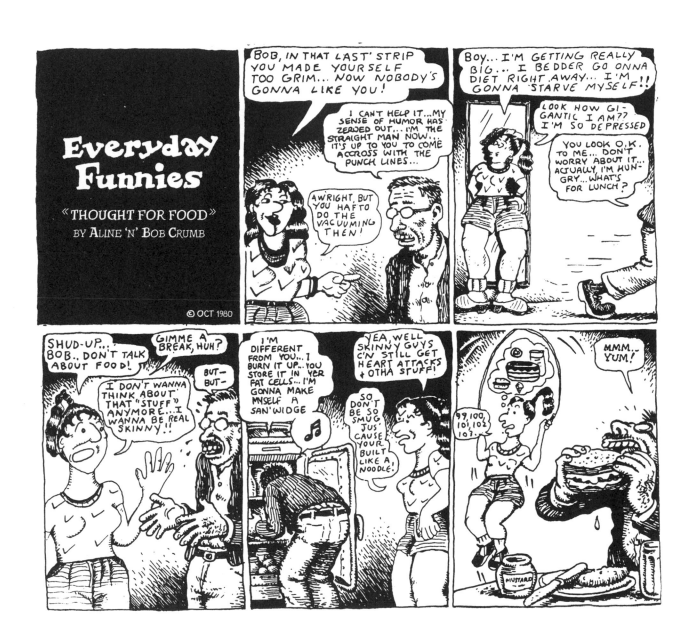

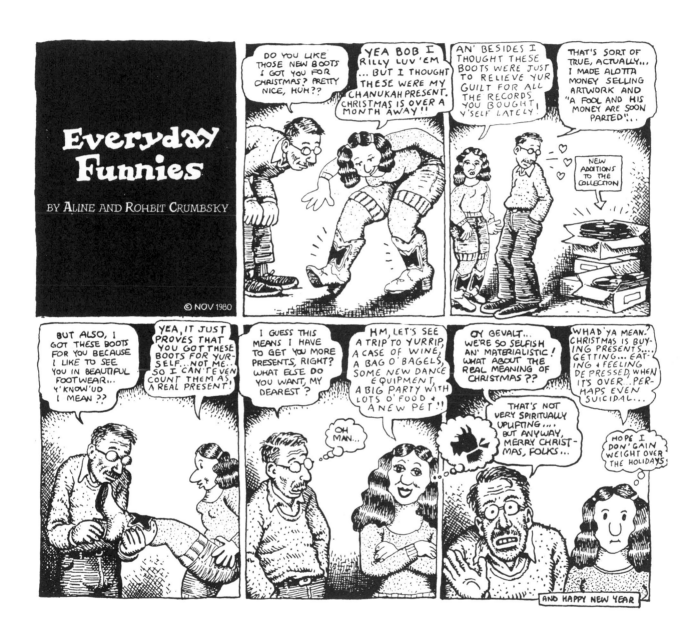

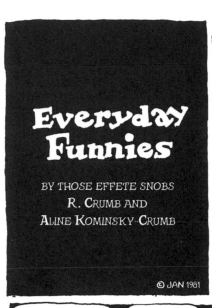

Everyday Funnies

BY THOSE EFFETE SNOBS
R. CRUMB AND
ALINE KOMINSKY-CRUMB

© JAN 1981

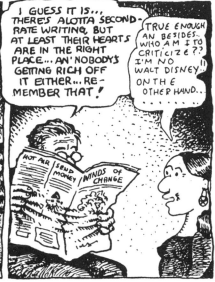

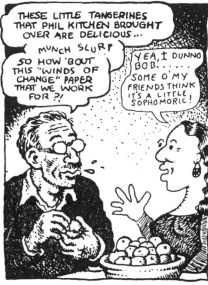

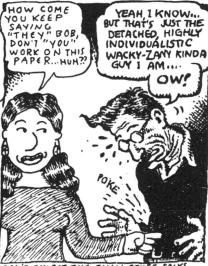

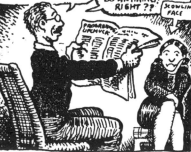

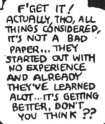

DON'T SWEAT THE SMALL STUFF... FOLKS...
REMEMBER THE DOOMSDAY CLOCK IS NOW
SET AT 4 MINUTES TO 12:00!!!!!

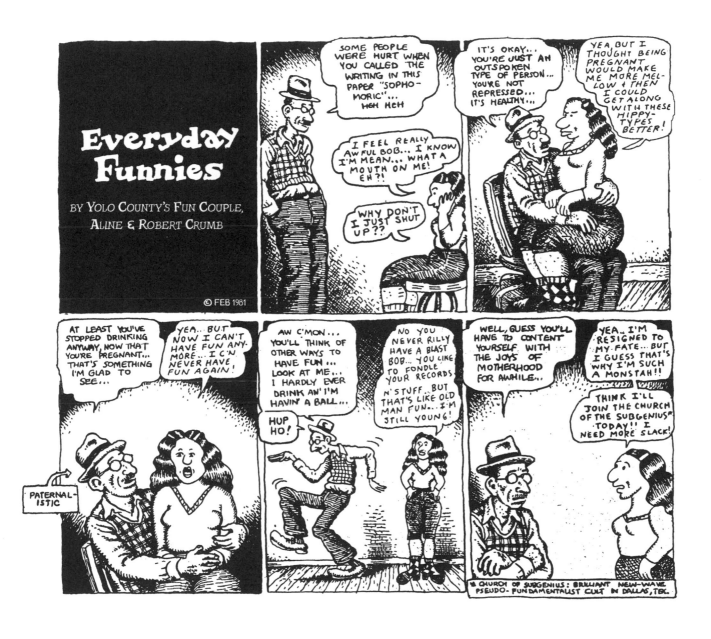

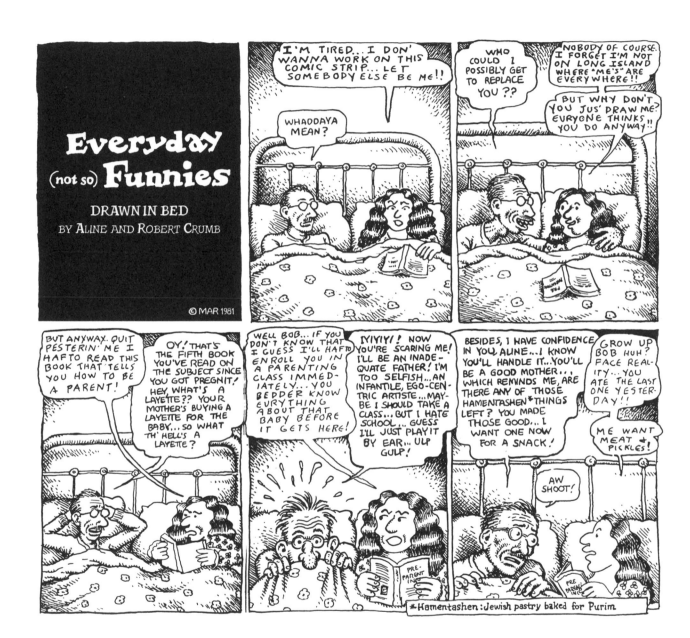

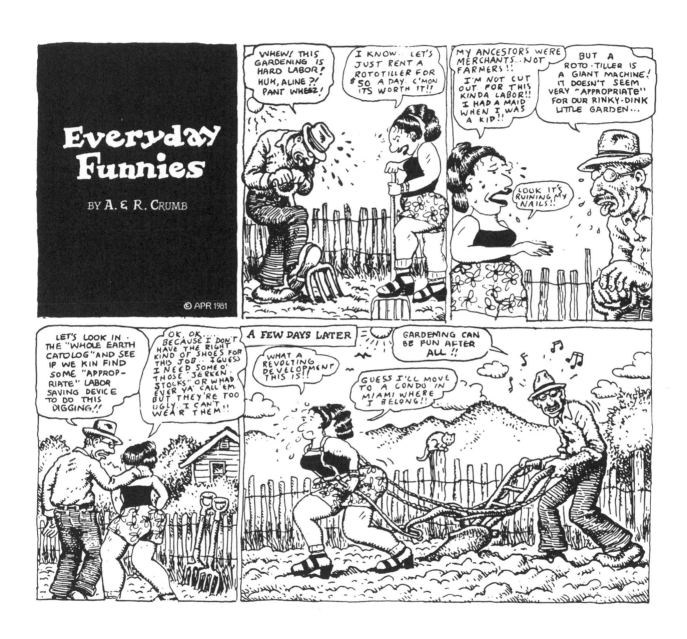

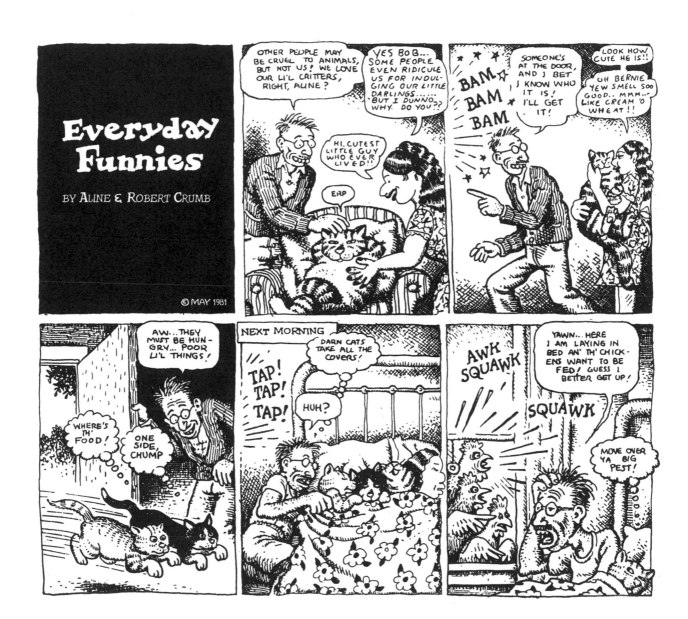

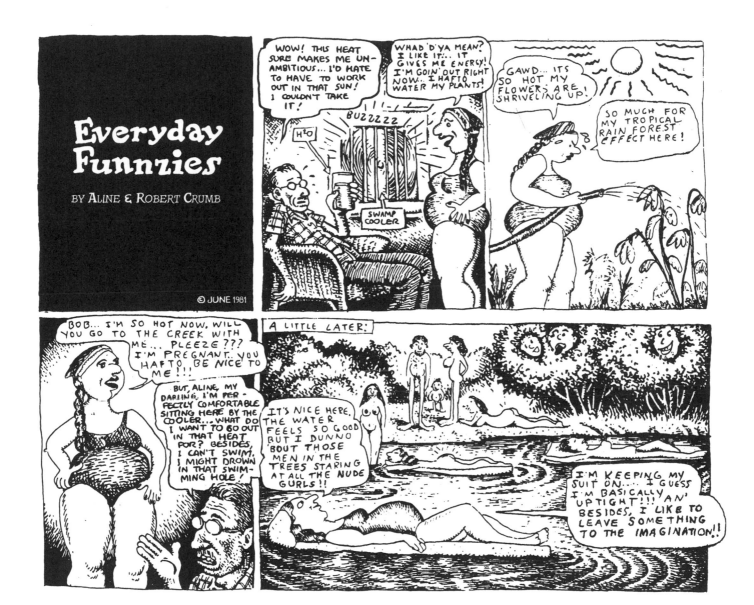

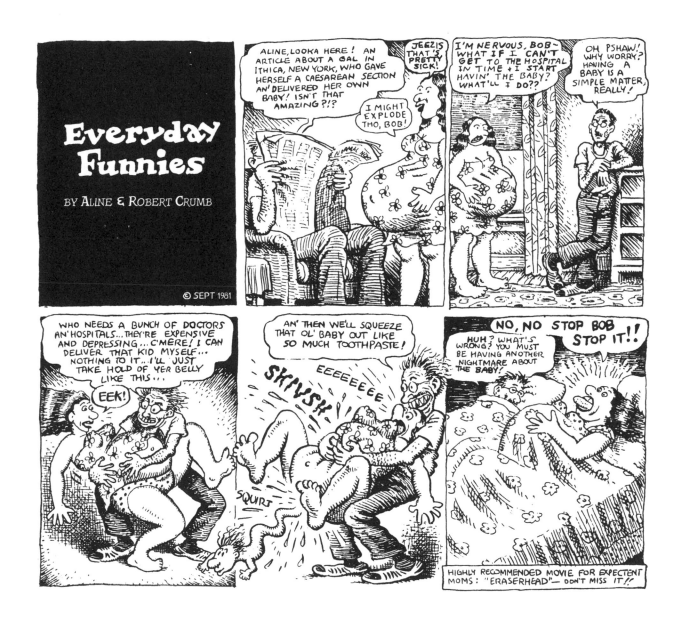

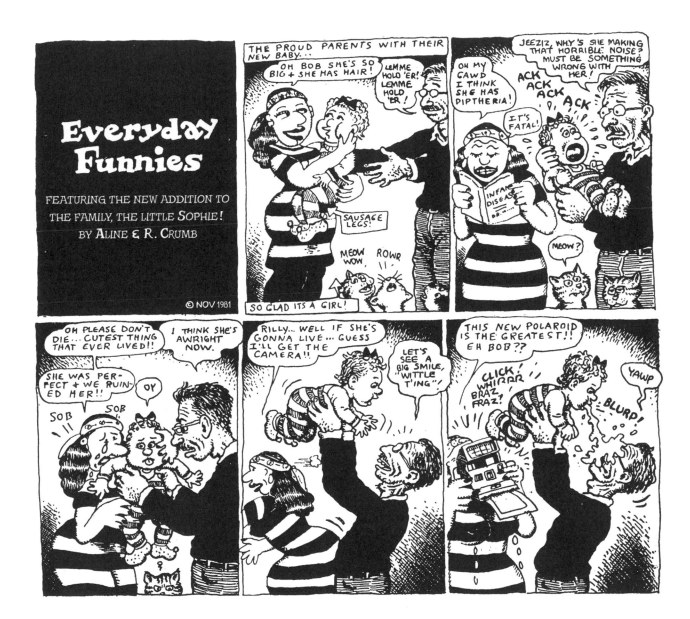

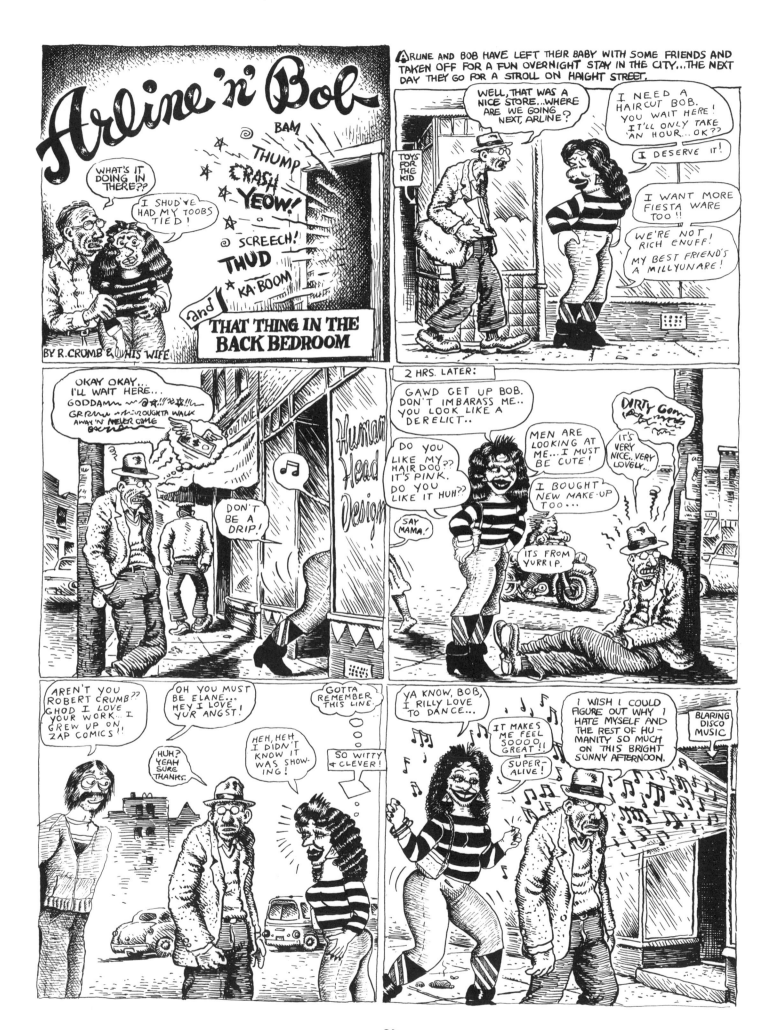

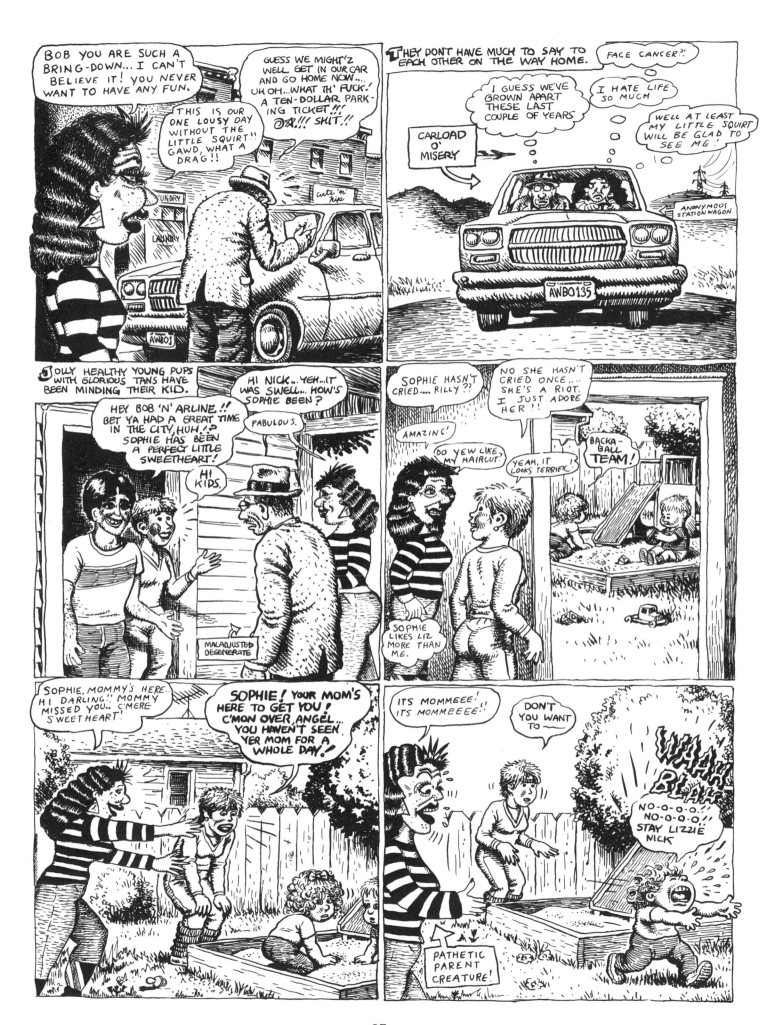

95

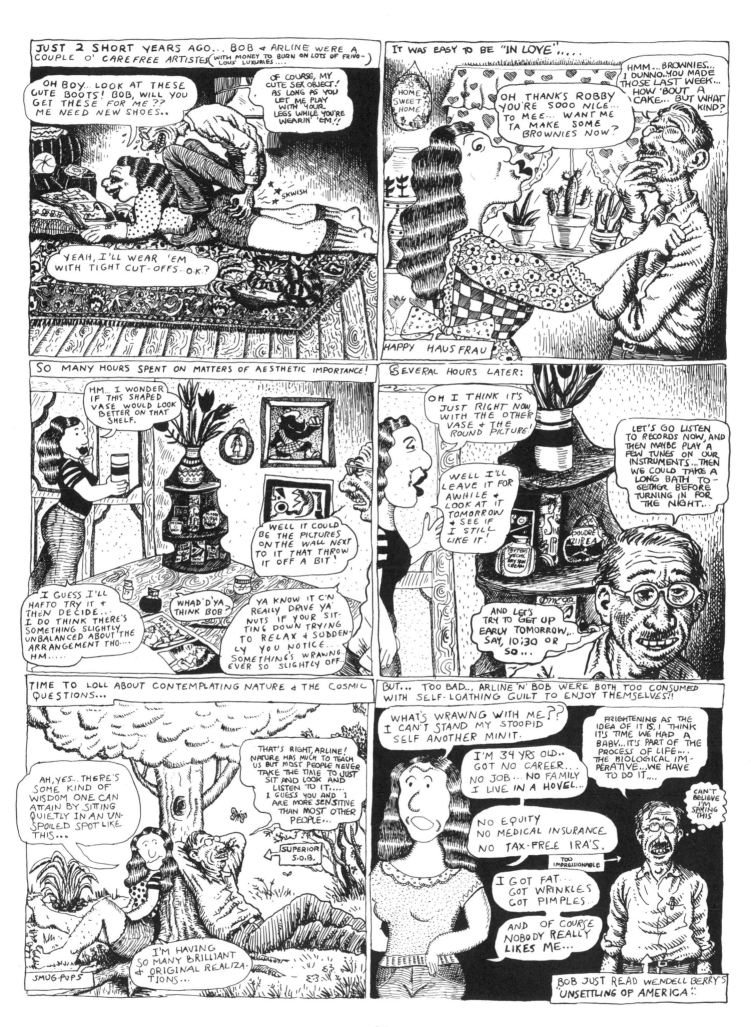

96

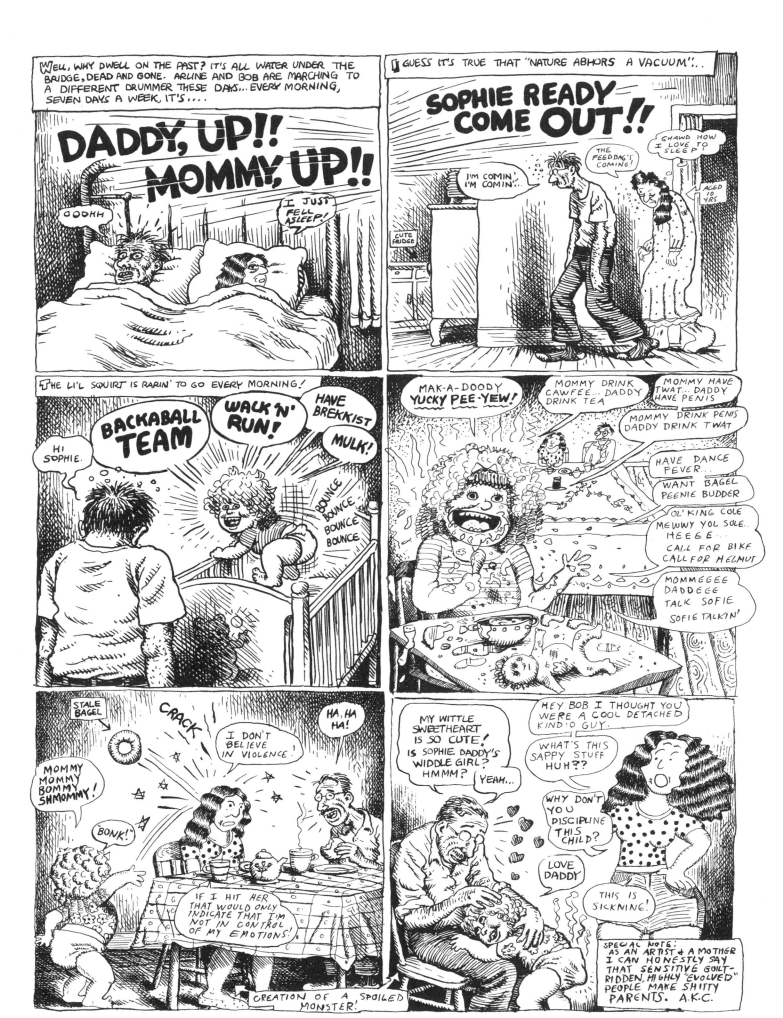

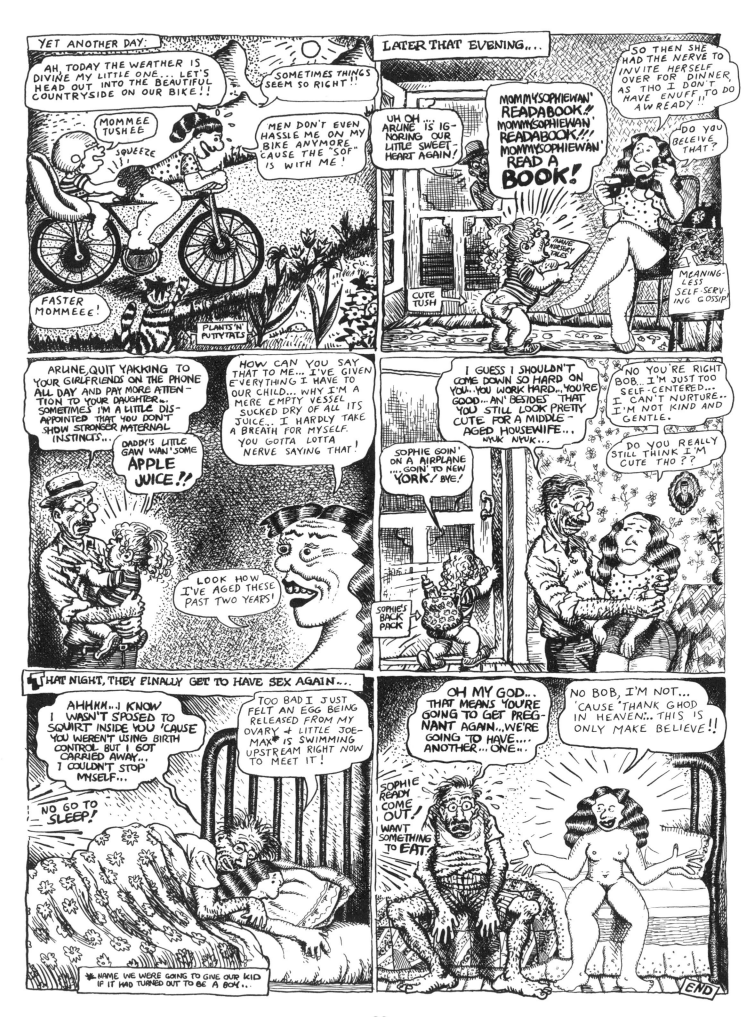

98

THE CRUMB FAMILY

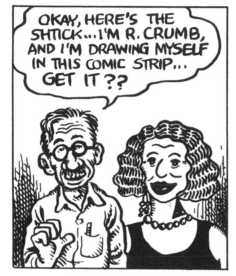

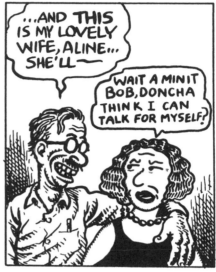

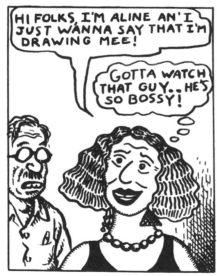

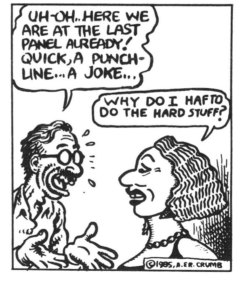

THE CRUMB FAMILY

BY A. & R. CRUMB

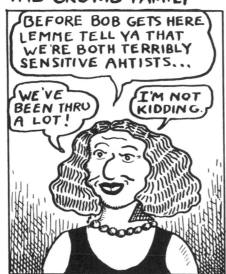

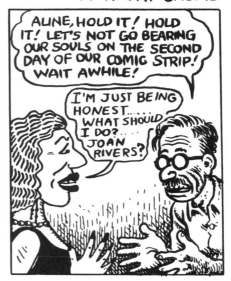

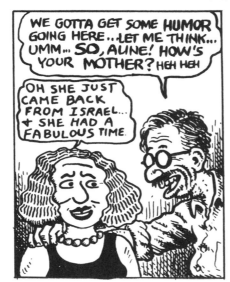

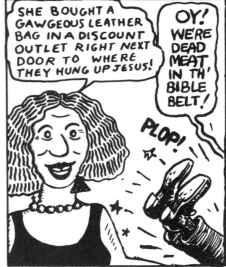

THE CRUMB FAMILY

BY A. & R. CRUMB

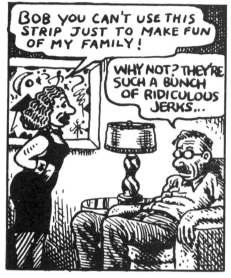

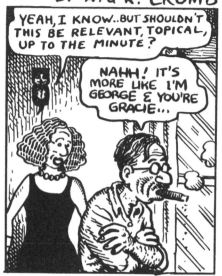

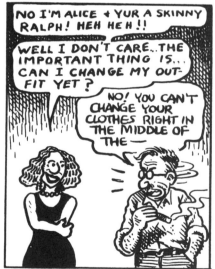

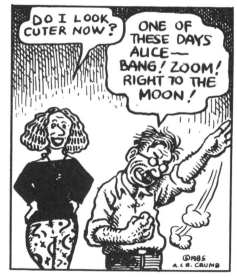

101

THE CRUMB FAMILY

BY A. & R. CRUMB

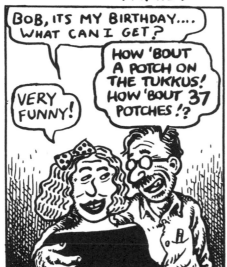

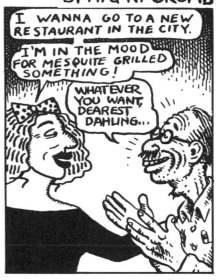

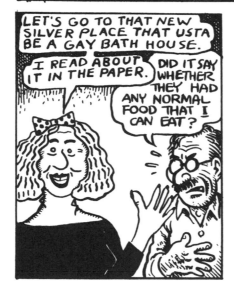

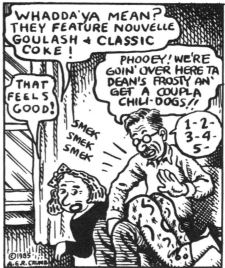

THE CRUMB FAMILY

BY A. & R. CRUMB

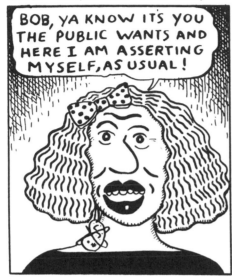

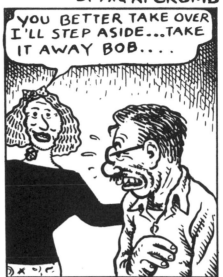

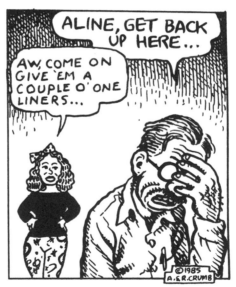

THE CRUMB FAMILY

BY A. & R. CRUMB

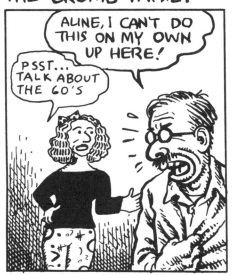

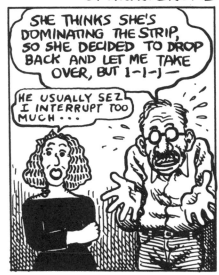

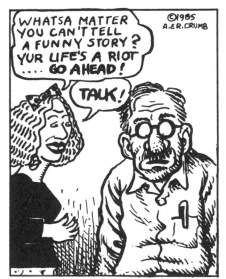

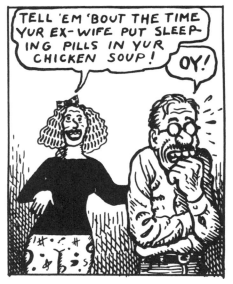

THE CRUMB FAMILY

BY A. & R. CRUMB

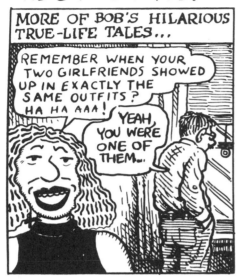

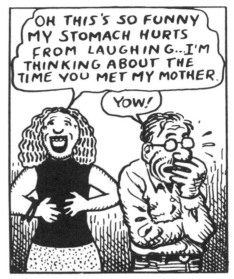

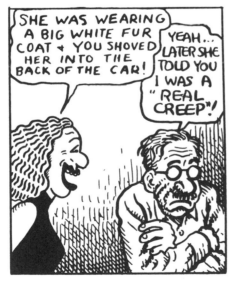

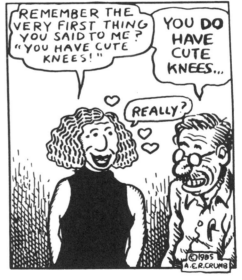

THE CRUMB FAMILY

BY A. & R. CRUMB

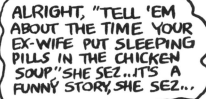
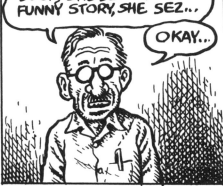
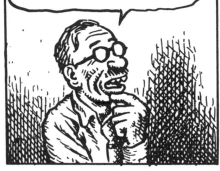
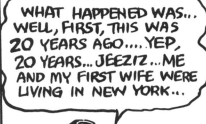
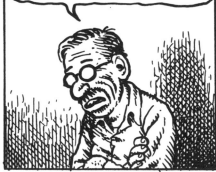
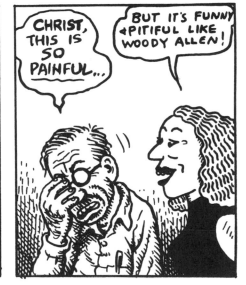

THE CRUMB FAMILY

BY A. & R. CRUMB

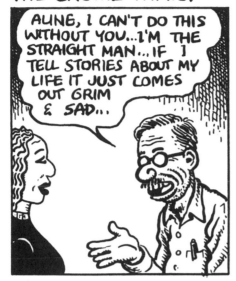

ALINE, I CAN'T DO THIS WITHOUT YOU...I'M THE STRAIGHT MAN...IF I TELL STORIES ABOUT MY LIFE IT JUST COMES OUT GRIM & SAD...

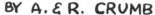
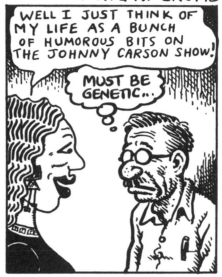

WELL I JUST THINK OF MY LIFE AS A BUNCH OF HUMOROUS BITS ON THE JOHNNY CARSON SHOW!

MUST BE GENETIC...

THE INSTANT SOMETHING IS OVER, IT BECOMES A BIG JOKE... I CAN DE- TACH MYSELF FROM IT!

IN MY FAMILY WE ALL BROOD FOR WEEKS OVER THE SLIGHTEST THING.

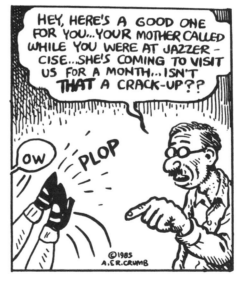

HEY, HERE'S A GOOD ONE FOR YOU...YOUR MOTHER CALLED WHILE YOU WERE AT JAZZER- CISE...SHE'S COMING TO VISIT US FOR A MONTH...ISN'T THAT A CRACK-UP??

OW PLOP

©1985
A.&R.CRUMB

THE CRUMB FAMILY BY A.&R. CRUMB

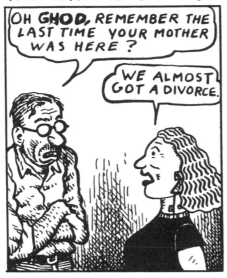

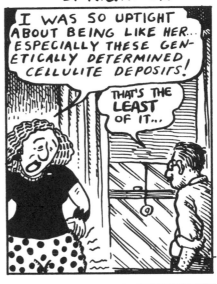

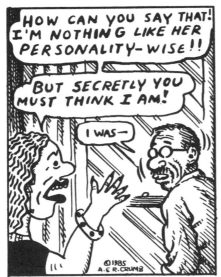

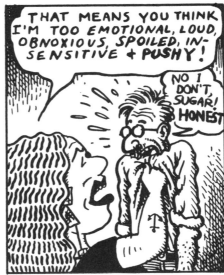

THE CRUMB FAMILY BY A. &R. CRUMB

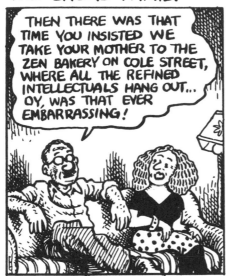

THEN THERE WAS THAT TIME YOU INSISTED WE TAKE YOUR MOTHER TO THE ZEN BAKERY ON COLE STREET, WHERE ALL THE REFINED INTELLECTUALS HANG OUT... OY, WAS THAT EVER EMBARRASSING!

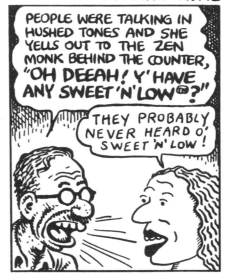

PEOPLE WERE TALKING IN HUSHED TONES AND SHE YELLS OUT TO THE ZEN MONK BEHIND THE COUNTER, "OH DEEAH! Y'HAVE ANY SWEET 'N' LOW®?"

THEY PROBABLY NEVER HEARD O' SWEET 'N' LOW!

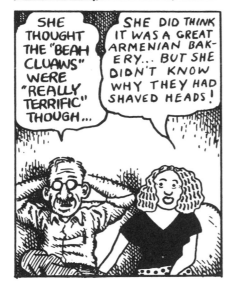

SHE THOUGHT THE "BEAH CLUAWS" WERE "REALLY TERRIFIC" THOUGH...

SHE DID THINK IT WAS A GREAT ARMENIAN BAKERY... BUT SHE DIDN'T KNOW WHY THEY HAD SHAVED HEADS!

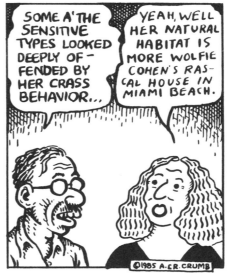

SOME A' THE SENSITIVE TYPES LOOKED DEEPLY OFFENDED BY HER CRASS BEHAVIOR...

YEAH, WELL HER NATURAL HABITAT IS MORE WOLFIE COHEN'S RASCAL HOUSE IN MIAMI BEACH.

©1985 A.&R.CRUMB

THE CRUMB FAMILY BY A. & R. CRUMB

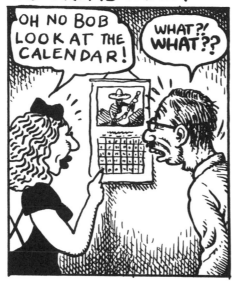

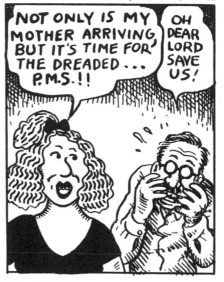

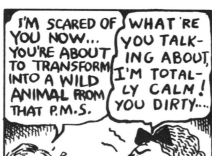

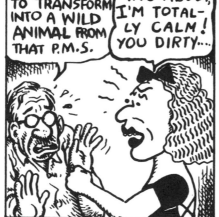

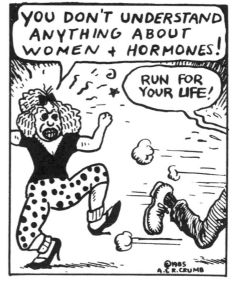

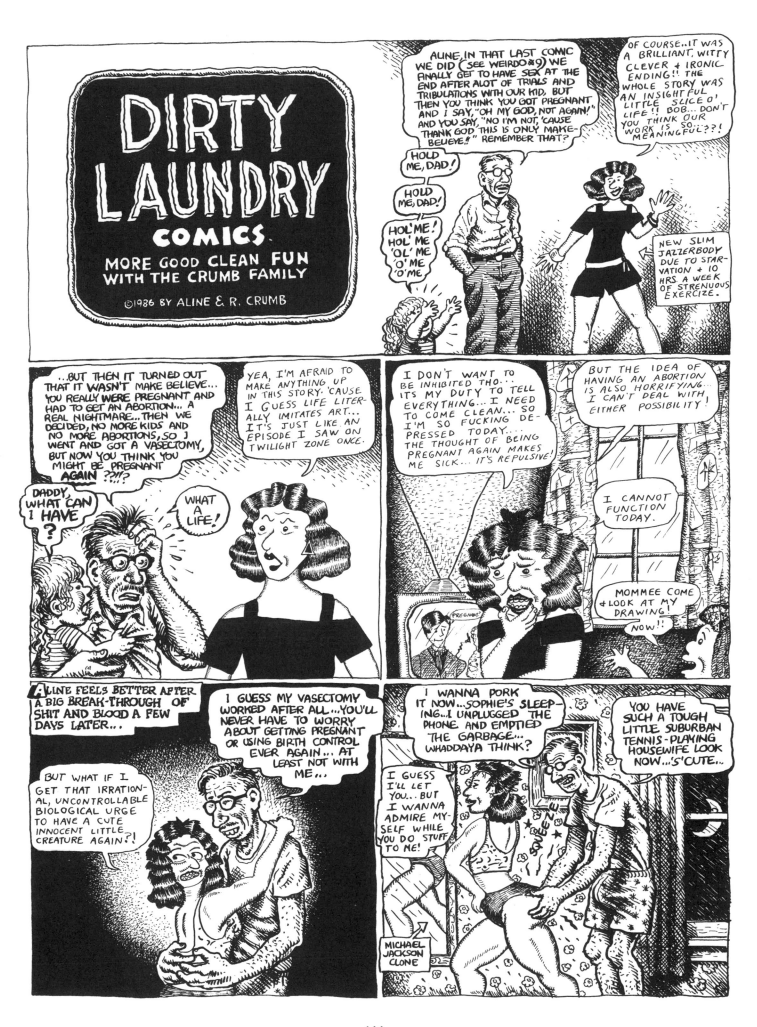

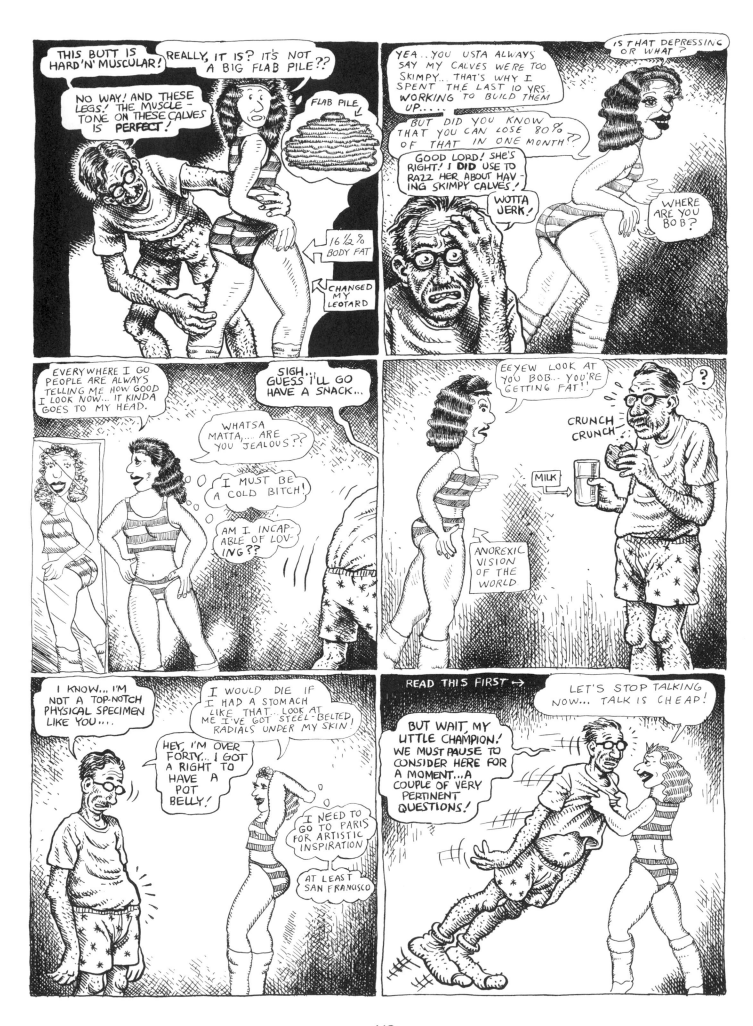

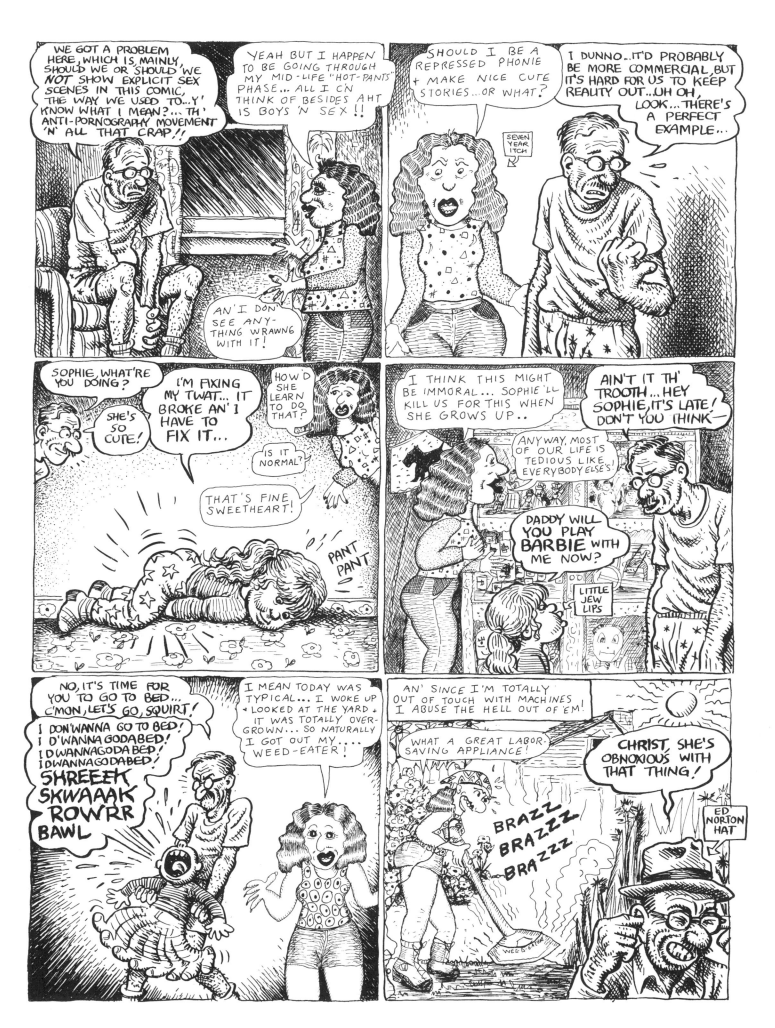

113

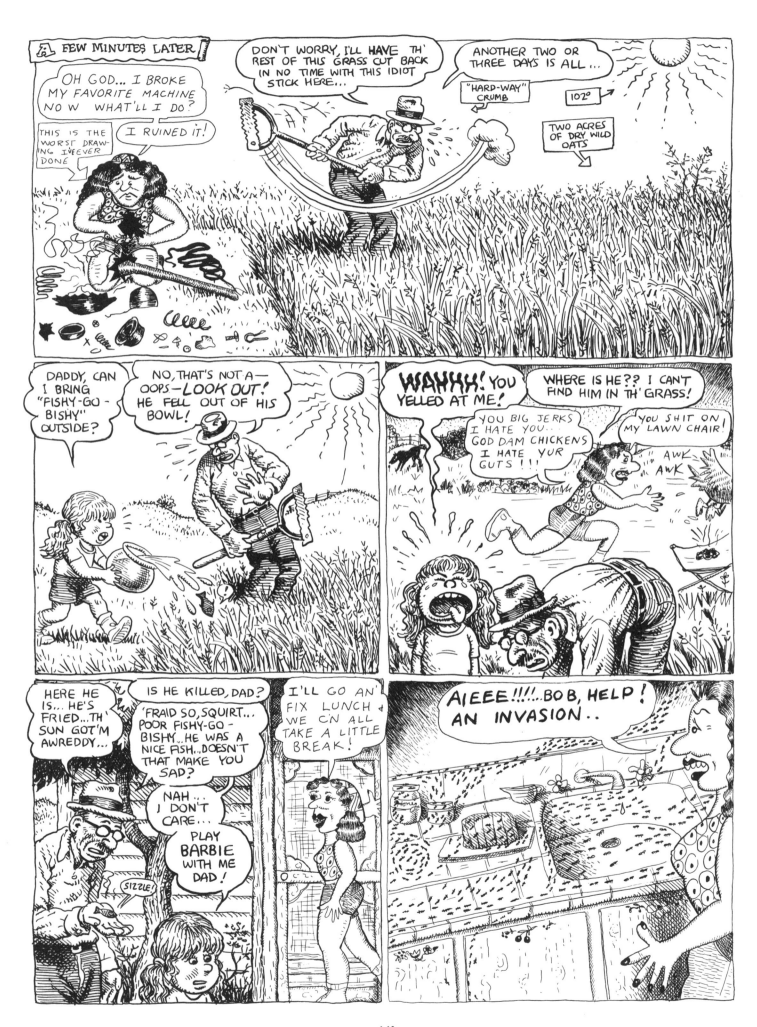

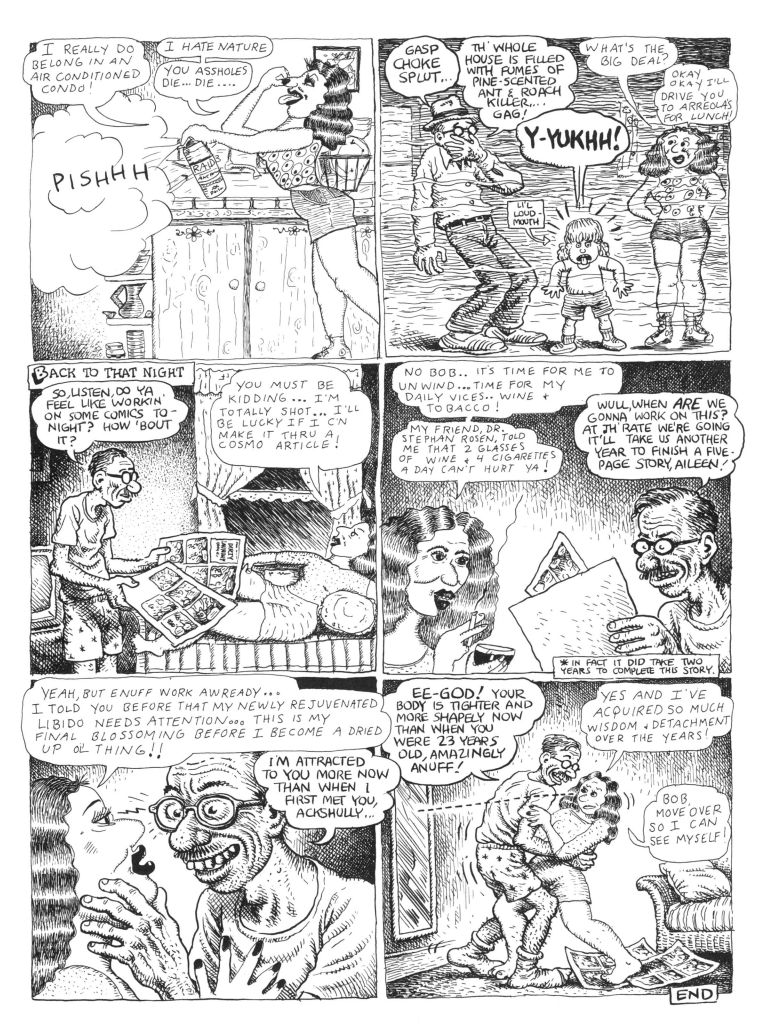

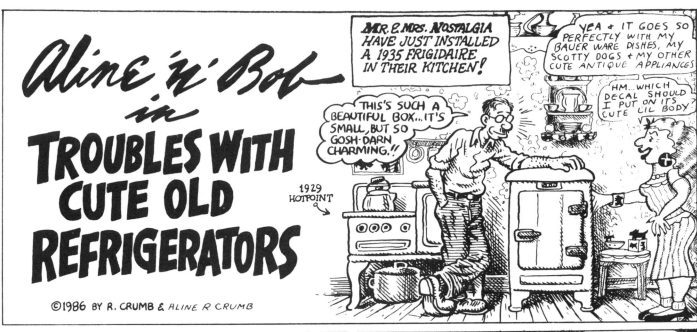

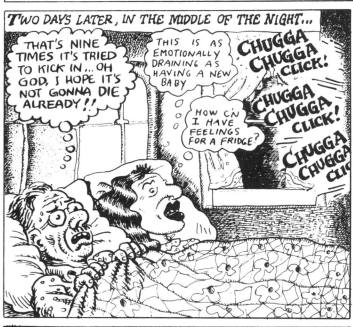

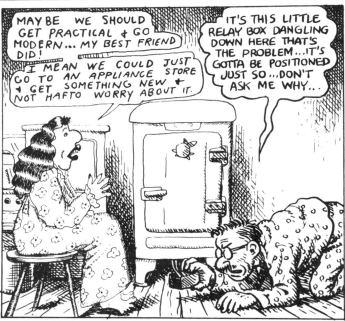

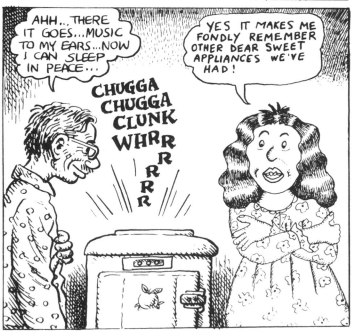

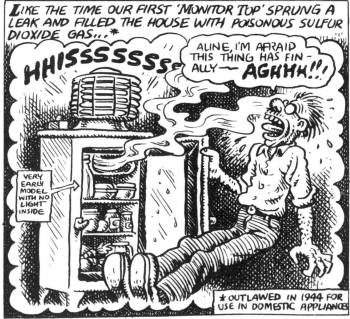

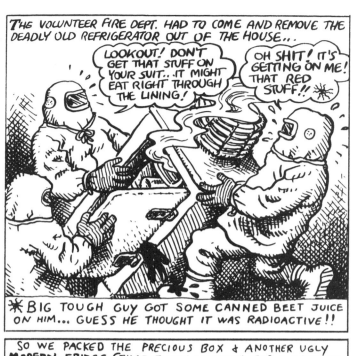

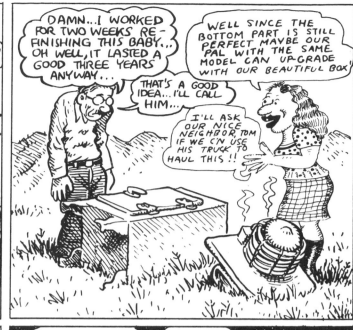

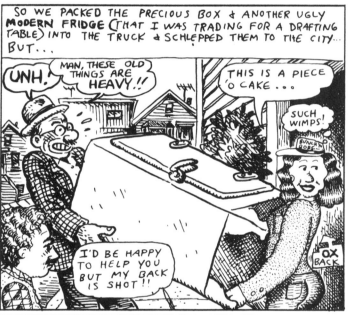

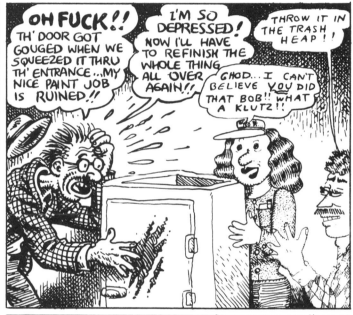

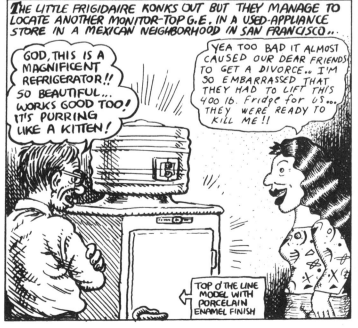

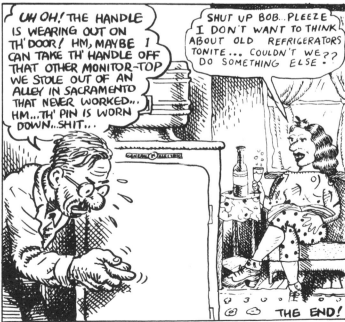

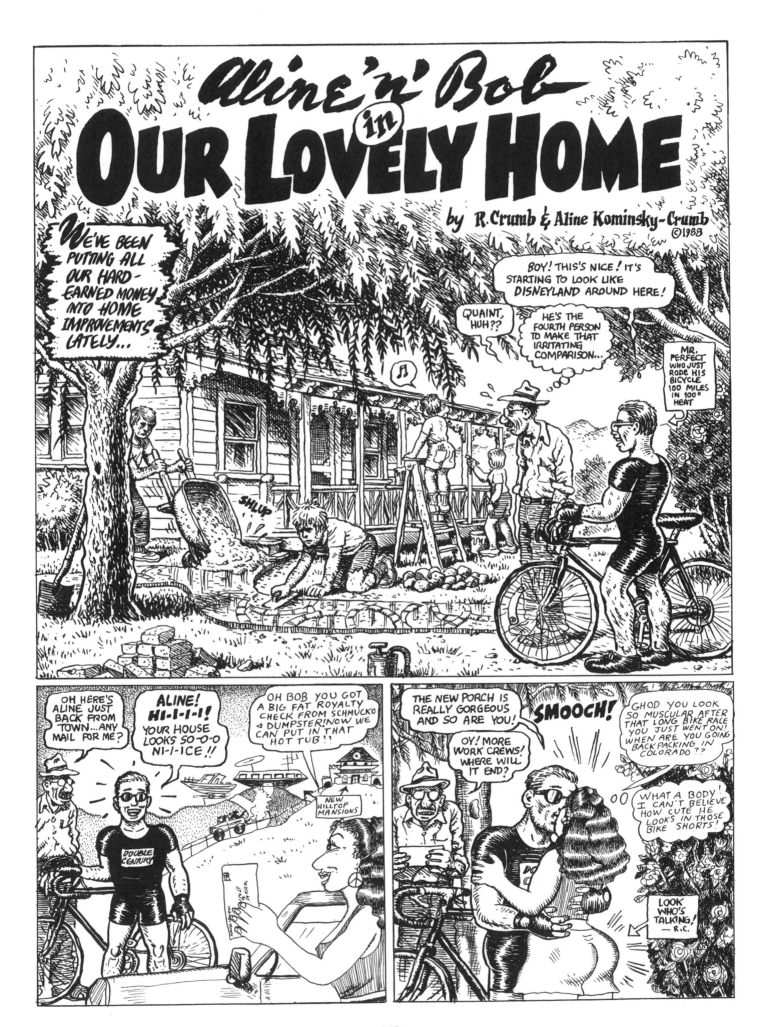

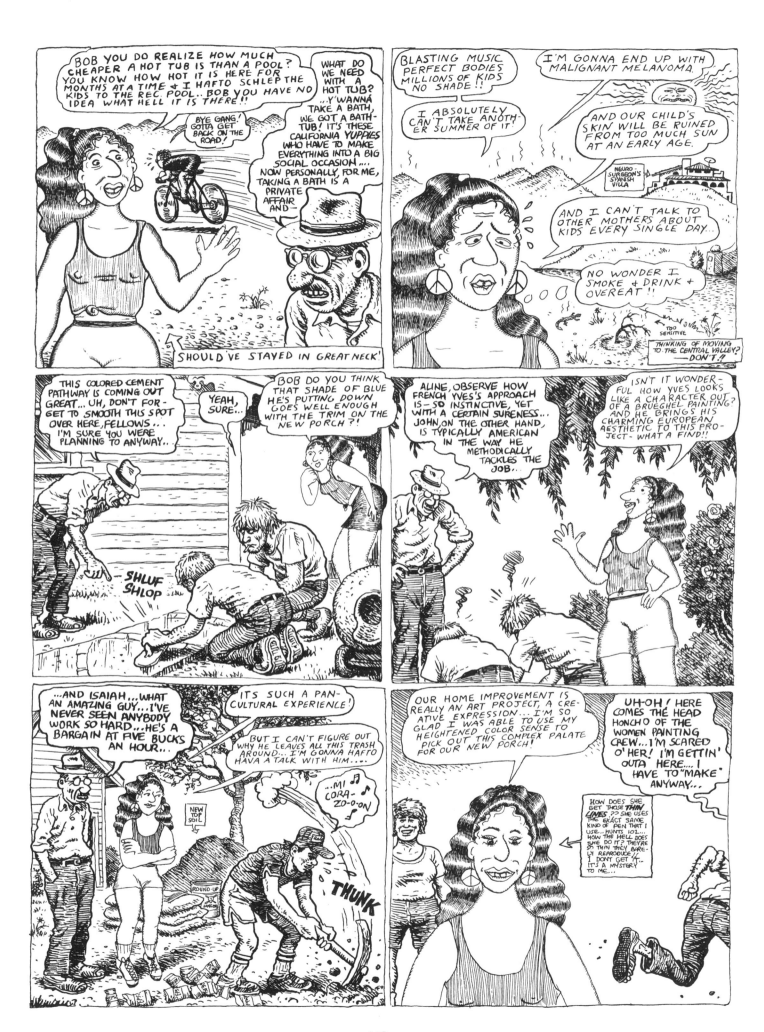

119

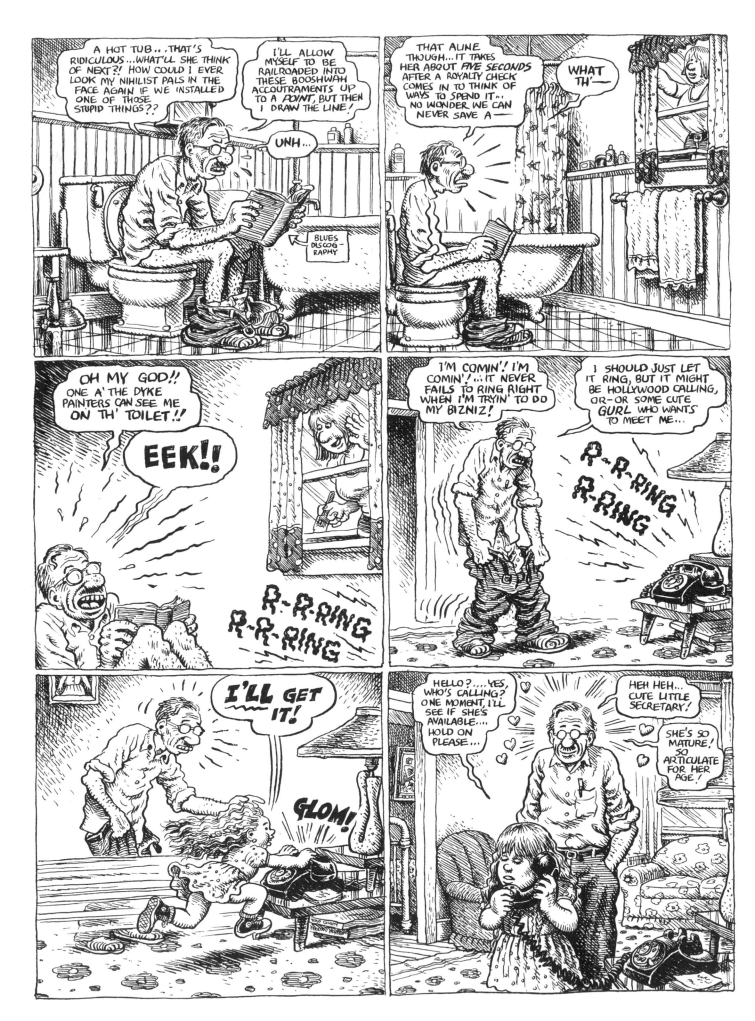

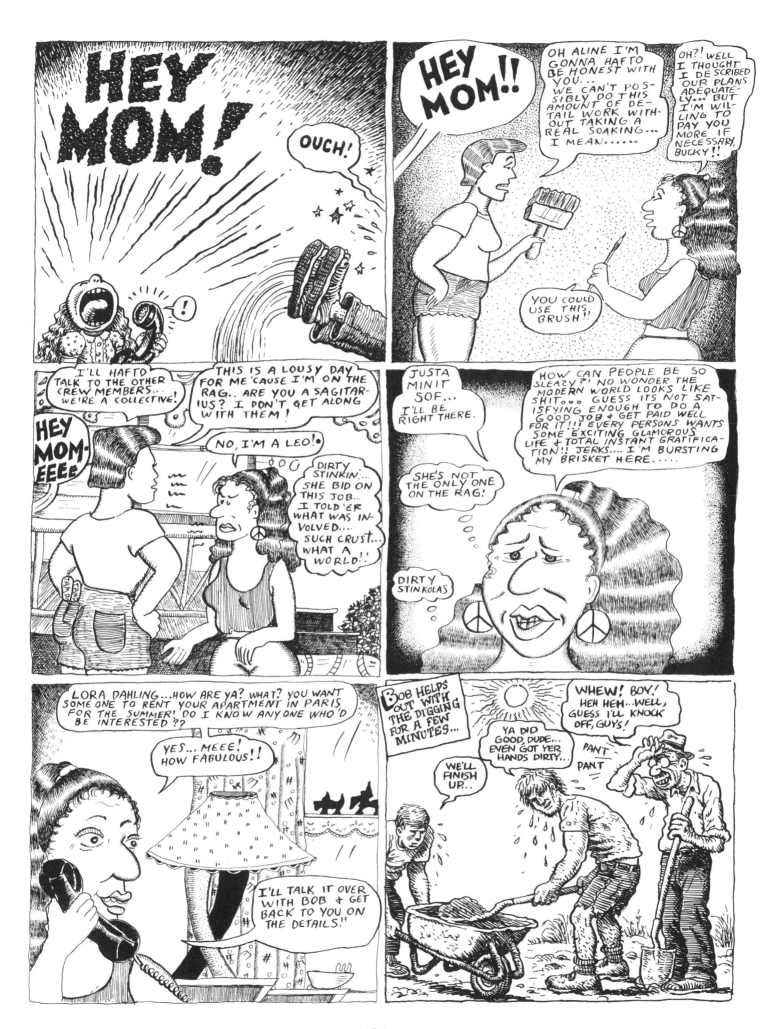

121

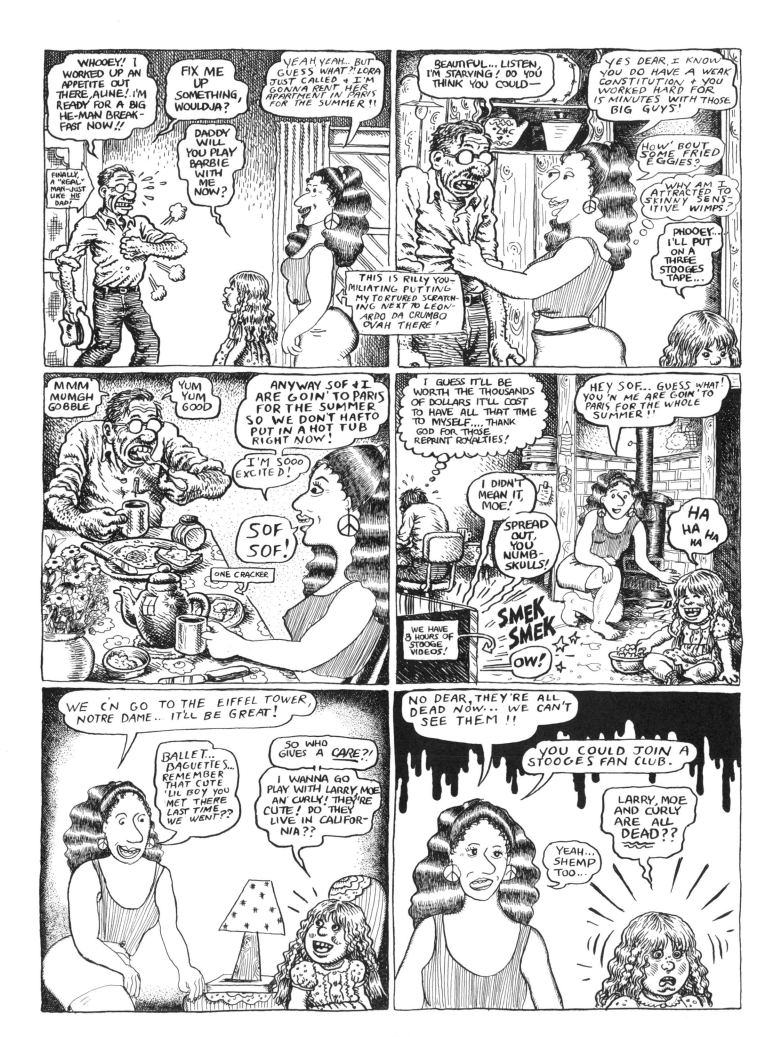

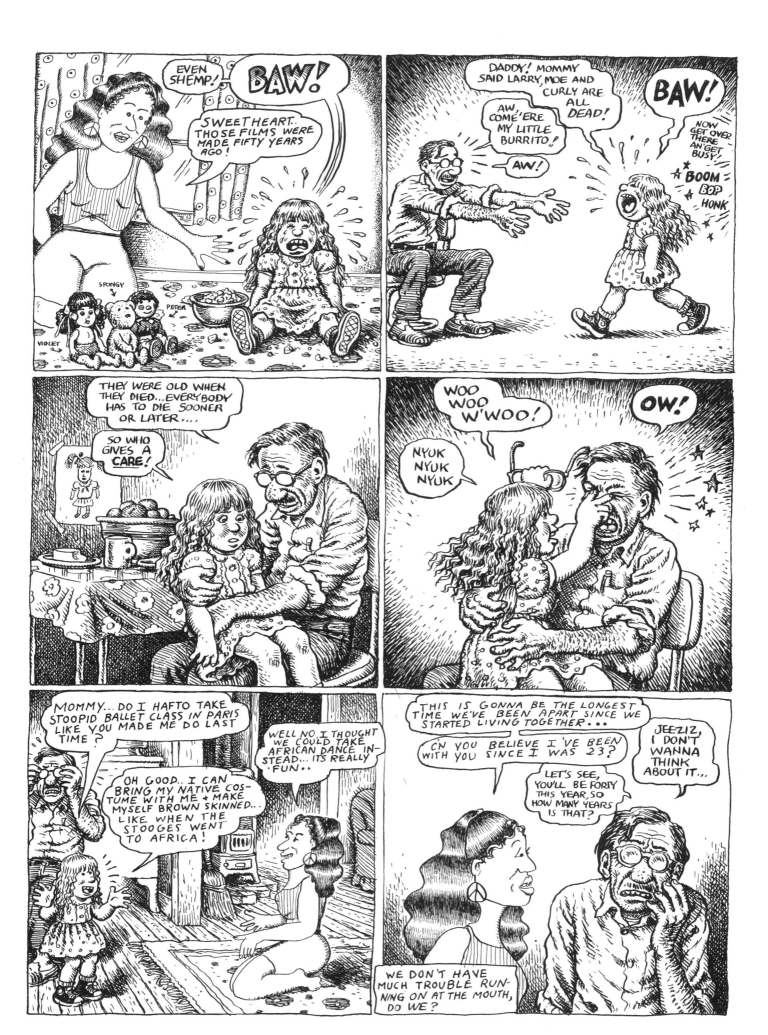

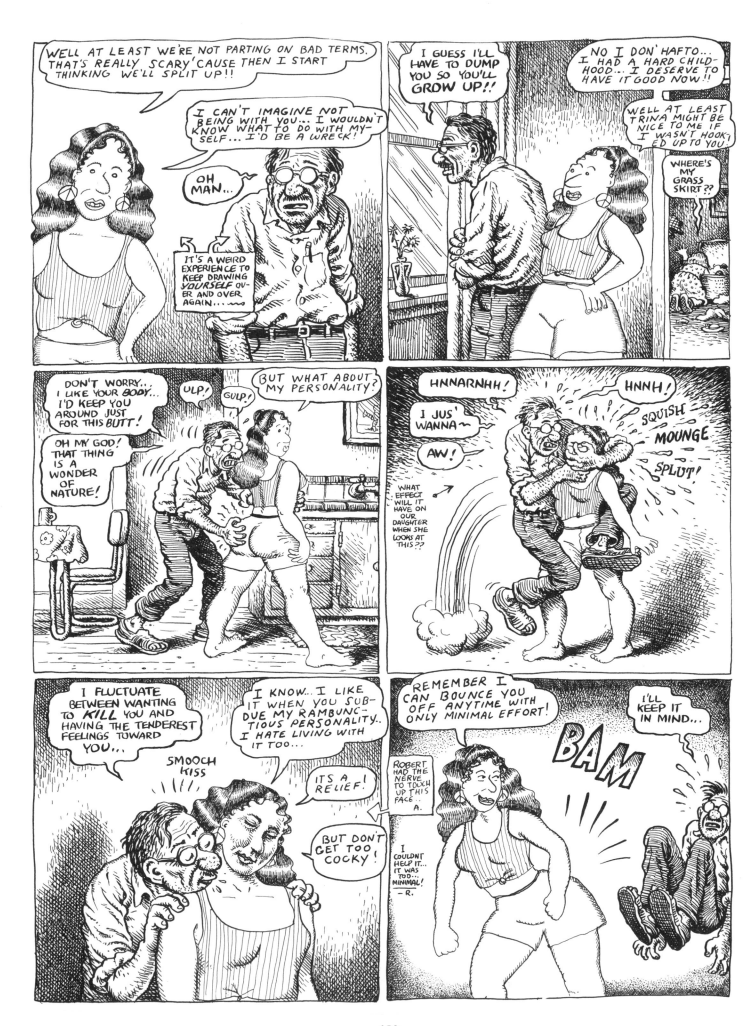

124

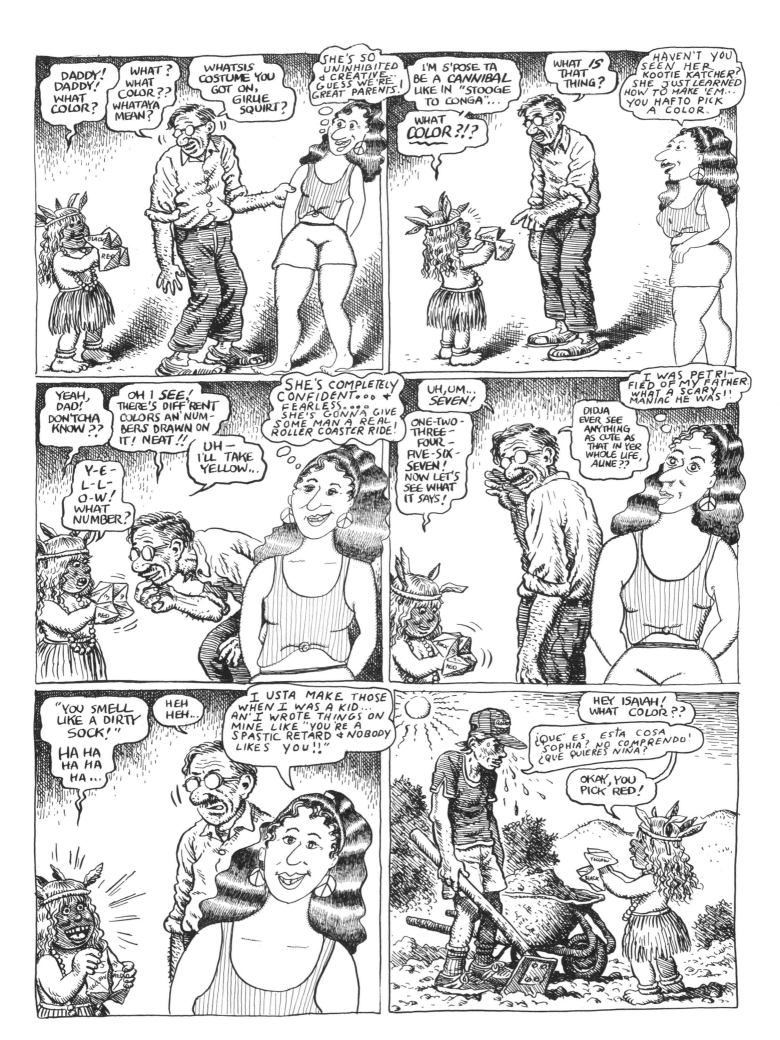

125

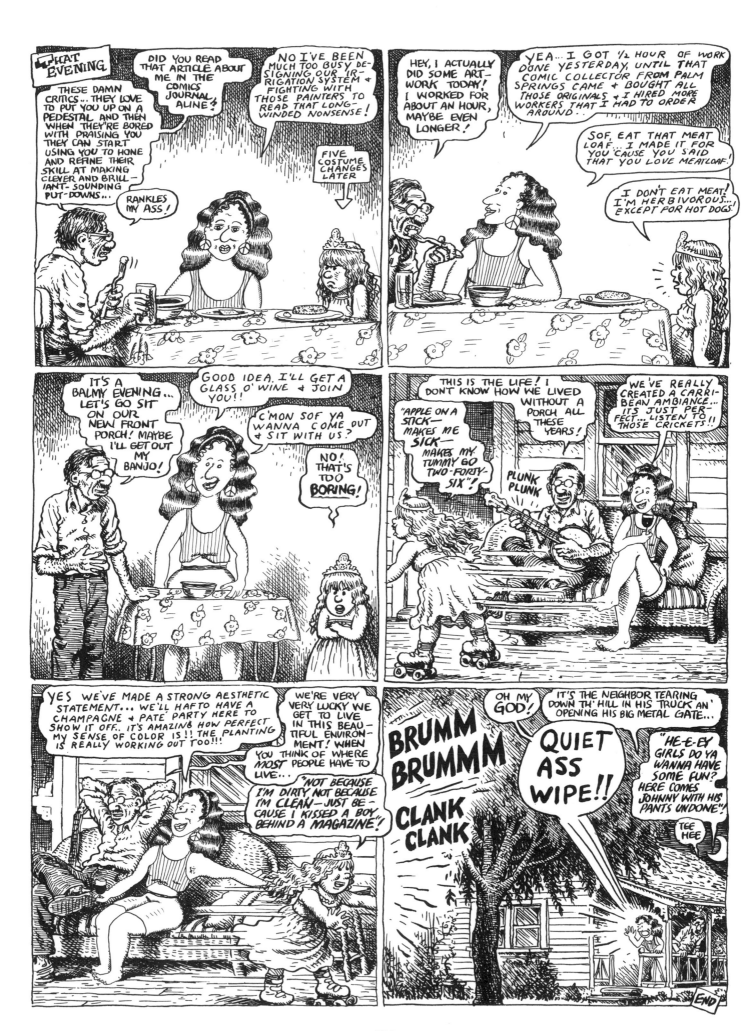

126

THE COMPLETE
DIRTY LAUNDRY
COMICS

A TRUE FAMILY COMIC STRIP, WRITTEN AND DRAWN BY
ALINE KOMINSKY-CRUMB, R.CRUMB and SOPHIE CRUMB*
* SOMETIMES, WHEN SHE FELT LIKE IT...

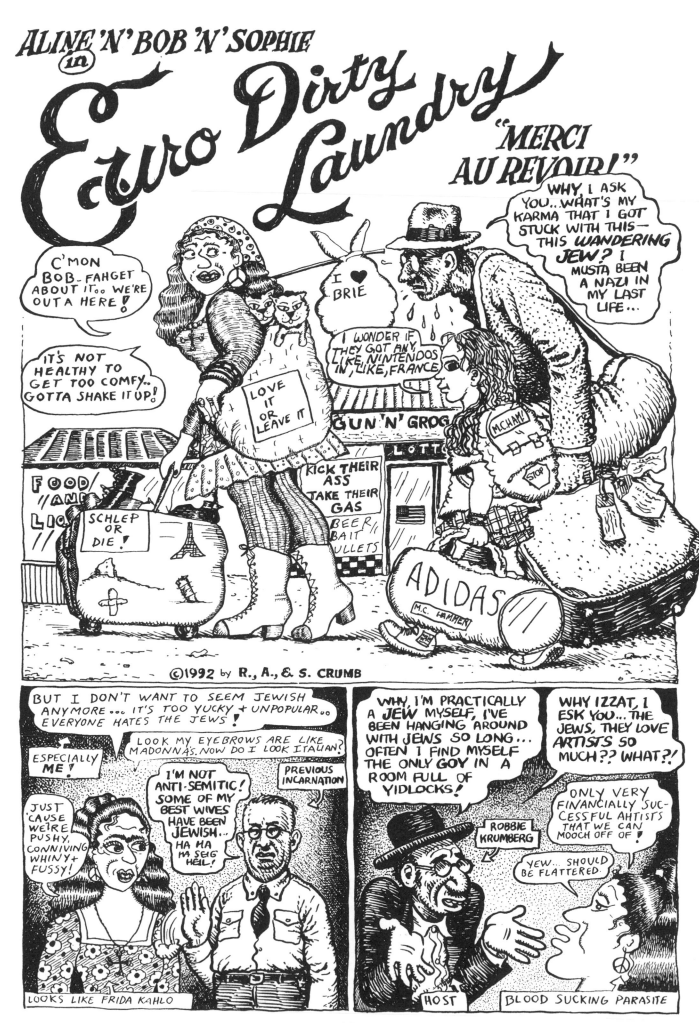

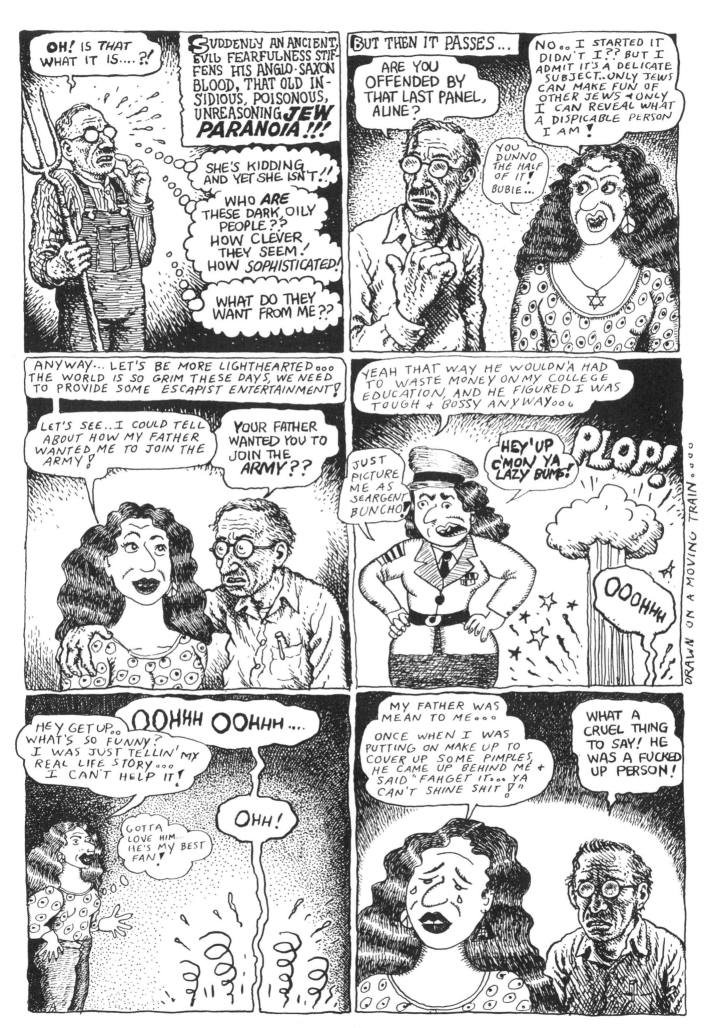

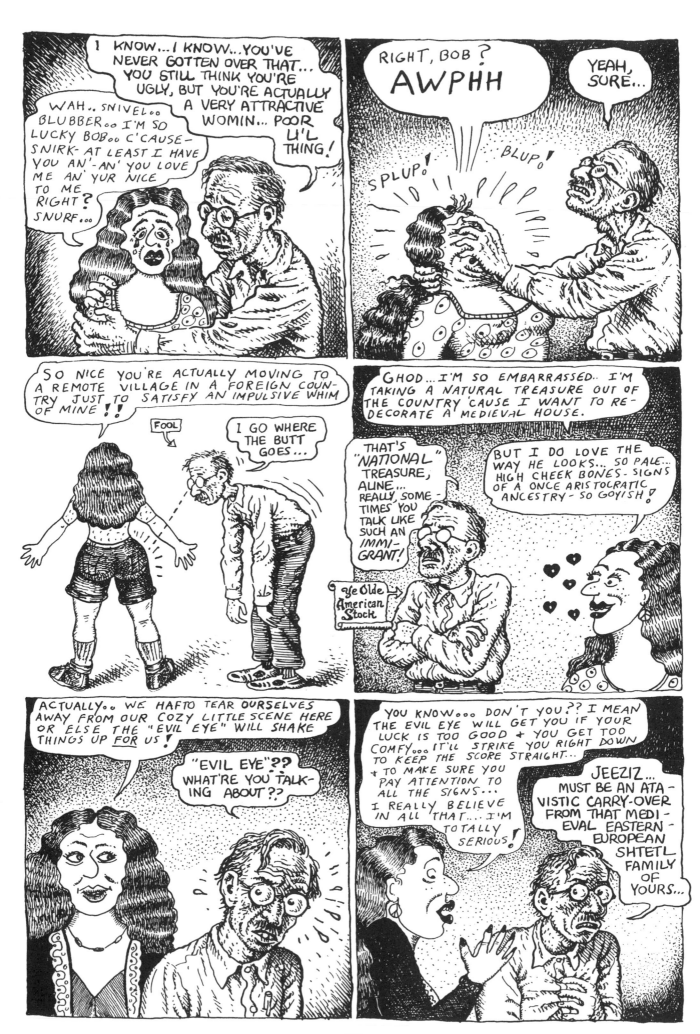

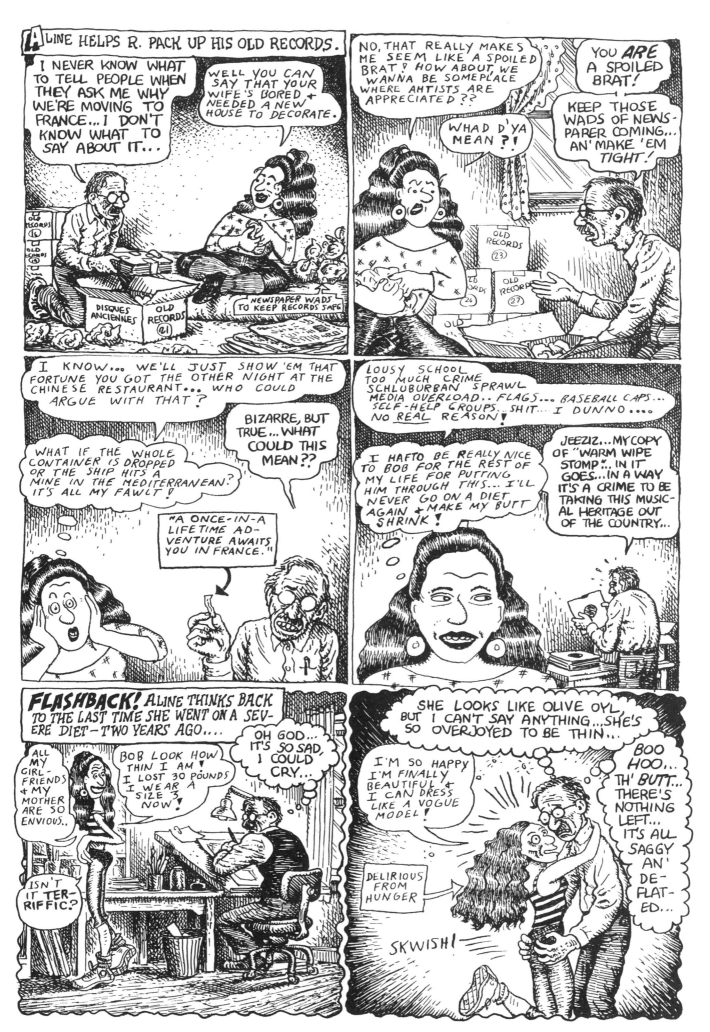

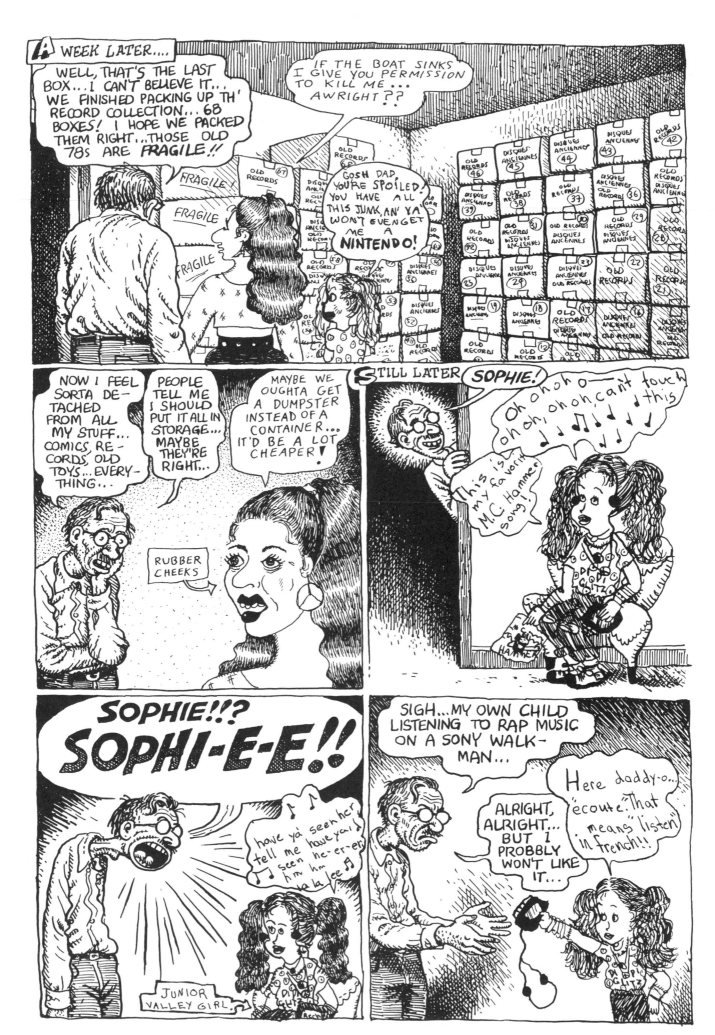

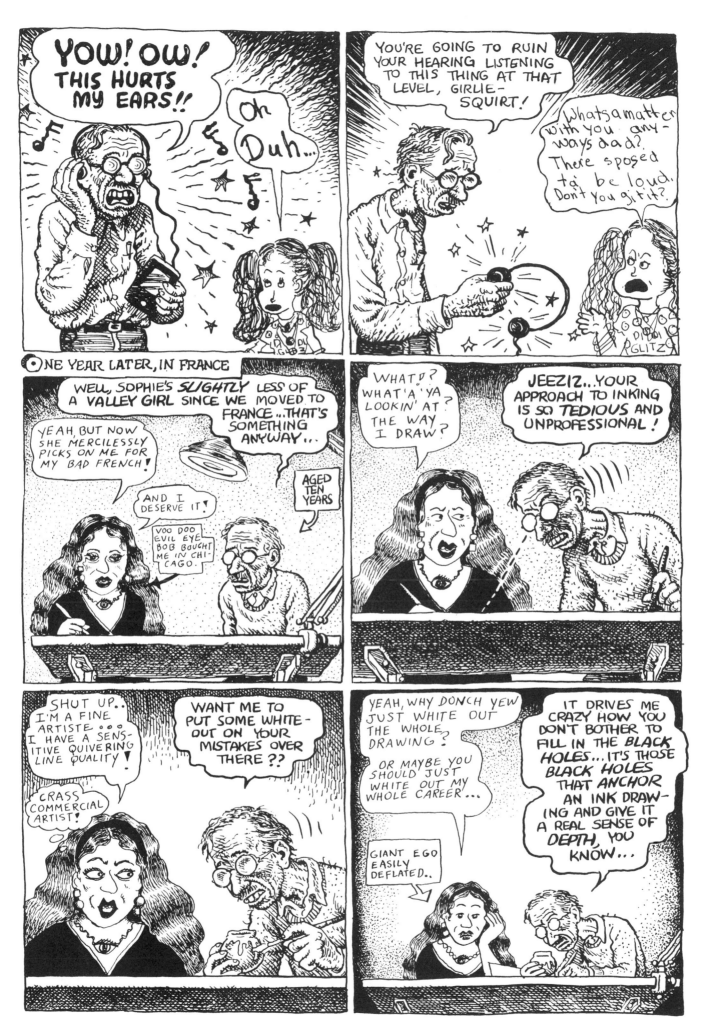

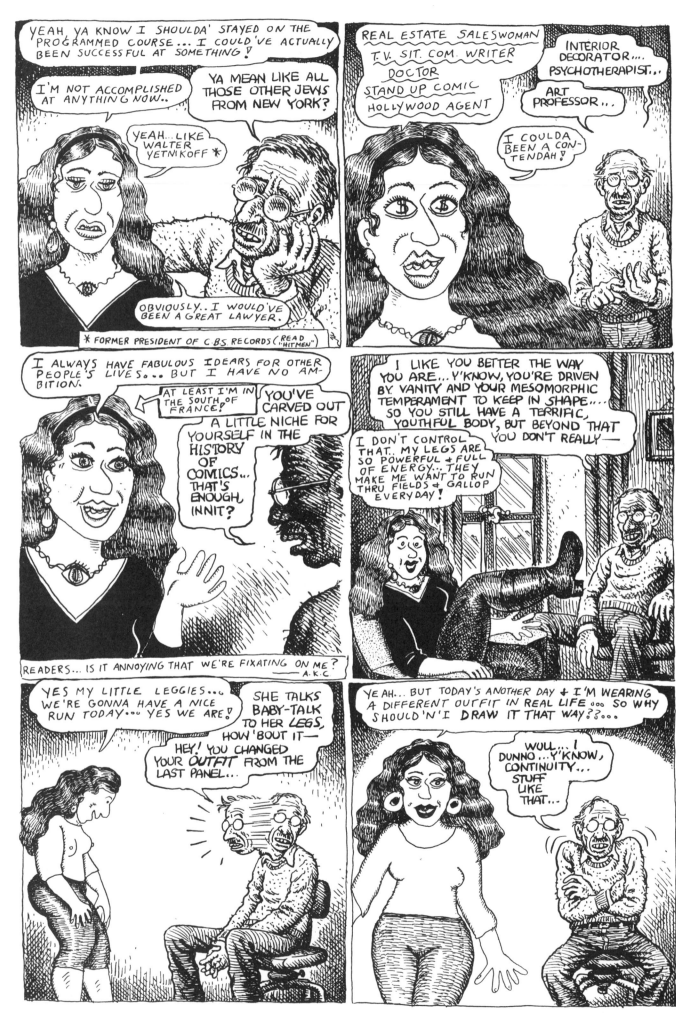

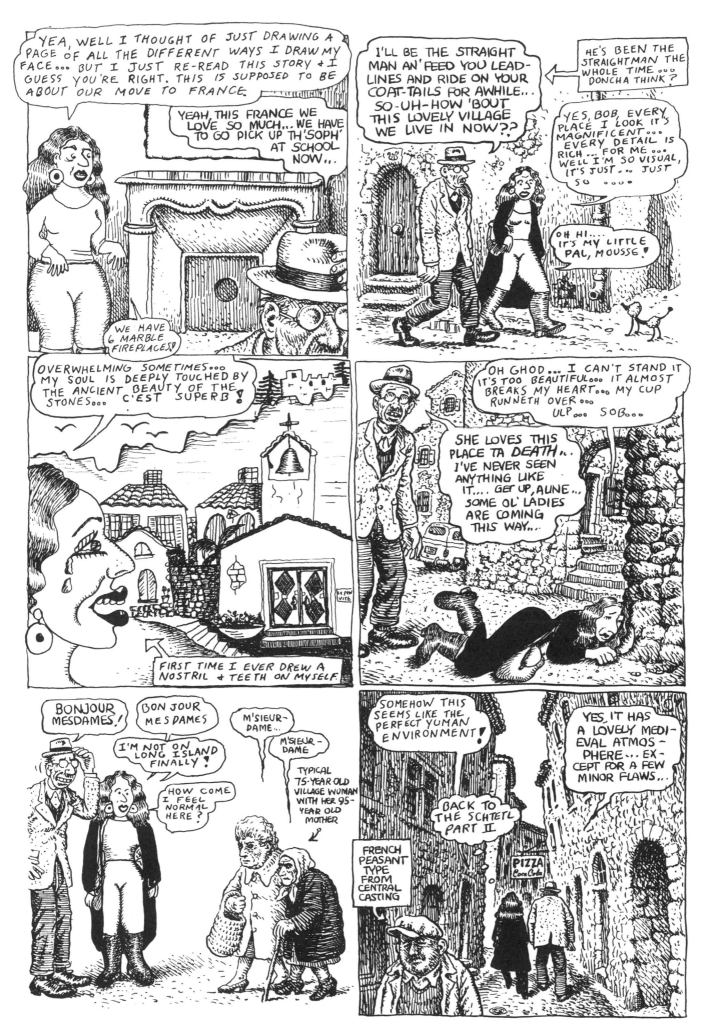

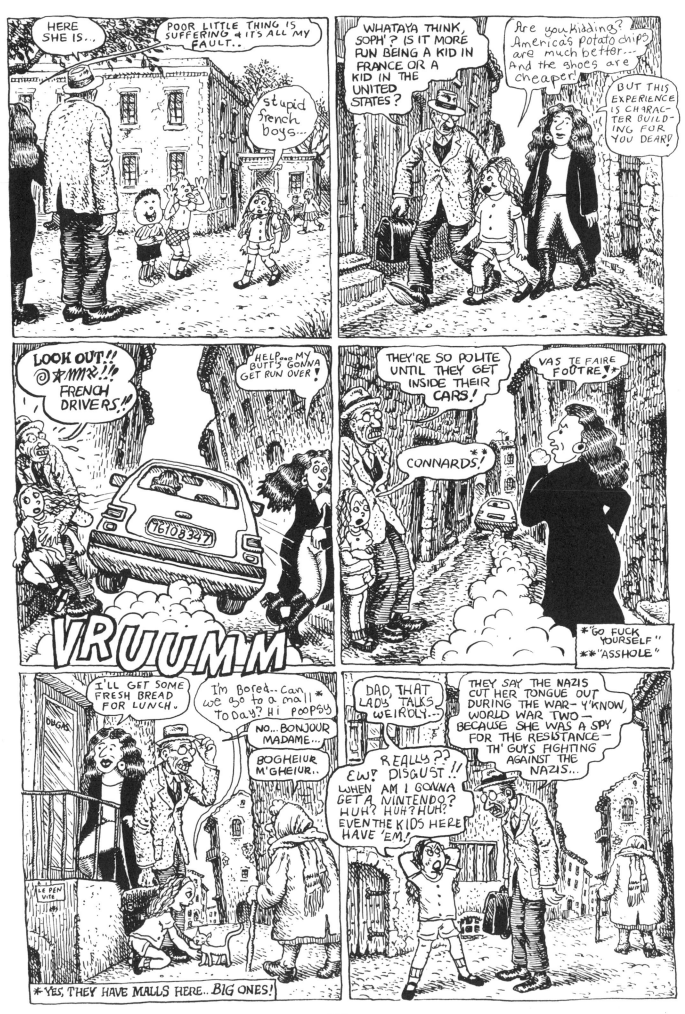

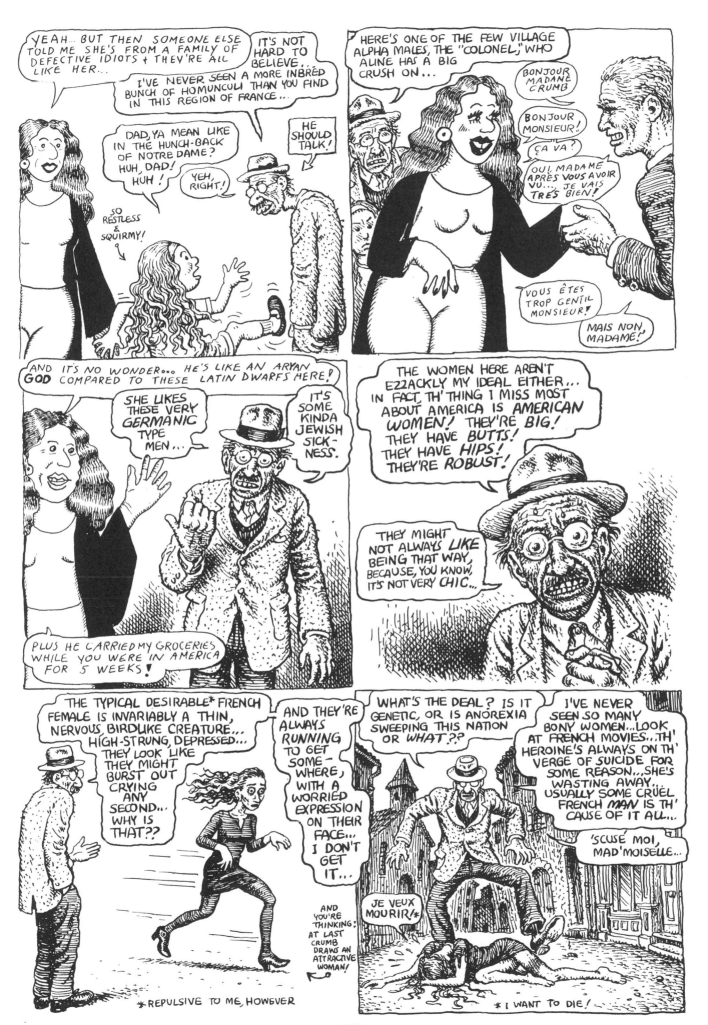

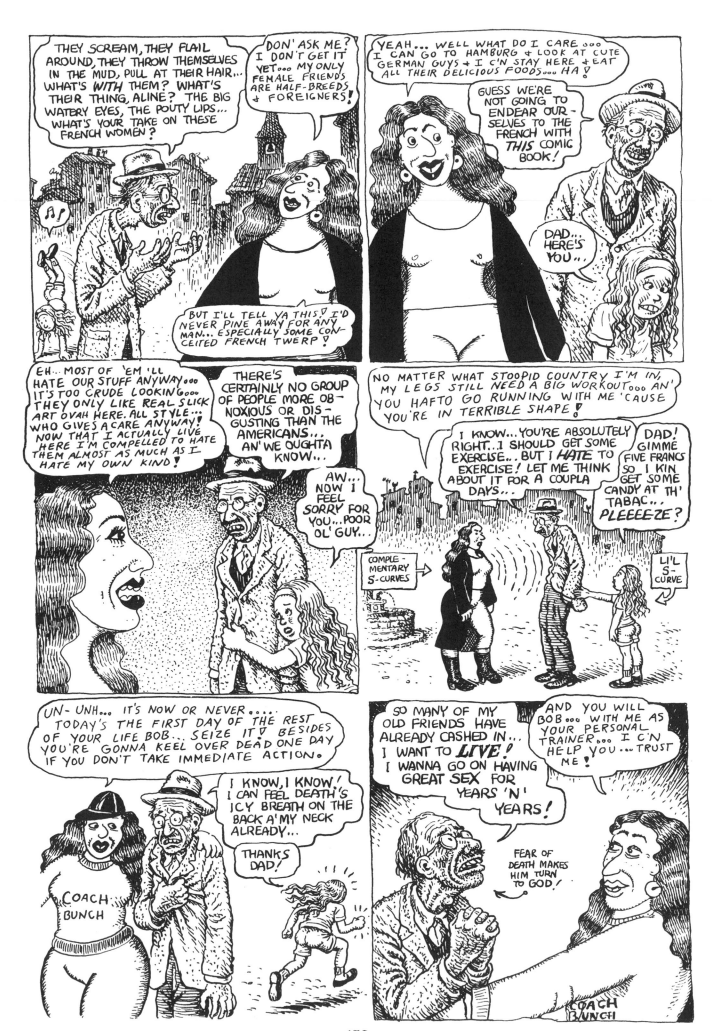

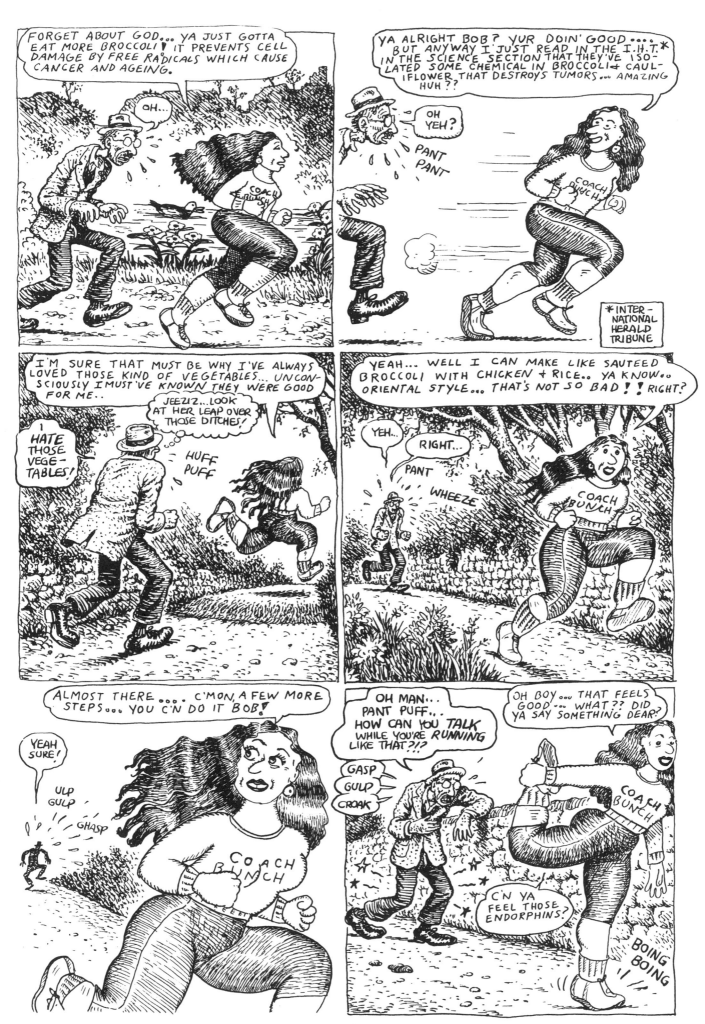

139

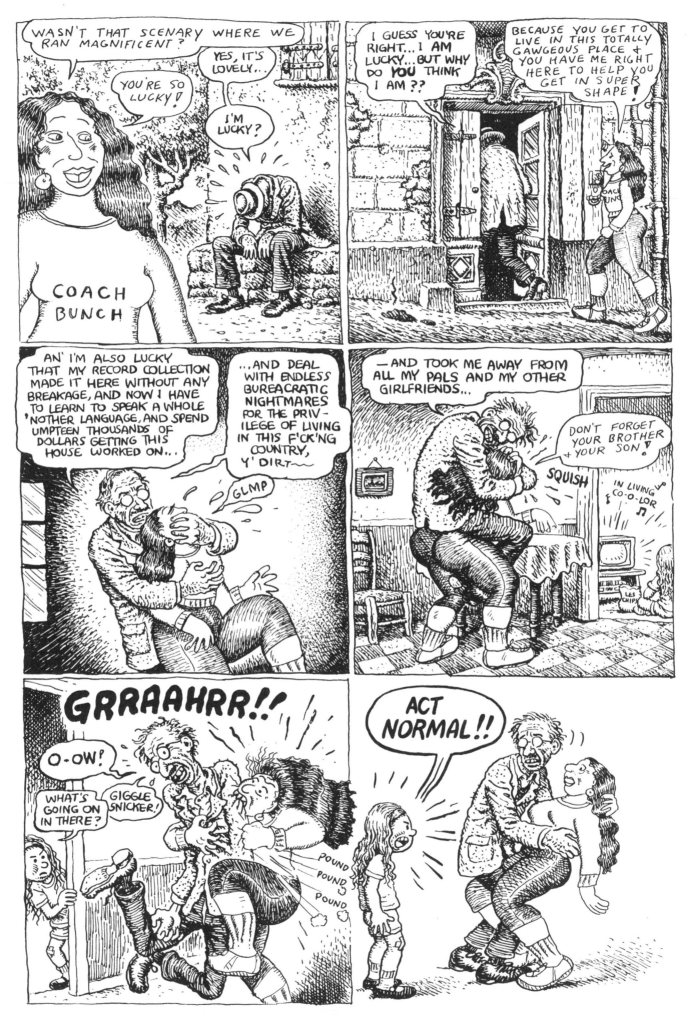

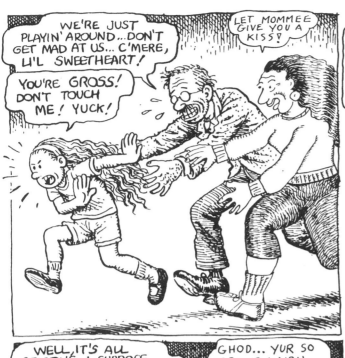

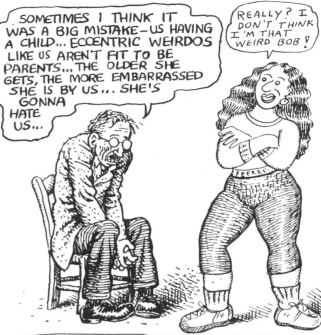

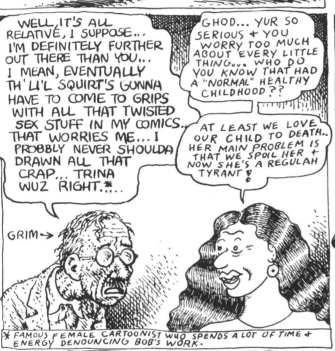

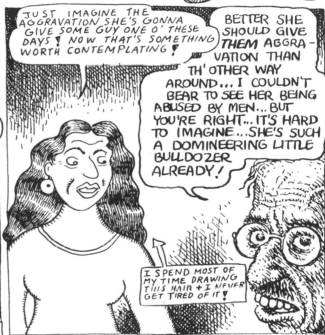

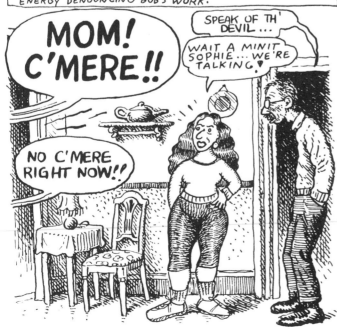

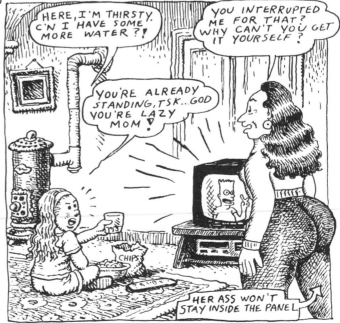

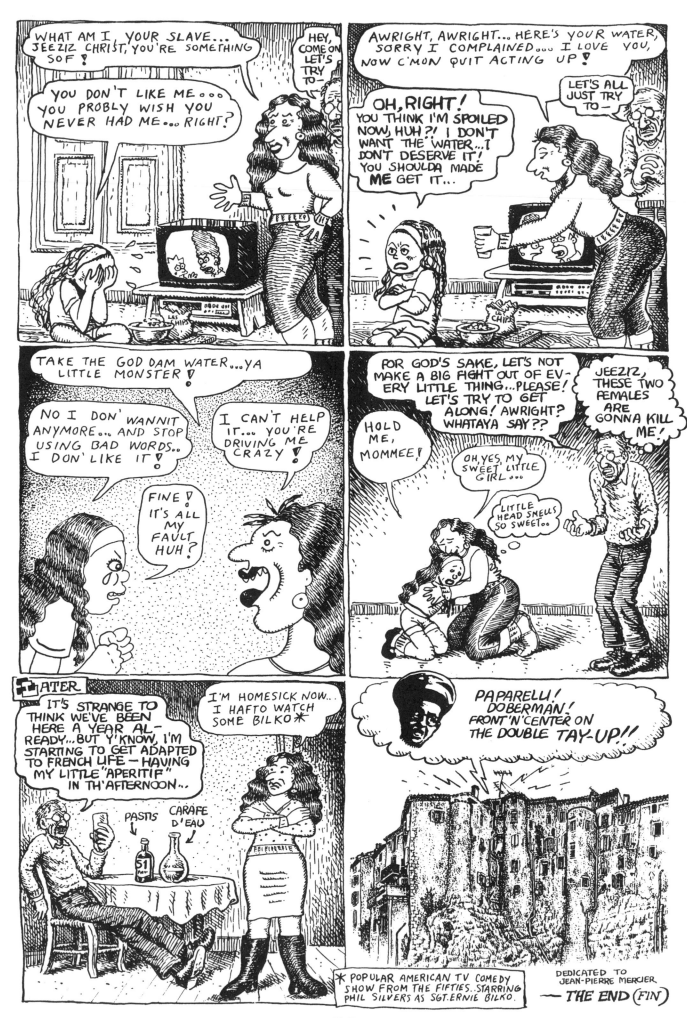

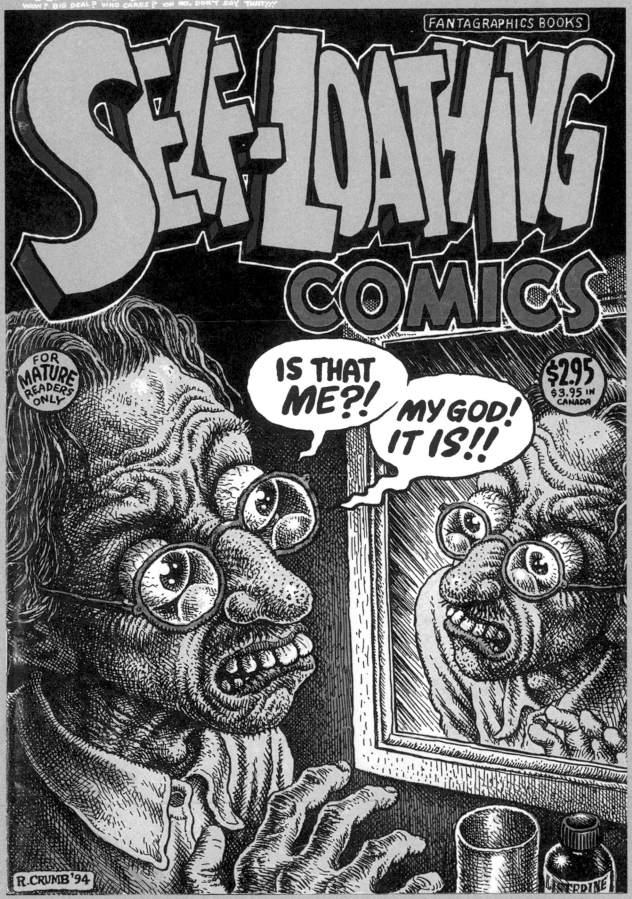

ALINE & BOB ··· "EPISMETIZIN' ON THE PUPPITUDES···"

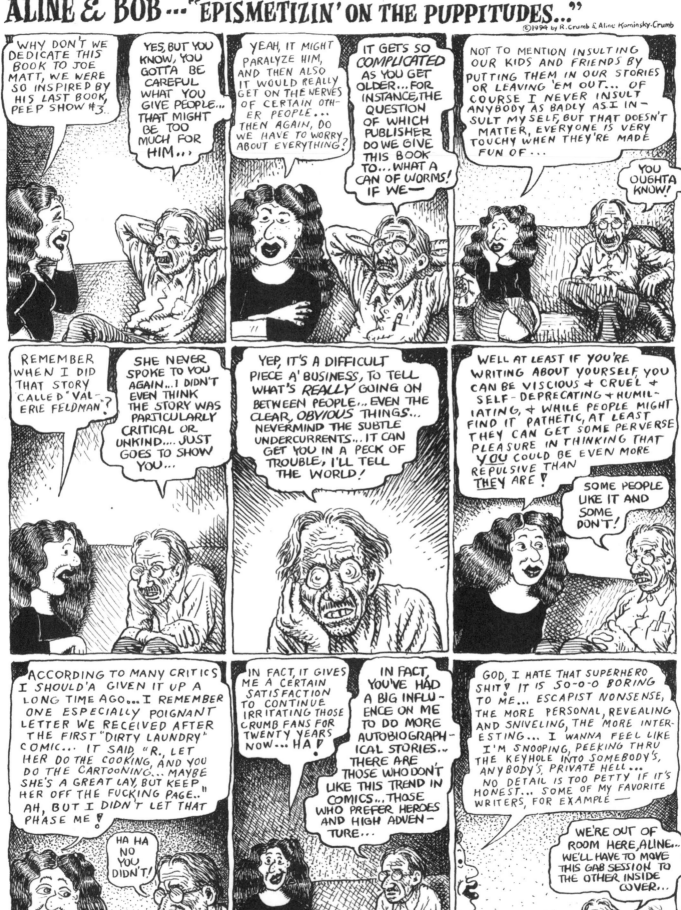

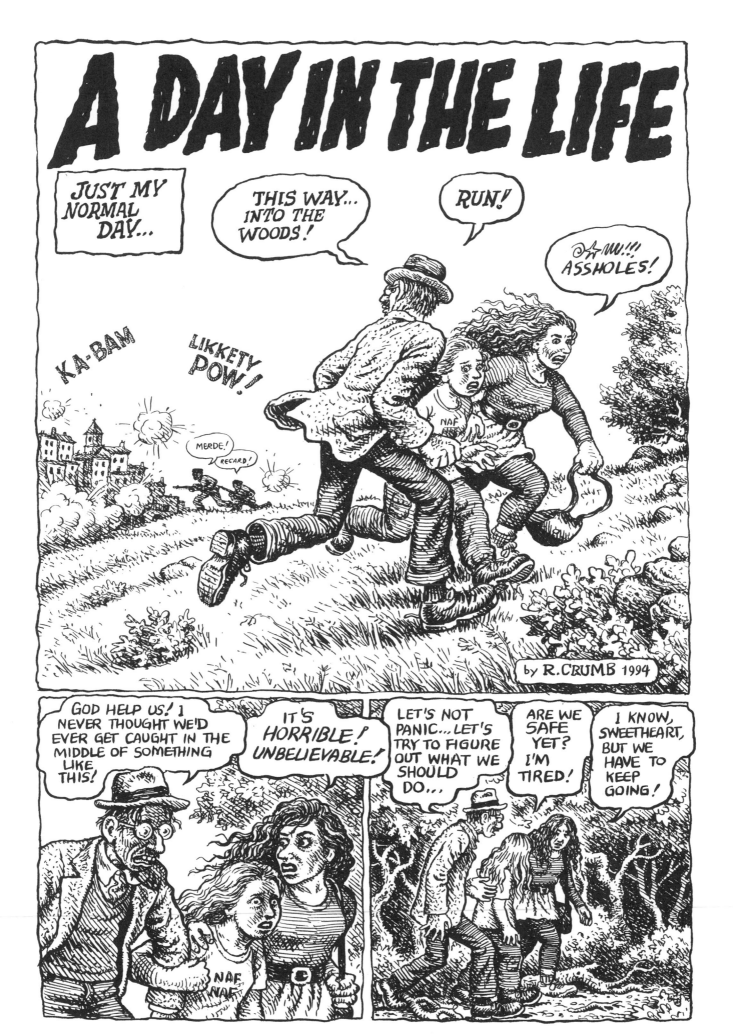

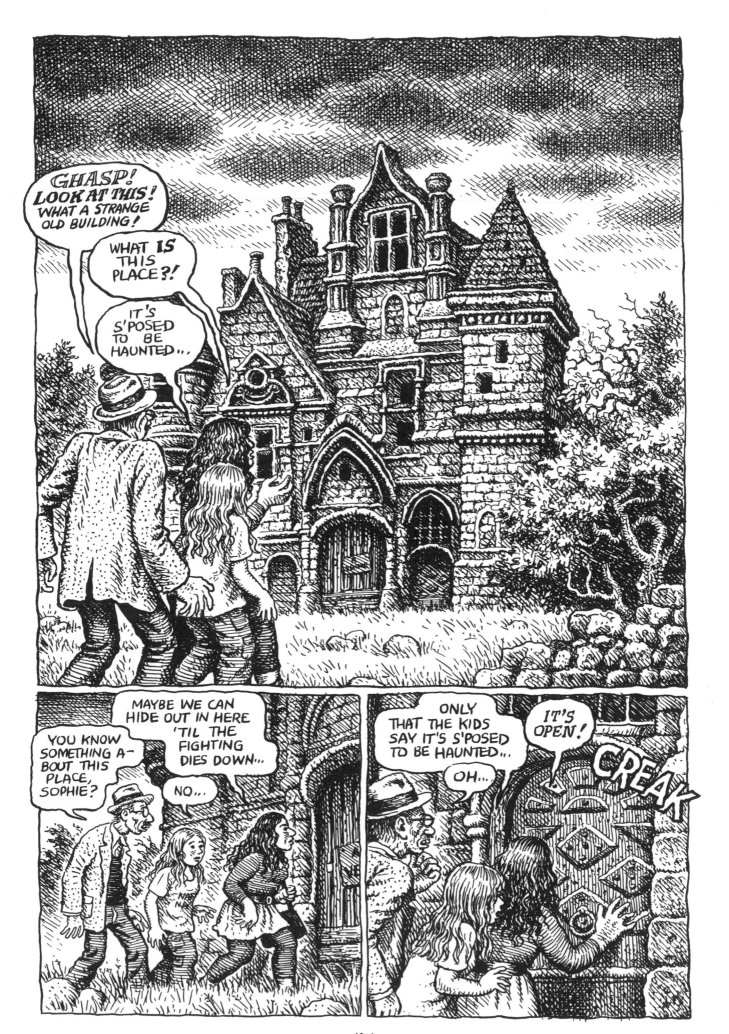

146

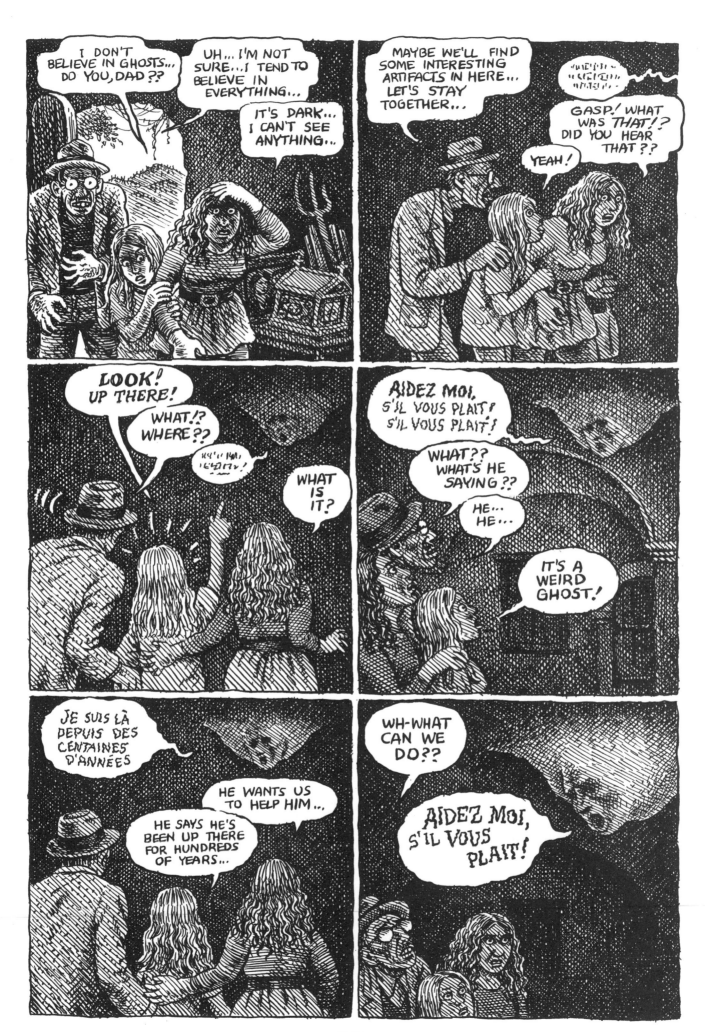

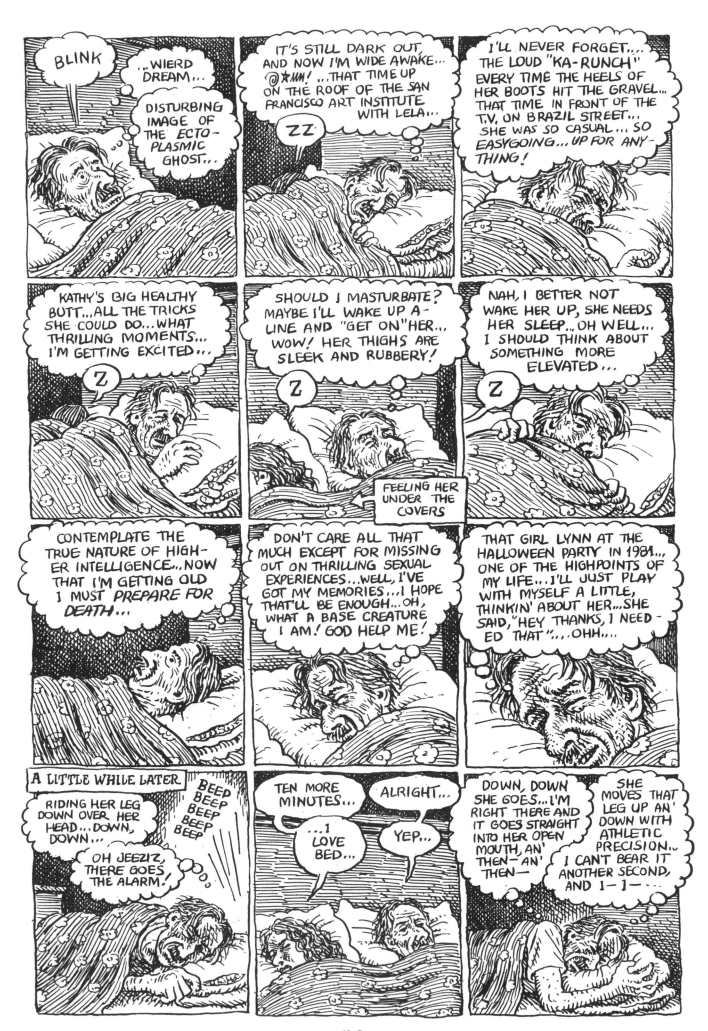

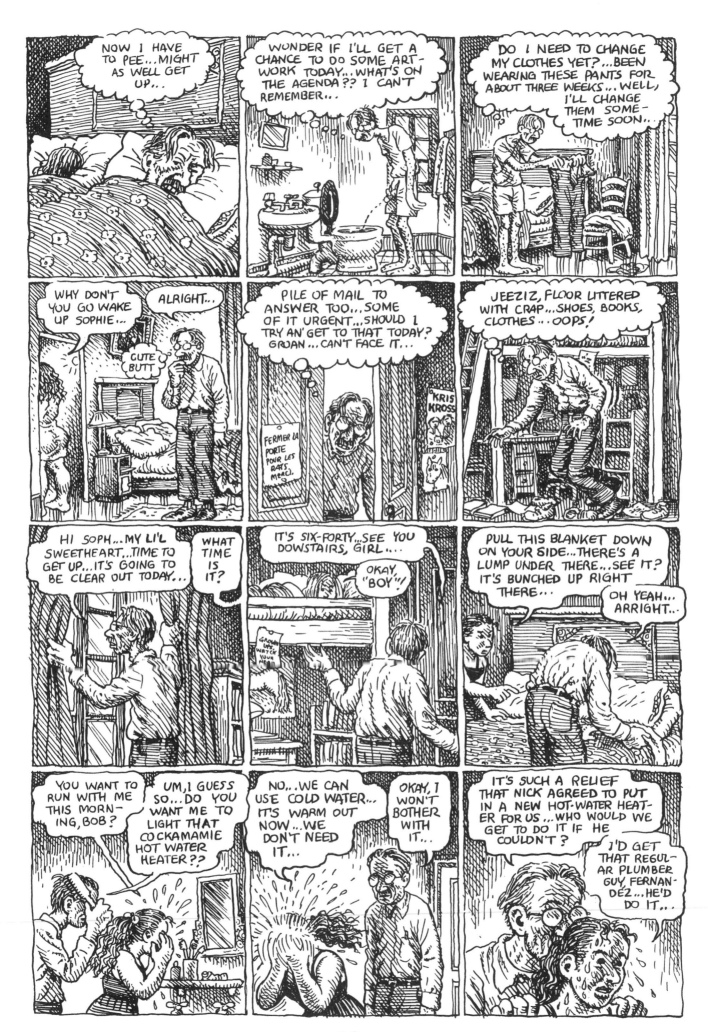

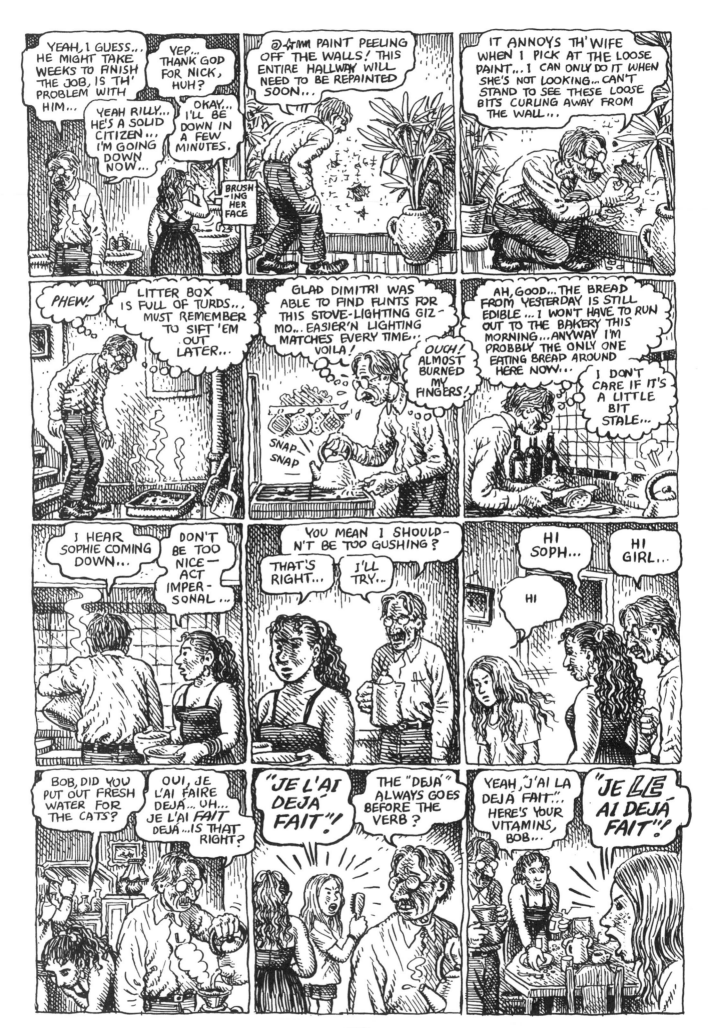

150

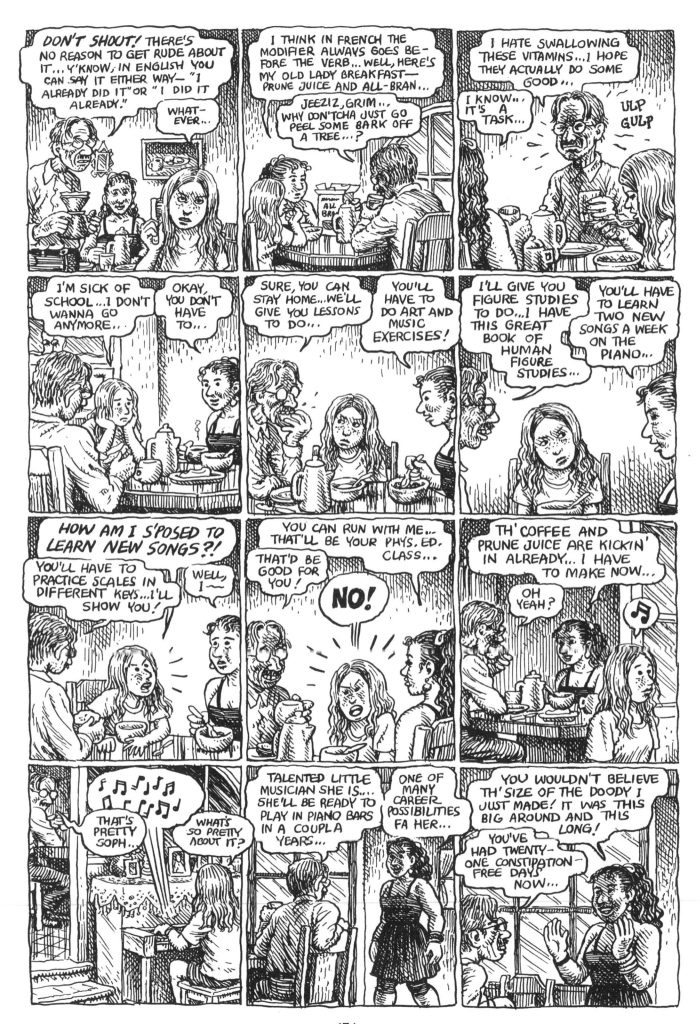

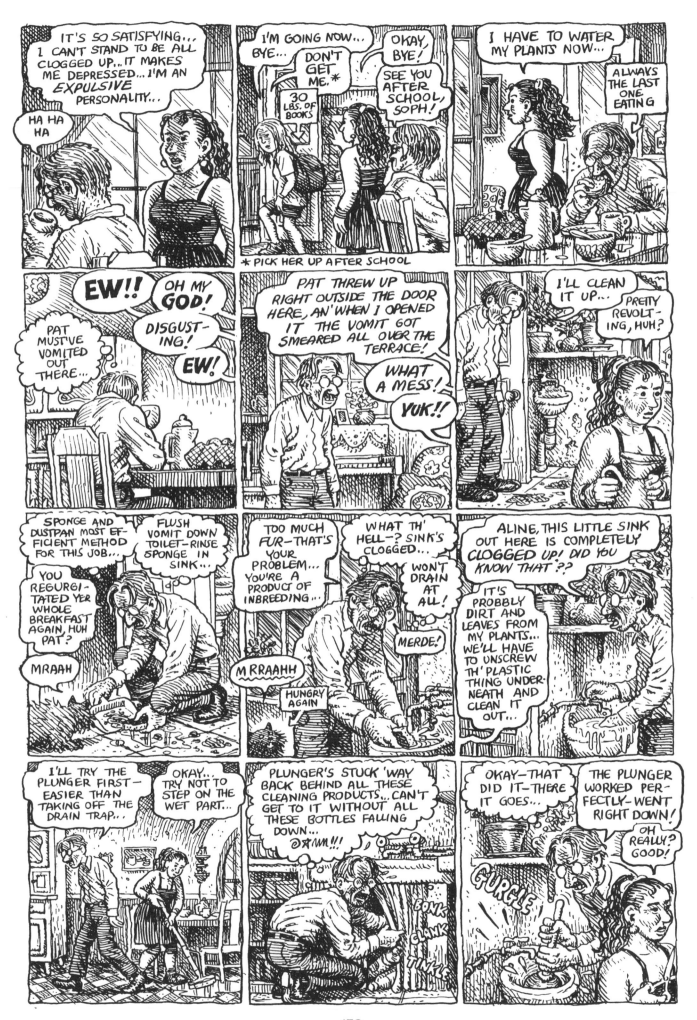

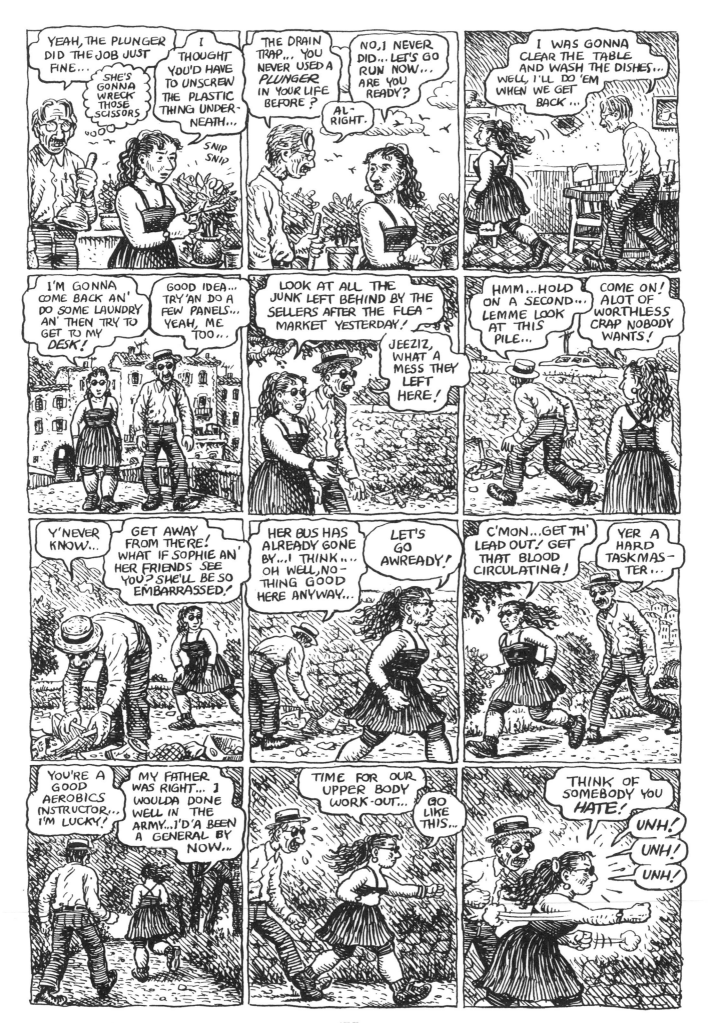

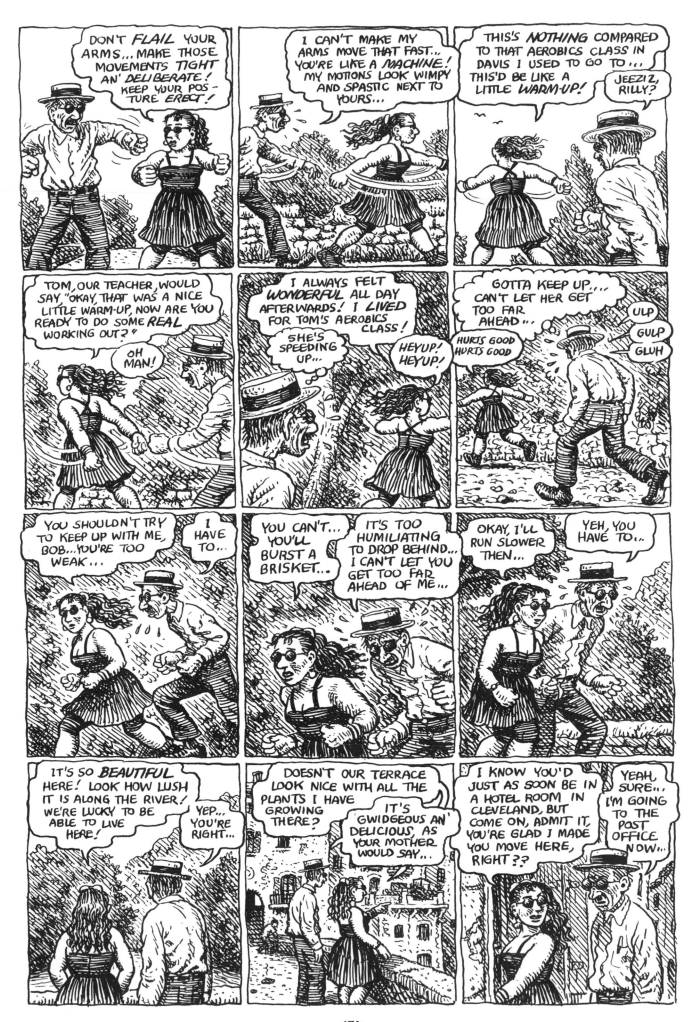

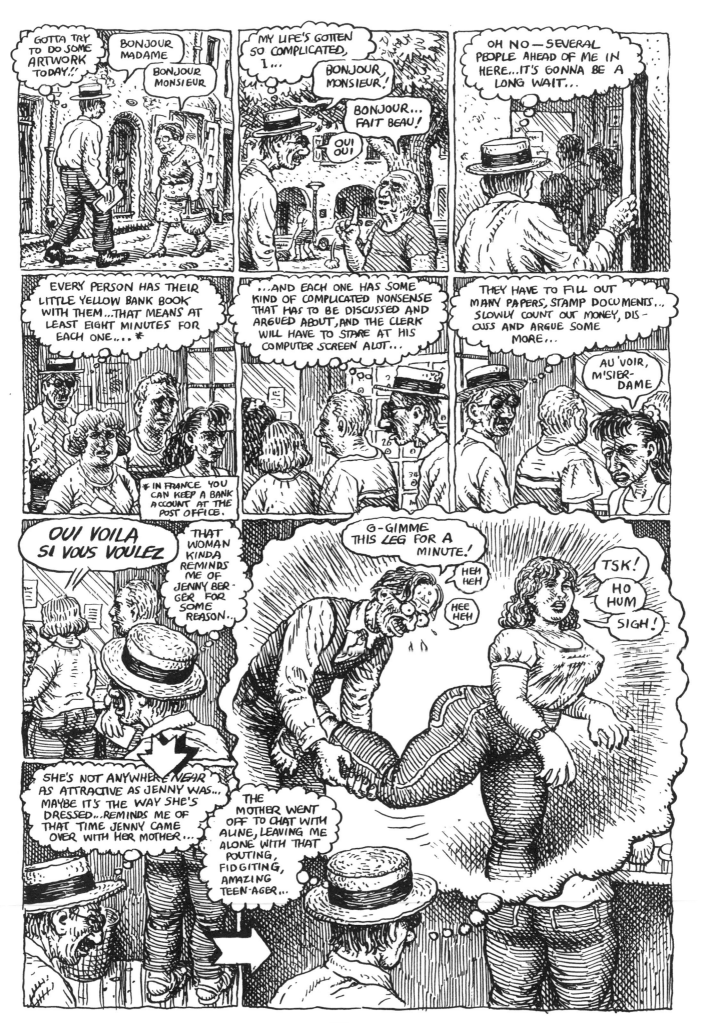

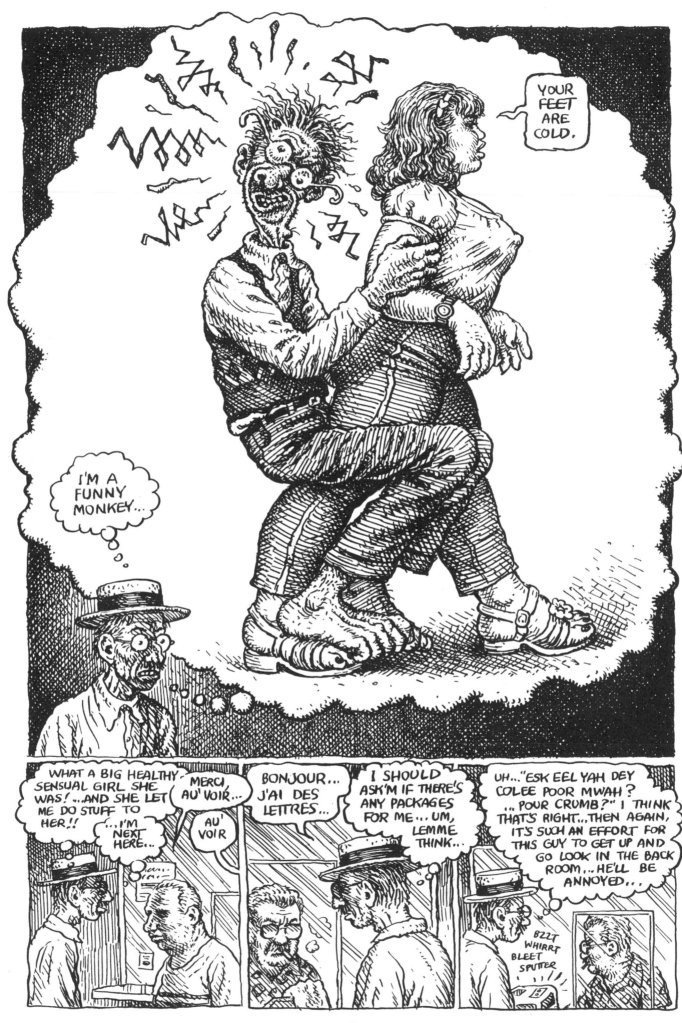

156

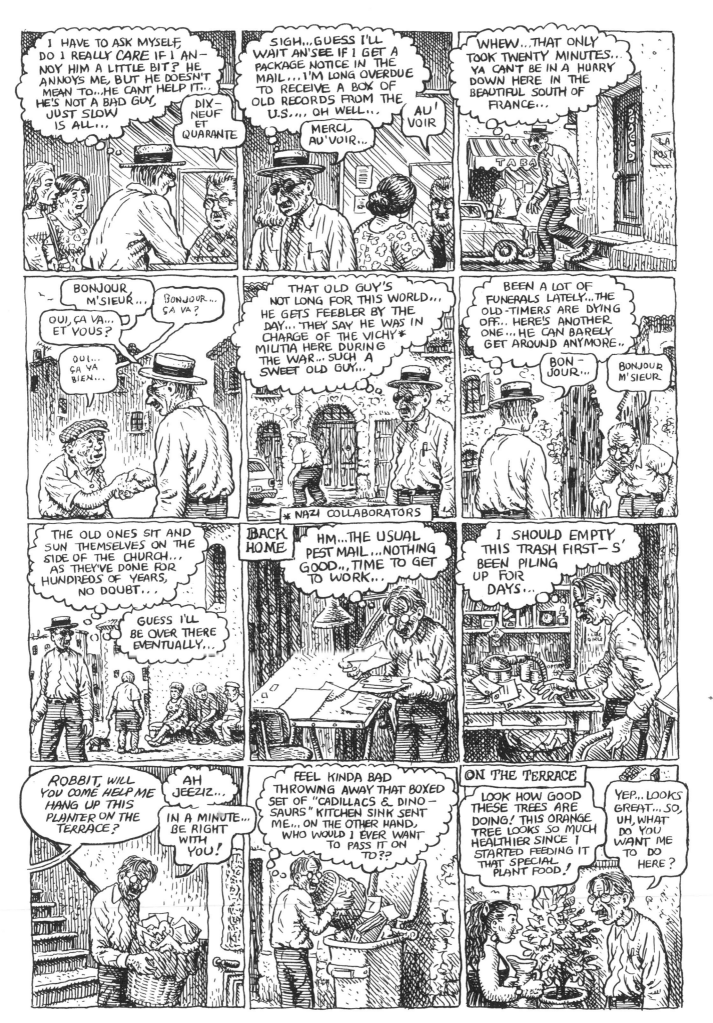

157

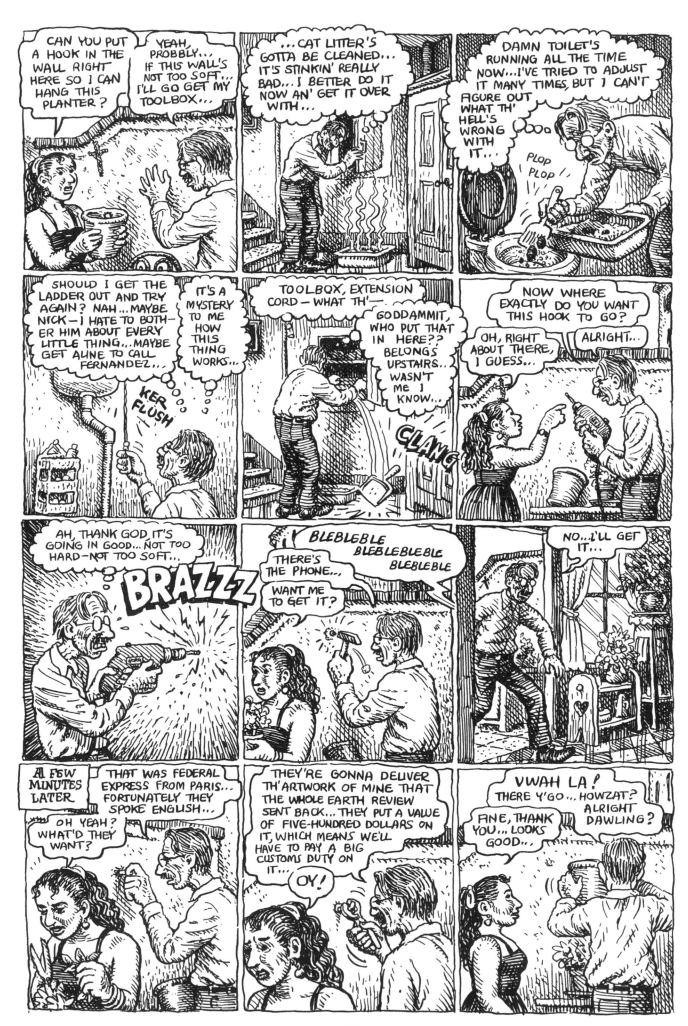

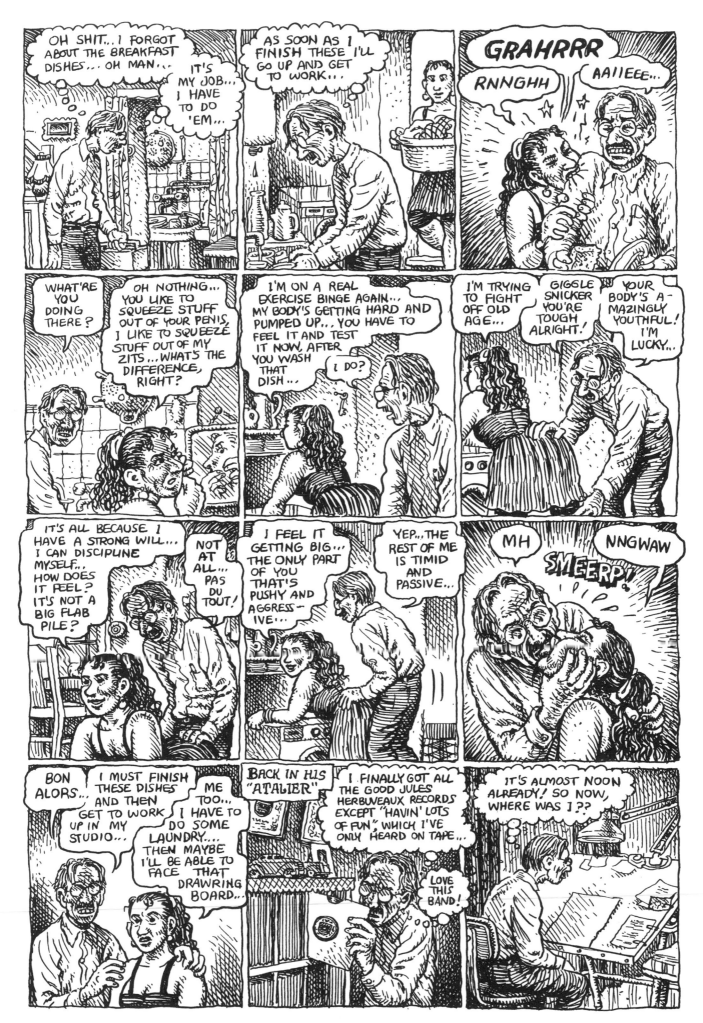

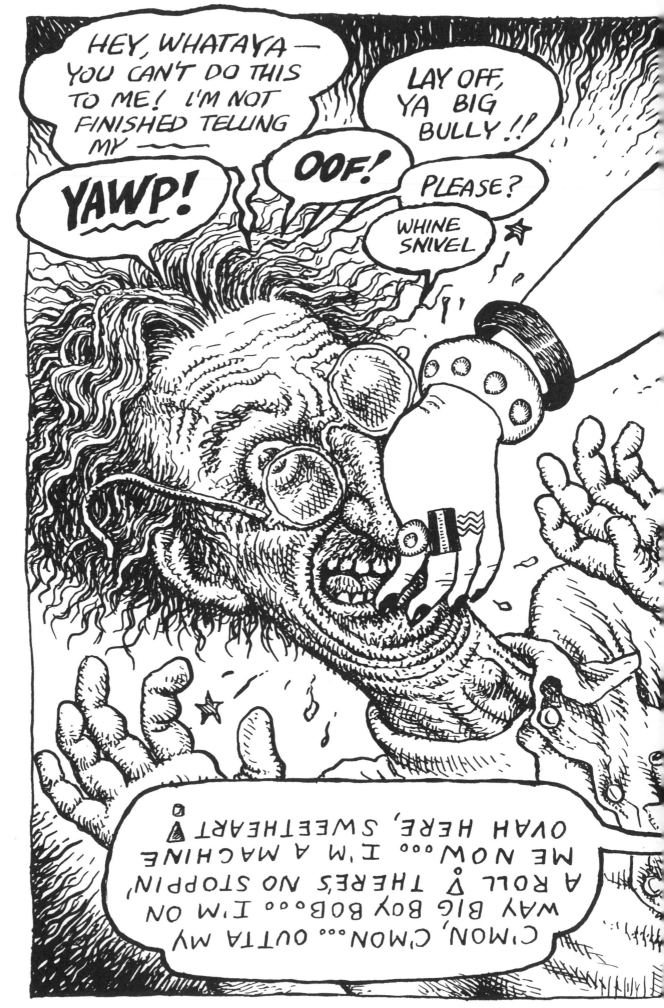

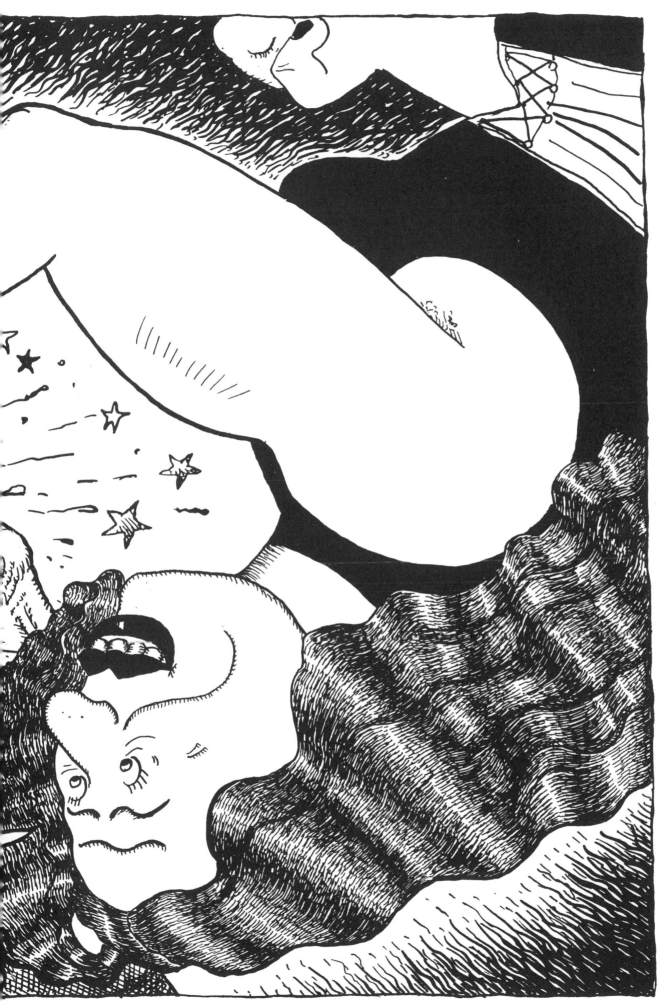

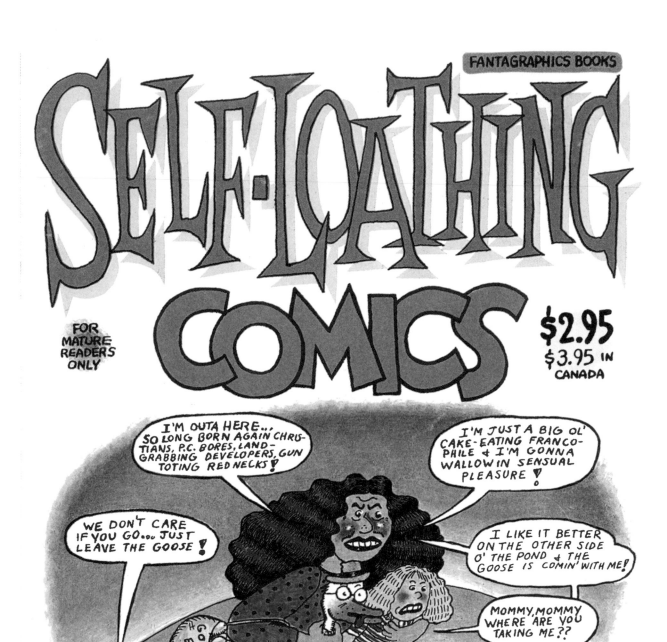

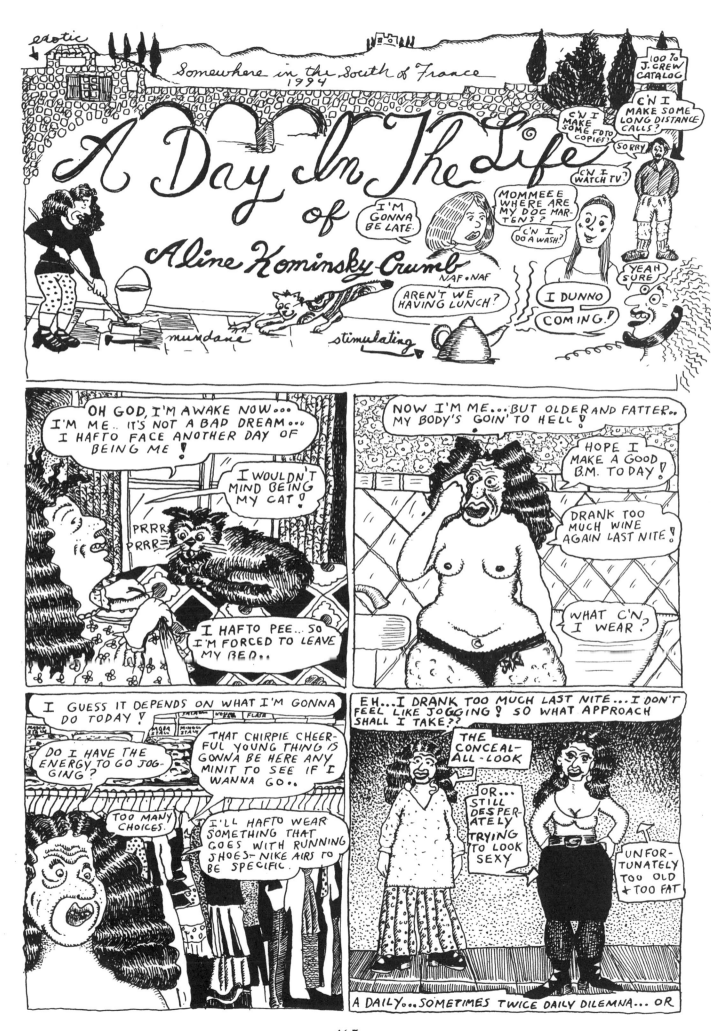

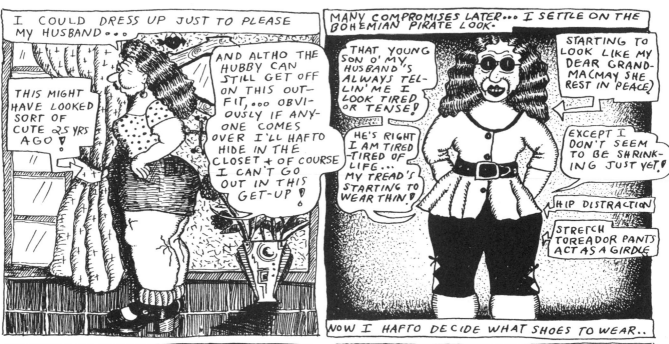

I COULD DRESS UP JUST TO PLEASE MY HUSBAND...

THIS MIGHT HAVE LOOKED SORT OF CUTE 25 YRS AGO!

AND ALTHO THE HUBBY CAN STILL GET OFF ON THIS OUTFIT... OBVIOUSLY IF ANYONE COMES OVER I'LL HAFTO HIDE IN THE CLOSET + OF COURSE I CAN'T GO OUT IN THIS GET-UP!

MANY COMPROMISES LATER... I SETTLE ON THE BOHEMIAN PIRATE LOOK.

THAT YOUNG SON O' MY HUSBAND'S ALWAYS TELLIN' ME I LOOK TIRED OR TENSE!

HE'S RIGHT I AM TIRED -TIRED OF LIFE... MY TREAD'S STARTING TO WEAR THIN!

STARTING TO LOOK LIKE MY DEAR GRANDMA (MAY SHE REST IN PEACE)

EXCEPT I DON'T SEEM TO BE SHRINKING JUST YET!

HIP DISTRACTION

STRETCH TOREADOR PANTS ACT AS A GIRDLE

NOW I HAFTO DECIDE WHAT SHOES TO WEAR..

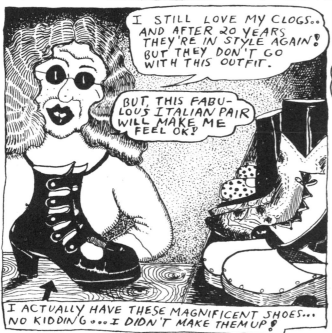

I STILL LOVE MY CLOGS.. AND AFTER 20 YEARS THEY'RE IN STYLE AGAIN! BUT THEY DON'T GO WITH THIS OUTFIT.

BUT, THIS FABULOUS ITALIAN PAIR WILL MAKE ME FEEL OK!

I ACTUALLY HAVE THESE MAGNIFICENT SHOES... NO KIDDING... I DIDN'T MAKE THEM UP!

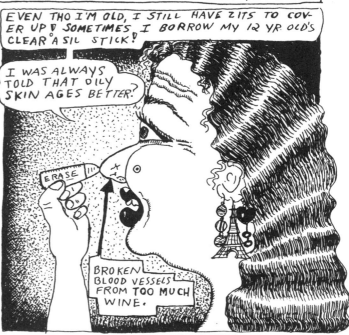

EVEN THO I'M OLD, I STILL HAVE ZITS TO COVER UP! SOMETIMES I BORROW MY 12 YR. OLD'S CLEARASIL STICK!

I WAS ALWAYS TOLD THAT OILY SKIN AGES BETTER?

ERASE

BROKEN BLOOD VESSELS FROM TOO MUCH WINE.

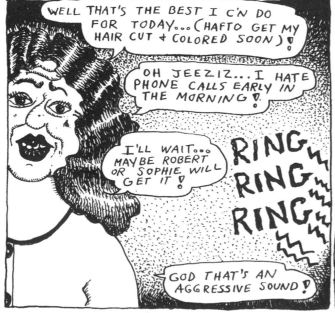

WELL THAT'S THE BEST I C'N DO FOR TODAY... (HAFTO GET MY HAIR CUT & COLORED SOON)!

OH JEEZIZ... I HATE PHONE CALLS EARLY IN THE MORNING!

I'LL WAIT... MAYBE ROBERT OR SOPHIE WILL GET IT!

RING RING RING

GOD THAT'S AN AGGRESSIVE SOUND!

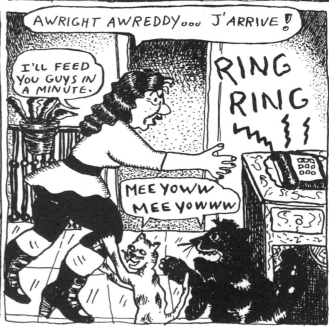

AWRIGHT AWREDDY... J'ARRIVE!

I'LL FEED YOU GUYS IN A MINUTE.

RING RING

MEE YOWW MEE YOWWW

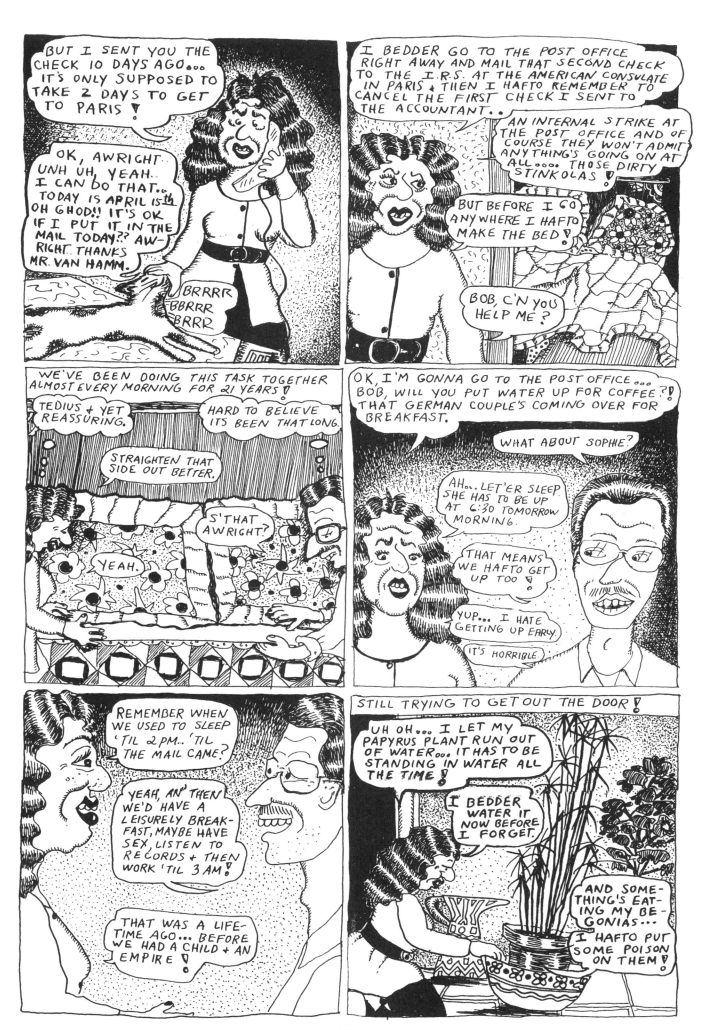

165

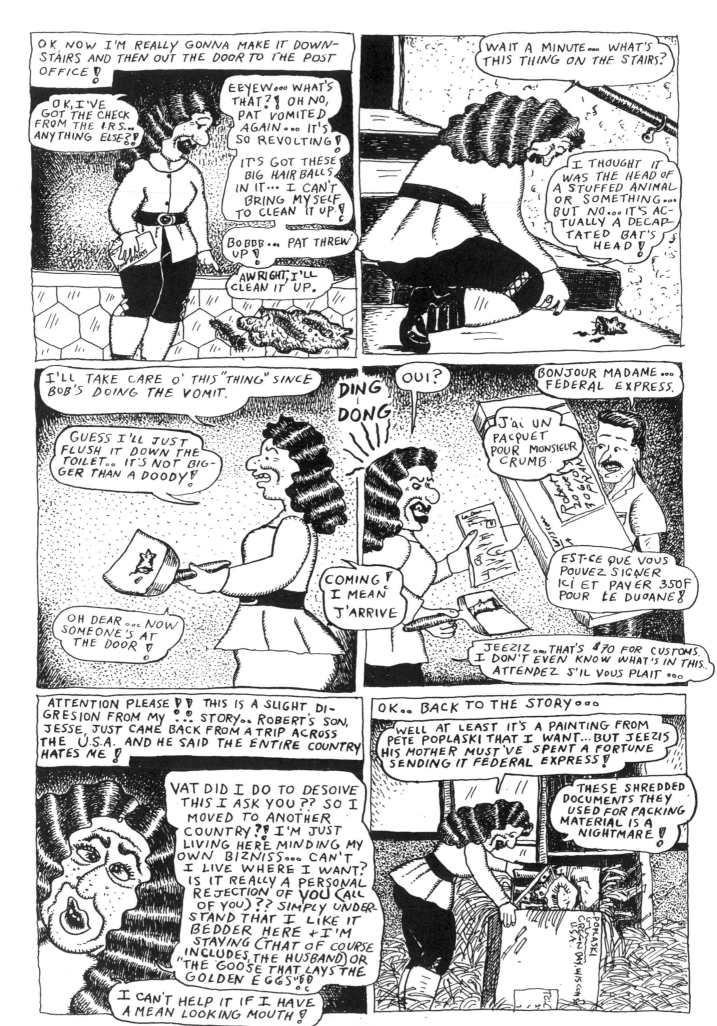

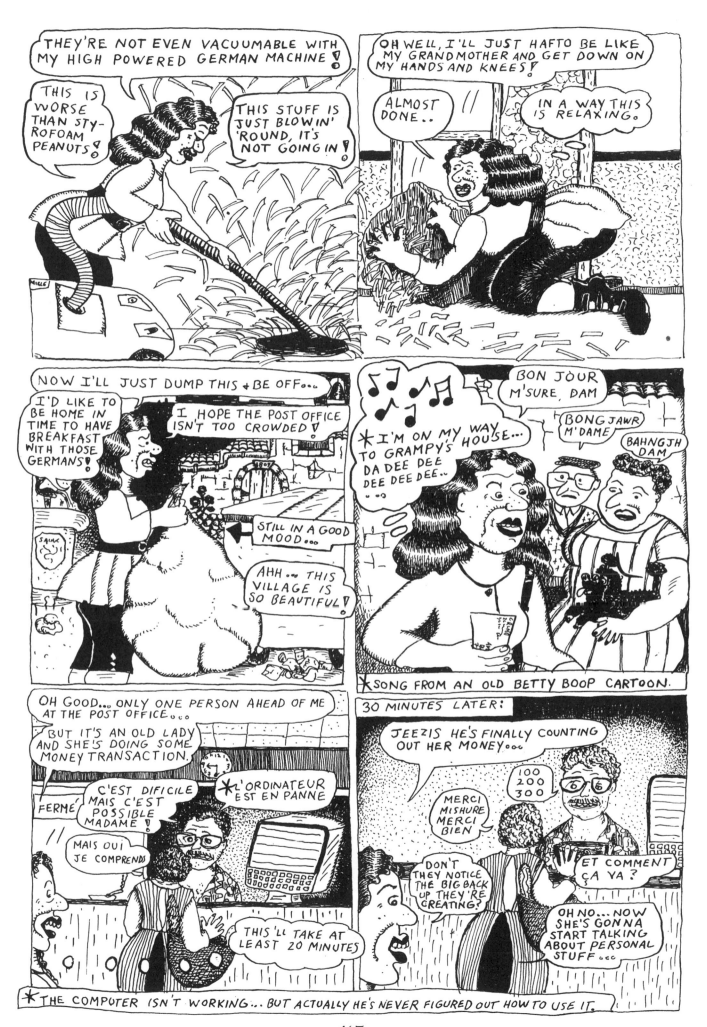

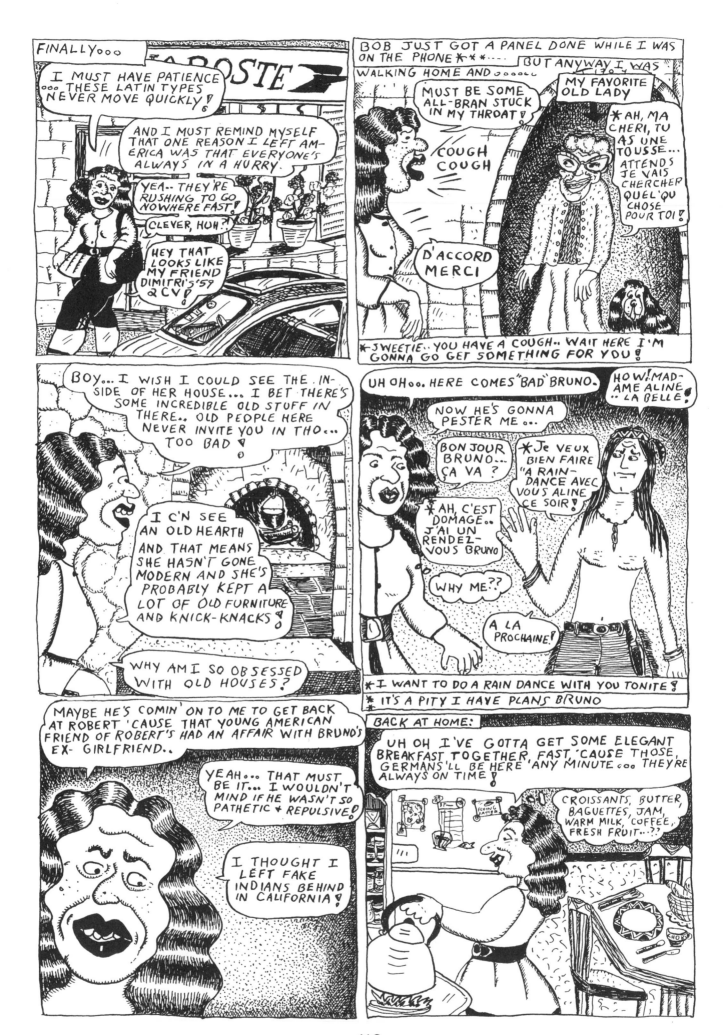

168

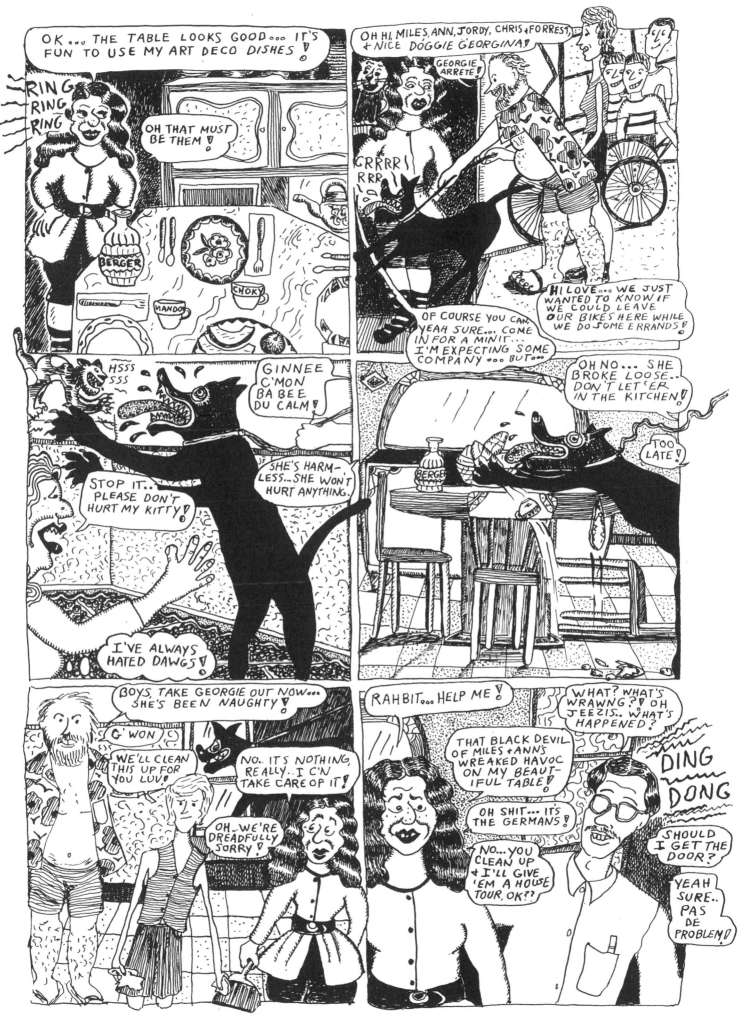

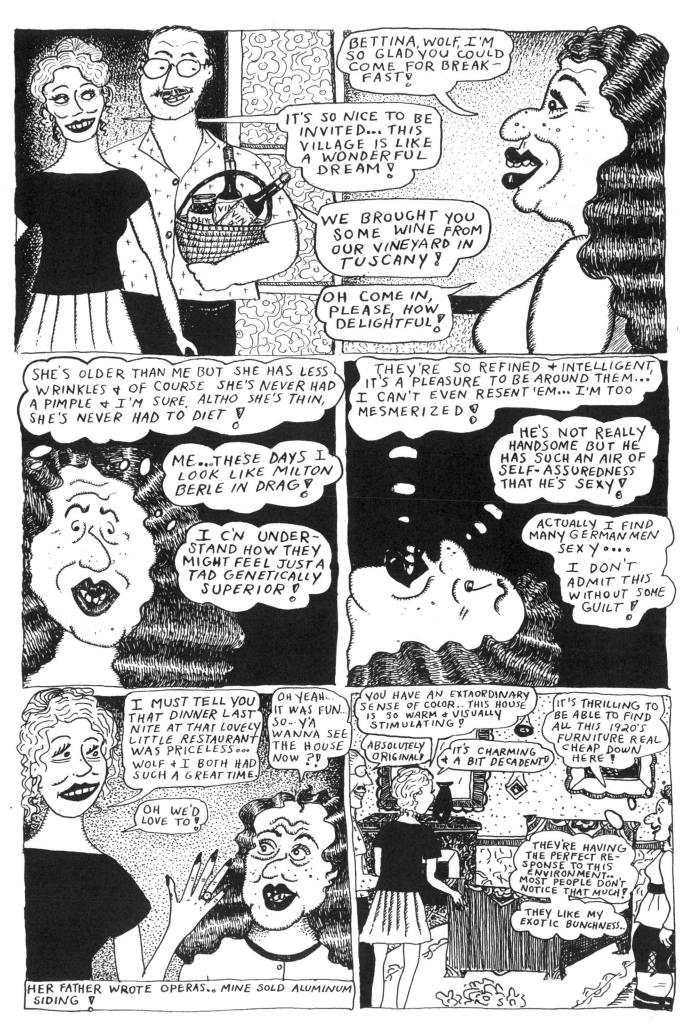

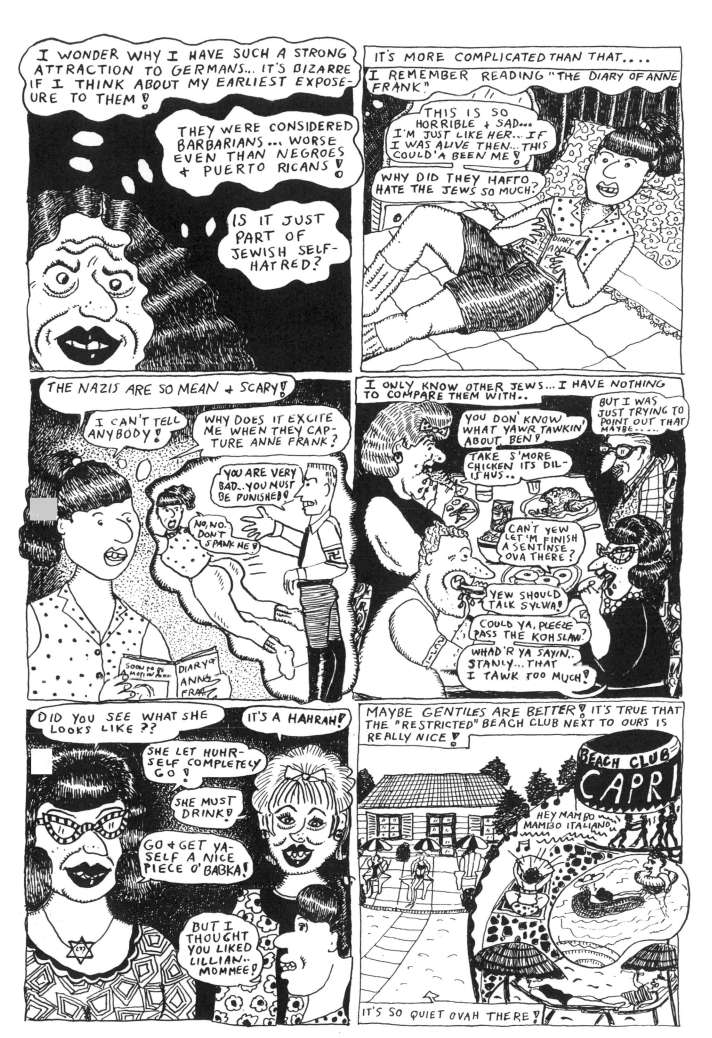

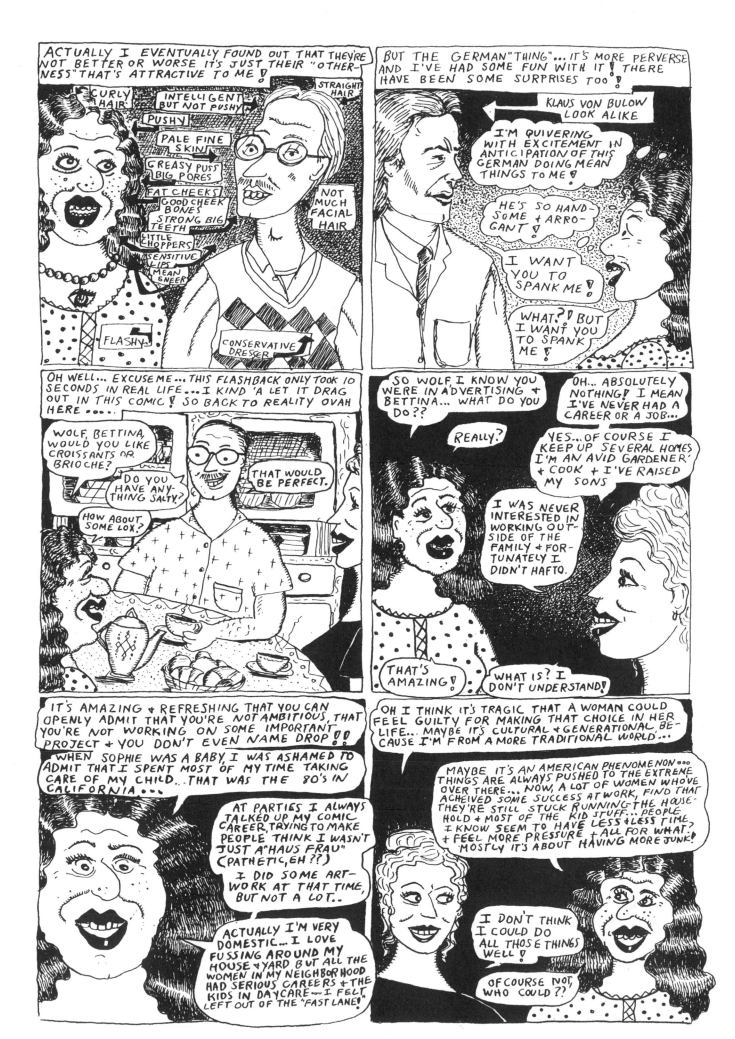

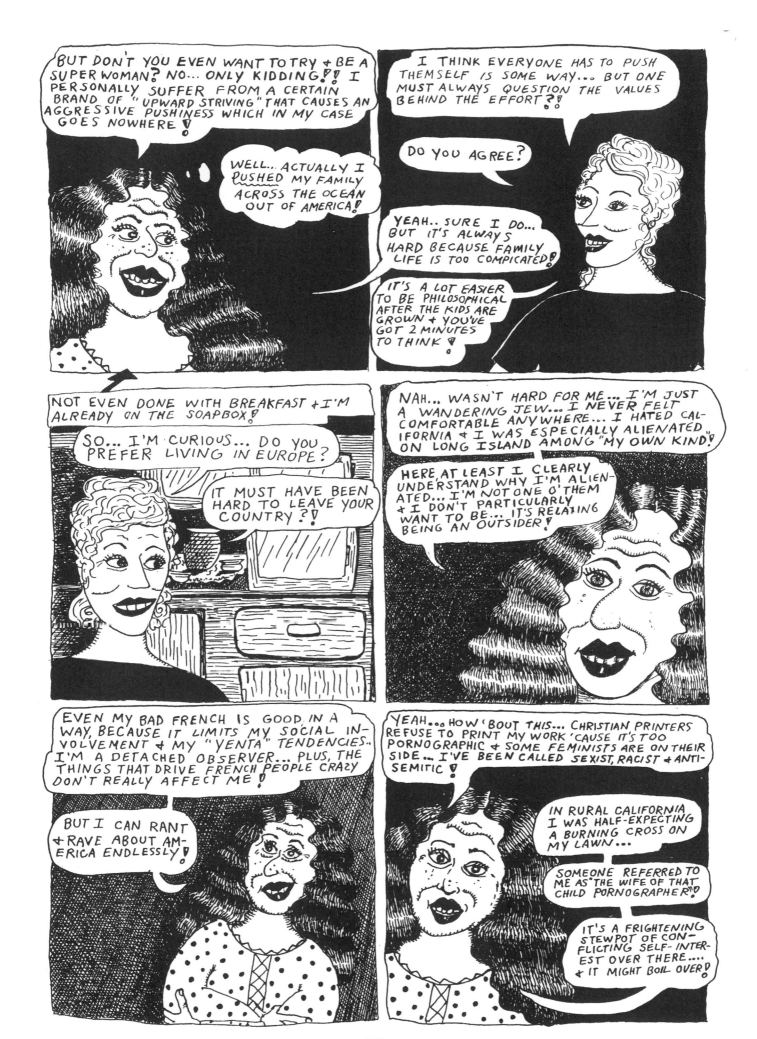

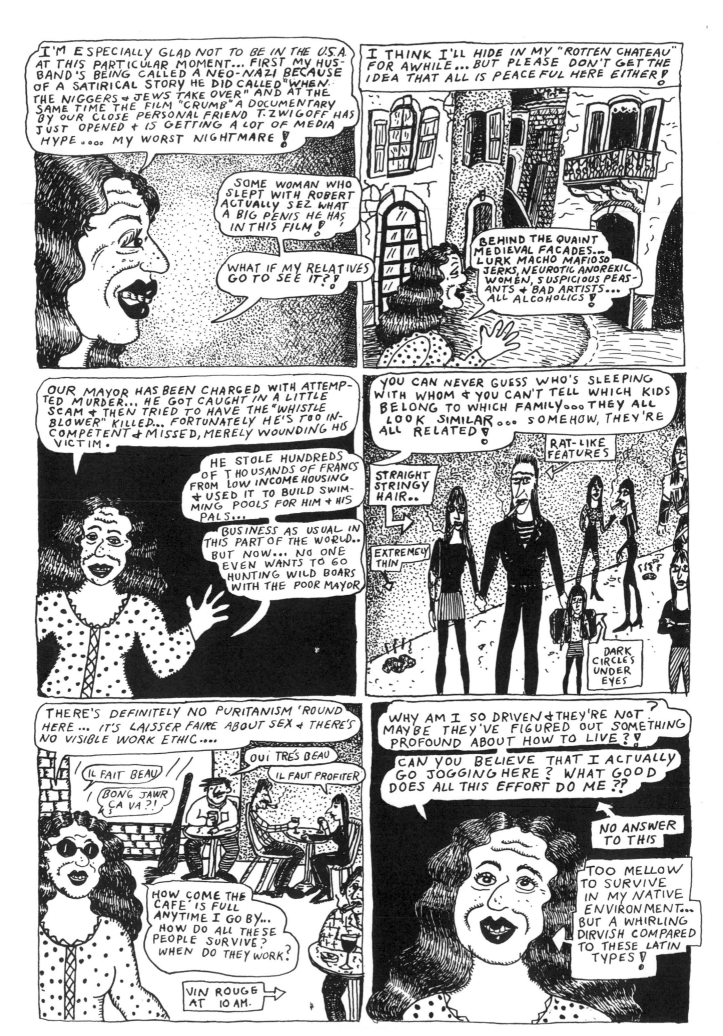

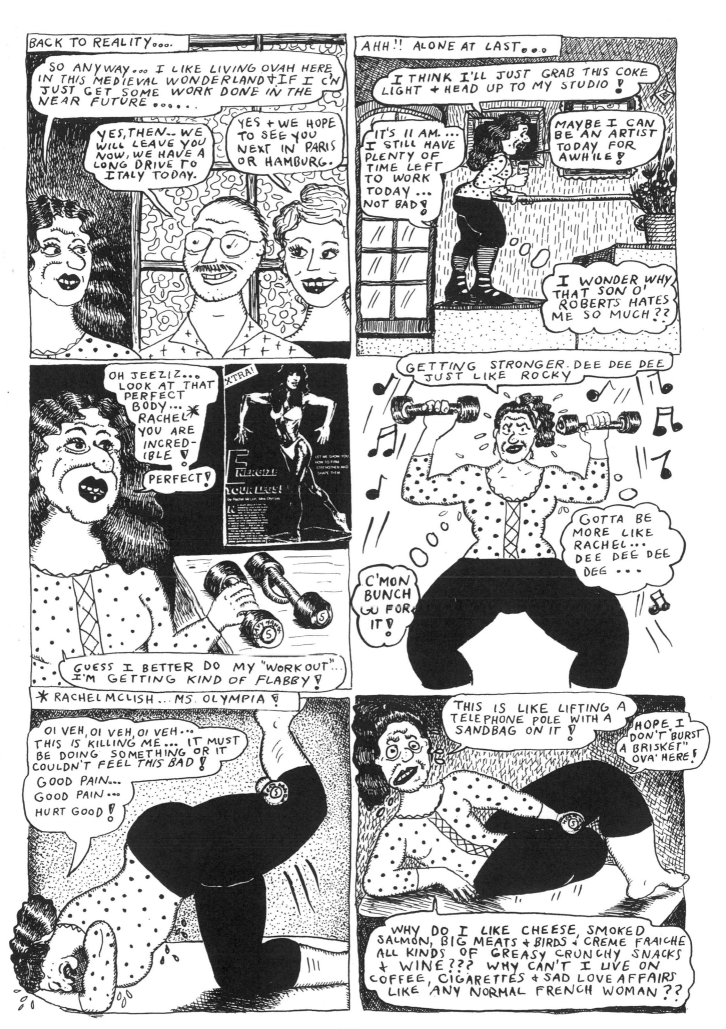

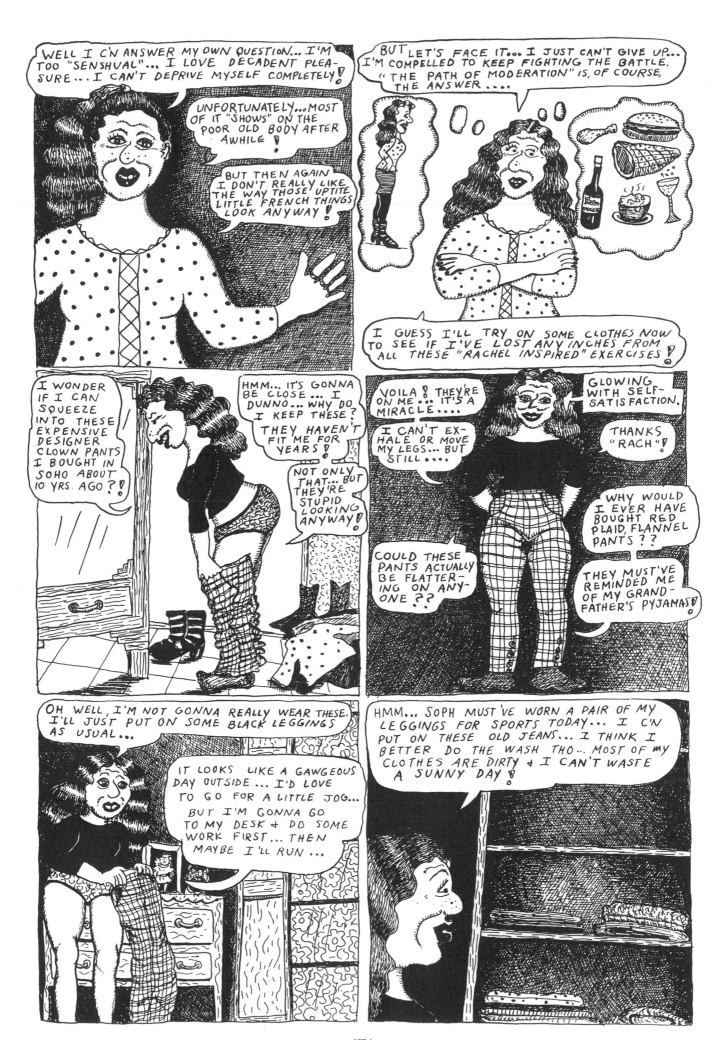

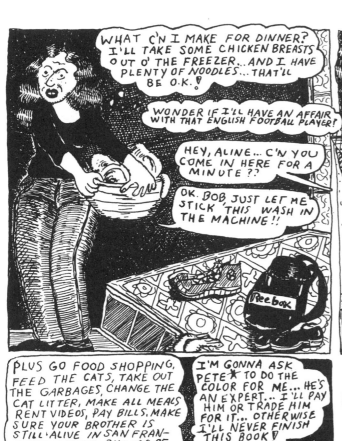

WHAT C'N I MAKE FOR DINNER? I'LL TAKE SOME CHICKEN BREASTS OUT O' THE FREEZER... AND I HAVE PLENTY OF NOODLES... THAT'LL BE O.K.!

WONDER IF I'LL HAVE AN AFFAIR WITH THAT ENGLISH FOOTBALL PLAYER!

HEY, ALINE... C'N YOU COME IN HERE FOR A MINUTE??

OK. BOB, JUST LET ME STICK THIS WASH IN THE MACHINE!!

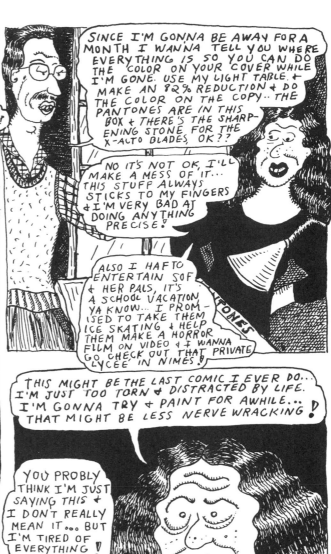

SINCE I'M GONNA BE AWAY FOR A MONTH I WANNA TELL YOU WHERE EVERYTHING IS SO YOU CAN DO THE COLOR ON YOUR COVER WHILE I'M GONE. USE MY LIGHT TABLE. MAKE AN 82% REDUCTION & DO THE COLOR ON THE COPY... THE PANTONES ARE IN THIS BOX & THERE'S THE SHARPENING STONE FOR THE X-ACTO BLADES, OK??

NO IT'S NOT OK, I'LL MAKE A MESS OF IT... THIS STUFF ALWAYS STICKS TO MY FINGERS & I'M VERY BAD AT DOING ANYTHING PRECISE!

ALSO I HAFTO ENTERTAIN SOF & HER PALS, IT'S A SCHOOL VACATION YA KNOW... I PROMISED TO TAKE THEM ICE SKATING & HELP THEM MAKE A HORROR FILM ON VIDEO & I WANNA GO CHECK OUT THAT PRIVATE LYCEE' IN NIMES!

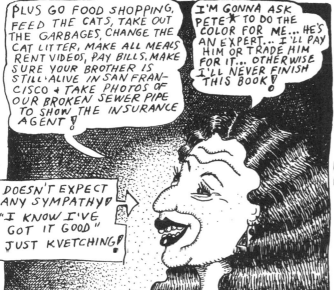

PLUS GO FOOD SHOPPING, FEED THE CATS, TAKE OUT THE GARBAGES, CHANGE THE CAT LITTER, MAKE ALL MEALS RENT VIDEOS, PAY BILLS, MAKE SURE YOUR BROTHER IS STILL ALIVE IN SAN FRANCISCO & TAKE PHOTOS OF OUR BROKEN SEWER PIPE TO SHOW THE INSURANCE AGENT!

I'M GONNA ASK PETE* TO DO THE COLOR FOR ME... HE'S AN EXPERT... I'LL PAY HIM OR TRADE HIM FOR IT... OTHERWISE I'LL NEVER FINISH THIS BOOK!

DOESN'T EXPECT ANY SYMPATHY!) "I KNOW I'VE GOT IT GOOD" JUST KVETCHING!

*PETE POPLASKI - A GREAT ARTIST & COLORIST LIVING IN SAUVE!

THIS MIGHT BE THE LAST COMIC I EVER DO... I'M JUST TOO TORN & DISTRACTED BY LIFE. I'M GONNA TRY & PAINT FOR AWHILE... THAT MIGHT BE LESS NERVE WRACKING!

YOU PROBLY THINK I'M JUST SAYING THIS & I DON'T REALLY MEAN IT... BUT I'M TIRED OF EVERYTHING!

I'D LIKE TO JUST STAY IN BED!!

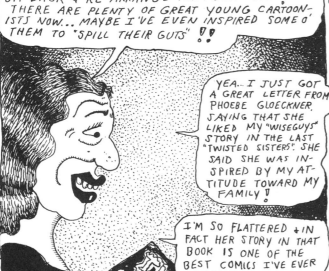

ACTUALLY I DON'T EVEN HAVE MUCH TO SAY! PERHAPS I'VE "SHOT MY WAD" & I C'N JUST SIT BACK & RE-ARRANGE THE FURNITURE! THERE ARE PLENTY OF GREAT YOUNG CARTOONISTS NOW... MAYBE I'VE EVEN INSPIRED SOME O' THEM TO "SPILL THEIR GUTS"!!

YEA... I JUST GOT A GREAT LETTER FROM PHOEBE GLOECKNER, SAYING THAT SHE LIKED MY "WISEGUYS" STORY IN THE LAST "TWISTED SISTERS". SHE SAID SHE WAS INSPIRED BY MY ATTITUDE TOWARD MY FAMILY!

I'M SO FLATTERED & IN FACT HER STORY IN THAT BOOK IS ONE OF THE BEST COMICS I'VE EVER READ!

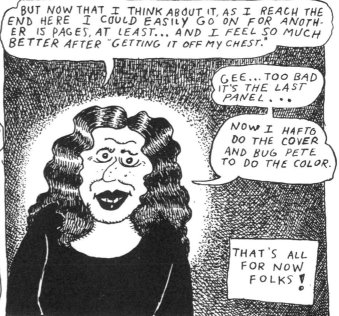

BUT NOW THAT I THINK ABOUT IT, AS I REACH THE END HERE I COULD EASILY GO ON FOR ANOTHER 15 PAGES, AT LEAST... AND I FEEL SO MUCH BETTER AFTER "GETTING IT OFF MY CHEST."

GEE... TOO BAD IT'S THE LAST PANEL...

NOW I HAFTO DO THE COVER AND BUG PETE TO DO THE COLOR.

THAT'S ALL FOR NOW FOLKS!

ALINE & BOB... "APERITIF TIME IN THE SOUTH OF FRANCE"

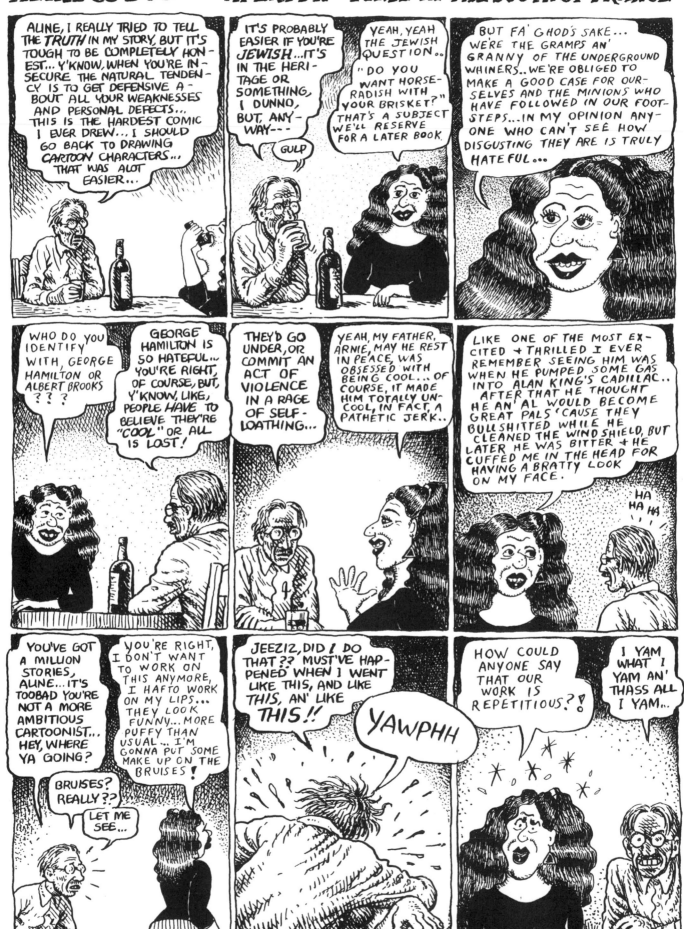

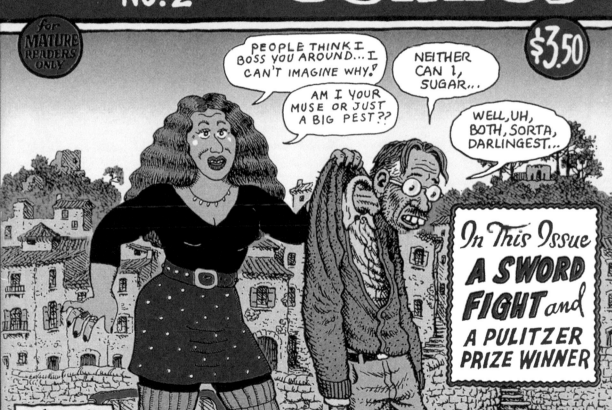

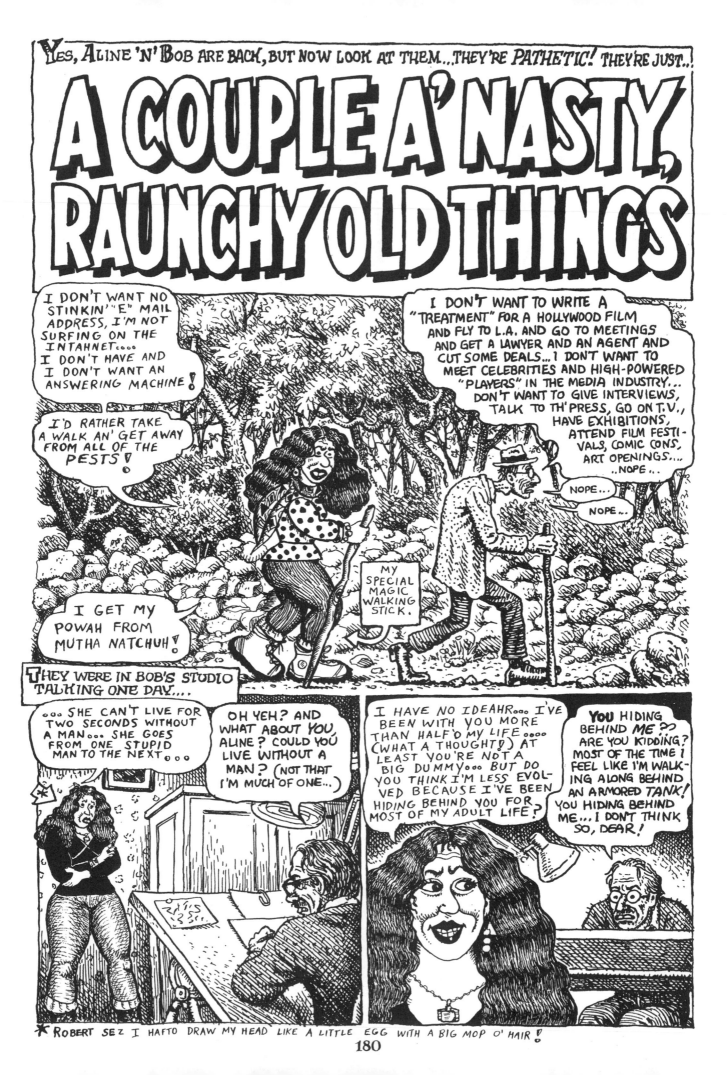

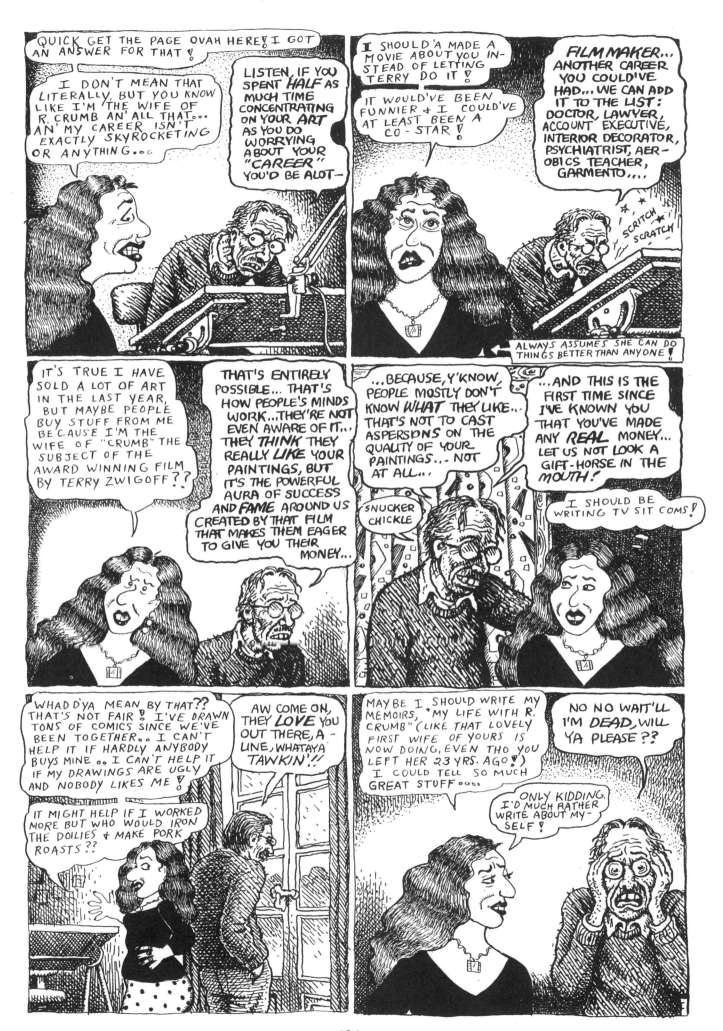

181

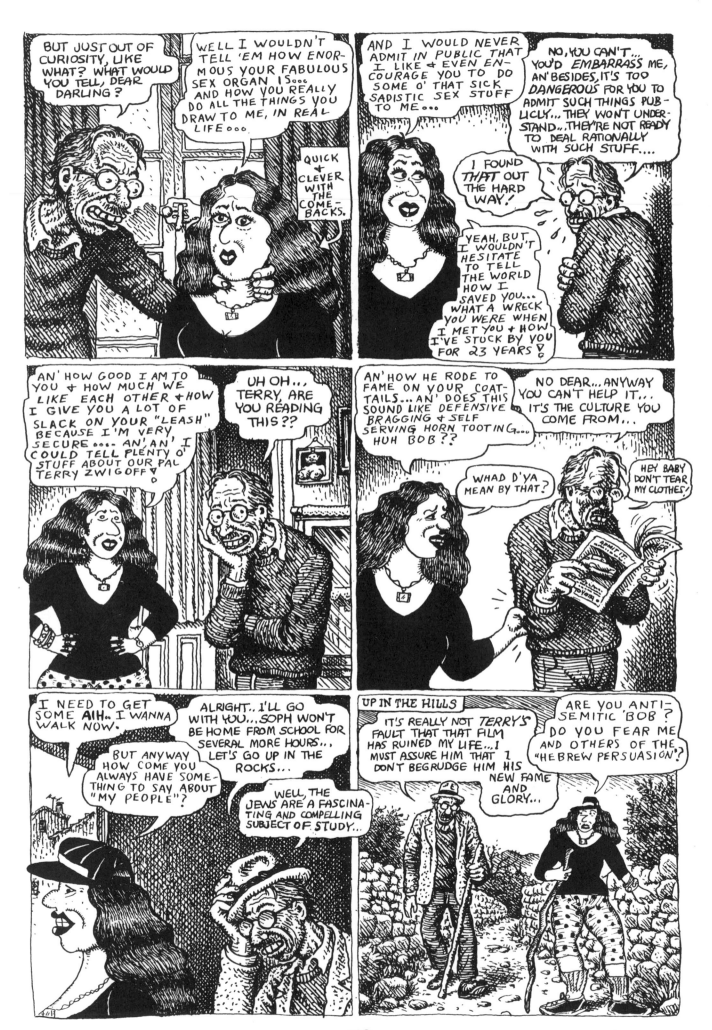

182

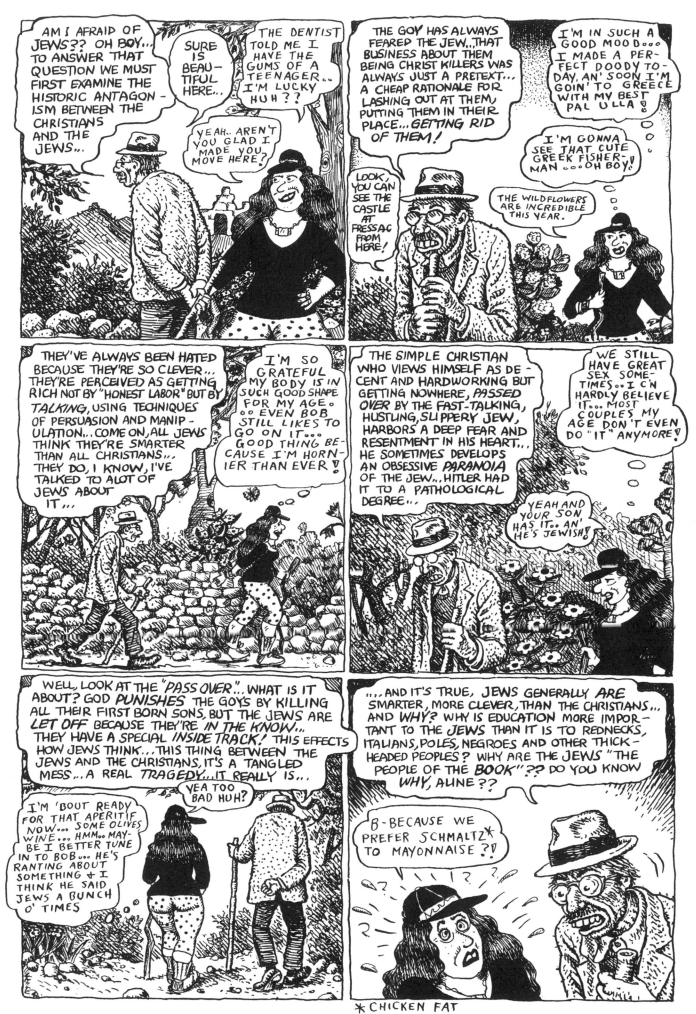

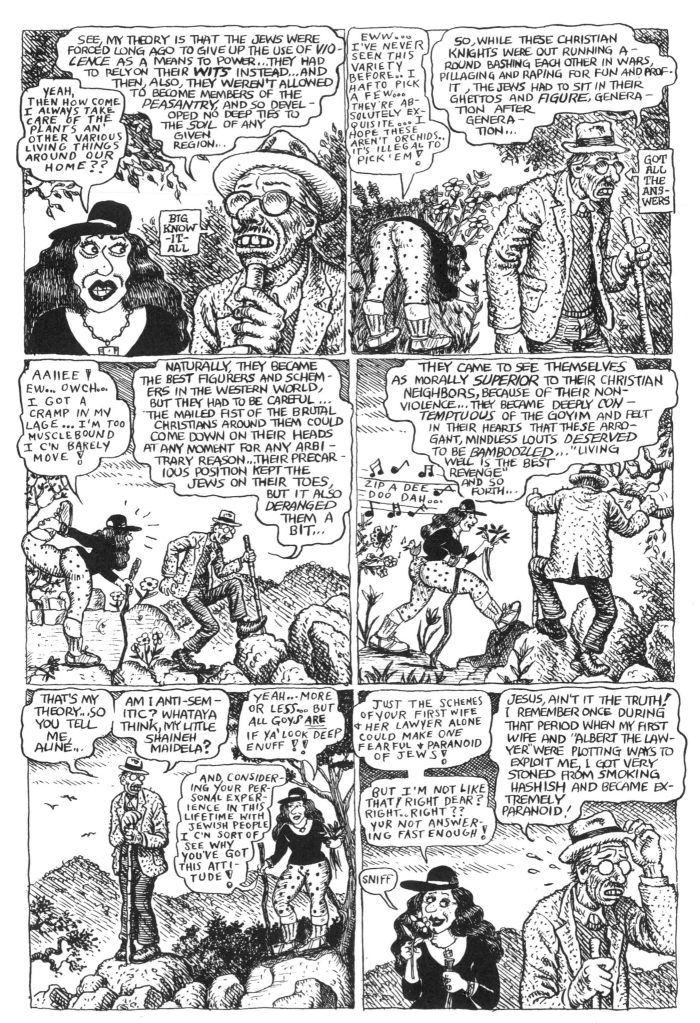

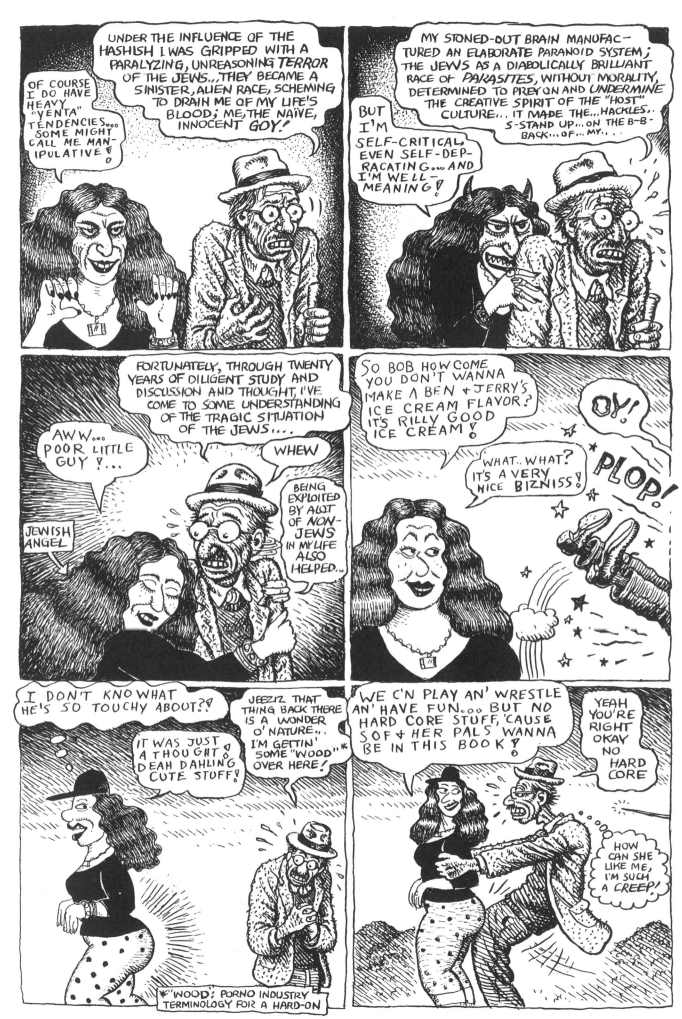

185

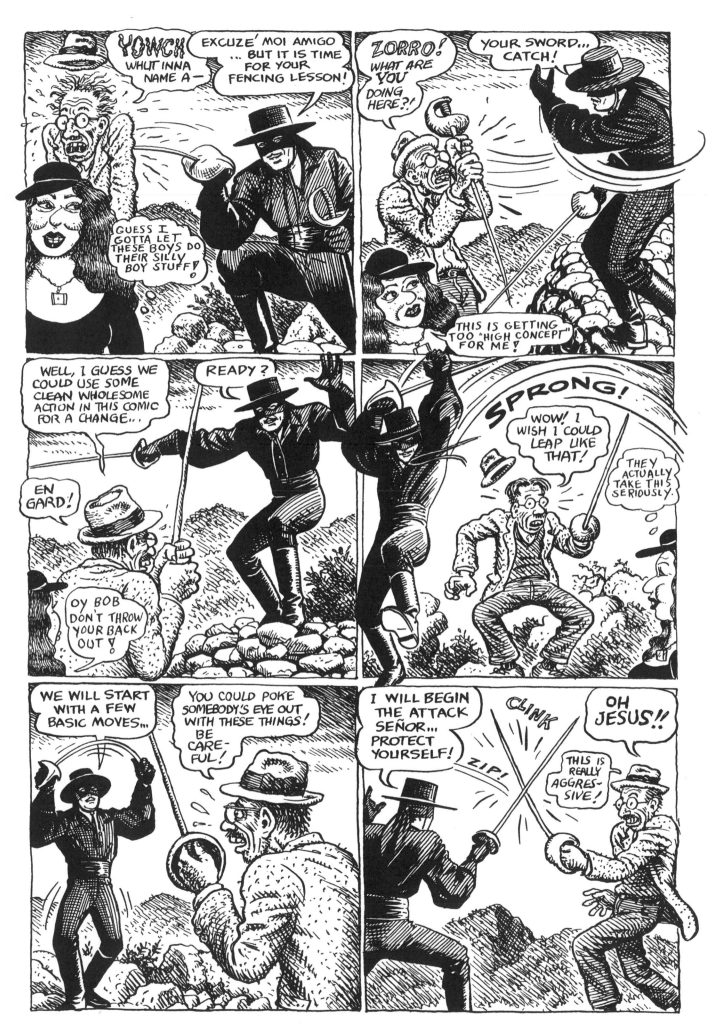

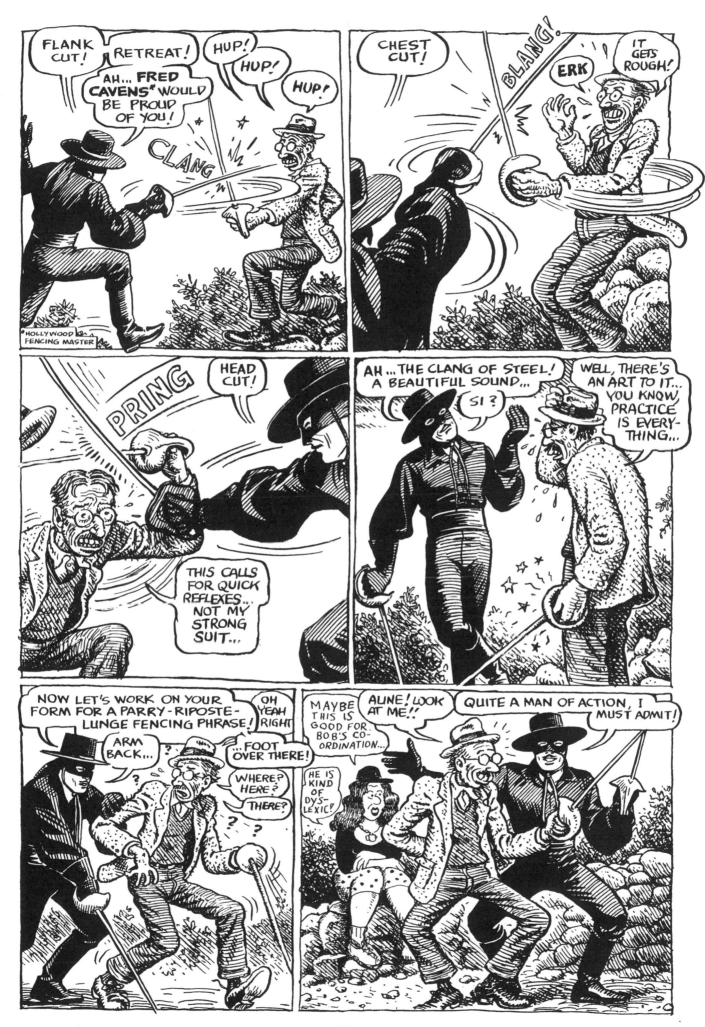

187

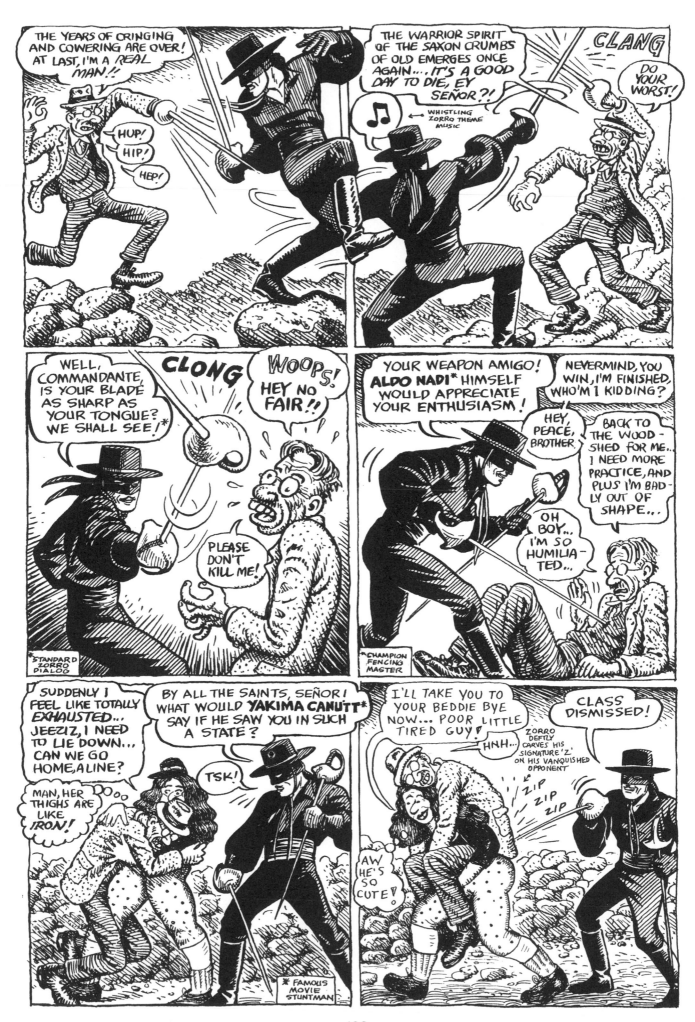

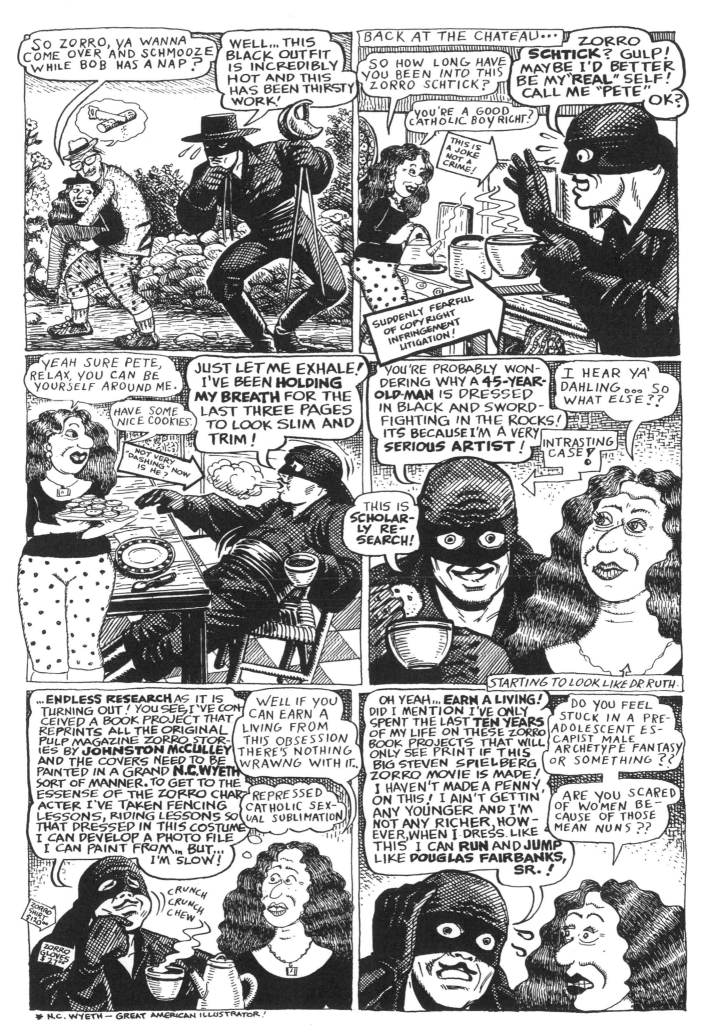

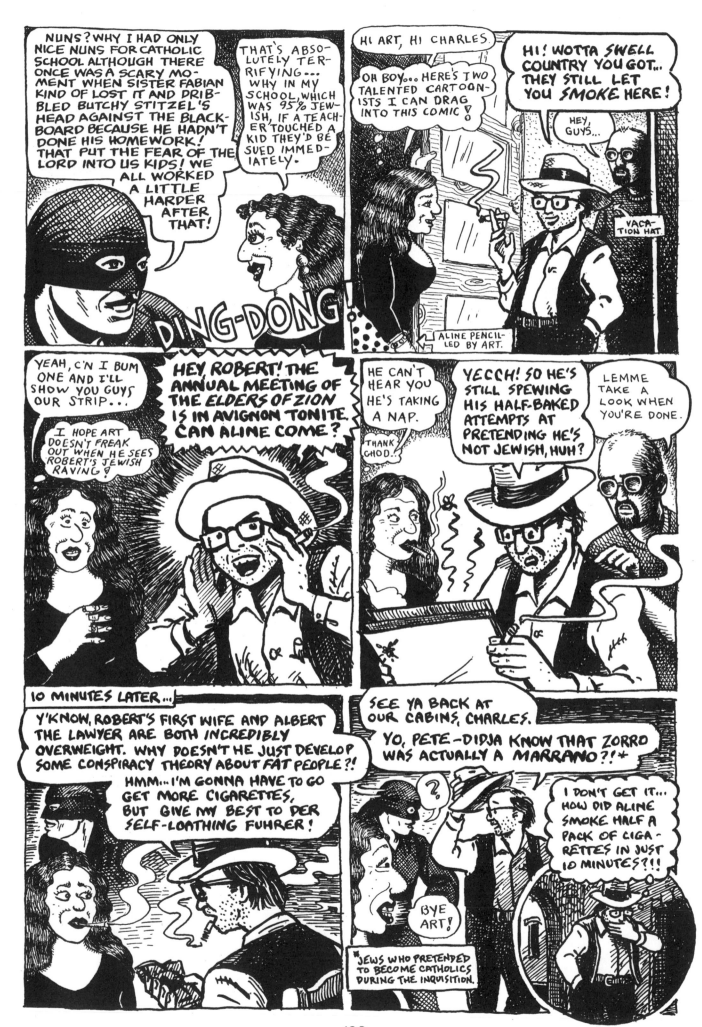

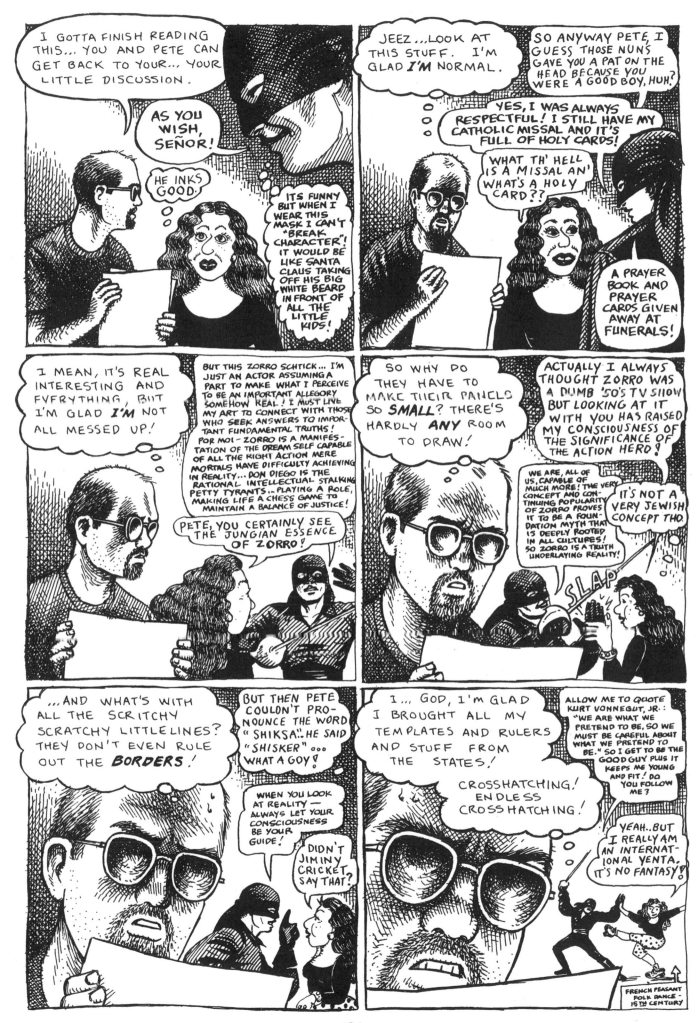

I GOTTA FINISH READING THIS... YOU AND PETE CAN GET BACK TO YOUR... YOUR LITTLE DISCUSSION.

AS YOU WISH, SEÑOR!

HE INKS GOOD.

IT'S FUNNY BUT WHEN I WEAR THIS MASK I CAN'T "BREAK CHARACTER"! IT WOULD BE LIKE SANTA CLAUS TAKING OFF HIS BIG WHITE BEARD IN FRONT OF ALL THE LITTLE KIDS!

JEEZ...LOOK AT THIS STUFF. I'M GLAD I'M NORMAL.

SO ANYWAY PETE, I GUESS THOSE NUNS GAVE YOU A PAT ON THE HEAD BECAUSE YOU WERE A GOOD BOY, HUH?

YES, I WAS ALWAYS RESPECTFUL! I STILL HAVE MY CATHOLIC MISSAL AND IT'S FULL OF HOLY CARDS!

WHAT TH' HELL IS A MISSAL AN' WHAT'S A HOLY CARD??

A PRAYER BOOK AND PRAYER CARDS GIVEN AWAY AT FUNERALS!

I MEAN, IT'S REAL INTERESTING AND EVERYTHING, BUT I'M GLAD I'M NOT ALL MESSED UP!

BUT THIS ZORRO SCHTICK... I'M JUST AN ACTOR ASSUMING A PART TO MAKE WHAT I PERCEIVE TO BE AN IMPORTANT ALLEGORY SOMEHOW REAL! I MUST LIVE MY ART TO CONNECT WITH THOSE WHO SEEK ANSWERS TO IMPORTANT FUNDAMENTAL TRUTHS! POR MOI - ZORRO IS A MANIFESTATION OF THE DREAM SELF CAPABLE OF ALL THE RIGHT ACTION MERE MORTALS HAVE DIFFICULTY ACHIEVING IN REALITY... DON DIEGO IS THE RATIONAL INTELLECTUAL STALKING PETTY TYRANTS... PLAYING A ROLE, MAKING LIFE A CHESS GAME TO MAINTAIN A BALANCE OF JUSTICE!

PETE, YOU CERTAINLY SEE THE JUNGIAN ESSENCE OF ZORRO!

SO WHY DO THEY HAVE TO MAKE THEIR PANELS SO SMALL? THERE'S HARDLY ANY ROOM TO DRAW!

ACTUALLY I ALWAYS THOUGHT ZORRO WAS A DUMB '50'S TV SHOW BUT LOOKING AT IT WITH YOU HAS RAISED MY CONSCIOUSNESS OF THE SIGNIFICANCE OF THE ACTION HERO!

WE ARE, ALL OF US, CAPABLE OF MUCH MORE! THE VERY CONCEPT AND CONTINUING POPULARITY OF ZORRO PROVES IT TO BE A FOUNDATION MYTH THAT IS DEEPLY ROOTED IN ALL CULTURES! SO ZORRO IS A TRUTH UNDERLAYING REALITY!

IT'S NOT A VERY JEWISH CONCEPT THO.

SLAP

...AND WHAT'S WITH ALL THE SCRITCHY SCRATCHY LITTLE LINES? THEY DON'T EVEN RULE OUT THE BORDERS!

BUT THEN PETE COULDN'T PRONOUNCE THE WORD "SHIKSA"... HE SAID "SHISKER"... WHAT A GOY!

WHEN YOU LOOK AT REALITY — ALWAYS LET YOUR CONSCIOUSNESS BE YOUR GUIDE!

DIDN'T JIMINY CRICKET SAY THAT?

I... GOD, I'M GLAD I BROUGHT ALL MY TEMPLATES AND RULERS AND STUFF FROM THE STATES!

CROSSHATCHING! ENDLESS CROSSHATCHING!

ALLOW ME TO QUOTE KURT VONNEGUT, JR.: "WE ARE WHAT WE PRETEND TO BE, SO WE MUST BE CAREFUL ABOUT WHAT WE PRETEND TO BE." SO I GET TO BE THE GOOD GUY PLUS IT KEEPS ME YOUNG AND FIT! DO YOU FOLLOW ME?

YEAH..BUT I REALLY AM AN INTERNATIONAL YENTA. IT'S NO FANTASY!

FRENCH PEASANT FOLK DANCE - 15TH CENTURY

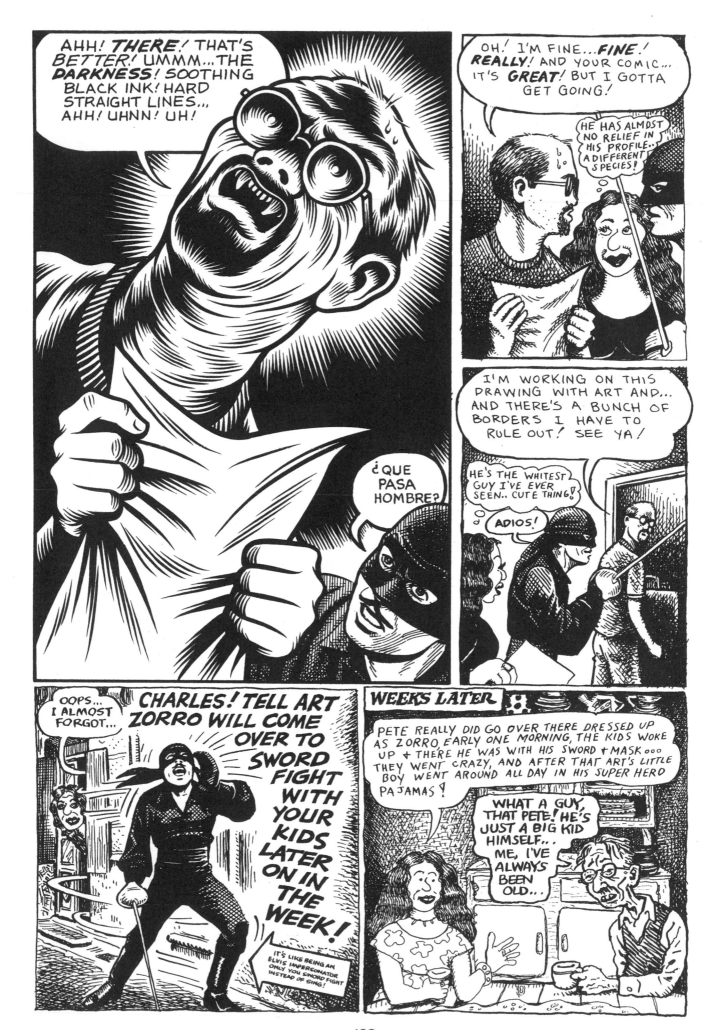

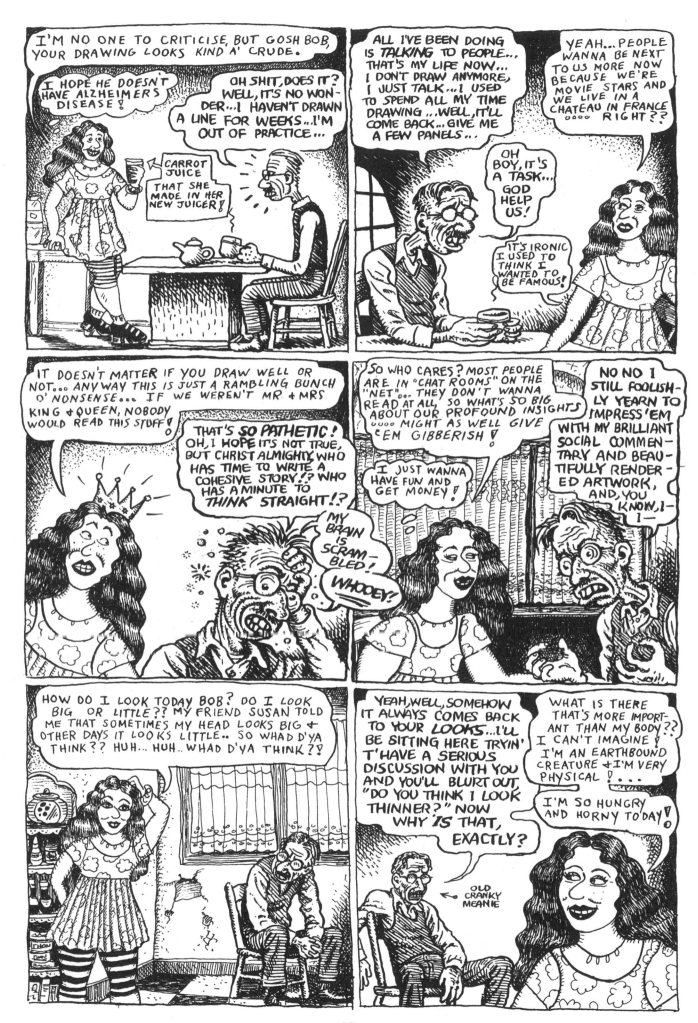

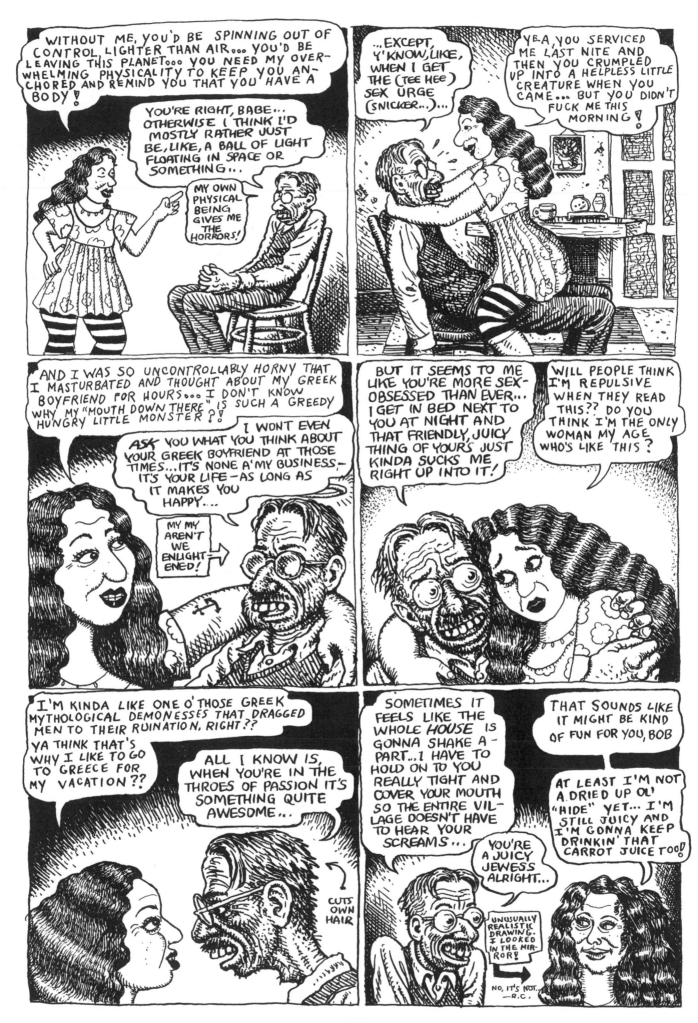

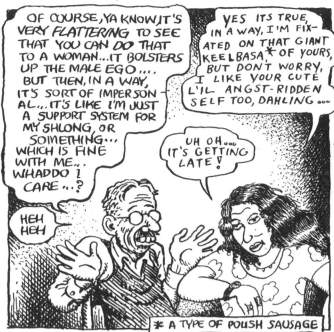

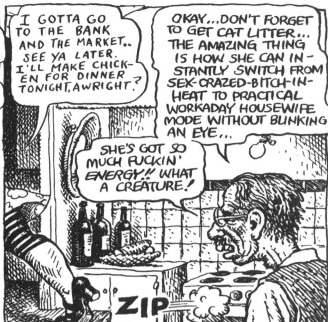

OF COURSE, YA KNOW, IT'S VERY *FLATTERING* TO SEE THAT YOU CAN *DO* THAT TO A WOMAN... IT BOLSTERS UP THE MALE EGO.... BUT THEN, IN A WAY, IT'S SORT OF IMPERSONAL... IT'S LIKE I'M JUST A SUPPORT SYSTEM FOR MY SHLONG, OR SOMETHING... WHICH IS FINE WITH ME... WHADDO I CARE...?

HEH HEH

YES IT'S TRUE, IN A WAY, I'M FIXATED ON THAT GIANT KEELBASA* OF YOURS, BUT DON'T WORRY, I LIKE YOUR CUTE L'IL ANGST-RIDDEN SELF TOO, DAHLING...

UH OH... IT'S GETTING LATE!

*A TYPE OF POLISH SAUSAGE

I GOTTA GO TO THE BANK AND THE MARKET... SEE YA LATER. I'LL MAKE CHICKEN FOR DINNER TONIGHT, AWRIGHT?

OKAY... DON'T FORGET TO GET CAT LITTER... THE AMAZING THING IS HOW SHE CAN INSTANTLY SWITCH FROM SEX-CRAZED-BITCH-IN-HEAT TO PRACTICAL WORKADAY HOUSEWIFE MODE WITHOUT BLINKING AN EYE...

SHE'S GOT SO MUCH FUCKIN' ENERGY!! WHAT A CREATURE!

ZIP

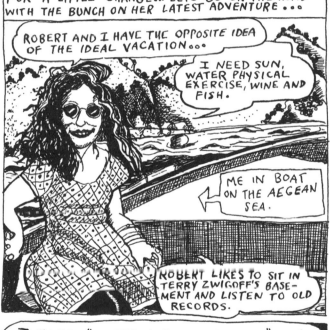

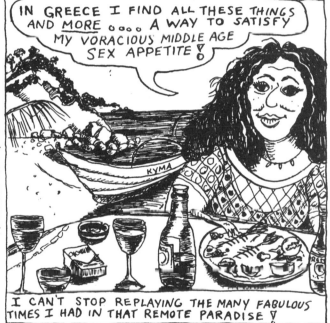

FOR A LITTLE CHANGE... LET'S GO ON THE ROAD WITH THE BUNCH ON HER LATEST ADVENTURE...

ROBERT AND I HAVE THE OPPOSITE IDEA OF THE IDEAL VACATION...

I NEED SUN, WATER PHYSICAL EXERCISE, WINE AND FISH.

ME IN BOAT ON THE AEGEAN SEA.

ROBERT LIKES TO SIT IN TERRY ZWIGOFF'S BASEMENT AND LISTEN TO OLD RECORDS.

IN GREECE I FIND ALL THESE *THINGS* AND *MORE* A WAY TO SATISFY MY VORACIOUS MIDDLE AGE SEX APPETITE!

I CAN'T STOP REPLAYING THE MANY FABULOUS TIMES I HAD IN THAT REMOTE PARADISE!

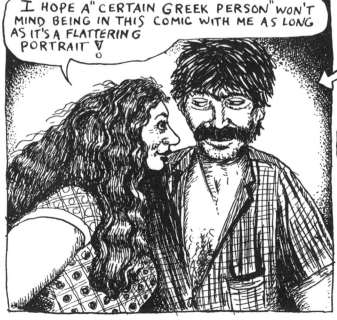

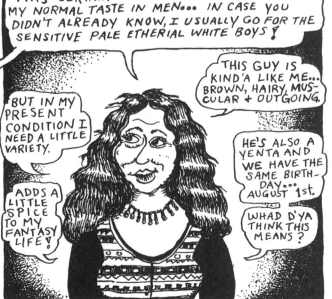

I HOPE A "CERTAIN GREEK PERSON" WON'T MIND BEING IN THIS COMIC WITH ME AS LONG AS IT'S A FLATTERING PORTRAIT!

THIS "CERTAIN PERSON" IS THE ANTITHESIS OF MY NORMAL TASTE IN MEN... IN CASE YOU DIDN'T ALREADY KNOW, I USUALLY GO FOR THE SENSITIVE PALE ETHERIAL WHITE BOYS!

BUT IN MY PRESENT CONDITION I NEED A LITTLE VARIETY.

ADDS A LITTLE SPICE TO MY FANTASY LIFE!

THIS GUY IS KIND'A LIKE ME... BROWN, HAIRY, MUSCULAR + OUTGOING.

HE'S ALSO A YENTA AND WE HAVE THE SAME BIRTHDAY—AUGUST 1st.

WHAD D'YA THINK THIS MEANS?

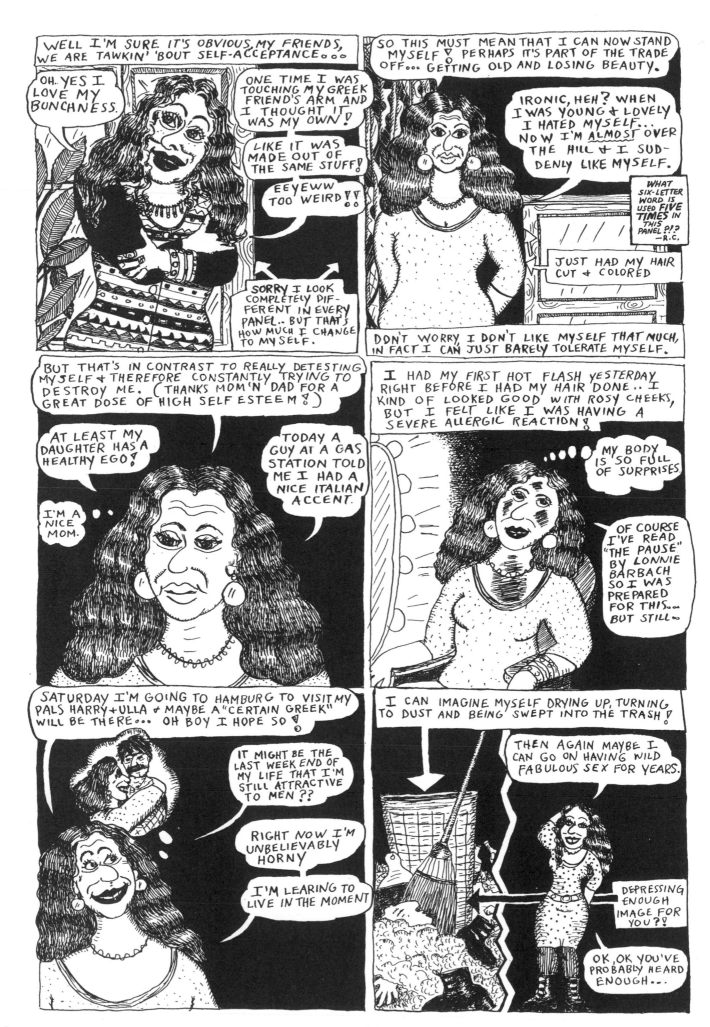

WELL I'M SURE IT'S OBVIOUS, MY FRIENDS, WE ARE TAWKIN' 'BOUT SELF-ACCEPTANCE...

OH..YES I LOVE MY BUNCHNESS.

ONE TIME I WAS TOUCHING MY GREEK FRIEND'S ARM AND I THOUGHT IT WAS MY OWN!

LIKE IT WAS MADE OUT OF THE SAME STUFF!

EEYEWW TOO WEIRD!!

SORRY I LOOK COMPLETELY DIFFERENT IN EVERY PANEL.. BUT THAT'S HOW MUCH I CHANGE TO MYSELF.

SO THIS MUST MEAN THAT I CAN NOW STAND MYSELF. PERHAPS IT'S PART OF THE TRADE OFF... GETTING OLD AND LOSING BEAUTY.

IRONIC, HEH? WHEN I WAS YOUNG & LOVELY I HATED MYSELF... NOW I'M ALMOST OVER THE HILL & I SUDDENLY LIKE MYSELF.

WHAT SIX-LETTER WORD IS USED FIVE TIMES IN THIS PANEL ?!? —R.C.

JUST HAD MY HAIR CUT & COLORED

DON'T WORRY I DON'T LIKE MYSELF THAT MUCH, IN FACT I CAN JUST BARELY TOLERATE MYSELF.

BUT THAT'S IN CONTRAST TO REALLY DETESTING MYSELF & THEREFORE CONSTANTLY TRYING TO DESTROY ME. (THANKS MOM 'N' DAD FOR A GREAT DOSE OF HIGH SELF ESTEEM!)

AT LEAST MY DAUGHTER HAS A HEALTHY EGO!

TODAY A GUY AT A GAS STATION TOLD ME I HAD A NICE ITALIAN ACCENT.

I'M A NICE MOM.

I HAD MY FIRST HOT FLASH YESTERDAY RIGHT BEFORE I HAD MY HAIR DONE.. I KIND OF LOOKED GOOD WITH ROSY CHEEKS, BUT I FELT LIKE I WAS HAVING A SEVERE ALLERGIC REACTION!

MY BODY IS SO FULL OF SURPRISES.

OF COURSE I'VE READ "THE PAUSE" BY LONNIE BARBACH SO I WAS PREPARED FOR THIS... BUT STILL...

SATURDAY I'M GOING TO HAMBURG TO VISIT MY PALS HARRY + ULLA & MAYBE A "CERTAIN GREEK" WILL BE THERE... OH BOY I HOPE SO!

IT MIGHT BE THE LAST WEEKEND OF MY LIFE THAT I'M STILL ATTRACTIVE TO MEN ??

RIGHT NOW I'M UNBELIEVABLY HORNY

I'M LEARING TO LIVE IN THE MOMENT

I CAN IMAGINE MYSELF DRYING UP, TURNING TO DUST AND BEING SWEPT INTO THE TRASH!

THEN AGAIN MAYBE I CAN GO ON HAVING WILD FABULOUS SEX FOR YEARS.

DEPRESSING ENOUGH IMAGE FOR YOU?!

OK, OK YOU'VE PROBABLY HEARD ENOUGH...

196

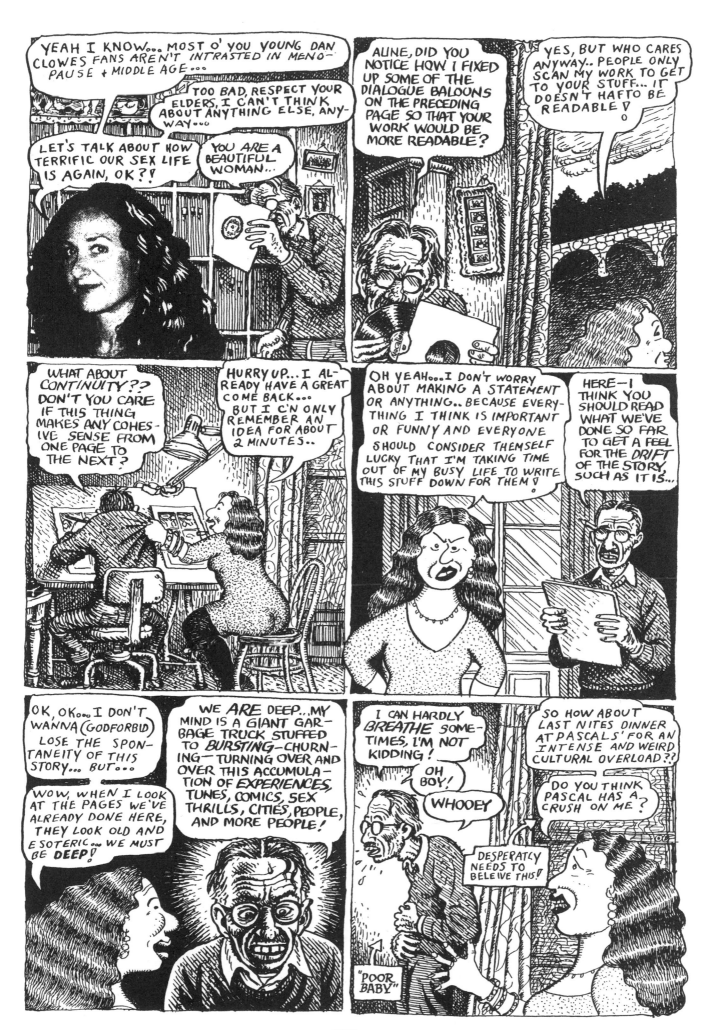

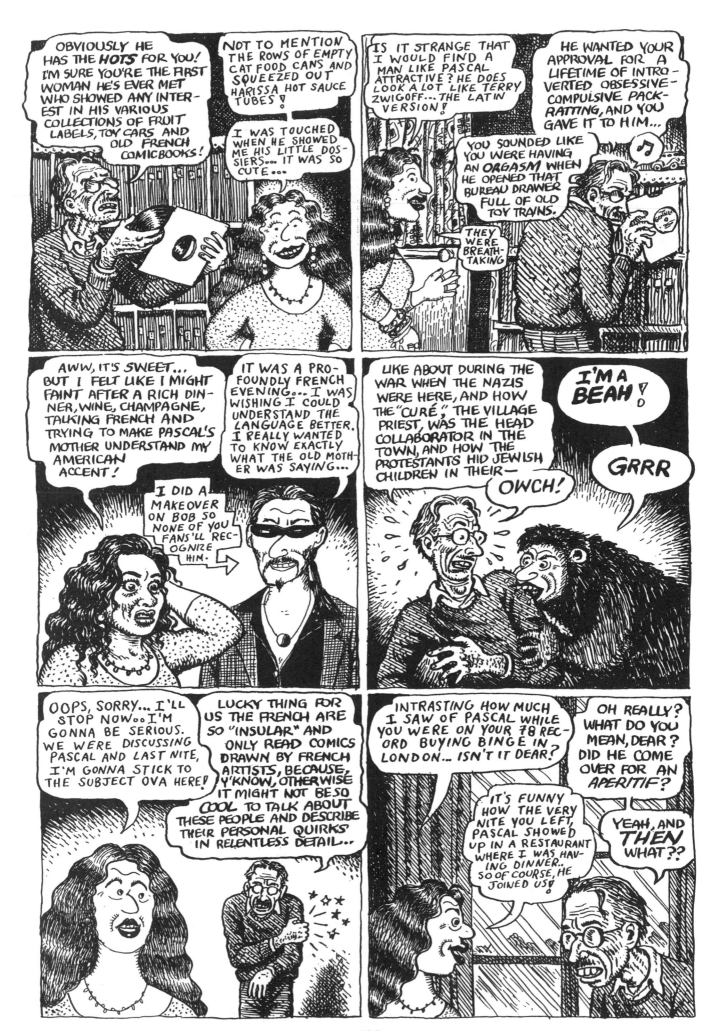

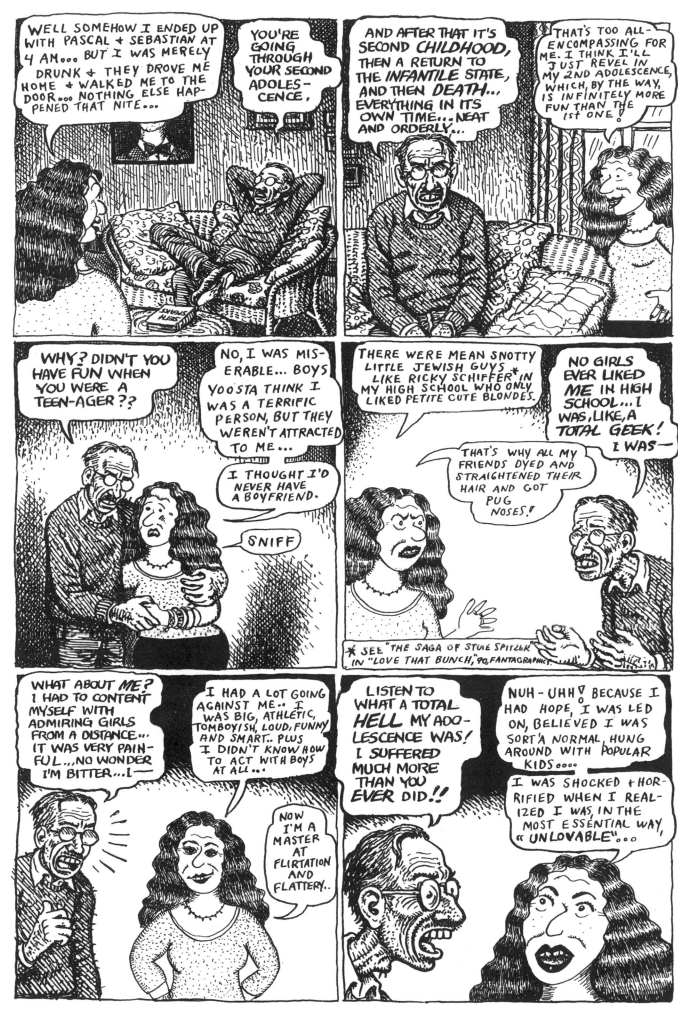

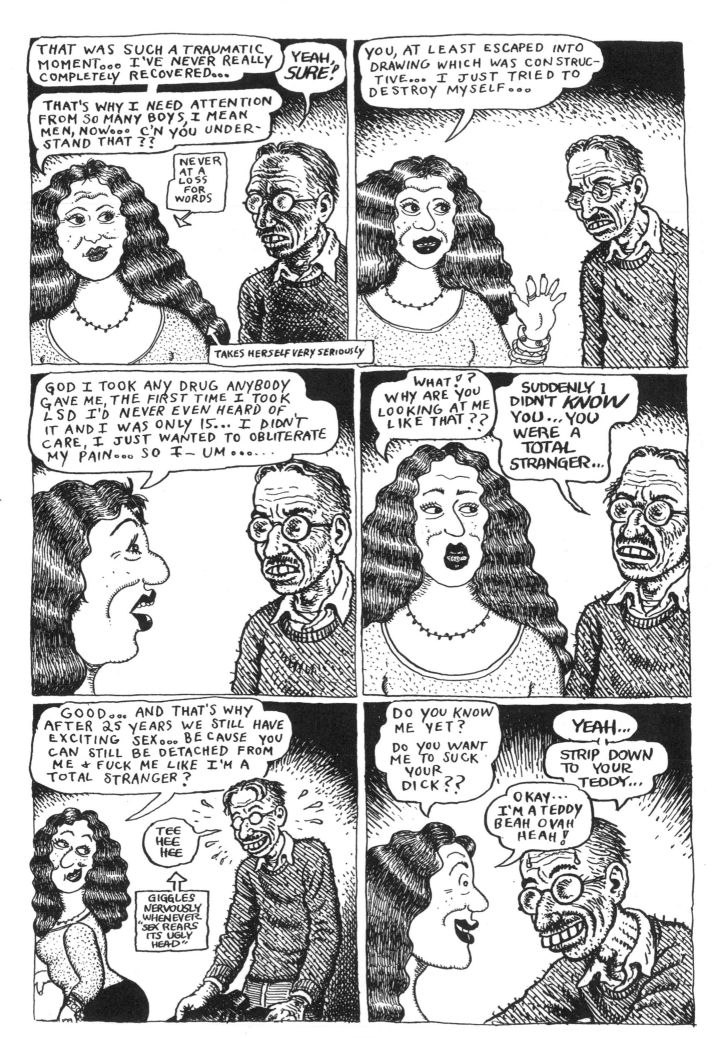

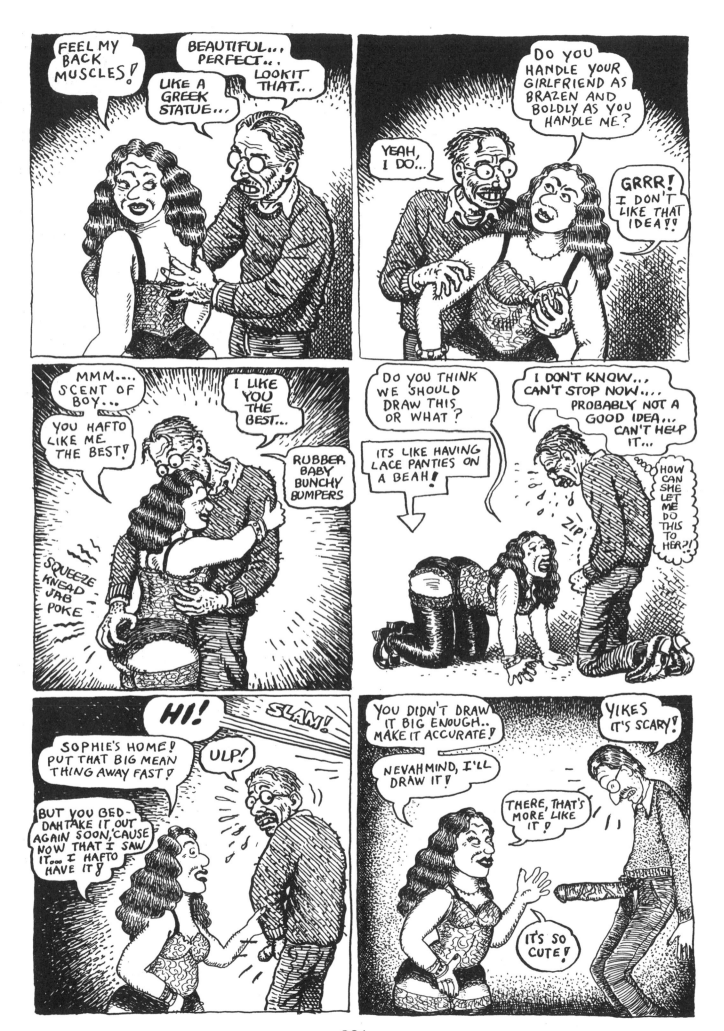

201

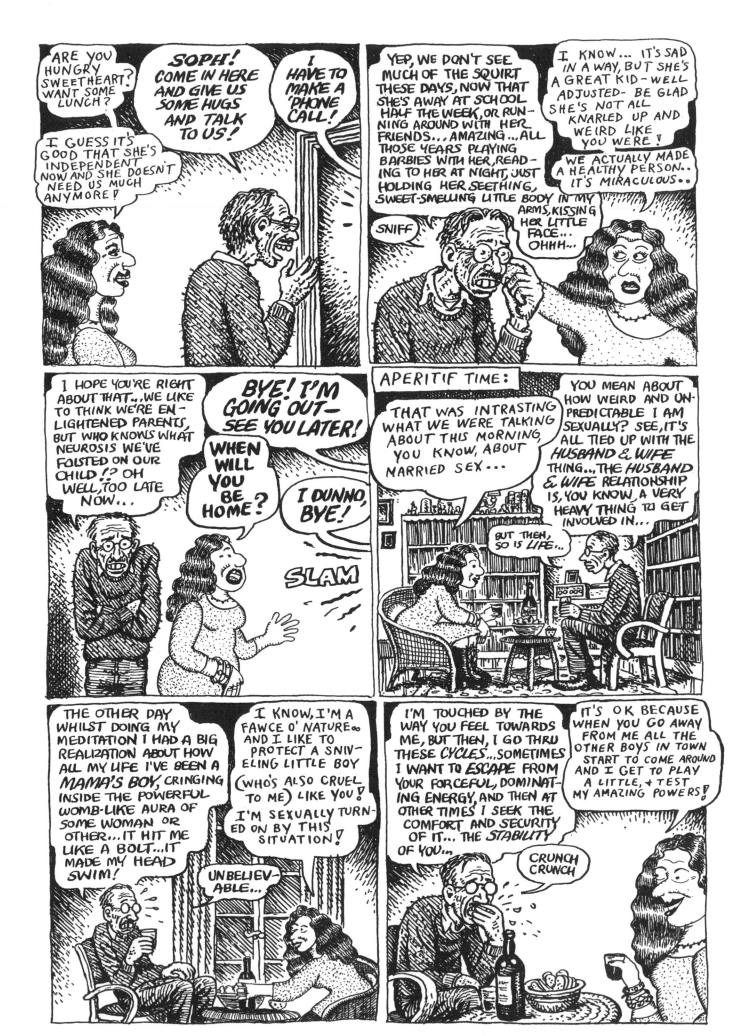

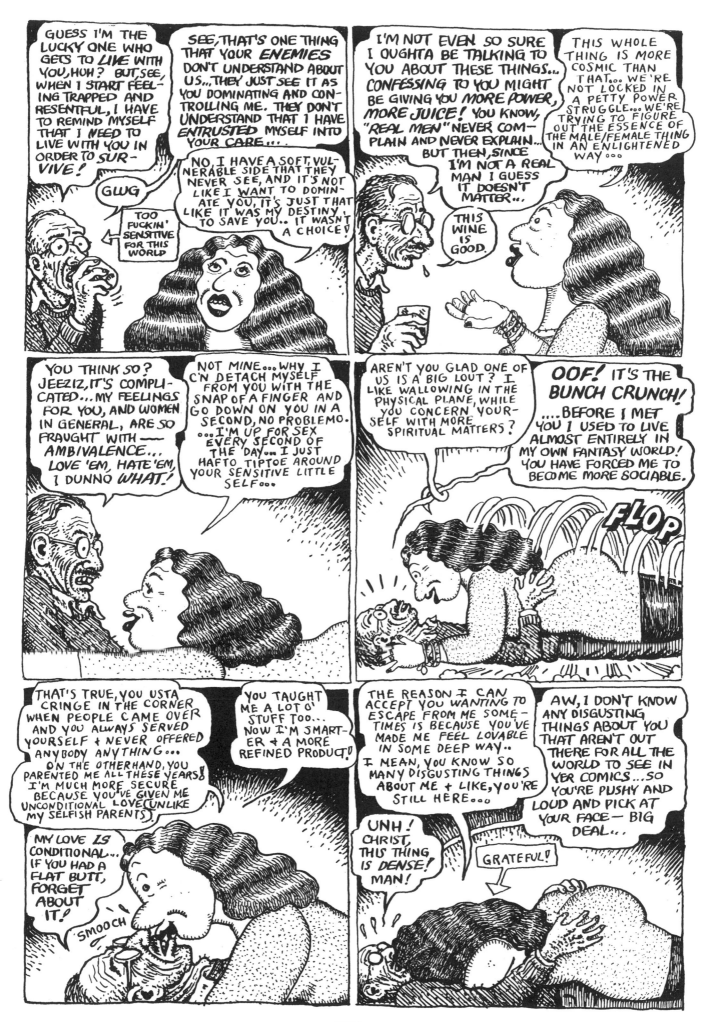

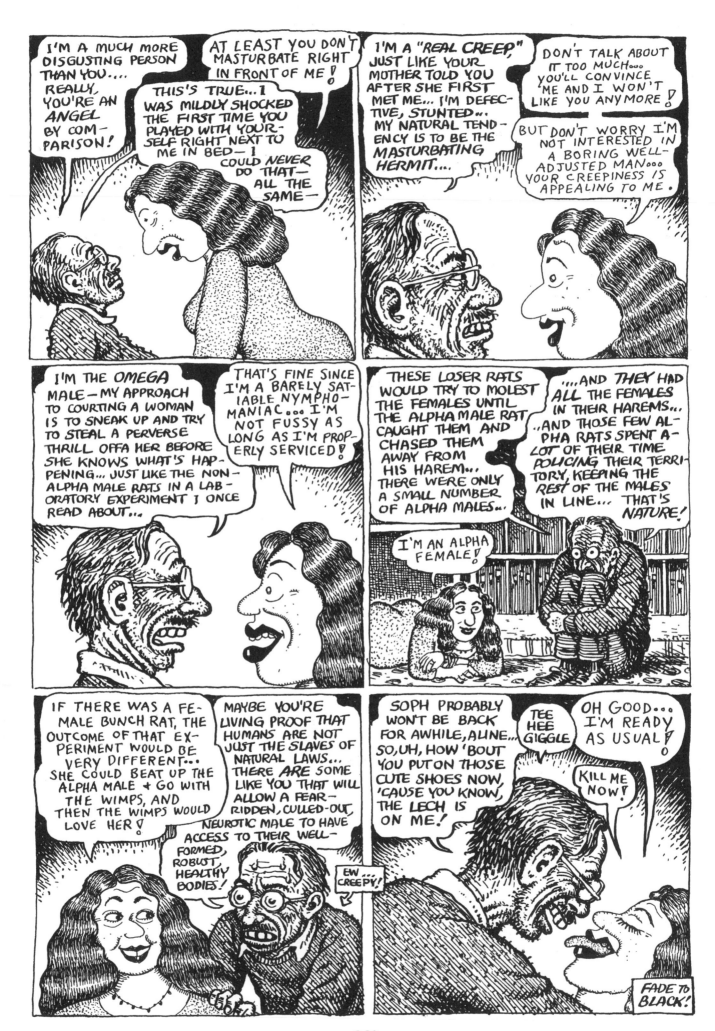

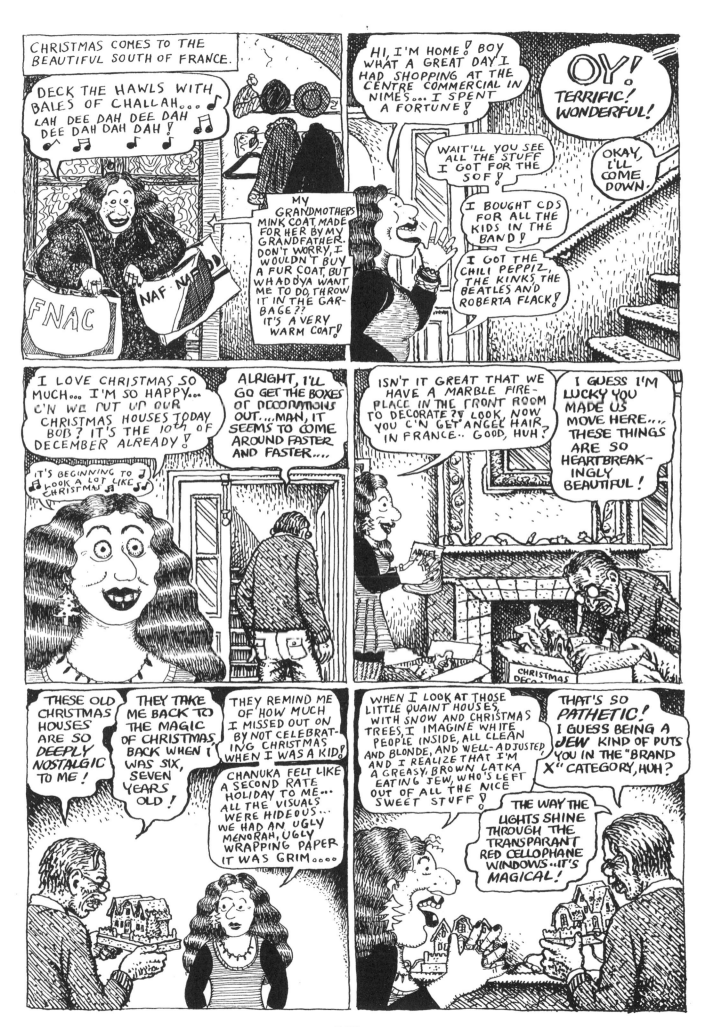

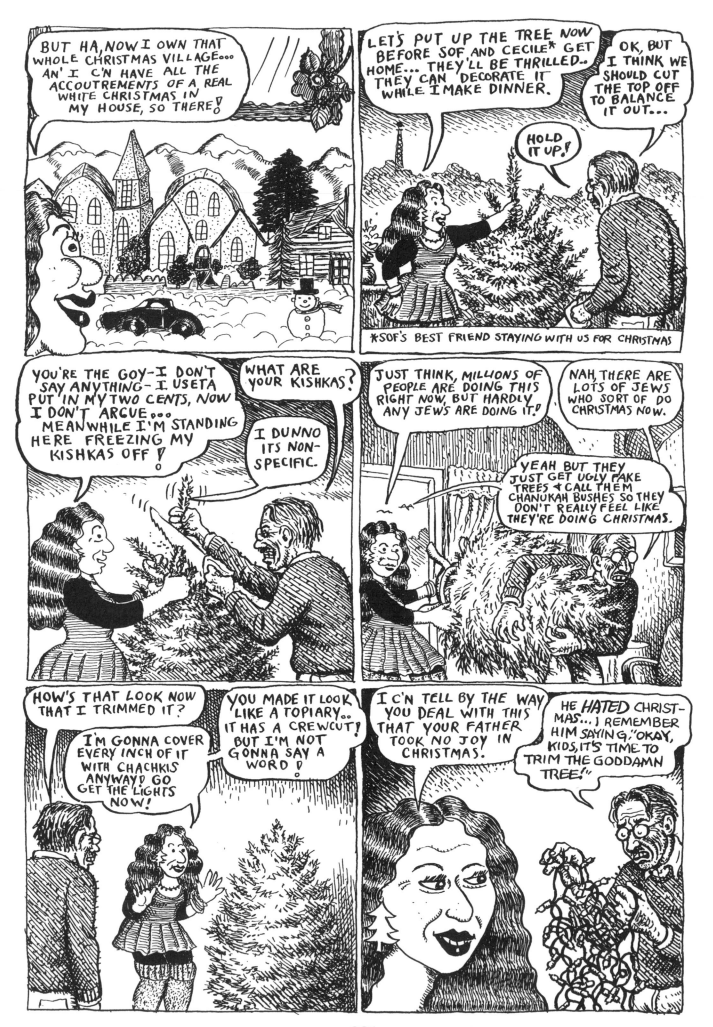

206

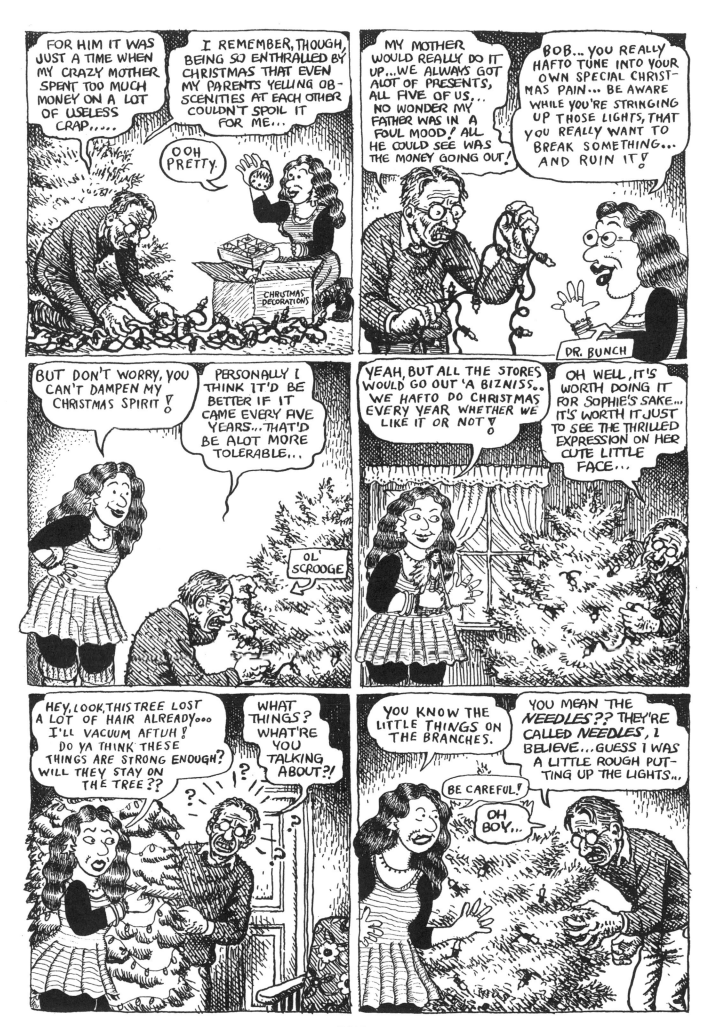

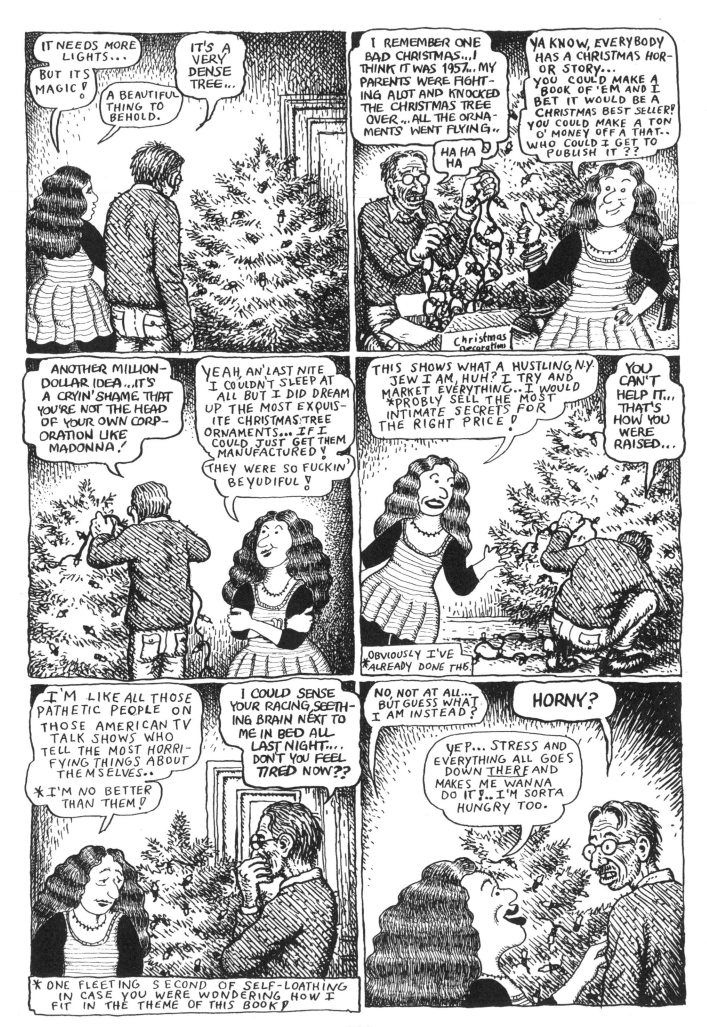

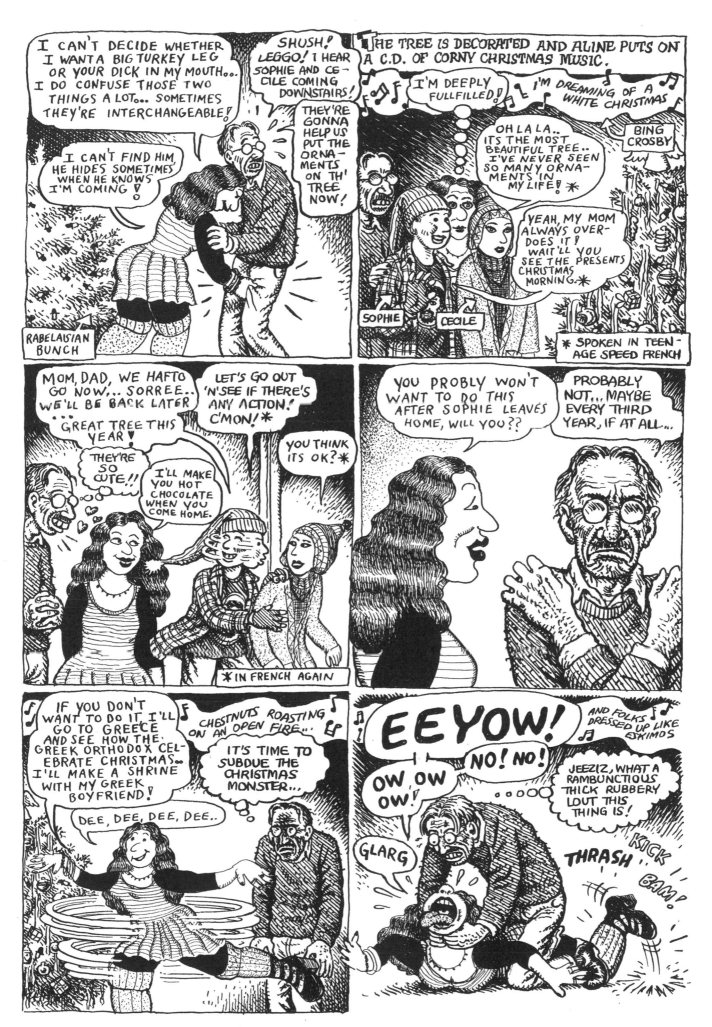

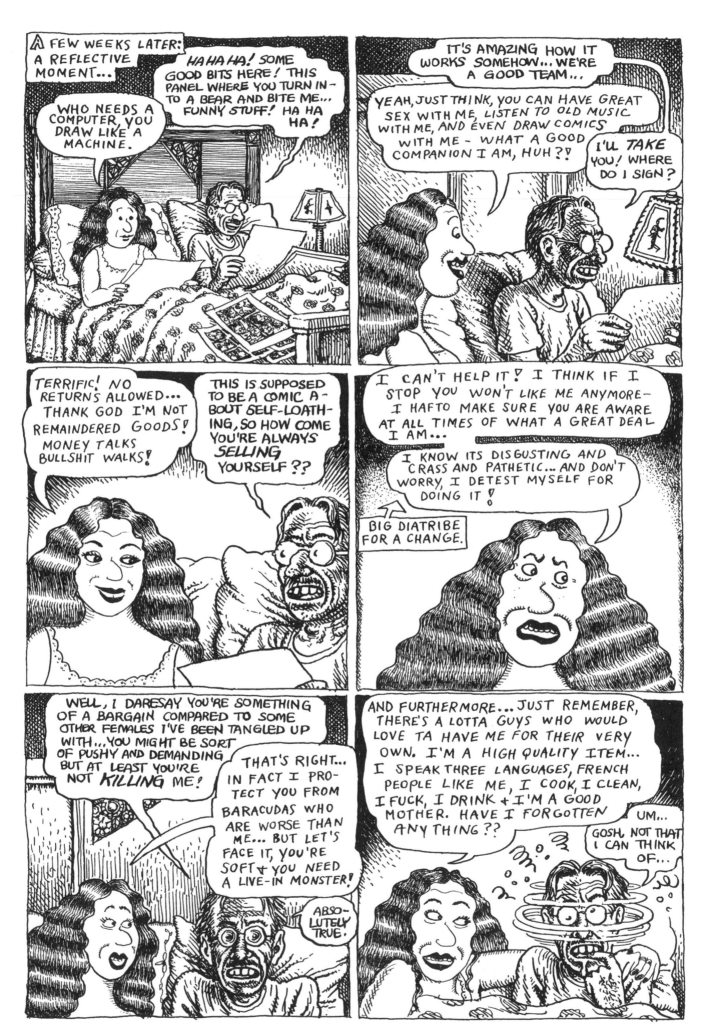

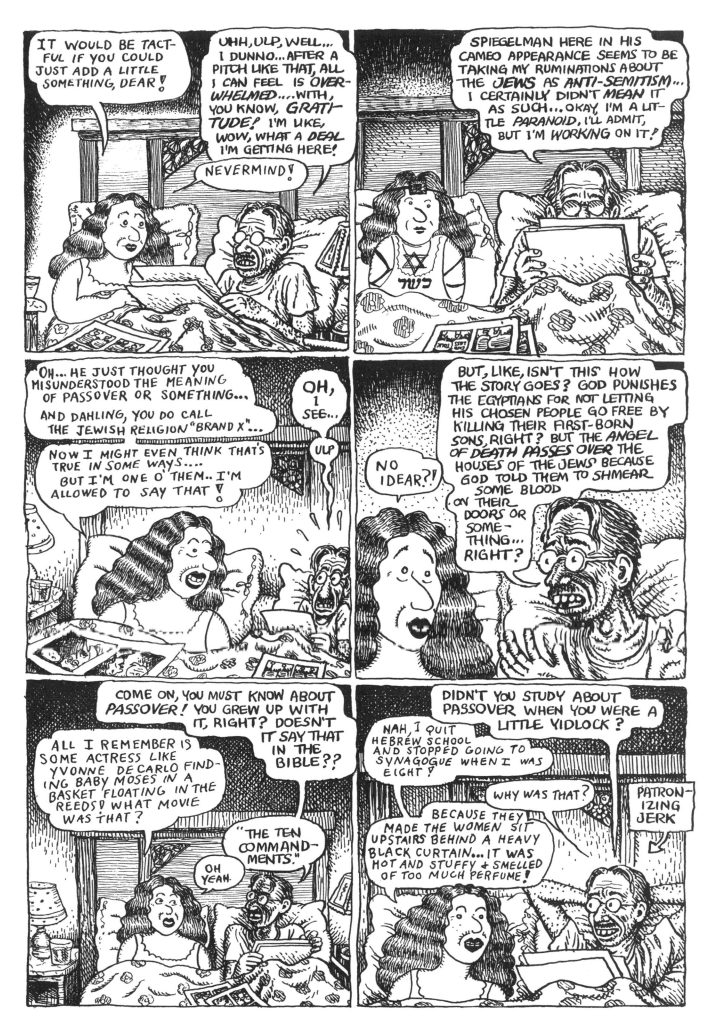

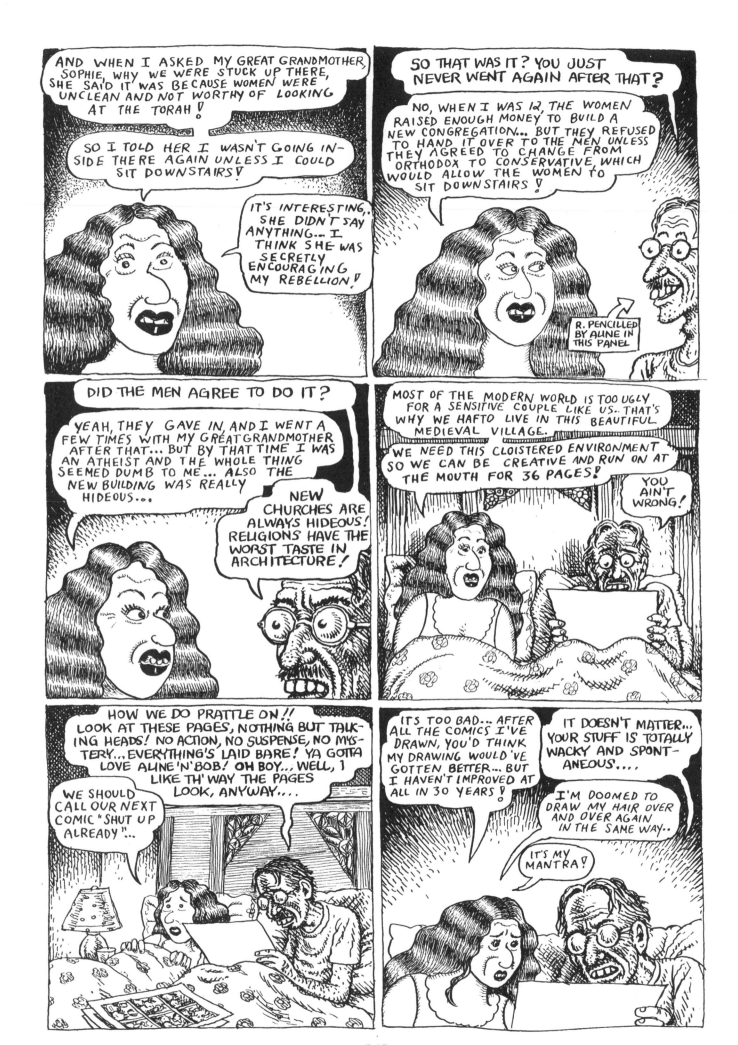

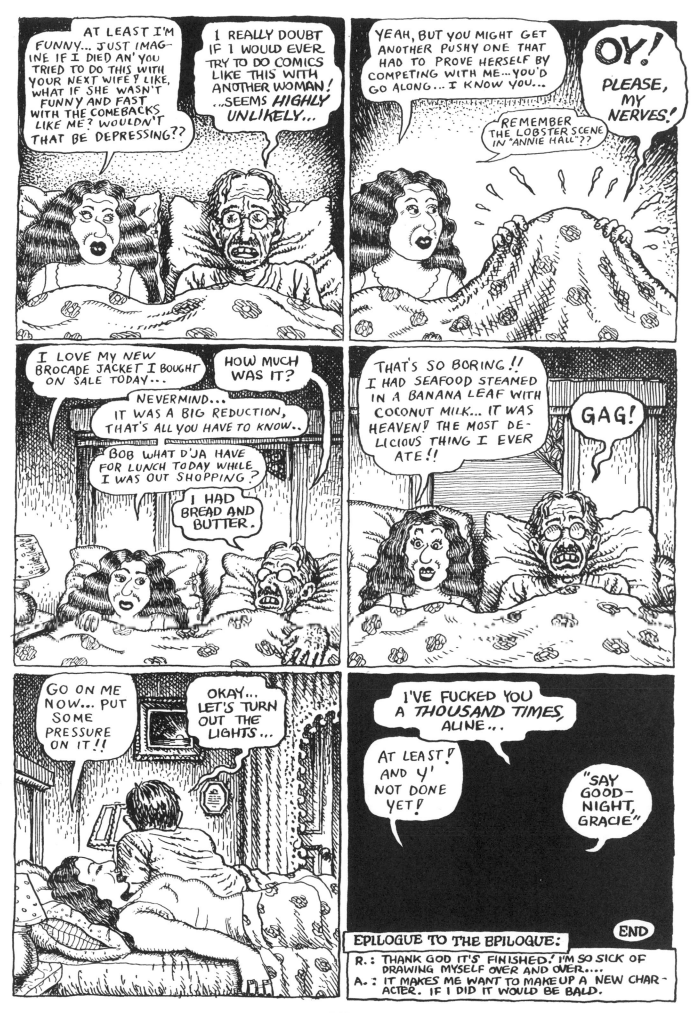

213

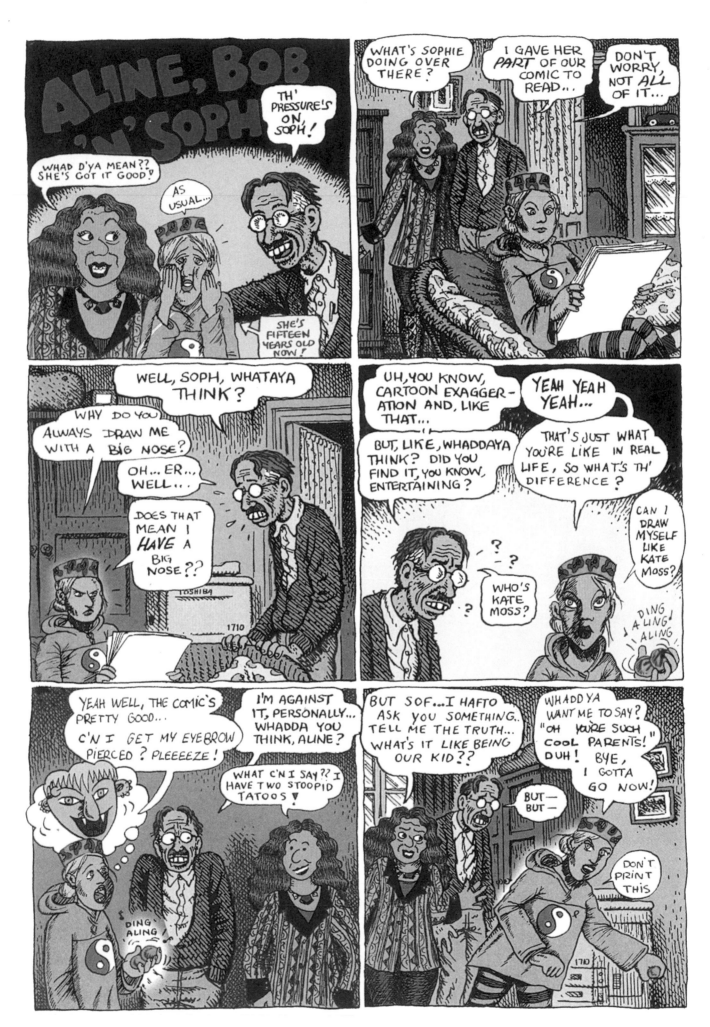

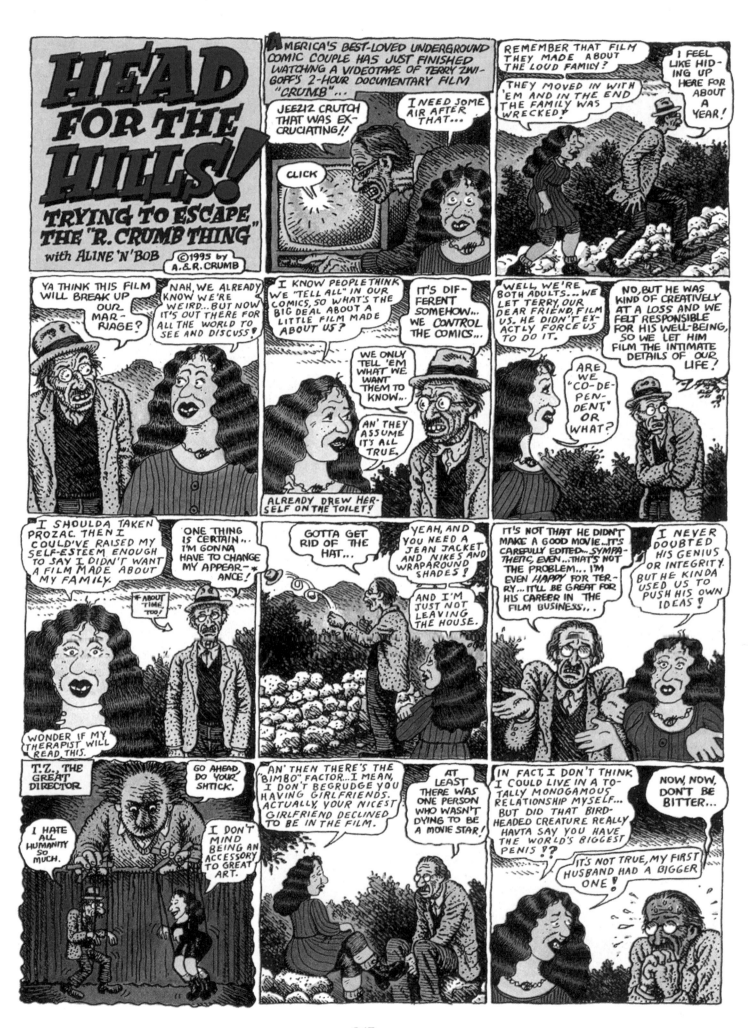

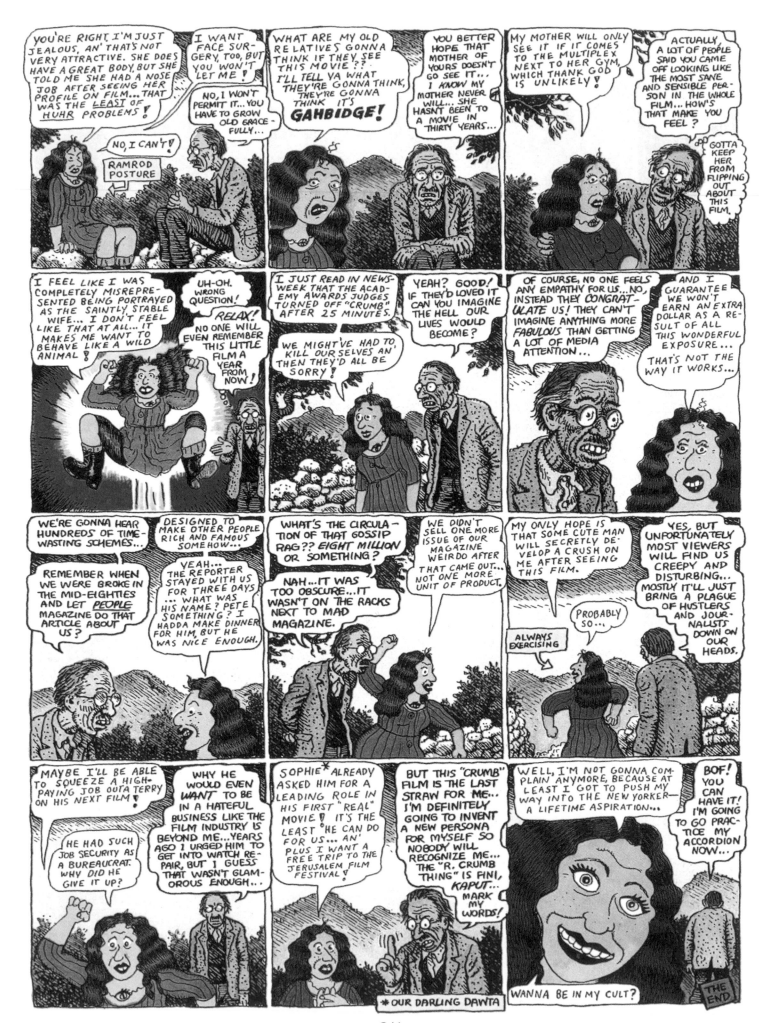

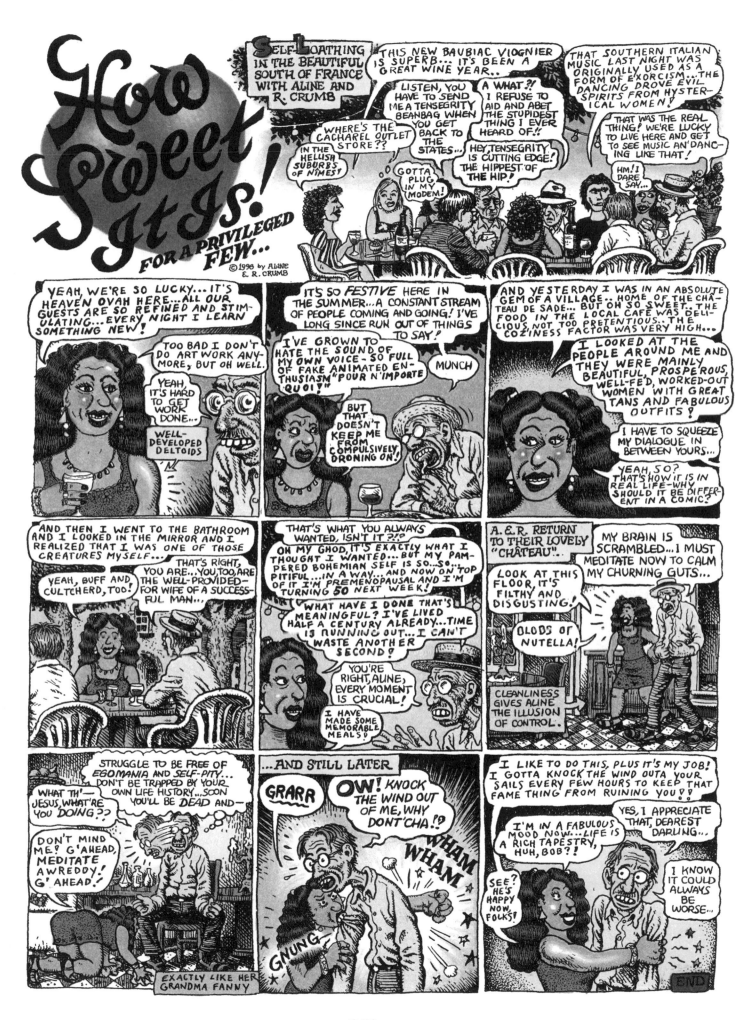

A LESSON IN FRENCH

R. Crumb merged '60s cool with the comics, and critic Robert Hughes called him "the Brueghel of the twentieth century." Now, artist (and wife) move on

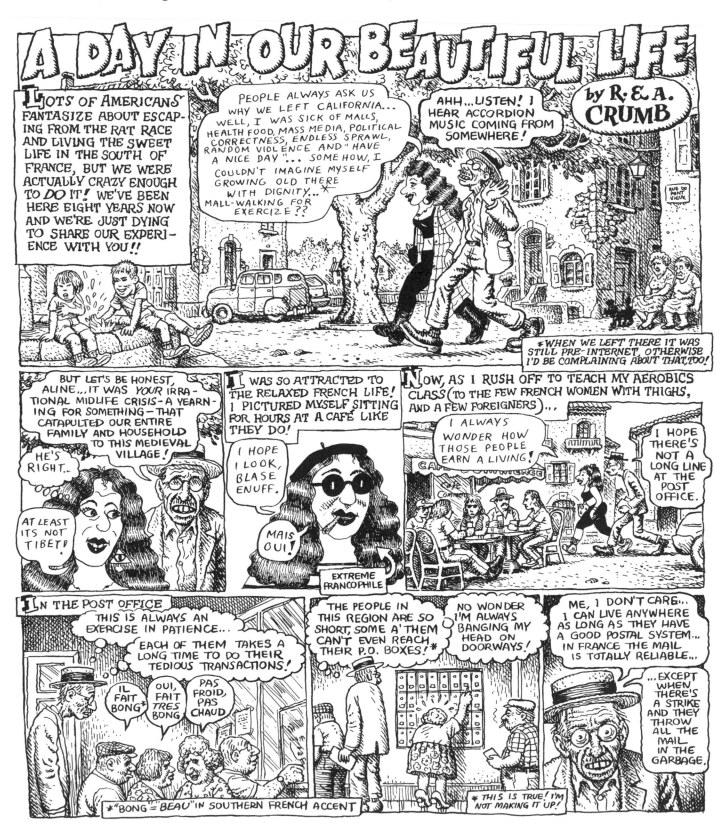

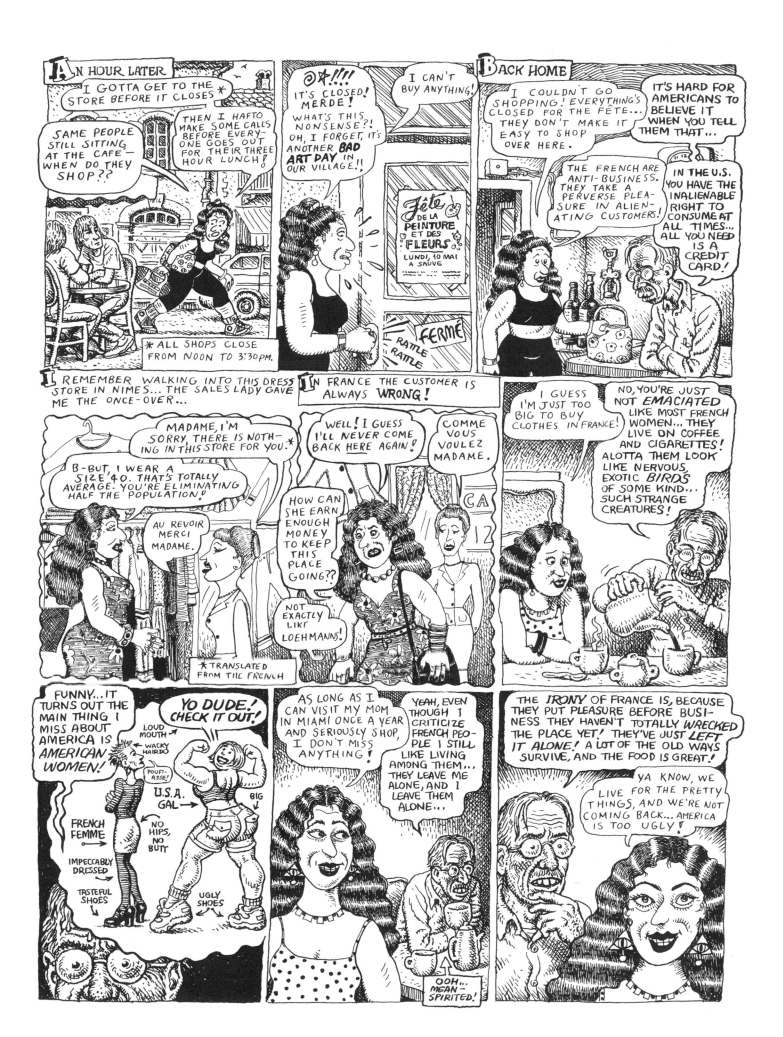

Fashion Week in New York
or GLAMOUR and FREE LINT REMOVERS
SEPTEMBER 12~19, 2003

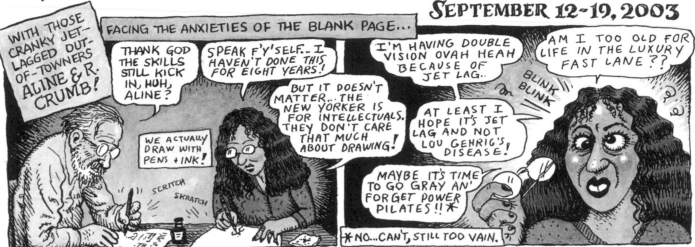

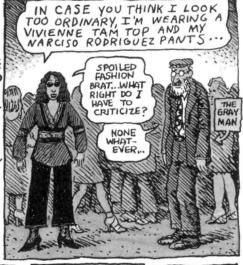

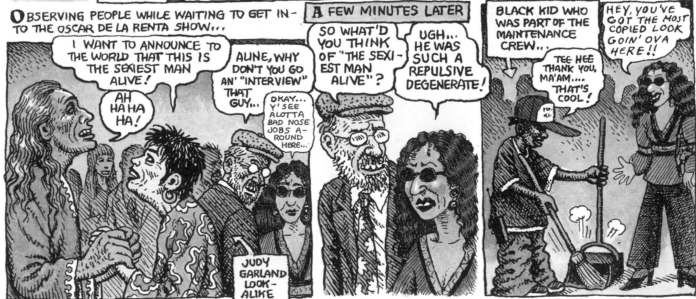

WE HAD INVITATIONS TO THE OSCAR DE LA RENTA SHOW, BUT *WITHOUT* SEAT ASSIGNMENTS. AFTER 45 MINUTES OF WAITING WE WERE DEMOTED TO THE STANDING-ROOM-ONLY LINE. WE WAITED FOR ANOTHER HALF AN HOUR AND THEN WERE TOLD....

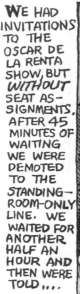

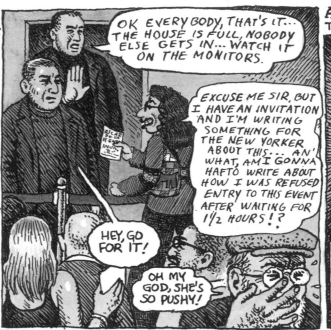

OK EVERYBODY, THAT'S IT... THE HOUSE IS FULL, NOBODY ELSE GETS IN... WATCH IT ON THE MONITORS.

EXCUSE ME SIR, BUT I HAVE AN INVITATION AND I'M WRITING SOMETHING FOR THE NEW YORKER ABOUT THIS... AN' WHAT, AM I GONNA HAFTO WRITE ABOUT HOW I WAS REFUSED ENTRY TO THIS EVENT AFTER WAITING FOR 1½ HOURS!?

HEY, GO FOR IT!

OH MY GOD, SHE'S SO PUSHY!

ALINE'S PUSHY BUT SHE CERTAINLY WASN'T THE MOST AGGRESSIVE ONE THERE!

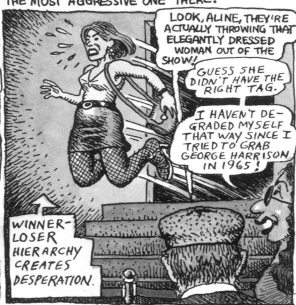

LOOK, ALINE, THEY'RE ACTUALLY THROWING THAT ELEGANTLY DRESSED WOMAN OUT OF THE SHOW!

GUESS SHE DIDN'T HAVE THE RIGHT TAG.

I HAVEN'T DE-GRADED MYSELF THAT WAY SINCE I TRIED TO GRAB GEORGE HARRISON IN 1965!

WINNER-LOSER HIERARCHY CREATES DESPERATION.

VARIOUS LOOKS WORTH MENTIONING

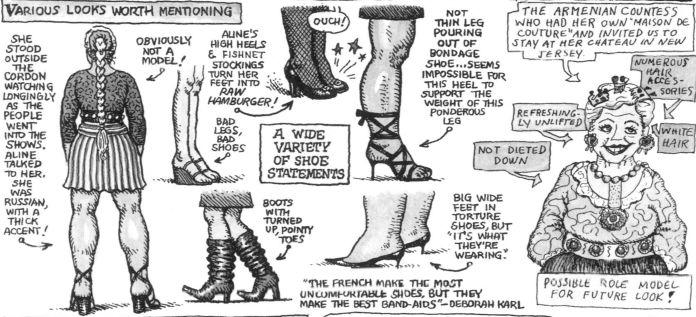

SHE STOOD OUTSIDE THE CORDON WATCHING LONGINGLY AS THE PEOPLE WENT INTO THE SHOWS. ALINE TALKED TO HER. SHE WAS RUSSIAN, WITH A THICK ACCENT!

OBVIOUSLY NOT A MODEL!

ALINE'S HIGH HEELS & FISHNET STOCKINGS TURN HER FEET INTO *RAW HAMBURGER!*

OUCH!

BAD LEGS, BAD SHOES

A WIDE VARIETY OF SHOE STATEMENTS

NOT THIN LEG POURING OUT OF BONDAGE SHOE... SEEMS IMPOSSIBLE FOR THIS HEEL TO SUPPORT THE WEIGHT OF THIS PONDEROUS LEG

BOOTS WITH TURNED UP, POINTY TOES

BIG WIDE FEET IN TORTURE SHOES, BUT "IT'S WHAT THEY'RE WEARING."

"THE FRENCH MAKE THE MOST UNCOMFORTABLE SHOES, BUT THEY MAKE THE BEST BAND-AIDS"—DEBORAH KARL

THE ARMENIAN COUNTESS WHO HAD HER OWN "MAISON DE COUTURE" AND INVITED US TO STAY AT HER CHATEAU IN NEW JERSEY.

NUMEROUS HAIR ACCESSORIES

REFRESHINGLY UNLIFTED

NOT DIETED DOWN

WHITE HAIR

POSSIBLE ROLE MODEL FOR FUTURE LOOK!

CAFÉ IN THE TENT: WELL-BRED ASIAN GIRLS, FREE LANCE WRITERS, WENT TO GOOD SCHOOLS... IBM THINK PADS...

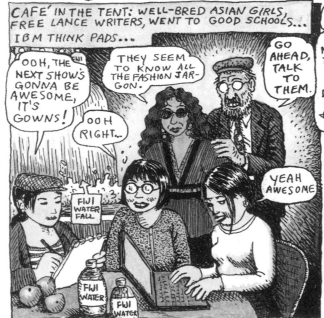

OOH, THE NEXT SHOW'S GONNA BE AWESOME, IT'S GOWNS!

OOH RIGHT...

THEY SEEM TO KNOW ALL THE FASHION JAR-GON.

GO AHEAD, TALK TO THEM.

FIJI WATER FALL

FIJI WATER

FIJI WATER

YEAH AWESOME

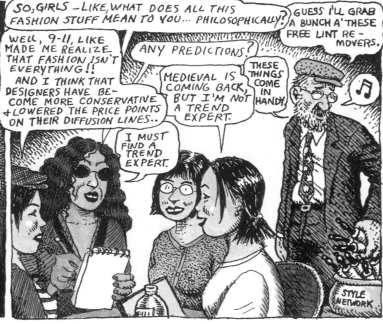

SO, GIRLS—LIKE, WHAT DOES ALL THIS FASHION STUFF MEAN TO YOU... PHILOSOPHICALLY!

WELL, 9-11, LIKE MADE ME REALIZE THAT FASHION ISN'T EVERYTHING!! AND I THINK THAT DESIGNERS HAVE BE-COME MORE CONSERVATIVE + LOWERED THE PRICE POINTS ON THEIR DIFFUSION LINES..

ANY PREDICTIONS!

MEDIEVAL IS COMING BACK, BUT I'M NOT A TREND EXPERT.

I MUST FIND A TREND EXPERT.

GUESS I'LL GRAB A BUNCH A' THESE FREE LINT RE-MOVERS.

THESE THINGS COME IN HANDY!

STYLE NETWORK

WE FINALLY GOT IN TO SEE A COUPLE OF THE RUNWAY SHOWS...

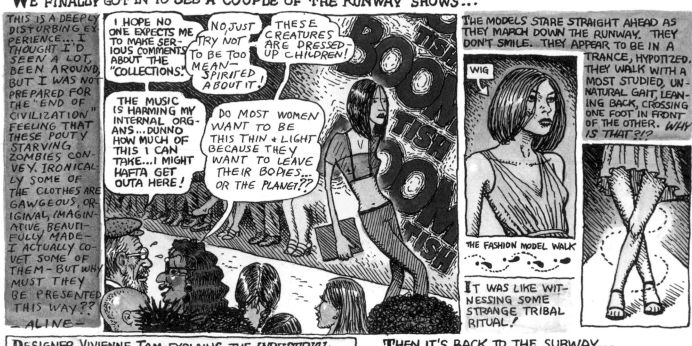

THIS IS A DEEPLY DISTURBING EXPERIENCE... I THOUGHT I'D SEEN A LOT, BEEN AROUND, BUT I WAS NOT PREPARED FOR THE "END OF CIVILIZATION" FEELING THAT THESE POUTY STARVING ZOMBIES CONVEY. IRONICALLY SOME OF THE CLOTHES ARE GAWGEOUS, ORIGINAL, IMAGINATIVE, BEAUTIFULLY MADE — I ACTUALLY COVET SOME OF THEM — BUT WHY MUST THEY BE PRESENTED THIS WAY?? — ALINE —

I HOPE NO ONE EXPECTS ME TO MAKE SERIOUS COMMENTS ABOUT THE "COLLECTIONS."

NO, JUST TRY NOT TO BE TOO MEAN-SPIRITED ABOUT IT!

THESE CREATURES ARE DRESSED-UP CHILDREN!

THE MUSIC IS HARMING MY INTERNAL ORGANS... DUNNO HOW MUCH OF THIS I CAN TAKE... I MIGHT HAFTA GET OUTA HERE!

DO MOST WOMEN WANT TO BE THIS THIN & LIGHT BECAUSE THEY WANT TO LEAVE THEIR BODIES... OR THE PLANET??

THE MODELS STARE STRAIGHT AHEAD AS THEY MARCH DOWN THE RUNWAY. THEY DON'T SMILE. THEY APPEAR TO BE IN A TRANCE, HYPOTIZED. THEY WALK WITH A MOST STUDIED, UNNATURAL GAIT, LEANING BACK, CROSSING ONE FOOT IN FRONT OF THE OTHER. WHY IS THAT?!?

WIG

THE FASHION MODEL WALK

IT WAS LIKE WITNESSING SOME STRANGE TRIBAL RITUAL!

DESIGNER VIVIENNE TAM EXPLAINS THE *INDUSTRIAL REALITIES* OF FASHION OVER DINNER AT A NEW, TRENDY, EXPENSIVE RESTAURANT IN "TRIBECA" (SOMEONE ELSE PAID THE CHECK*)

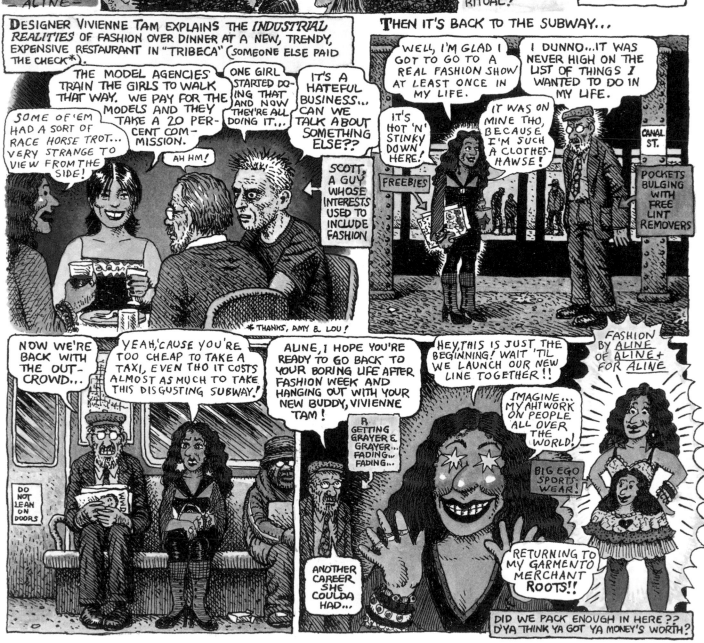

THE MODEL AGENCIES TRAIN THE GIRLS TO WALK THAT WAY. WE PAY FOR THE MODELS AND THEY TAKE A 20 PERCENT COMMISSION.

SOME OF 'EM HAD A SORT OF RACE HORSE TROT... VERY STRANGE TO VIEW FROM THE SIDE!

ONE GIRL STARTED DOING THAT AND NOW THEY'RE ALL DOING IT...

IT'S A HATEFUL BUSINESS... CAN WE TALK ABOUT SOMETHING ELSE??

AH HM!

SCOTT, A GUY WHOSE INTERESTS USED TO INCLUDE FASHION

* THANKS, AMY & LOU!

THEN IT'S BACK TO THE SUBWAY...

WELL, I'M GLAD I GOT TO GO TO A REAL FASHION SHOW AT LEAST ONCE IN MY LIFE.

I DUNNO... IT WAS NEVER HIGH ON THE LIST OF THINGS I WANTED TO DO IN MY LIFE.

IT'S HOT 'N' STINKY DOWN HERE!

IT WAS ON MINE THO, BECAUSE I'M SUCH A CLOTHES-HAWSE!

FREEBIES

CANAL ST.

POCKETS BULGING WITH FREE LINT REMOVERS

NOW WE'RE BACK WITH THE OUT-CROWD...

YEAH, 'CAUSE YOU'RE TOO CHEAP TO TAKE A TAXI, EVEN THO IT COSTS ALMOST AS MUCH TO TAKE THIS DISGUSTING SUBWAY!

DO NOT LEAN ON DOORS

ALINE, I HOPE YOU'RE READY TO GO BACK TO YOUR BORING LIFE AFTER FASHION WEEK AND HANGING OUT WITH YOUR NEW BUDDY, VIVIENNE TAM!

R GETTING GRAYER & GRAYER... FADING... FADING...

ANOTHER CAREER SHE COULDA HAD...

HEY, THIS IS JUST THE BEGINNING! WAIT 'TIL WE LAUNCH OUR NEW LINE TOGETHER!!

IMAGINE.... MY AHTWORK ON PEOPLE ALL OVER THE WORLD!

FASHION BY ALINE OF ALINE + FOR ALINE

BIG EGO SPORTSWEAR!

RETURNING TO MY GARMENTO MERCHANT ROOTS!!

DID WE PACK ENOUGH IN HERE?? D'YA THINK YA GOT YA MONEY'S WORTH?

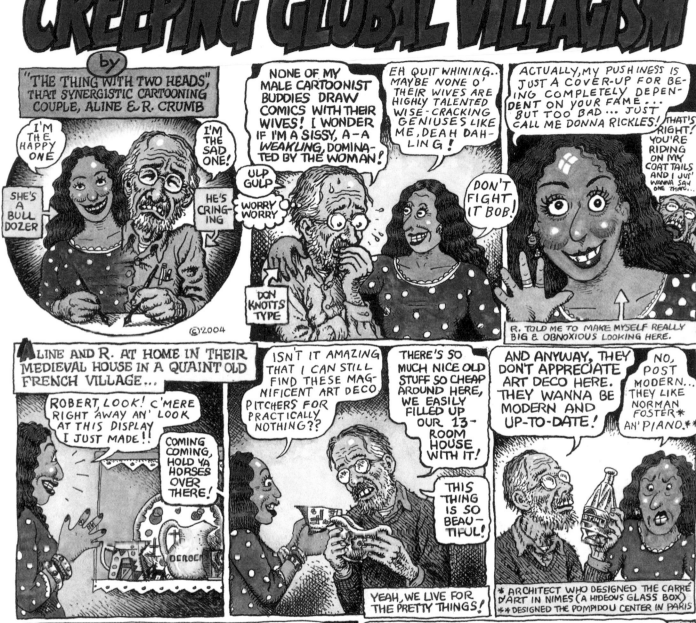
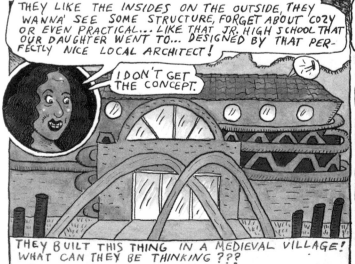
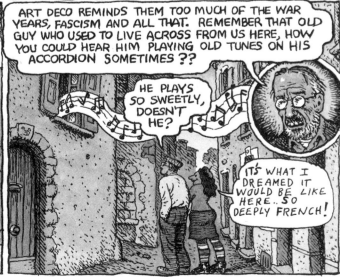

THEN WE FOUND OUT THAT THIS SWEET OLD MAN HAD BEEN THE LOCAL LEADER OF THE *VICHY MILITIA* DURING THE GERMAN OCCUPATION, A MAJOR COLLABORATOR... NONE OF THE OTHER OLD PEOPLE WOULD ASSOCIATE WITH HIM.

BENCHES BY THE CHURCH WHERE THE OLD PEOPLE HAVE ALWAYS SAT TO SUN THEMSELVES AND TALK

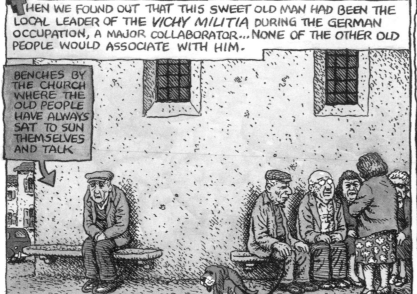

HE'S LONG GONE NOW... REMEMBER ALL THOSE OLD PEOPLE THAT USED TO LIVE ON OUR STREET WHEN WE FIRST MOVED HERE IN 1991? ALL GONE NOW! ALL OF 'EM!

YEAH, I FEEL KINDA NOSTALGIC ABOUT OUR FIRST YEARS HERE...

EVEN THOUGH I BARELY SPOKE A WORD OF FRENCH

STILL CAN'T SPEAK THE DOGGONE LANGUAGE

I ATE A LOT O' FABULOUS PATE IN THOSE DAYS.

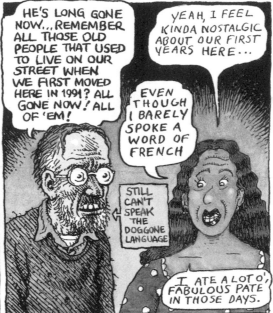

IT REMINDED ME OF BROOKLYN, OR MY GRANDMA'S CONDO IN MIAMI, AND PROBABLY THE SHTETL IN EASTERN EUROPE WHERE MY FAMILY CAME FROM.

PAS CHAUD

IL FAIT BEAU

PAS FROID

QUAND MÊME

DU GAS BOULANGERIE PATISSERIE

M. DUGAS, THE BAKER WAS ALWAYS TOO HOT HE'S LONG GONE...

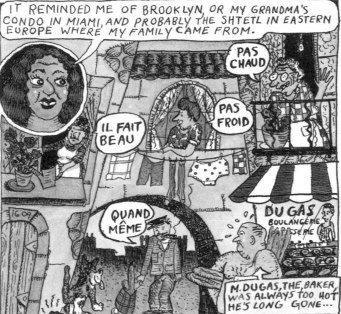

NOW OUR STREET IS FULL OF KIDS WHO DRESS LIKE SNOOP DOGGY DOG, AND THE SOUNDS OF "GANGSTA RAP" AND "TECHNO" NIGHT AND DAY!

ACTUALLY THEY'RE PRETTY HARMLESS. THEY'RE JUST PLAY-ACTING...

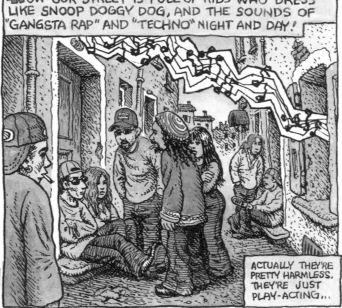

NO, THEY JUST KNOCK OVER MY @#%! GERANIUMS NOW AND THEN!

THESE KIDS TODAY HAVE NO RESPECT AT ALL! @#%! BALLBARIONS!!

I STILL WON FIRST PRIZE THIS YEAR FOR THE BEST FLOWER DISPLAY ON ANY BALCONY!

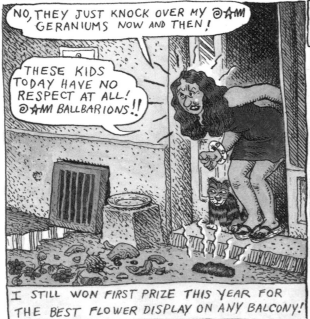

AND BACK WHEN WE FIRST CAME HERE A LOT OF THE PEOPLE DIDN'T OWN CARS! THE TOWN SQUARE WAS A BIG OPEN AREA!

NOW IT'S ONE VAST PARKING LOT, CARS AND S.U.V.S CRAMMED INTO EVERY AVAILABLE SPACE!

PARABOLES

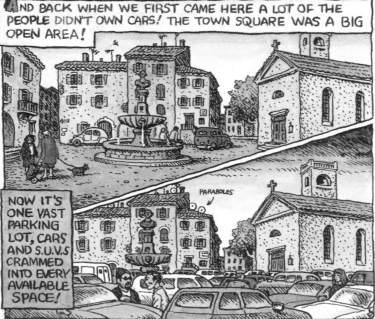

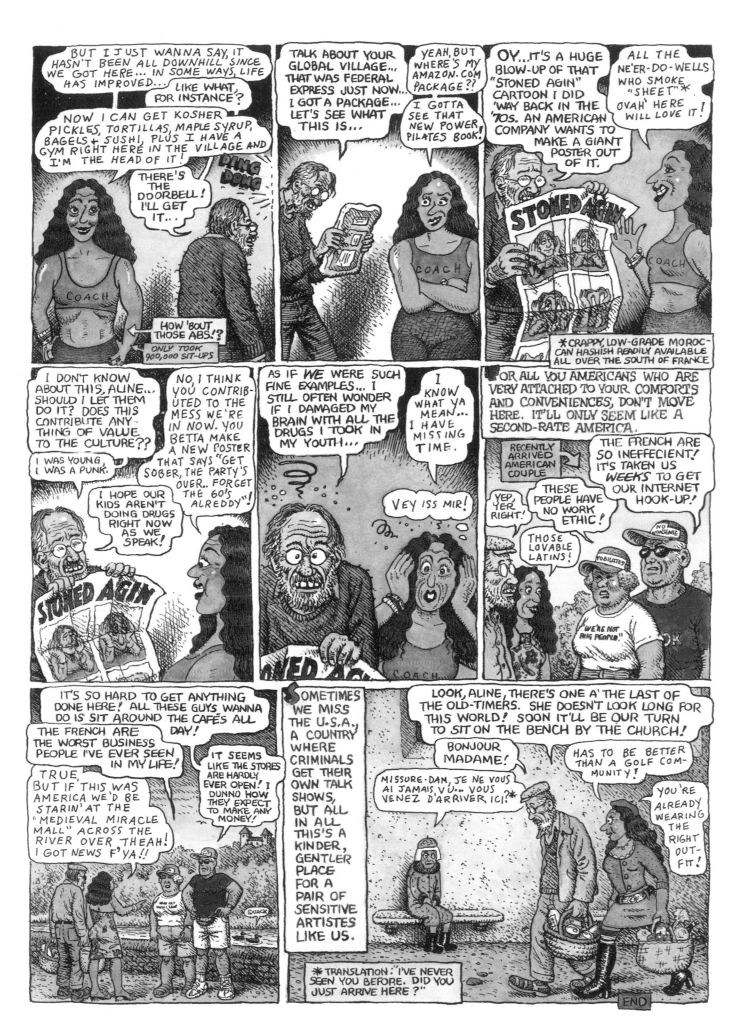

225

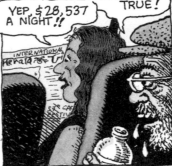
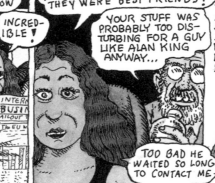
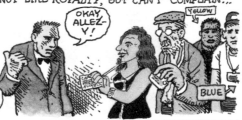
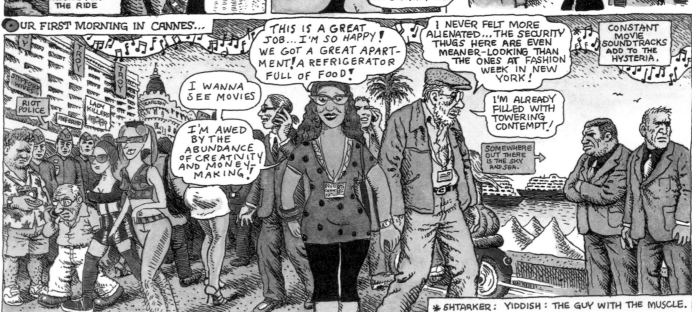

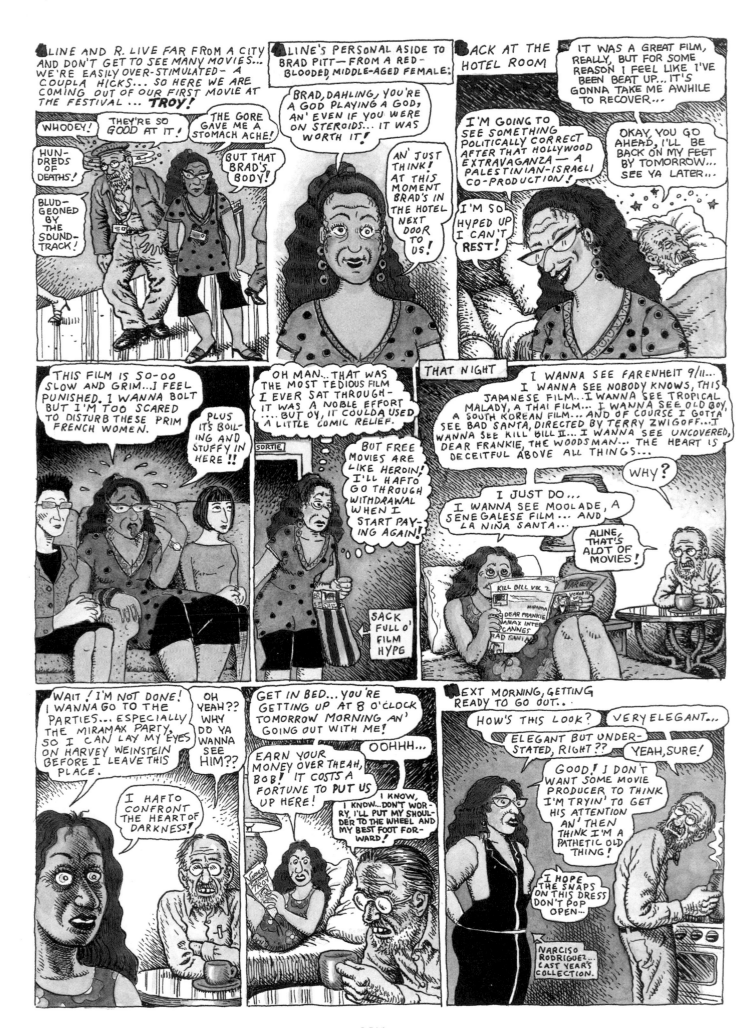

ALINE AND R. LIVE FAR FROM A CITY AND DON'T GET TO SEE MANY MOVIES... WE'RE EASILY OVER-STIMULATED — A COUPLA HICKS... SO HERE WE ARE COMING OUT OF OUR FIRST MOVIE AT THE FESTIVAL ... *TROY*!

WHOOEY!

THEY'RE SO *GOOD* AT IT!

THE GORE GAVE ME A STOMACH ACHE!

HUNDREDS OF DEATHS!

BUT THAT BRAD'S BODY!

BLUDGEONED BY THE SOUNDTRACK!

ALINE'S PERSONAL ASIDE TO BRAD PITT — FROM A RED-BLOODED, MIDDLE-AGED FEMALE:

BRAD, DAHLING, YOU'RE A GOD PLAYING A GOD, AN' EVEN IF YOU WERE ON STEROIDS... IT WAS WORTH IT!

AN' JUST THINK! AT THIS MOMENT BRAD'S IN THE HOTEL NEXT DOOR TO US!

BACK AT THE HOTEL ROOM

IT WAS A GREAT FILM, REALLY, BUT FOR SOME REASON I FEEL LIKE I'VE BEEN BEAT UP... IT'S GONNA TAKE ME AWHILE TO RECOVER...

I'M GOING TO SEE SOMETHING POLITICALLY CORRECT AFTER THAT HOLLYWOOD EXTRAVAGANZA — A PALESTINIAN-ISRAELI CO-PRODUCTION!

I'M SO HYPED UP I CAN'T REST!

OKAY, YOU GO AHEAD, I'LL BE BACK ON MY FEET BY TOMORROW... SEE YA LATER...

THIS FILM IS SO-OO SLOW AND GRIM...I FEEL PUNISHED. I WANNA BOLT BUT I'M TOO SCARED TO DISTURB THESE PRIM FRENCH WOMEN.

PLUS IT'S BOILING AND STUFFY IN HERE!!

SORTIE

OH MAN... THAT WAS THE MOST TEDIOUS FILM I EVER SAT THROUGH — IT WAS A NOBLE EFFORTBUT OY, IT COULDA USED A LITTLE COMIC RELIEF.

BUT FREE MOVIES ARE LIKE HEROIN! I'LL HAFTO GO THROUGH WITHDRAWAL WHEN I START PAYING AGAIN!

SACK FULL O' FILM HYPE

THAT NIGHT

I WANNA SEE FARENHEIT 9/11... I WANNA SEE NOBODY KNOWS, THIS JAPANESE FILM...I WANNA SEE TROPICAL MALADY, A THAI FILM... I WANNA SEE OLD BOY, A SOUTH KOREAN FILM... AND OF COURSE I GOTTA SEE BAD SANTA, DIRECTED BY TERRY ZWIGOFF...I WANNA SEE KILL BILL II... I WANNA SEE UNCOVERED, DEAR FRANKIE, THE WOODSMAN... THE HEART IS DECEITFUL ABOVE ALL THINGS...

WHY?

I JUST DO... I WANNA SEE MOOLADE, A SENEGALESE FILM ... AND LA NIÑA SANTA...

ALINE, THAT'S ALOT OF MOVIES!

KILL BILL VOL. 2

VARIETY

DEAR FRANKIE

JMAX INTER P CANNES

BAD SANTA

WAIT! I'M NOT DONE! I WANNA GO TO THE PARTIES... ESPECIALLY THE MIRAMAX PARTY, SO I CAN LAY MY EYES ON HARVEY WEINSTEIN BEFORE I LEAVE THIS PLACE.

I HAFTO CONFRONT THE HEART OF DARKNESS!

OH YEAH?? WHY DO YA WANNA SEE HIM??

GET IN BED... YOU'RE GETTING UP AT 8 O'CLOCK TOMORROW MORNING AN' GOING OUT WITH ME!

EARN YOUR MONEY OVER THEAH, BOB! IT COSTS A FORTUNE TO PUT US UP HERE!

OOHHH...

I KNOW...DON'T WORRY, I'LL PUT MY SHOULDER TO THE WHEEL AND MY BEST FOOT FORWARD!

NEXT MORNING, GETTING READY TO GO OUT...

HOW'S THIS LOOK?

VERY ELEGANT...

ELEGANT BUT UNDER-STATED, RIGHT??

YEAH, SURE!

GOOD! I DON'T WANT SOME MOVIE PRODUCER TO THINK I'M TRYIN' TO GET HIS ATTENTION AN' THEN THINK I'M A PATHETIC OLD THING!

I HOPE THE SNAPS ON THIS DRESS DON'T POP OPEN...

NARCISO RODRIGUEZ... LAST YEAR'S COLLECTION.

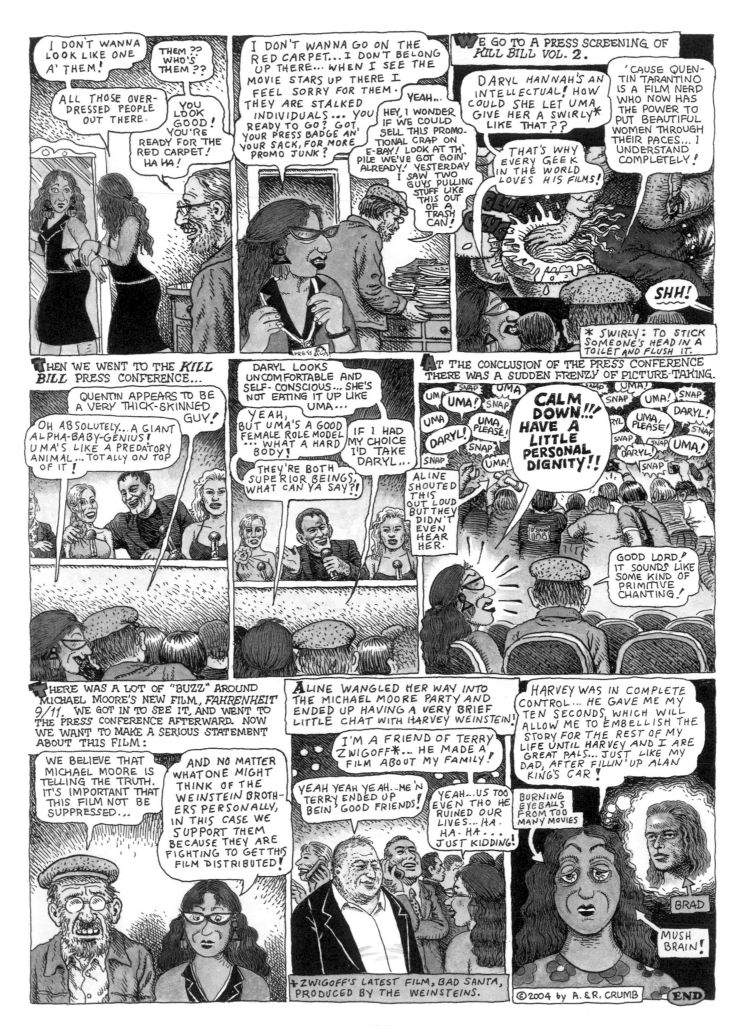

Aline & Bob on HUMAN DEPRAVITY or ME and GEORGE

Sitting at an outdoor café in the beautiful South of France... Yes, it's lovely, but no matter where you are, you can't run away from the dark side of the SELF!

I'M TRYIN' NOT TO PANIC ... TRYIN' TO STAY CALM ... TRYIN' TO AVOID THE NEXT ADDICTION!

THIS IS MOSTLY ABOUT HER...

HE'S A SAINT!

NOTHING'S EVER ACCOMPLISHED IN A STATE OF PANIC, ALINE, BUT, HEY, I'M PROUD OF YA FOR YOUR DECISION NEVER TO TOUCH ALCOHOL AGAIN!

EVERYTHING I EVER ACCOMPLISHED IN MY LIFE WAS DONE IN A STATE OF PANIC!

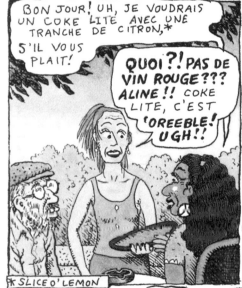

BON JOUR! UH, JE VOUDRAIS UN COKE LITE AVEC UNE TRANCHE DE CITRON,* S'IL VOUS PLAIT!

QUOI?! PAS DE VIN ROUGE??? ALINE!! COKE LITE, C'EST 'OREEBLE! UGH!!

* SLICE O' LEMON

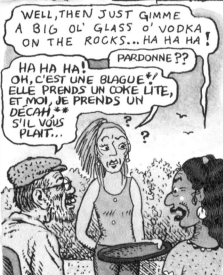

WELL, THEN JUST GIMME A BIG OL' GLASS O' VODKA ON THE ROCKS... HA HA HA!

PARDONNE??

HA HA HA! OH, C'EST UNE BLAGUE*! ELLE PRENDS UN COKE LITE, ET MOI, JE PRENDS UN DECAH,** S'IL VOUS PLAIT...

* IT'S A JOKE ** DECAF

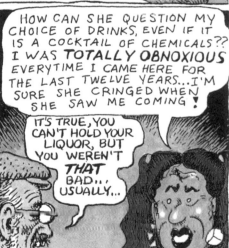

HOW CAN SHE QUESTION MY CHOICE OF DRINKS, EVEN IF IT IS A COCKTAIL OF CHEMICALS?? I WAS TOTALLY OBNOXIOUS EVERYTIME I CAME HERE FOR THE LAST TWELVE YEARS... I'M SURE SHE CRINGED WHEN SHE SAW ME COMING!

IT'S TRUE, YOU CAN'T HOLD YOUR LIQUOR, BUT YOU WEREN'T THAT BAD... USUALLY...

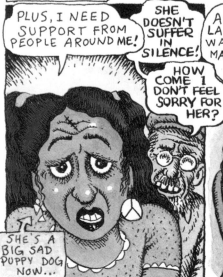

PLUS, I NEED SUPPORT FROM PEOPLE AROUND ME!

SHE DOESN'T SUFFER IN SILENCE!

HOW COME 1 DON'T FEEL SORRY FOR HER?

SHE'S A BIG SAD PUPPY DOG NOW...

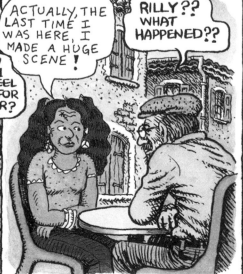

ACTUALLY, THE LAST TIME I WAS HERE, I MADE A HUGE SCENE!

RILLY?? WHAT HAPPENED??

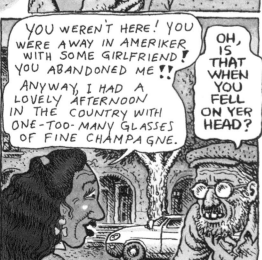

YOU WEREN'T HERE! YOU WERE AWAY IN AMERIKER WITH SOME GIRLFRIEND! YOU ABANDONED ME!! ANYWAY, I HAD A LOVELY AFTERNOON IN THE COUNTRY WITH ONE-TOO-MANY GLASSES OF FINE CHAMPAGNE.

OH, IS THAT WHEN YOU FELL ON YER HEAD?

UP TO NO GOOD, OBVIOUSLY

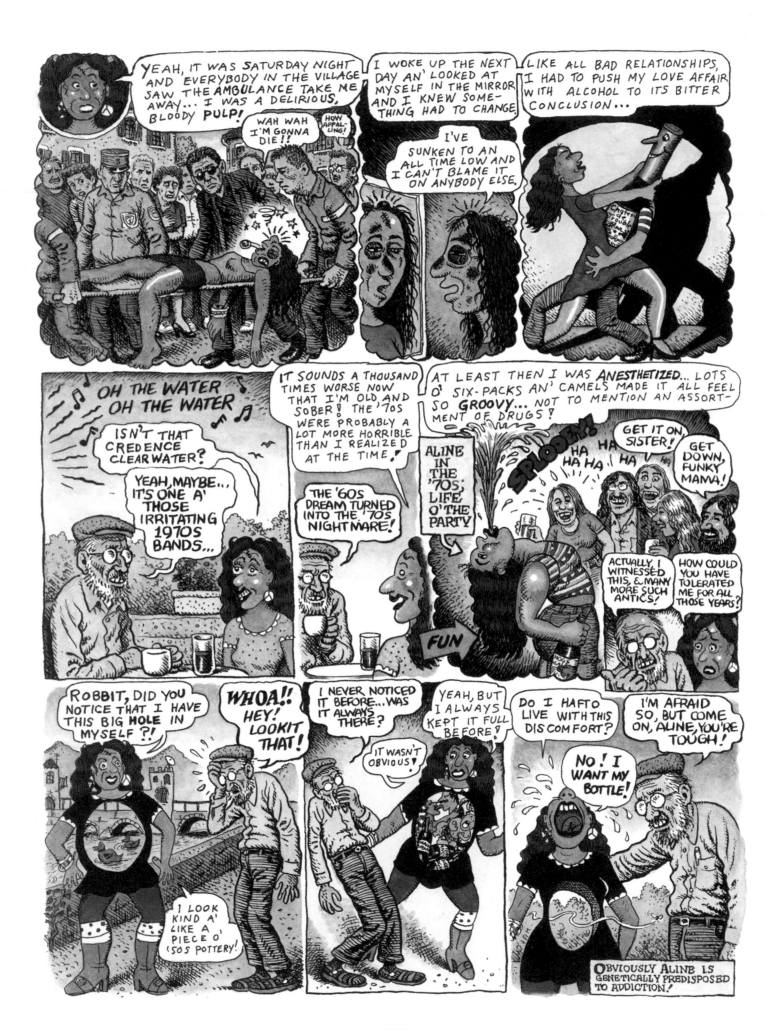

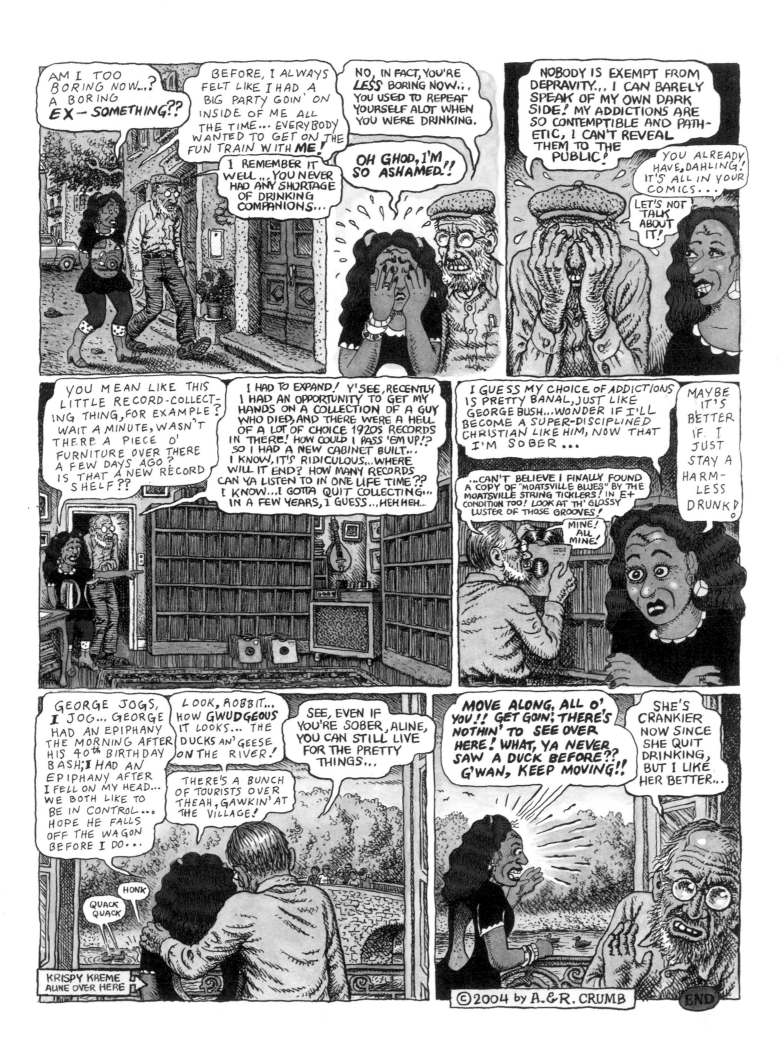

"SAVING FACE"

THE "ME" GENERATION CONFRONTS OLD AGE. AND IT'S NOT A PRETTY SIGHT.

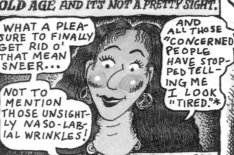

WHAT A PLEASURE TO FINALLY GET RID O' THAT MEAN SNEER...

NOT TO MENTION THOSE UNSIGHTLY NASO-LABIAL WRINKLES!

AND ALL THOSE "CONCERNED" PEOPLE HAVE STOPPED TELLING ME I LOOK "TIRED."*

*TIRED = OLD

BY ALINE & R. CRUMB ©2005

THAT CRAZY WIFE OF MINE WENT TO LONDON AND HAD SOME KIND OF "COSMETIC INTERVENTION" DONE ON HER FACE... SHE WARNED ME OVER THE TELEPHONE THAT IT STILL LOOKS A LITTLE STRANGE BUT THAT IT'LL LOOK "FABULOUS" WHEN THE SWELLING GOES DOWN...

SHE'S COMING HOME TODAY...

IN FACT, HERE SHE IS NOW... SHE SAID DON'T ACT ALL SHOCKED WHEN I FIRST SEE HER, 'CAUSE SHE'S FEELING VERY "VULNERABLE" RIGHT NOW...I'LL TRY TO BE NONCHALANT LIKE NOTHING'S ANY DIFFERENT...

HI BWOB!

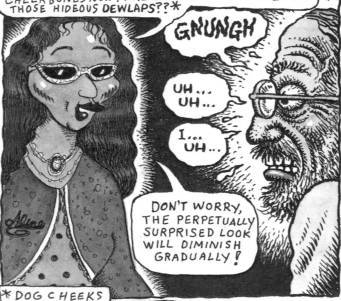

SO...WHAD D'YA THINK? DON'T I HAVE GREAT CHEEKBONES NOW?! REMEMBER BEFORE... I HAD THOSE HIDEOUS DEWLAPS??*

GNUNGH

UH... UH...

I... UH...

DON'T WORRY, THE PERPETUALLY SURPRISED LOOK WILL DIMINISH GRADUALLY!

*DOG CHEEKS

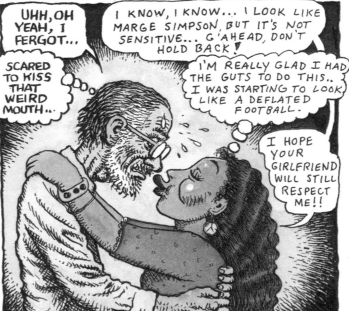

I MET AN ACTRESS IN LONDON WHO HAD THIS DONE AN' SHE WAS GUAWGEOUS! IT JUST TAKES AWHILE FOR IT TO, YA KNOW, NORMALIZE.

IZZAT RIGHT!?

I'M AFRAID TO ASK HOW MUCH IT COST!

WE COULDA BOUGHT A MORE FUEL EFFICIENT NEW CAR, BUT MY SELF-ESTEEM IS MORE IMPORTANT!

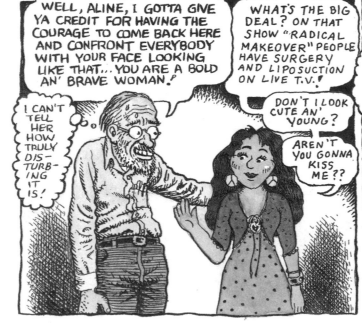

WELL, ALINE, I GOTTA GIVE YA CREDIT FOR HAVING THE COURAGE TO COME BACK HERE AND CONFRONT EVERYBODY WITH YOUR FACE LOOKING LIKE THAT... YOU ARE A BOLD AN' BRAVE WOMAN.

I CAN'T TELL HER HOW TRULY DISTURBING IT IS!

WHAT'S THE BIG DEAL? ON THAT SHOW "RADICAL MAKEOVER" PEOPLE HAVE SURGERY AND LIPOSUCTION ON LIVE T.V.!

DON'T I LOOK CUTE AN' YOUNG?

AREN'T YOU GONNA KISS ME??

UHH, OH YEAH, I FERGOT...

SCARED TO KISS THAT WEIRD MOUTH...

I KNOW, I KNOW... I LOOK LIKE MARGE SIMPSON, BUT IT'S NOT SENSITIVE... G'AHEAD, DON'T HOLD BACK!

I'M REALLY GLAD I HAD THE GUTS TO DO THIS.. I WAS STARTING TO LOOK LIKE A DEFLATED FOOTBALL.

I HOPE YOUR GIRLFRIEND WILL STILL RESPECT ME!!

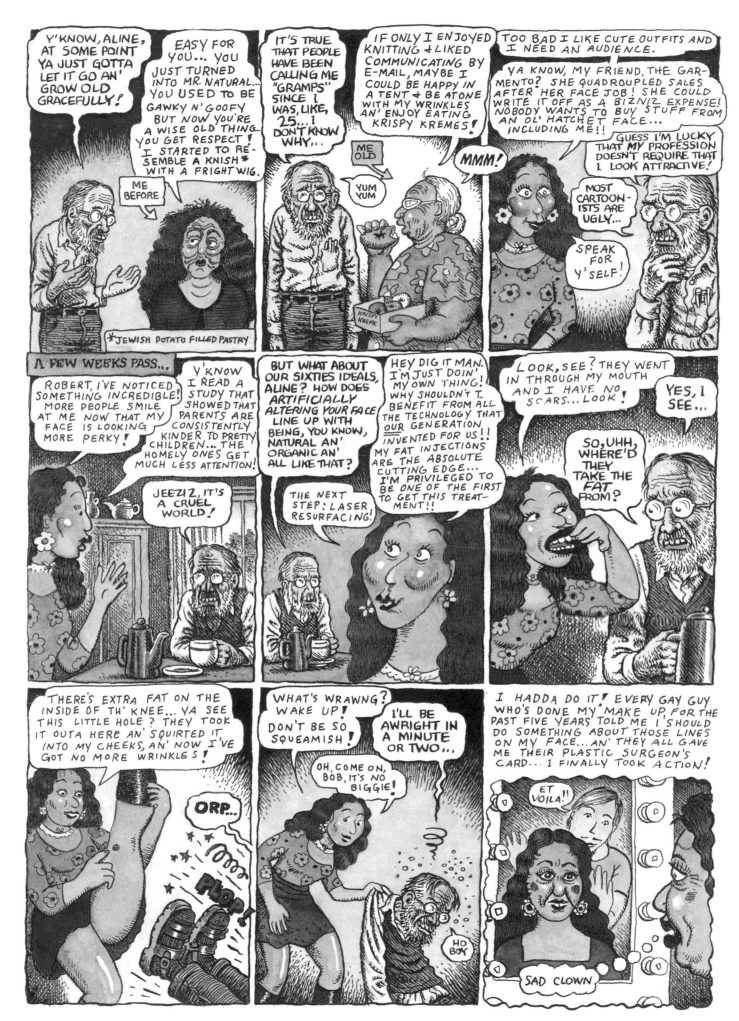

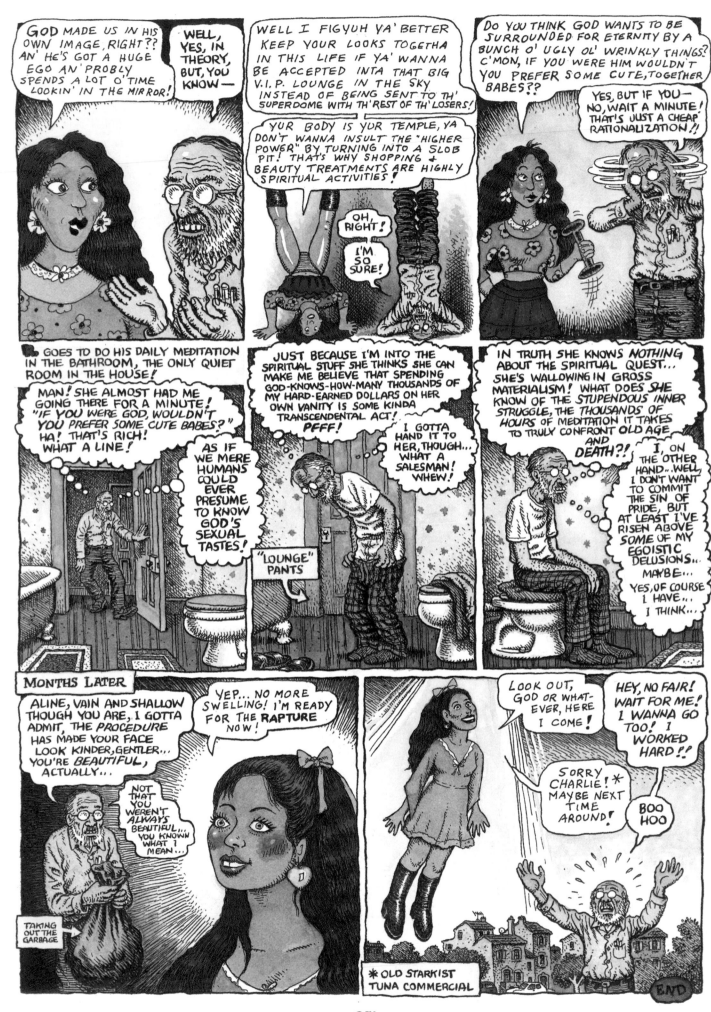

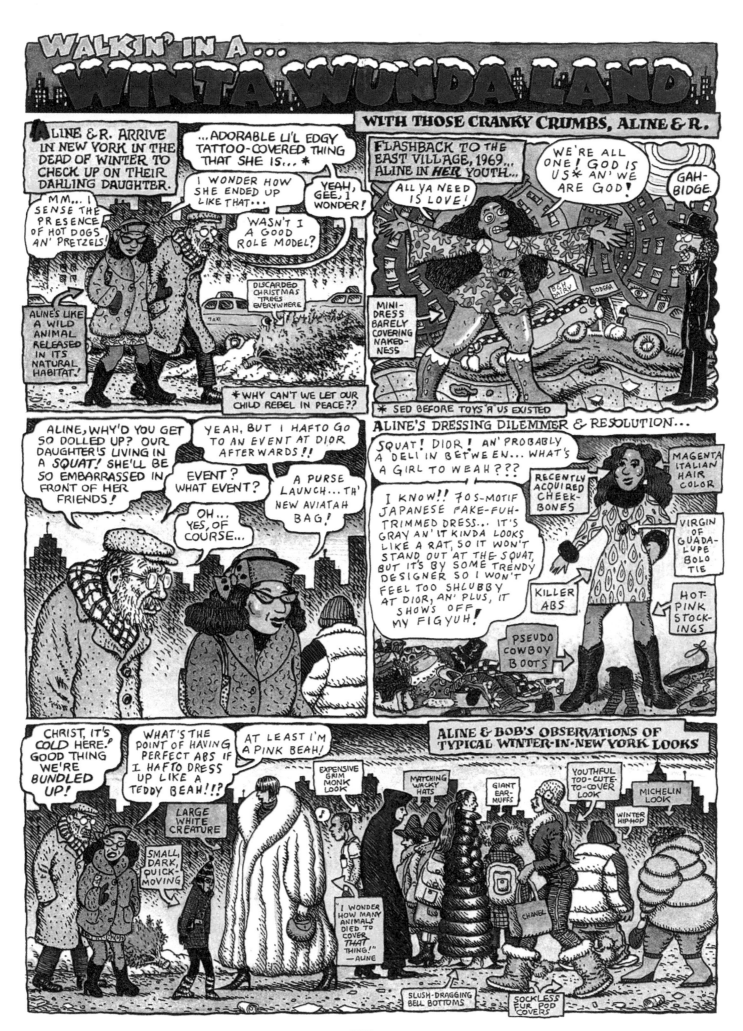

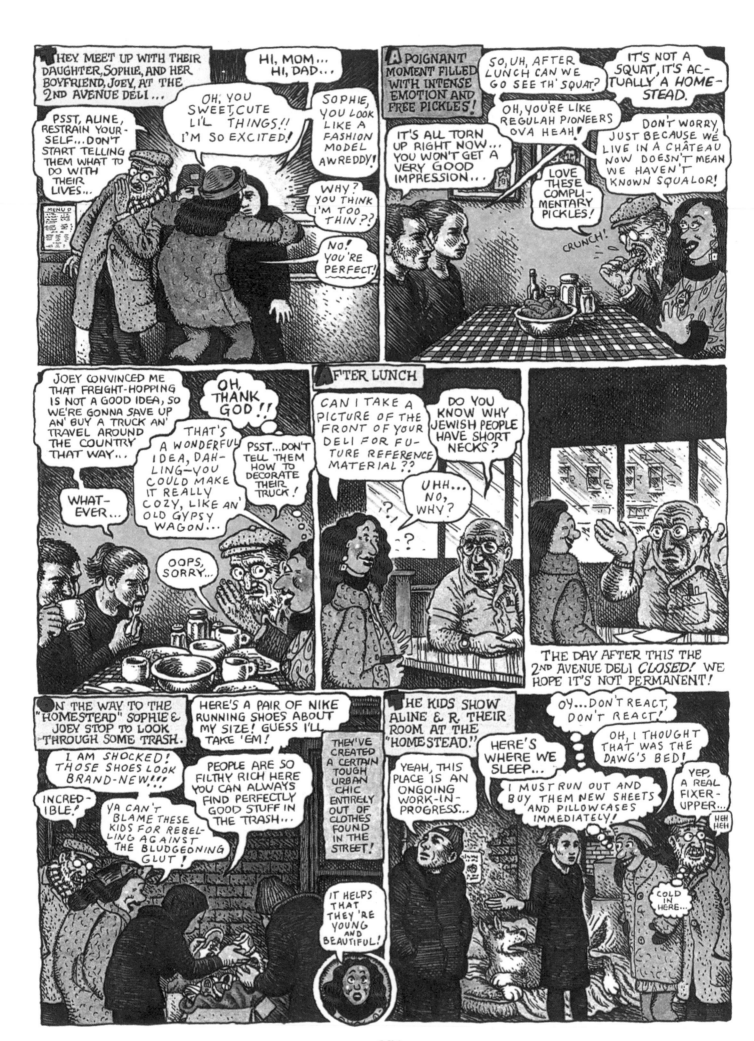

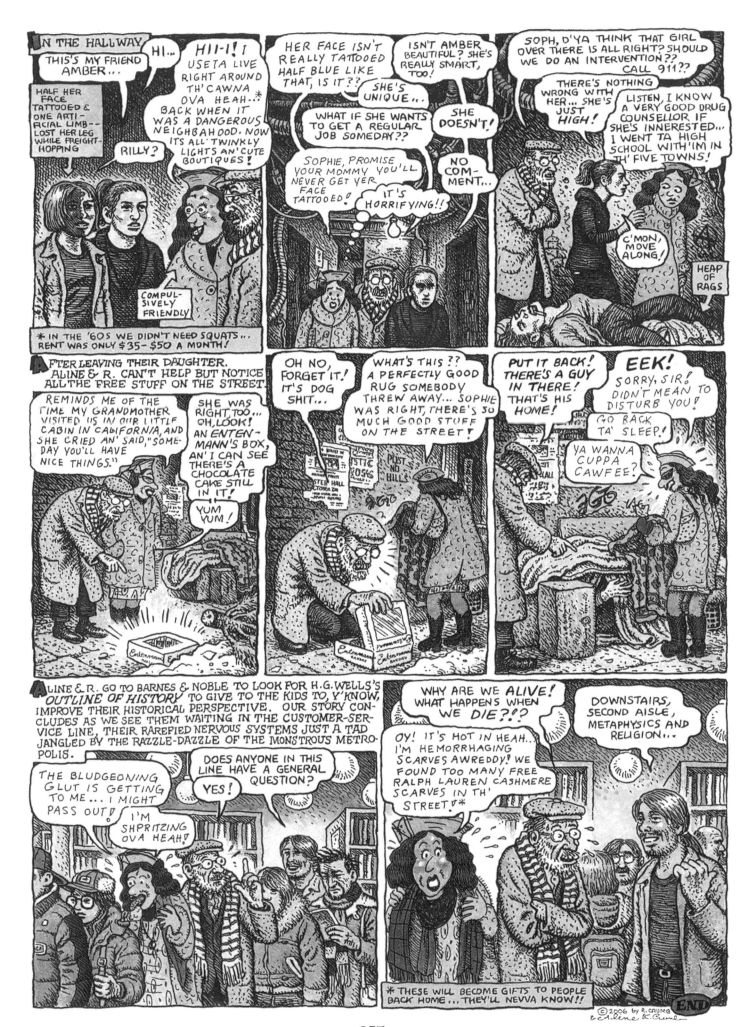

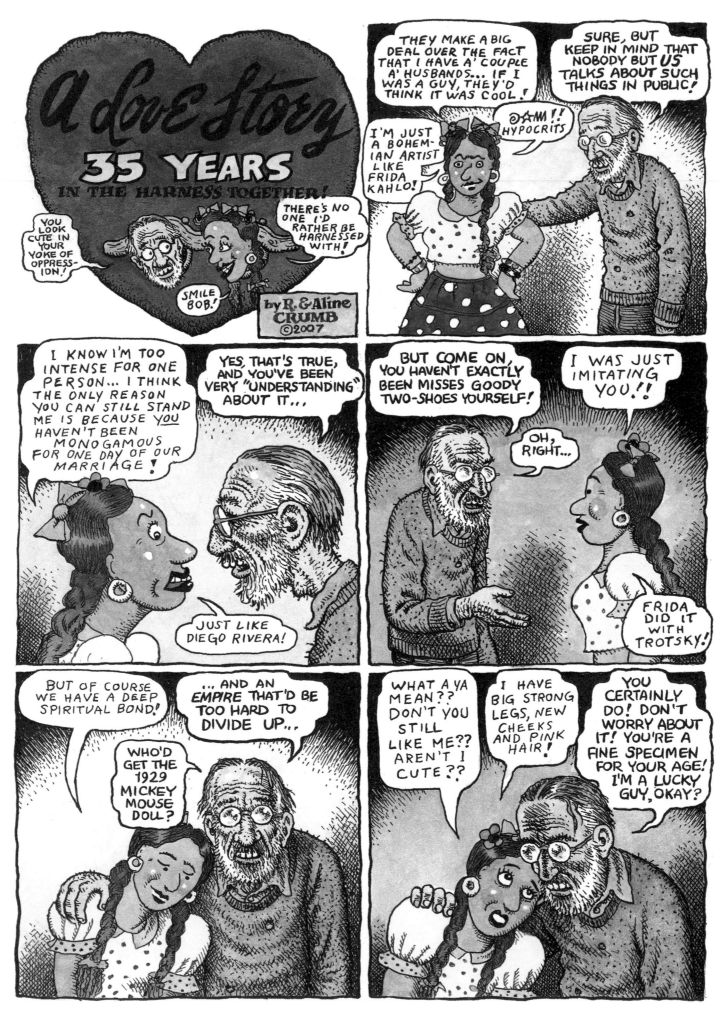

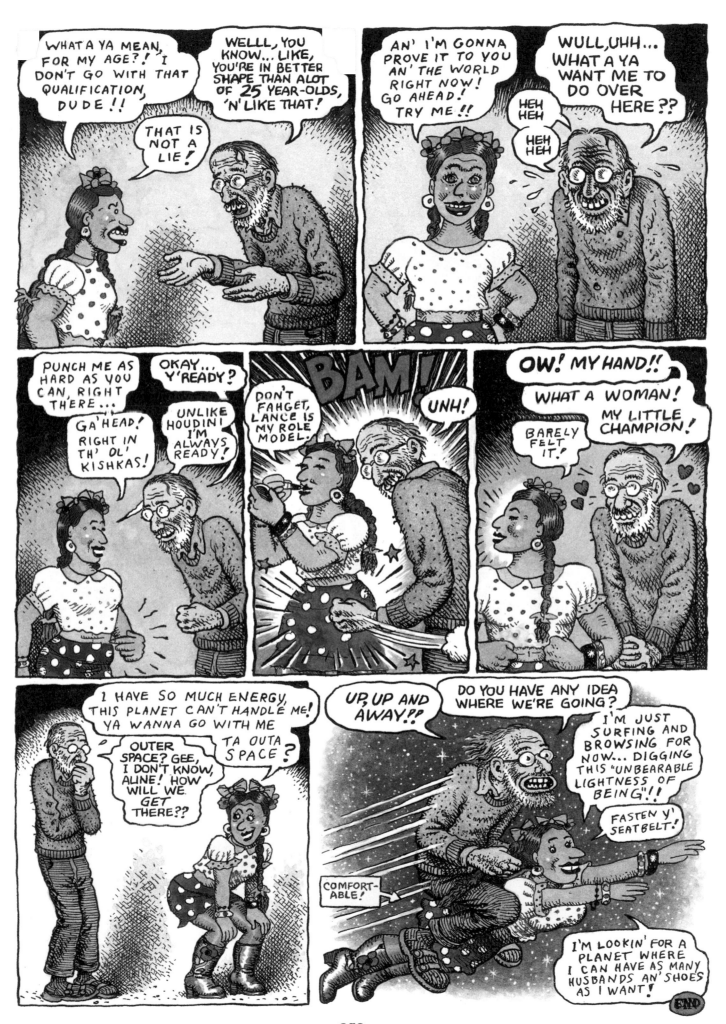

239

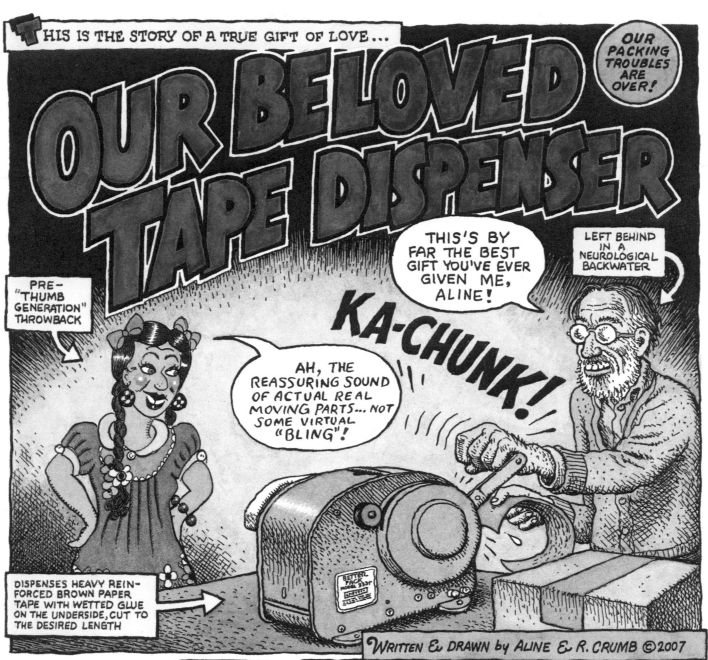
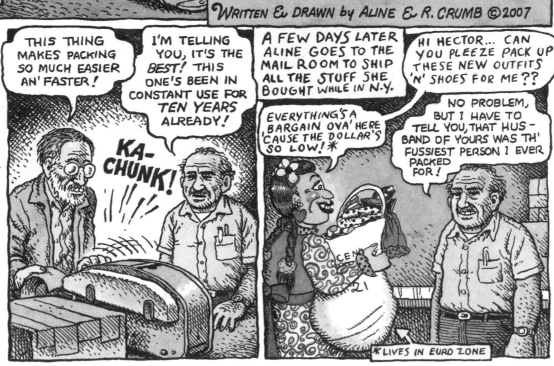

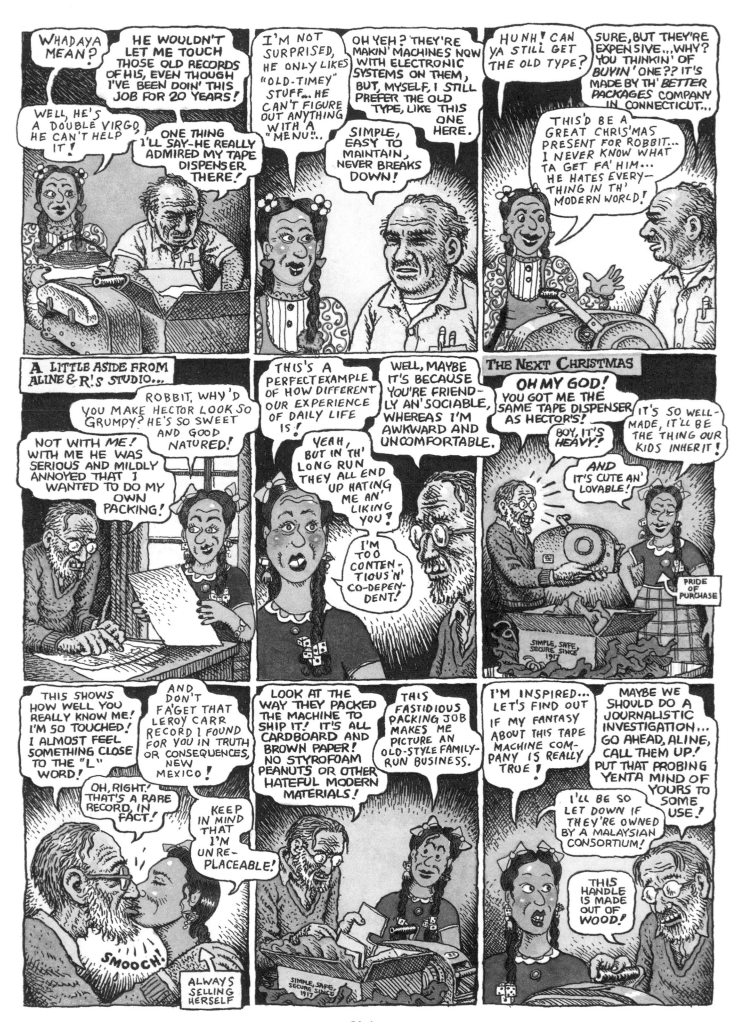

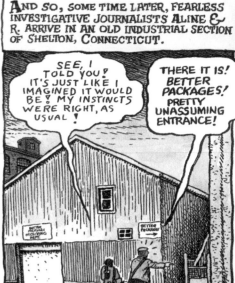
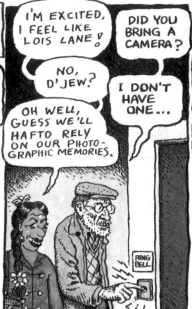
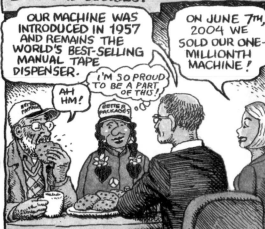
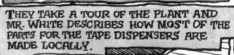

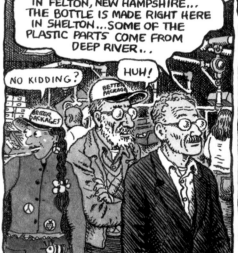
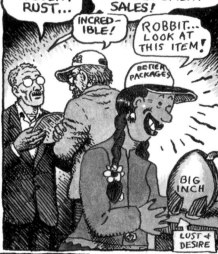
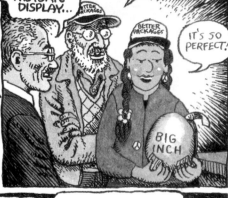
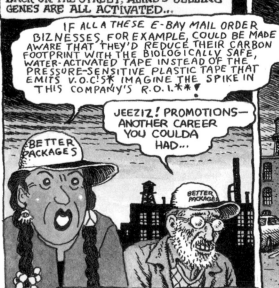
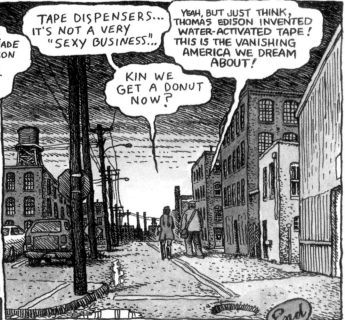

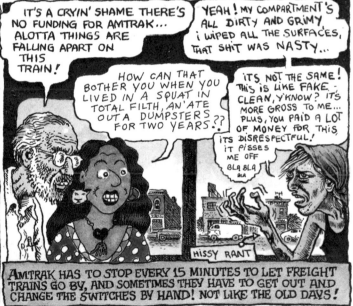
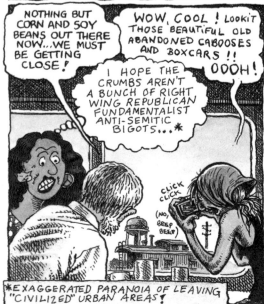
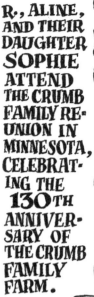
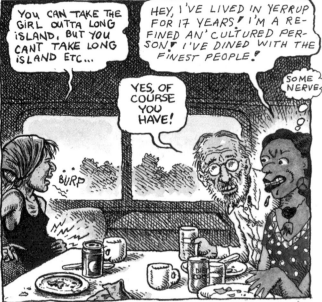
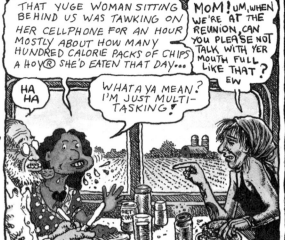
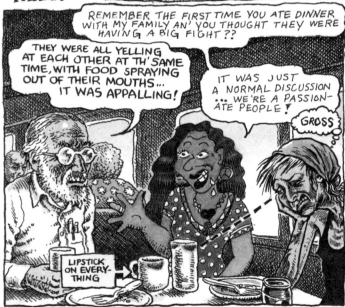
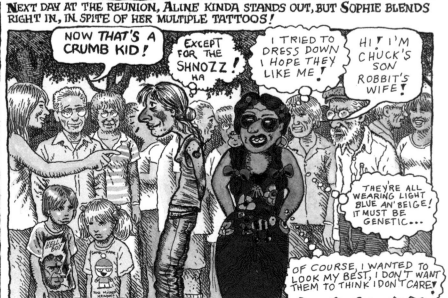

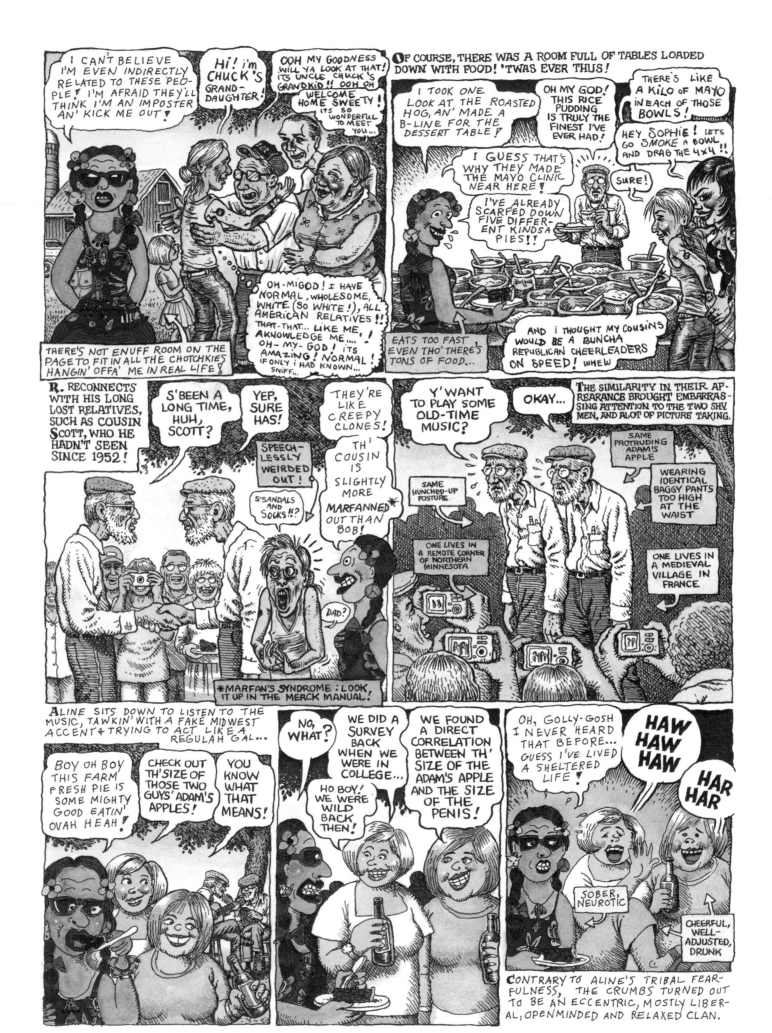

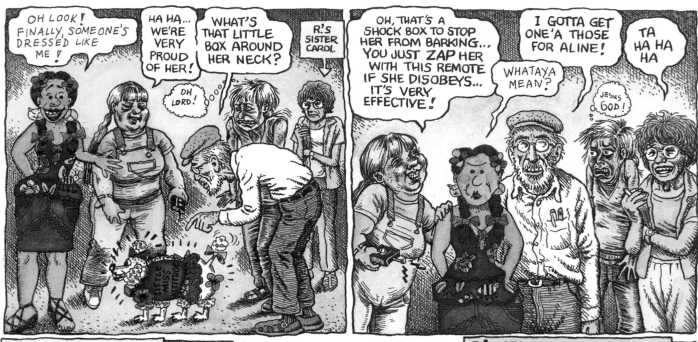

OH LOOK! FINALLY, SOMEONE'S DRESSED LIKE ME!

HA HA... WE'RE VERY PROUD OF HER!

WHAT'S THAT LITTLE BOX AROUND HER NECK?

OH LORD!

R.'S SISTER CAROL

OH, THAT'S A SHOCK BOX TO STOP HER FROM BARKING... YOU JUST ZAP HER WITH THIS REMOTE IF SHE DISOBEYS... IT'S VERY EFFECTIVE!

WHATAYA MEAN?

I GOTTA GET ONE 'A THOSE FOR ALINE!

TA HA HA HA

JESUS GOD!

R. TALKS TO UNCLE MAC ABOUT FARMING...

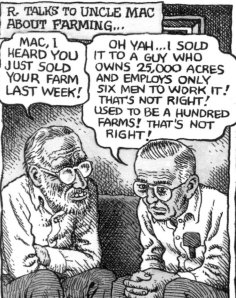

MAC, I HEARD YOU JUST SOLD YOUR FARM LAST WEEK!

OH YAH... I SOLD IT TO A GUY WHO OWNS 25,000 ACRES AND EMPLOYS ONLY SIX MEN TO WORK IT! THAT'S NOT RIGHT! USED TO BE A HUNDRED FARMS! THAT'S NOT RIGHT!

DESPITE ALL THE INDULGENT EATING THE CRUMBS ARE A WIRY LOT, BUT THEY TEND TO MATE WITH ROBUST, DEMONSTRATIVE TYPES... THERE WAS A LOT OF HUGGING GOING ON...

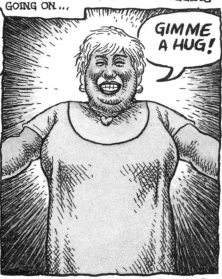

GIMME A HUG!

R.'S UNTOUCHY-FEELY SISTER CAROL COULDN'T HANDLE IT...

IF ONE MORE PERSON TRIES TO HUG ME, I'M GONNA SLUG 'EM, I SWEAR TO GOD!

OH COME ON, CAROL! BETTER TO BE OVER-HUGGED THAN UNDER HUGGED!

LOVE THEM... WANNA BE LIKE THEM!

COUSIN DIANE, OWNS A BAR IN WASECA

SOPHIE IS FASCINATED BY THE OLD PHOTOS OF EARLY CRUMB FAMILY SETTLERS...

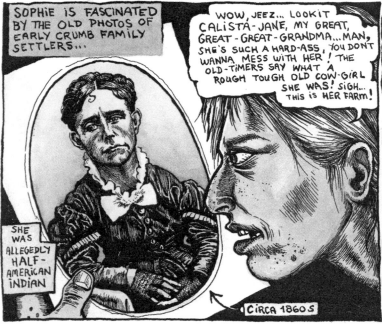

WOW, JEEZ... LOOKIT CALISTA-JANE, MY GREAT, GREAT-GREAT-GRANDMA... MAN, SHE'S SUCH A HARD-ASS, YOU DON'T WANNA MESS WITH HER! THE OLD-TIMERS SAY WHAT A ROUGH TOUGH OLD COW-GIRL SHE WAS! SIGH... THIS IS HER FARM!

SHE WAS ALLEGEDLY HALF-AMERICAN INDIAN

CIRCA 1860S

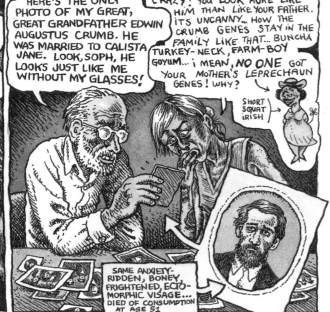

HERE'S THE ONLY PHOTO OF MY GREAT, GREAT GRANDFATHER EDWIN AUGUSTUS CRUMB. HE WAS MARRIED TO CALISTA JANE. LOOK, SOPH, HE LOOKS JUST LIKE ME WITHOUT MY GLASSES!

CRAZY! YOU LOOK MORE LIKE HIM THAN LIKE YOUR FATHER. ITS UNCANNY... HOW THE CRUMB GENES STAY IN THE FAMILY LIKE THAT... BUNCHA TURKEY-NECK, FARM-BOY GOYUM... I MEAN, NO ONE GOT YOUR MOTHER'S LEPRECHAUN GENES! WHY?

SHORT SQUAT IRISH

SAME ANXIETY-RIDDEN, BONEY, FRIGHTENED, ECTO-MORPHIC VISAGE... DIED OF CONSUMPTION AT AGE 51

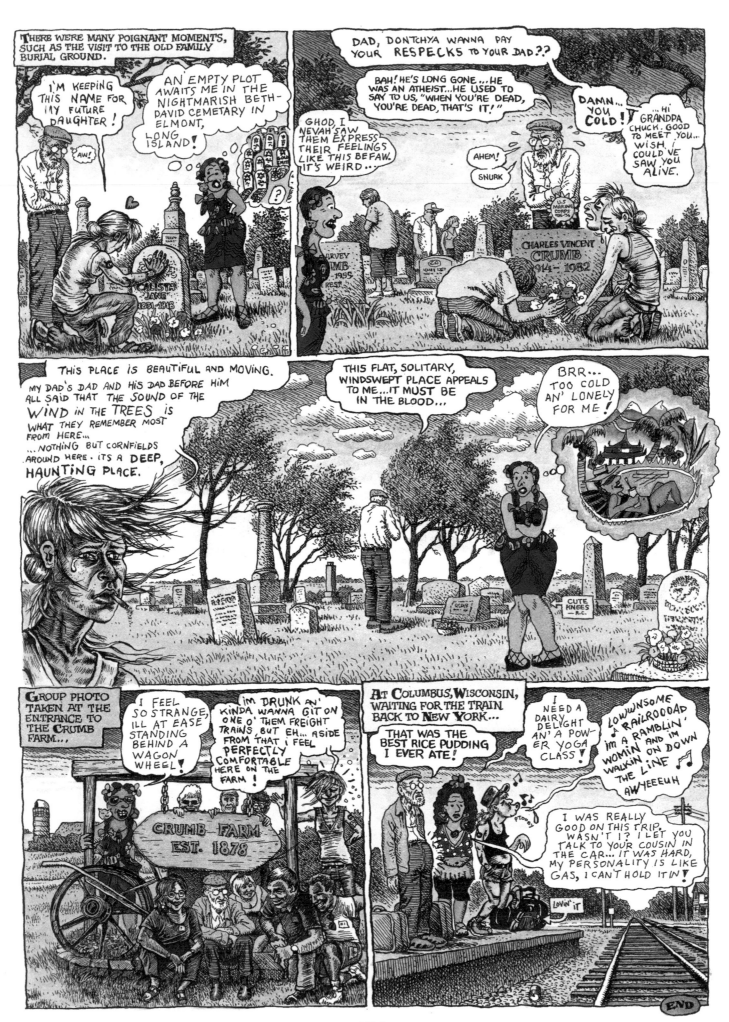

Aline & Bob in HIGH ROAD TO THE SHMUCK SEAT

featuring

MORE THAN YOU WANNA KNOW ABOUT SENIOR SEX

©2010

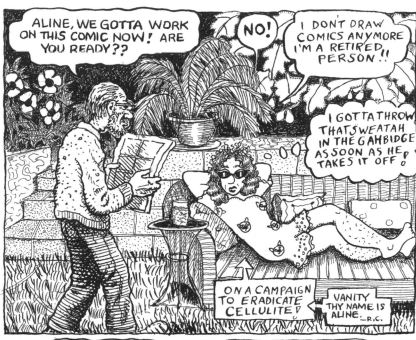

ALINE, WE GOTTA WORK ON THIS COMIC NOW! ARE YOU READY??

NO!

I DON'T DRAW COMICS ANYMORE I'M A RETIRED PERSON!!

I GOTTA THROW THAT SWEATAH IN THE GAHBIDGE AS SOON AS HE TAKES IT OFF.

ON A CAMPAIGN TO ERADICATE CELLULITE!

VANITY THY NAME IS ALINE —R.C.

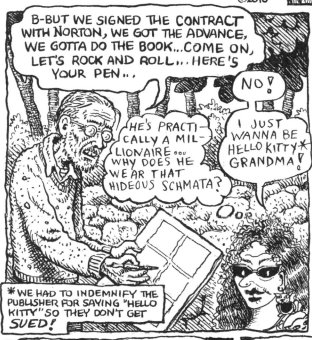

B-BUT WE SIGNED THE CONTRACT WITH NORTON, WE GOT THE ADVANCE, WE GOTTA DO THE BOOK...COME ON, LET'S ROCK AND ROLL...HERE'S YOUR PEN...

NO!

HE'S PRACTICALLY A MILLIONAIRE... WHY DOES HE WEAR THAT HIDEOUS SCHMATA?

I JUST WANNA BE HELLO KITTY* GRANDMA!

*WE HAD TO INDEMNIFY THE PUBLISHER FOR SAYING "HELLO KITTY" SO THEY DON'T GET SUED!

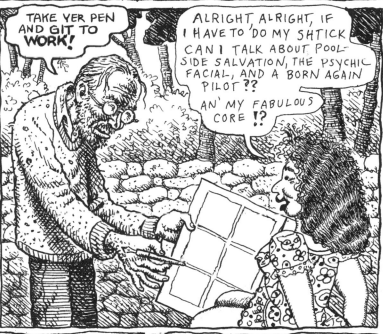

TAKE YER PEN AND GIT TO WORK!

ALRIGHT, ALRIGHT, IF I HAVE TO 'DO MY SHTICK CAN I TALK ABOUT POOL-SIDE SALVATION, THE PSYCHIC FACIAL, AND A BORN AGAIN PILOT??

AN' MY FABULOUS CORE!?

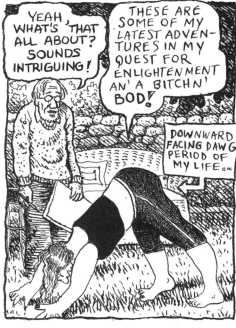

YEAH WHAT'S 'THAT ALL ABOUT? SOUNDS INTRIGUING!

THESE ARE SOME OF MY LATEST ADVENTURES IN MY QUEST FOR ENLIGHTENMENT AN' A BITCHN' BOD!

DOWNWARD FACING DAWG PERIOD OF MY LIFE...

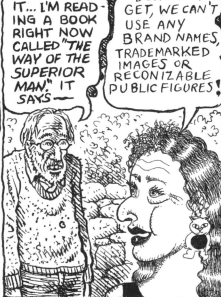

I CAN DIG IT... I'M READING A BOOK RIGHT NOW CALLED "THE WAY OF THE SUPERIOR MAN." IT SAYS—

DON'T FORGET, WE CAN'T USE ANY BRAND NAMES, TRADEMARKED IMAGES OR RECONIZABLE PUBLIC FIGURES!

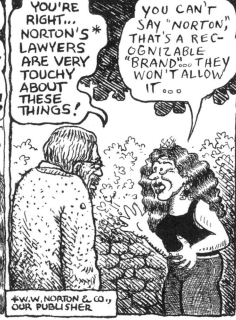

YOU'RE RIGHT... NORTON'S* LAWYERS ARE VERY TOUCHY ABOUT THESE THINGS!

YOU CAN'T SAY "NORTON," THAT'S A RECOGNIZABLE "BRAND"... THEY WON'T ALLOW IT...

*W.W. NORTON & CO., OUR PUBLISHER

247

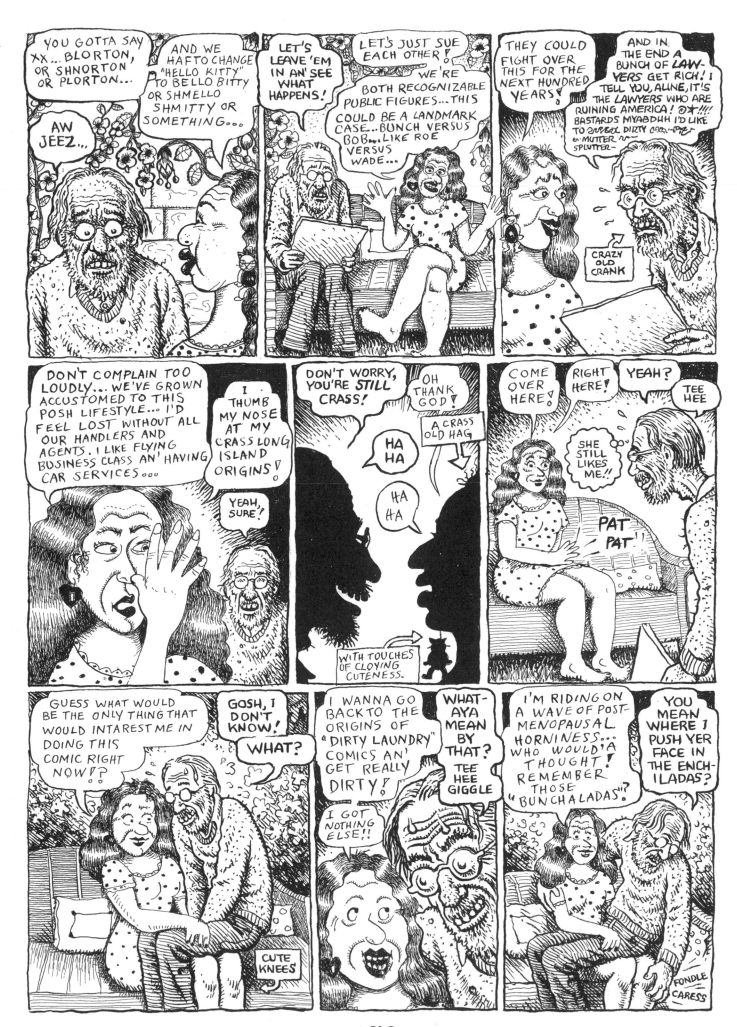

248

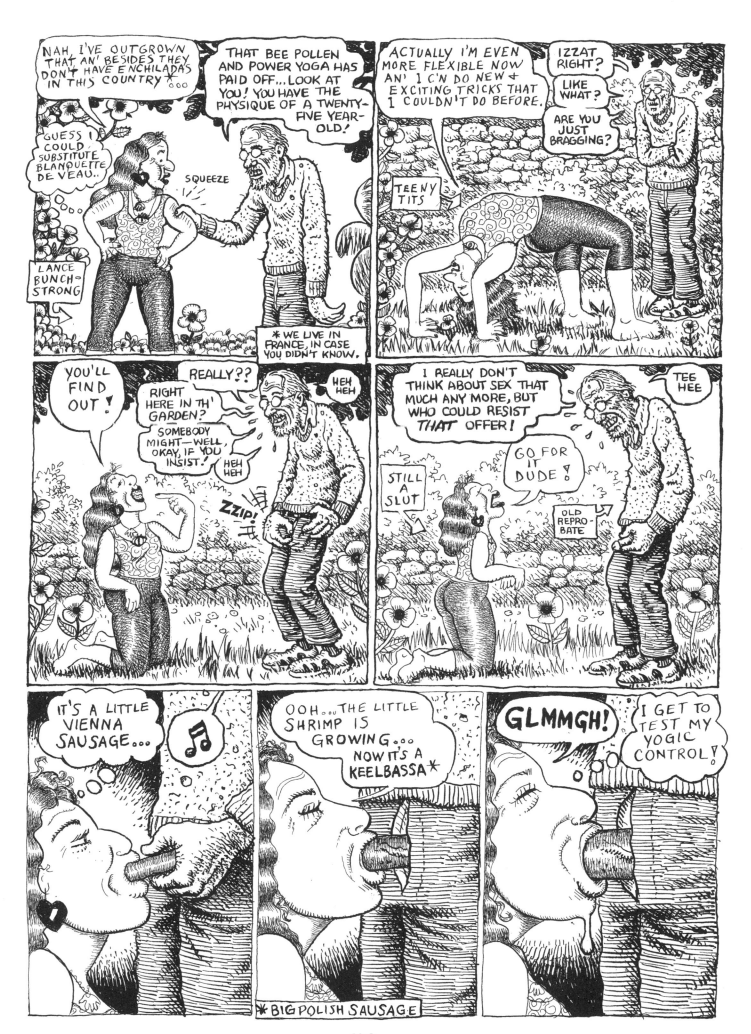

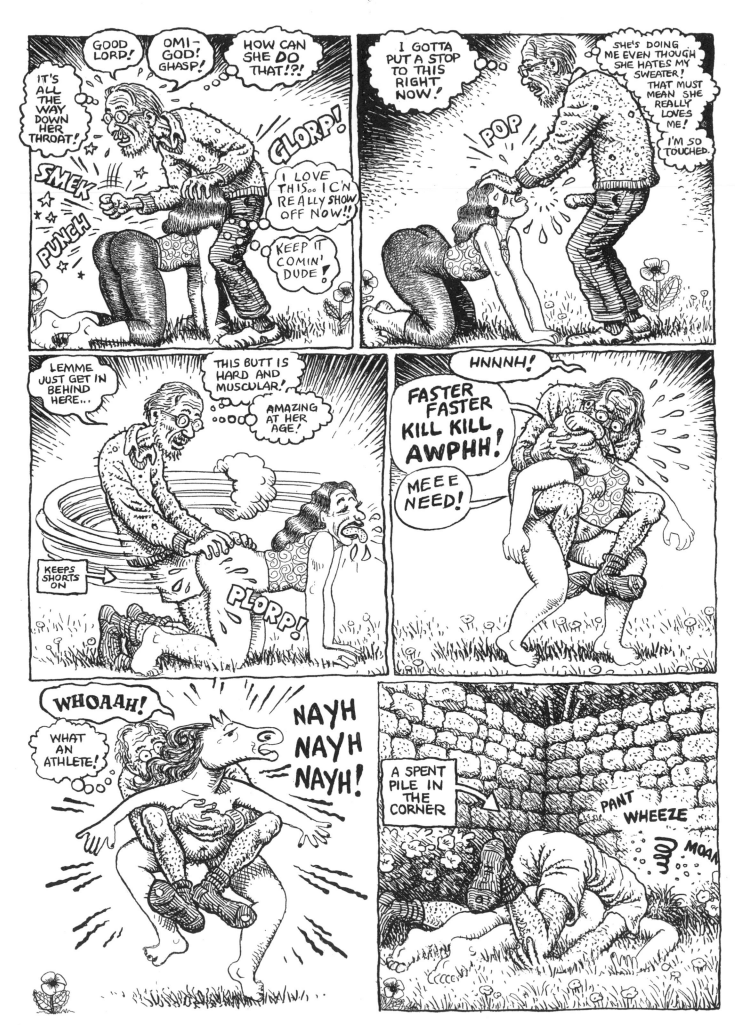

250

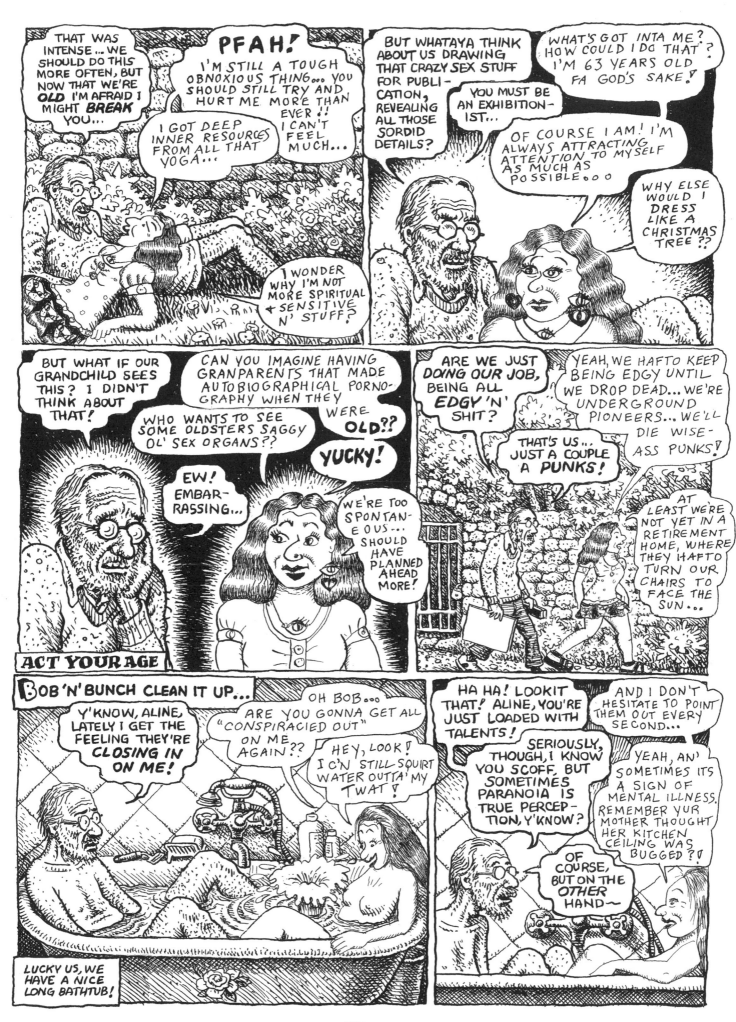

251

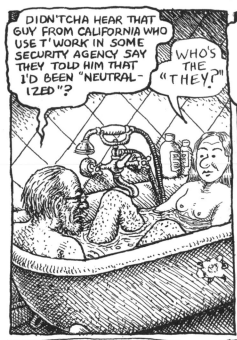

DIDN'TCHA HEAR THAT GUY FROM CALIFORNIA WHO USE T'WORK IN SOME SECURITY AGENCY SAY THEY TOLD HIM THAT I'D BEEN "NEUTRALIZED"?

WHO'S THE "THEY?"

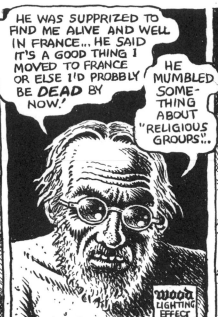

HE WAS SUPPRIZED TO FIND ME ALIVE AND WELL IN FRANCE... HE SAID IT'S A GOOD THING I MOVED TO FRANCE OR ELSE I'D PROBBLY BE *DEAD* BY NOW!

HE MUMBLED SOMETHING ABOUT "RELIGIOUS GROUPS"...

wood LIGHTING EFFECT

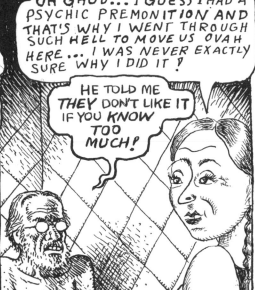

OH GHOD... I GUESS I HAD A PSYCHIC PREMONITION AND THAT'S WHY I WENT THROUGH SUCH HELL TO MOVE US OVAH HERE ... I WAS NEVER EXACTLY SURE WHY I DID IT!

HE TOLD ME *THEY* DON'T LIKE IT IF YOU *KNOW* TOO MUCH!

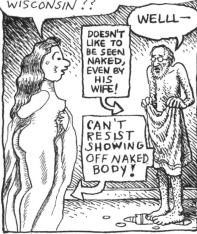

WELL, WHAT DO *YOU* KNOW THAT'S SUCH A BIG DEAL? STUFF YOU READ IN SOME BOOK BY JESSE VENTURA THAT YOUR PAL PETE GOT FROM HIS 90 YR. OLD MOM IN GREEN BAY WISCONSIN??

WELL—

DOESN'T LIKE TO BE SEEN NAKED, EVEN BY HIS WIFE!

CAN'T RESIST SHOWING OFF NAKED BODY!

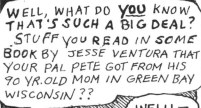

NEVERMIND... ALL I WANT YOU TO KNOW IS, IF I DIE SUDDENLY YOU CAN PRETTY WELL FIGURE OUT THE REASON WHY!

WHY? CAUSE YOU WORRY EXCESSIVELY, EAT RICH FOOD AN' NEVER EXERCISE??

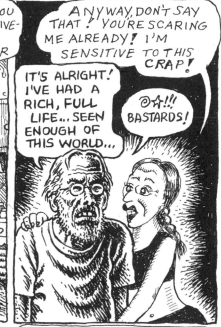

ANYWAY, DON'T SAY THAT! YOU'RE SCARING ME ALREADY! I'M SENSITIVE TO THIS CRAP!

IT'S ALRIGHT! I'VE HAD A RICH, FULL LIFE... SEEN ENOUGH OF THIS WORLD...

⊘✱!!! BASTARDS!

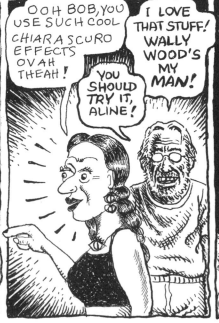

YOU KNOW, ULTIMATELY I GOT *EVERYTHING I EVER WANTED!* I'VE LEFT MY MARK... I'VE HAD THE MOST FABULOUS SEX IMAGINABLE, BEYOND MY WILDEST DREAMS! I'VE BEEN LUCKY THAT WAY! I HAVE TWO WONDERFUL CHILDREN AND A BEAUTIFUL GRANDCHILD!

PLUS I'VE AMASSED A RECORD COLLECTION THAT'S AN EMBARRASSMENT OF MUSICAL RICHES!

I'M FULFILLED.

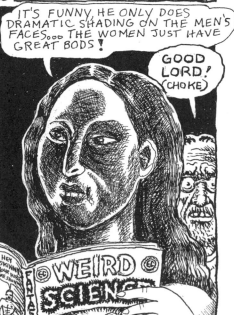

OOH BOB, YOU USE SUCH COOL CHIARASCURO EFFECTS OVAH THEAH!

I LOVE THAT STUFF! WALLY WOOD'S MY MAN!

YOU SHOULD TRY IT, ALINE!

IT'S FUNNY HE ONLY DOES DRAMATIC SHADING ON THE MEN'S FACES... THE WOMEN JUST HAVE GREAT BODS!

GOOD LORD! (CHOKE)

WEIRD SCIENCE

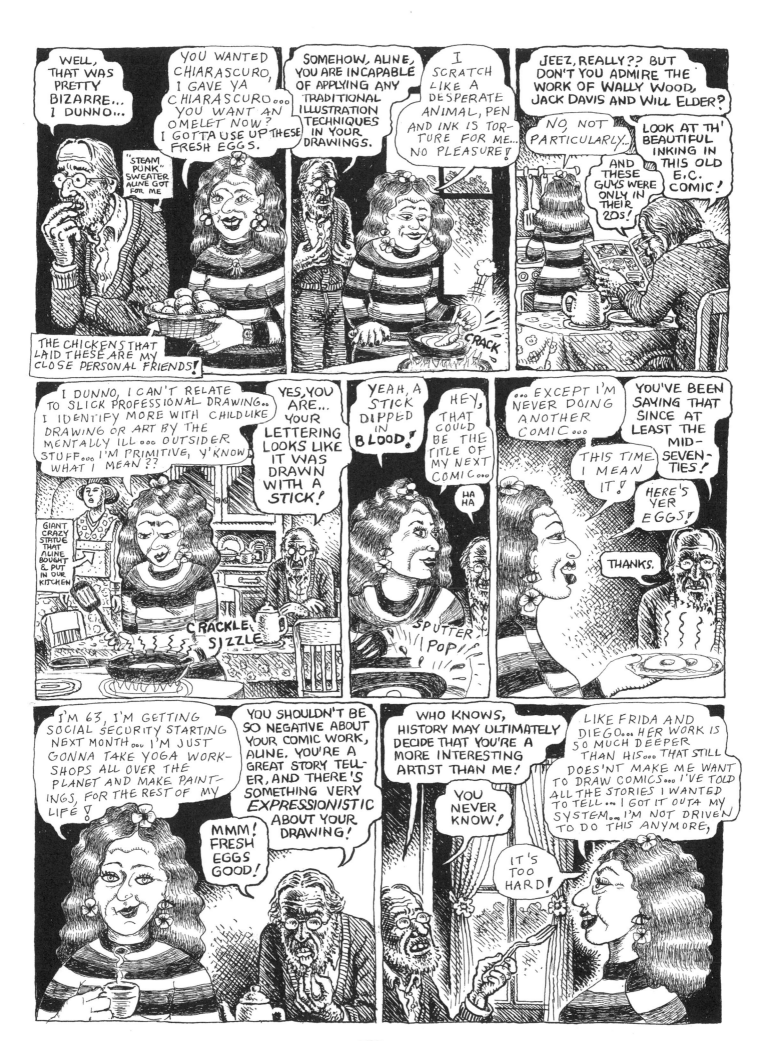

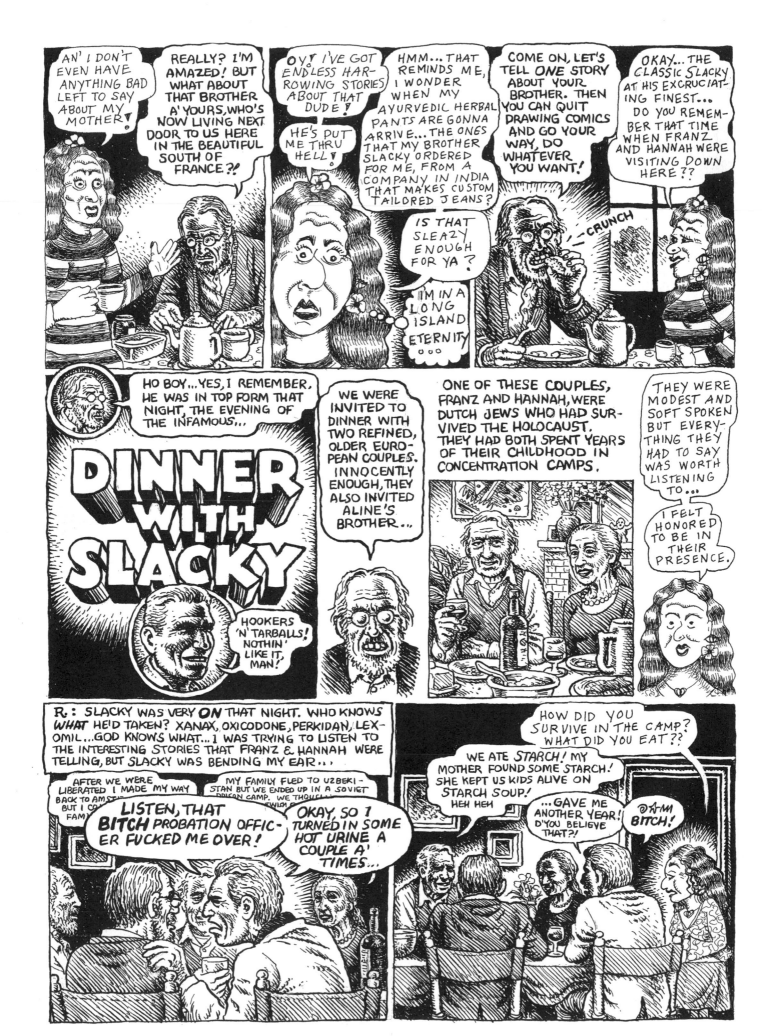

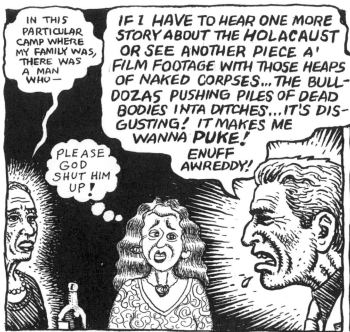

IN THIS PARTICULAR CAMP WHERE MY FAMILY WAS, THERE WAS A MAN WHO—

IF I HAVE TO HEAR ONE MORE STORY ABOUT THE HOLOCAUST OR SEE ANOTHER PIECE A' FILM FOOTAGE WITH THOSE HEAPS OF NAKED CORPSES... THE BULLDOZAS PUSHING PILES OF DEAD BODIES INTA DITCHES... IT'S DISGUSTING! IT MAKES ME WANNA PUKE! ENUFF AWREDDY!

PLEASE GOD SHUT HIM UP!

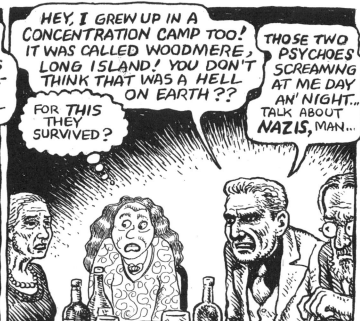

HEY, I GREW UP IN A CONCENTRATION CAMP TOO! IT WAS CALLED WOODMERE, LONG ISLAND! YOU DON'T THINK THAT WAS A HELL ON EARTH??

FOR THIS THEY SURVIVED?

THOSE TWO PSYCHOES SCREAMING AT ME DAY AN' NIGHT... TALK ABOUT NAZIS, MAN...

THE USUALLY TALKATIVE HOSTS WERE SPEECHLESS... AN AWKWARD SILENCE SET IN...

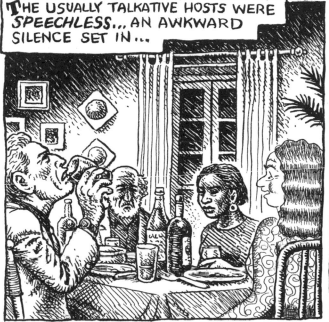

HANNAH STARTED TO SPEAK, BUT THEN SLACKY, OBLIVIOUS TO ALL IN HIS ALTERED STATE, BROUGHT UP ONE OF HIS FAVORITE TOPICS WHEN HE'S HIGH, HIS CLOTHING AND ACCESSORIES...

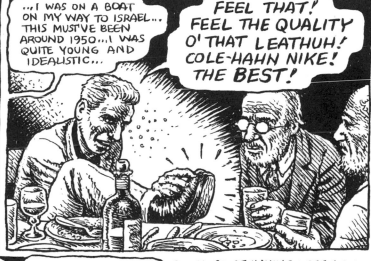

...I WAS ON A BOAT ON MY WAY TO ISRAEL... THIS MUST'VE BEEN AROUND 1950... I WAS QUITE YOUNG AND IDEALISTIC...

FEEL THAT! FEEL THE QUALITY O' THAT LEATHUH! COLE-HAHN NIKE! THE BEST!

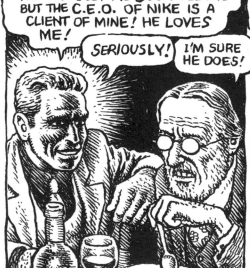

IF I HADDA PAY FULL PRICE FUH THESE SHOES THEY WOULDA COST ME 500 DOLLUHS BUT THE C.E.O. OF NIKE IS A CLIENT OF MINE! HE LOVES ME!

SERIOUSLY!

I'M SURE HE DOES!

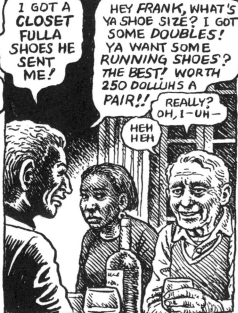

I GOT A CLOSET FULLA SHOES HE SENT ME!

HEY FRANK, WHAT'S YA SHOE SIZE? I GOT SOME DOUBLES! YA WANT SOME RUNNING SHOES? THE BEST! WORTH 250 DOLLUHS A PAIR!!

REALLY? OH, I—UH—

HEH HEH

ALL HOPE OF HAVING LEFT LONG ISLAND INSTANTLY EVAPORATED FOR ME AS THE CRASSNESS OF MY FAMILY WAS EXPOSED... MY EMBARRASSMENT WAS SO ACUTE THAT I HAD A FROZEN SMILE & ROSY CHEEKS LIKE A BEATIFIC MADONNA... I WAS PARALYZED...

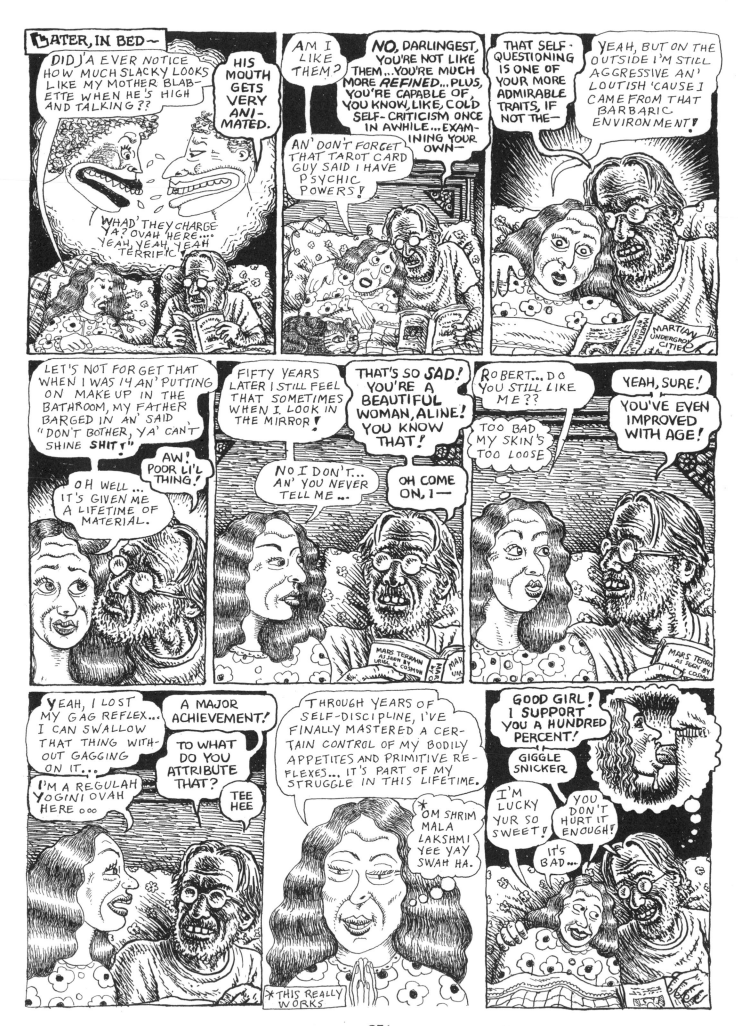

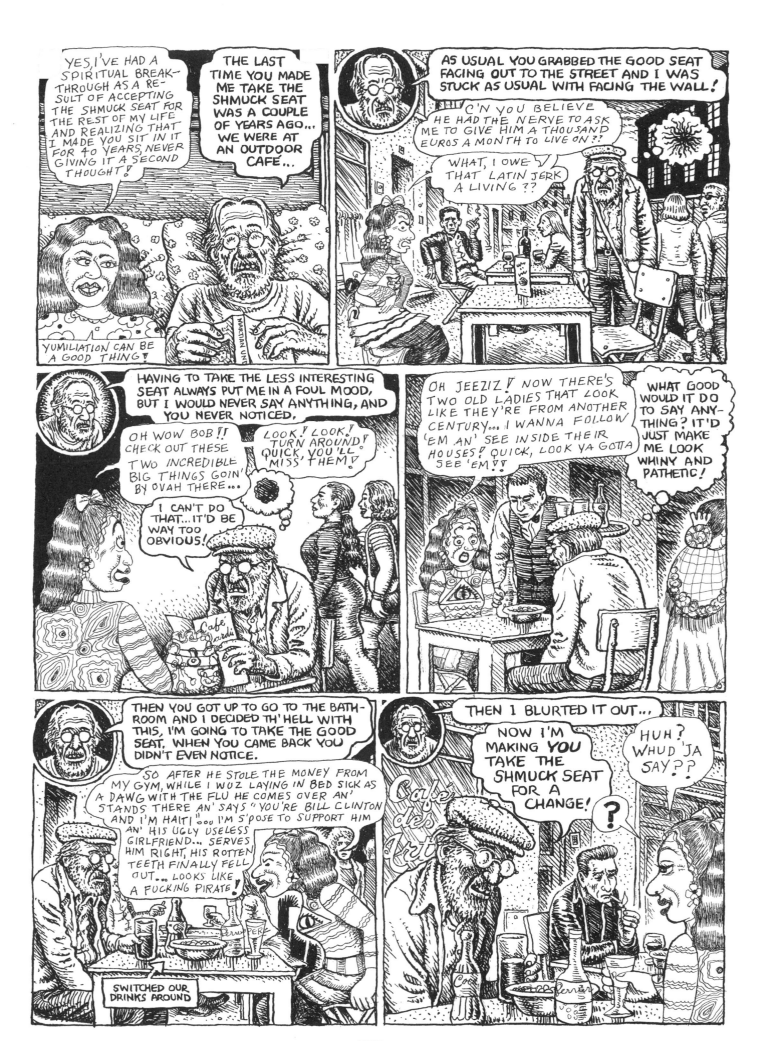

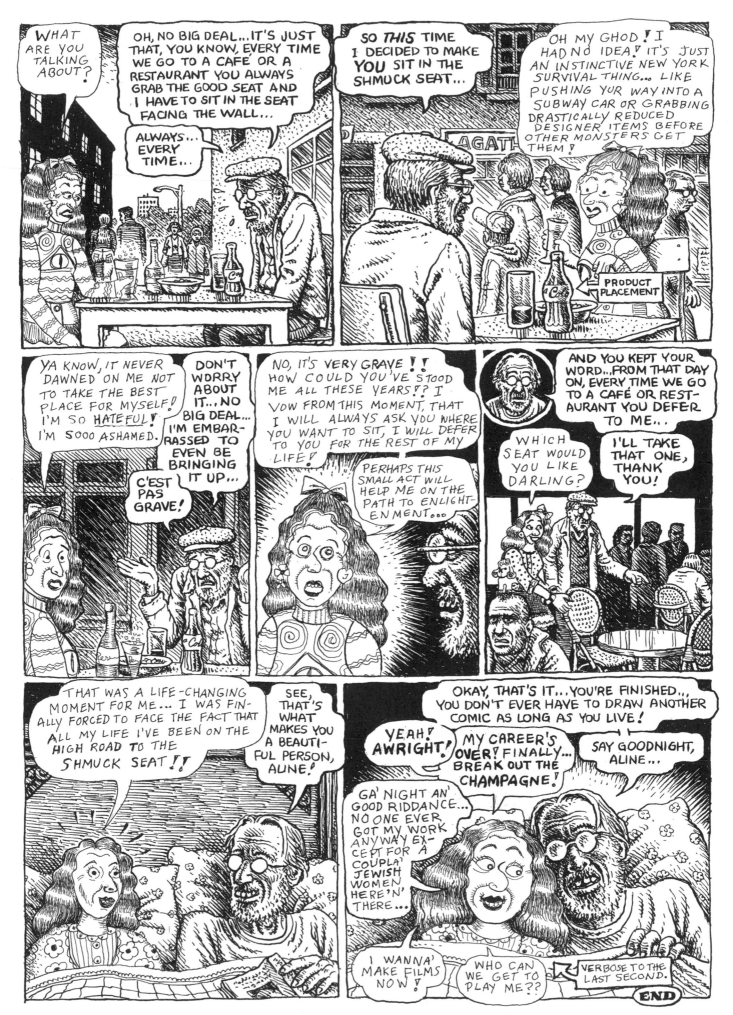

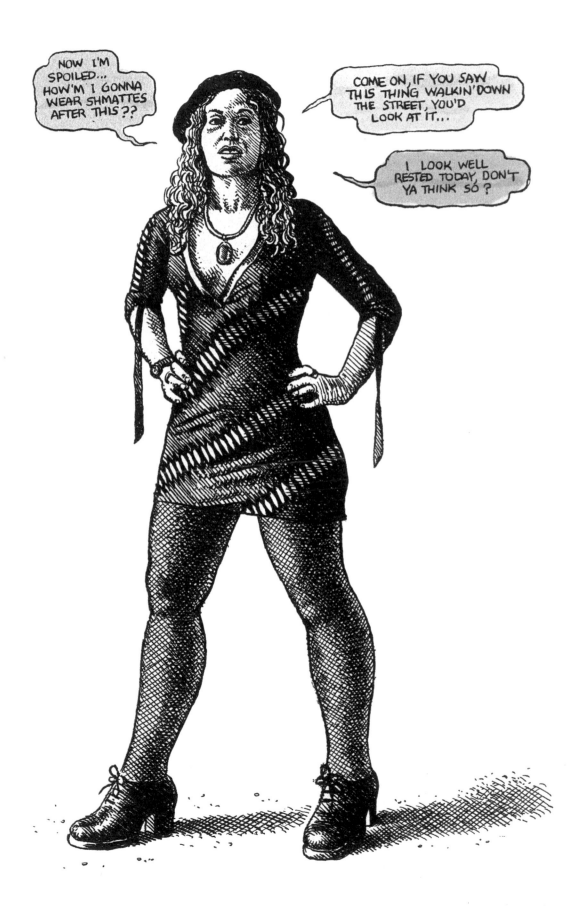

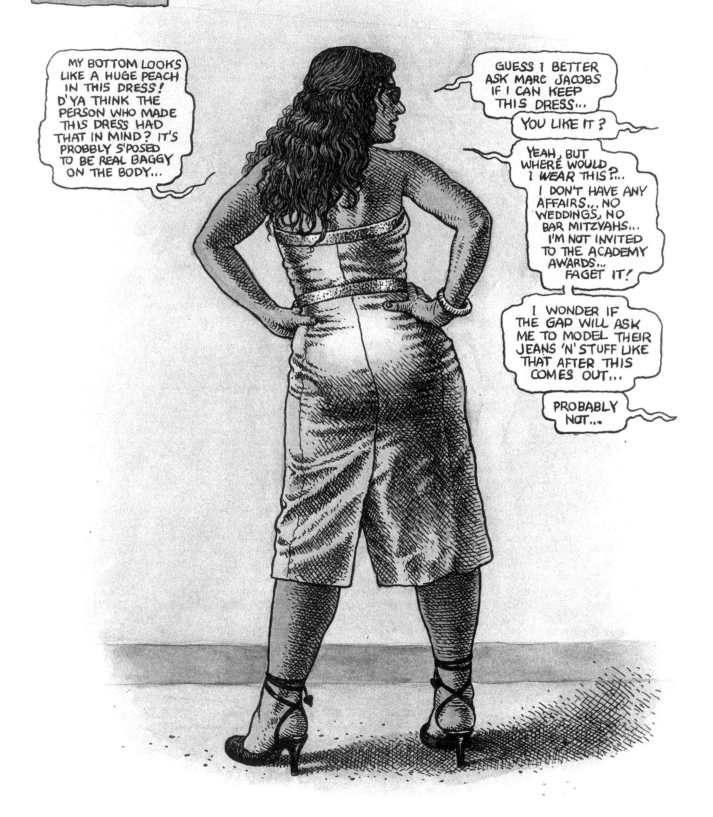

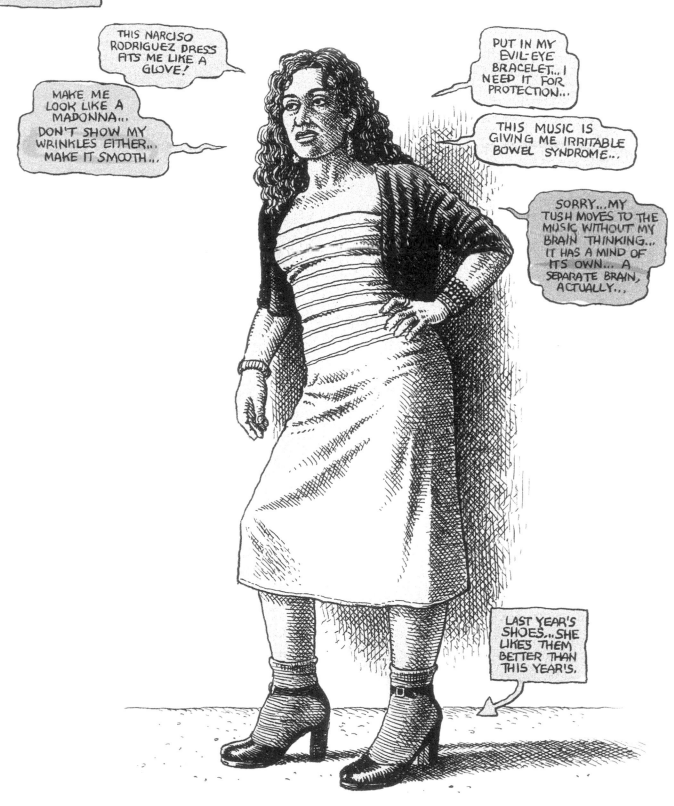

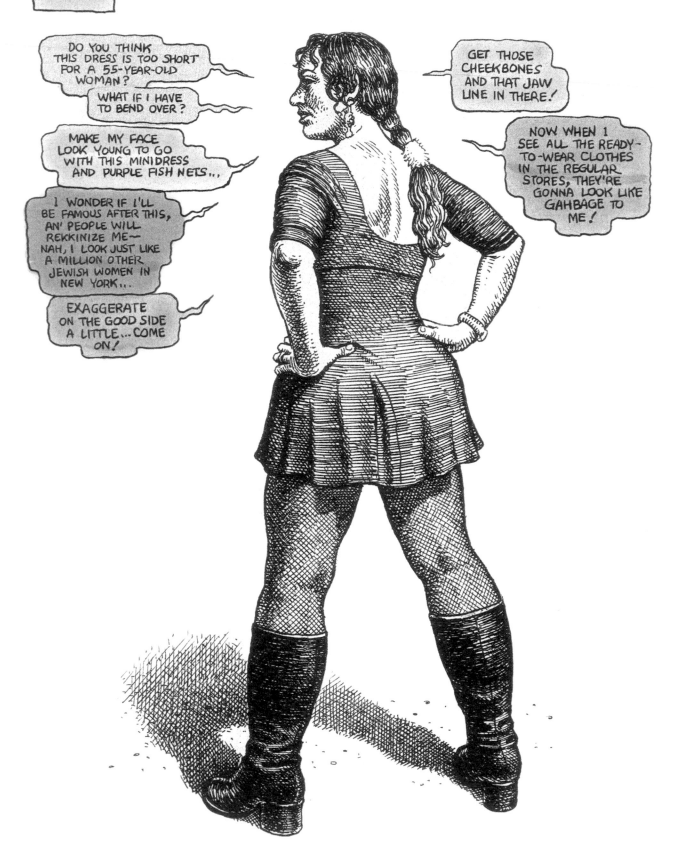

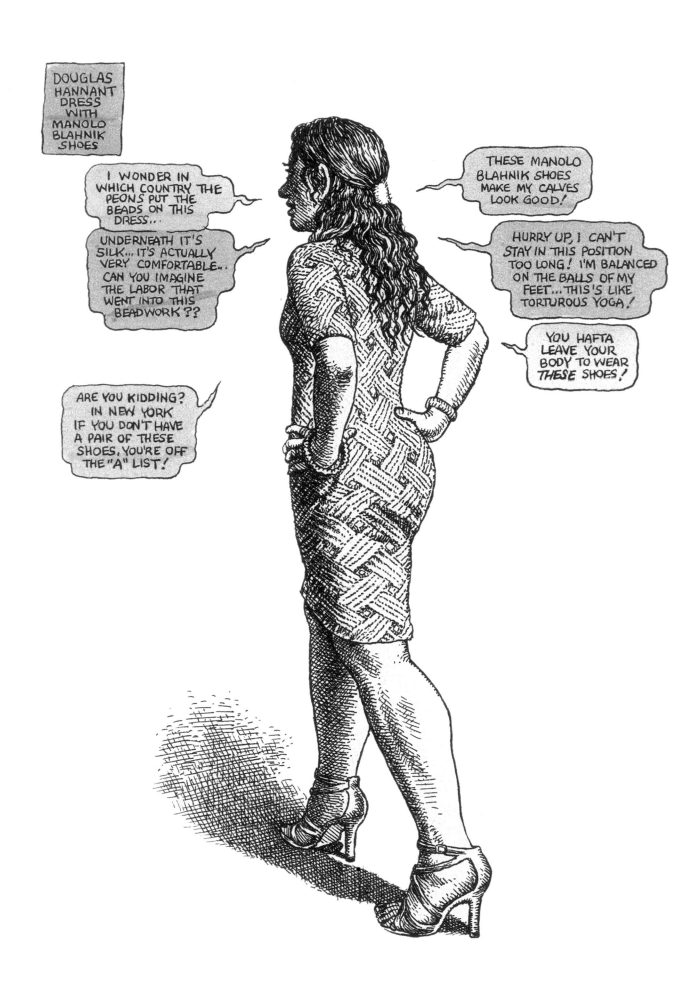

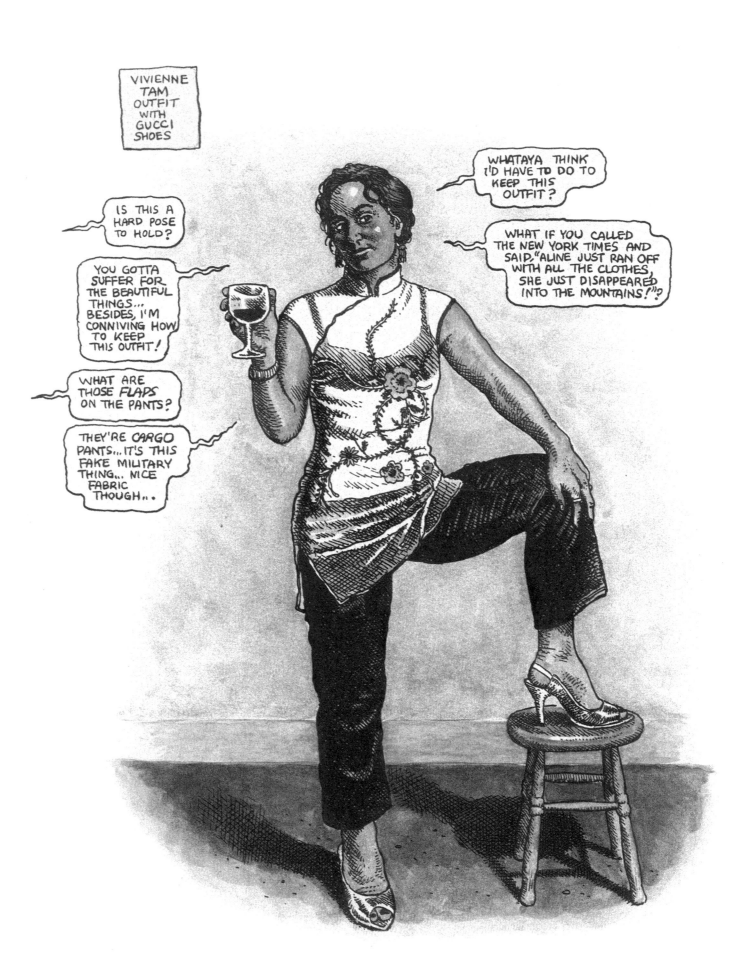

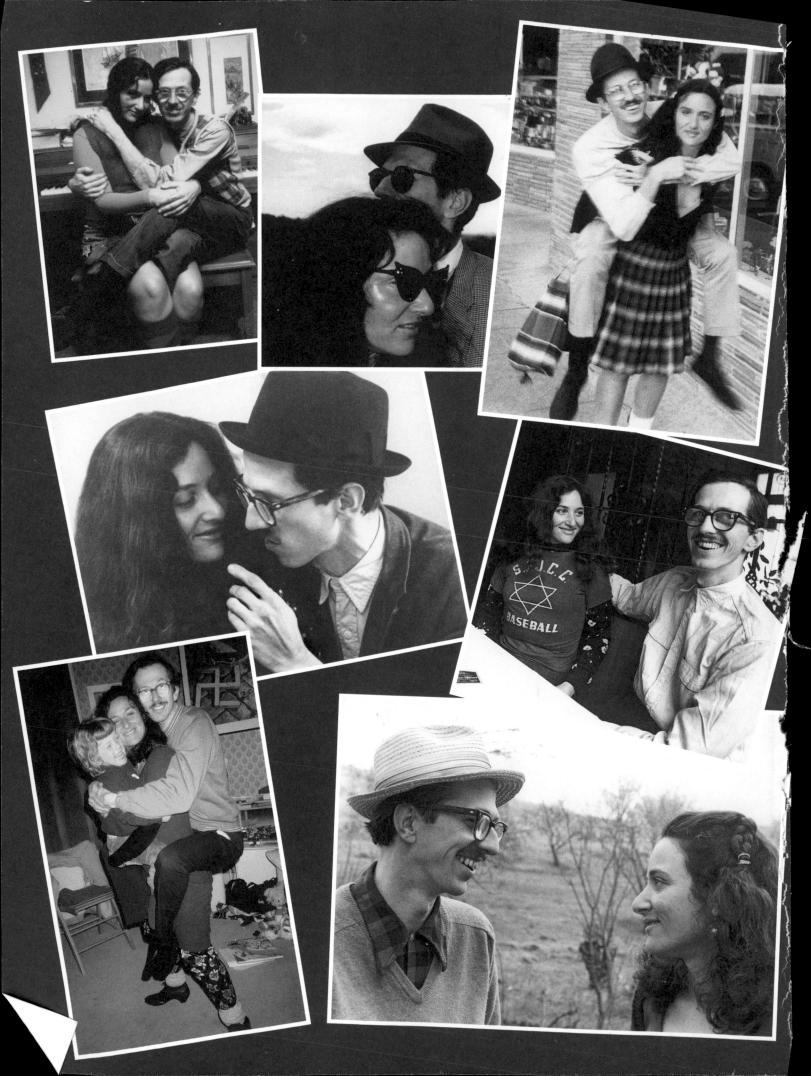